ANDRA F. STANTON

Foreword by
Josephine Stealey

DIMENSIONAL CLOTH

Sculpture by Contemporary Textile Artists

Schiffer
Publishing Ltd

4880 Lower Valley Road · Atglen, PA 19310

Designed by Brenda McCallum
Type set in Goudy/DINEngschrift/Dosis
ISBN: 978-0-7643-5536-3

Printed in China

Published by Schiffer Publishing, Ltd.
4880 Lower Valley Road
Atglen, PA 19310
Phone: (610) 593-1777;
Fax: (610) 593-2002
E-mail: Info@schifferbooks.com
Web: www.schifferbooks.com

For our complete selection of fine books on this and related subjects, please visit our website at www.schifferbooks.com. You may also write for a free catalog.

Schiffer Publishing's titles are available at special discounts for bulk purchases for sales promotions or premiums. Special editions, including personalized covers, corporate imprints, and excerpts, can be created in large quantities for special needs. For more information, contact the publisher.

We are always looking for people to write books on new and related subjects. If you have an idea for a book, please contact us at proposals@schifferbooks.com.

Front jacket image: Wilma Butts, *Anemone* (Photo: Perry Jackson).
Front jacket flap: Abigail Brown, *Blue Tit*.
Back jacket: Andrea Graham, *Monument 7*.

Title page: Mary McCauley, *Reef Forms*.
Pages 2–3: Barbara Shapiro, *Testing Testing II*.
Page 4, *l to r:* Wendy Moyer, *Flor del Dragon / Dragon Flower*. Mariko Kusumoto, *Brooch 1* (Courtesy of Mariko Kusumoto and Mobilia Gallery).
Page 5, *l to r:* Meghan Rowswell, *Morel*. Leisa Rich, *Put the Lime in the Lemon*.
Page 10: Pamela A. MacGregor, *Tea for Two*.
Page 16, *l to r:* Fiona Rainford, *Yesterday's Must Haves*. Pamela A. MacGregor, *Flowering Teapot*. Sandra Meech, *The Last Silence*.
Page 87, *l to r:* Susan Hotchkis, *Metamorphosis*. Andrea Graham, *Magnum Vasculum*. Amy Gross, *Amy's Biotope Collection 3*.
Page 130, *l to r:* Diane Núñez, *Spaces*. Sooo-z Mastropietro, *Impudent Flumpet*. Mariko Kusumoto, *Necklace 2: Seascape with Coral* (Courtesy of Mariko Kusumoto and Mobilia Gallery).
Page 186, *l to r:* Tina Maier, *Sieve Amour* (Photo: Don Felton). Saberah Malik, *Red Line Moving*. Judy Kahle, *I Will Not Be Silent* (Photo: Jerry Anthony).
Page 227, *l to r:* Diane Savona, *Maintain*. Diane Savona, *Mill Bobbins*. Deborah Kruger, *Red Basket*.
Page 253: Abigail Brown, *Woodcock*.
Page 255: Susan Else, *Nothing to Fear* (Photo: Marty McGillivray).

Front end sheets, *l to r:* Gwen Turner, *Seaweed Bowl*. Jennifer E. Moss, *Overgrowth*. Sandra Meech, *Continuum*.
Back end sheets, *l to r:* Leisa Rich, *Rhodocrosite* (Photo: Jonathan Reynolds). Phillippa K. Lack, *Portal*. Diane Núñez, *Spaces*.

Other Schiffer Books on Related Subjects:

Artistry in Fiber, Vol. 2: Sculpture, Anne Lee and E. Ashley Rooney, Foreword by Lois Russell, Introduction by Adrienne Sloane, ISBN 978-0-7643-5342-0

What If Textiles: The Art of Gerhardt Knodel, Contributions by Janet Koplos, Shelley Selim, Douglas Dawson, Rebecca A. T. Stevens, and Gerhardt Knodel, ISBN 978-0-7643-4994-2

Rooted, Revived, Reinvented: Basketry in America, Kristin Schwain and Josephine Stealey, ISBN 978-0-7643-5373-4

To Marty, a special three-dimensional design

CONTENTS

CHAPTER THREE
PLAYING WITH SPACE ... 130

CHAPTER FOUR
TELLING A STORY ... 186

CHAPTER FIVE
TAKE HEED ... 227

The story of the contemporary fiber movement and textile sculpture has its origins in England's arts and crafts movement (1880–1910), with whom the artist William Morris is associated, followed by Germany's Bauhaus School (1919–1933), founded by Walter Gropius, and, more specifically, the Bauhaus School Weaving Workshop.

The arts and crafts movement began as a reaction to the automation, uniformity, and inferiority of architecture and furniture brought on by the Industrial Revolution as well as by the excessive ornamentation typical of the Victorian era. Moreover, its schools meant to encourage the working classes, especially those in rural areas, to take up handicrafts because, according to the prevailing philosophy, without creative occupation, people become disconnected from their lives.

The Bauhaus School continued to explore the primary tenet of the integration of art and craft. The Bauhaus style, also known as the International Style, like the arts and crafts movement's style, was marked by the absence of ornamentation in favor of functional design. Gropius wanted to unite art and craft to arrive at high-end products with artistic merit.

The Bauhaus School Weaving Workshop, however, was a neglected part of the School, made up almost entirely of women. Many of these women, drawn to the self-proclaimed egalitarian aspect of the School, were interested in other aspects of art, such as architectural design, but were shunted into the understaffed weaving program as a result of sexist attitudes. Nevertheless, when textile artist Gunta Stölzl became the director of the Weaving Workshop in 1925, she expanded its technical instruction to include courses in mathematics, and taught techniques in modern weaving and dyeing. The Weaving Workshop became one of the most successful of the Bauhaus initiatives.

The third influence—after England's arts and crafts movement and Germany's Bauhaus School—on the contemporary fiber movement and textile sculpture was Expressionism, a German art movement that grew out of Post-Impressionism, the goal of which was the use of color and nonfigurative abstraction to convey emotion. This movement is exemplified by the work of Wassily Kandinsky and Paul Klee.

All these movements sparked an unprecedented level of innovation, including new designs and the use of unorthodox materials such as cellophane and early synthetics. The brightly colored geometric objects enlivened interest in handweaving and inspired new fabric designs for mass production.

From this point forward, weaving began to evolve. In the United States, the inventive arts and crafts education of the Bauhaus School was introduced through Black Mountain College in North Carolina. Starting in the early 1940s, former Bauhaus School Weaving Workshop innovator Annie Albers, and others, began training a generation of textile artists who went on to be the movers and shakers of the international fiber art movement in the United States.

One such artist was Kay Sekimachi, whose multilayer woven fiber sculptures introduced a method of using shape and dimensionality to achieve visual complexity. Another, Ruth Asawa, crocheted dimensional wire sculptures of abstract forms, which eventually evolved into her use of tied wire to create sculptures rooted in nature.

The studio craft movement marks the fourth influence on the contemporary fiber movement. This was a nationwide trend following World War II, which embraced craft as a serious discipline worthy of university academic study. The Bauhaus model of the artist–designer–craftsperson was integral to these programs and resulted in a new understanding of craft as art. For the first time, craft was discussed and evaluated with an eye toward contemporary art.

Subsequently, artists from a variety of media (e.g., textiles, painting, sculpture) studied and intellectualized the history of textiles, and embraced the artistic potential of fiber. Artists of this postwar era reacted to the modern aesthetic by blurring the boundaries of all media and making connections across disciplines. They turned to a variety of materials to make meaning in their works of art. For example, as early as 1955, Robert Rauschenberg produced his groundbreaking *Bed*, in which he applied quilts, like paint, to his canvas. During the early 1960s, Eva Hesse's practice as an expressionist painter led her to experiment with industrial and found materials such as rope, string, wire, rubber, and fiberglass, and to explore minimalist forms suggesting psychological moods.

Drawn to fiber's aesthetic possibilities, structural potential, and expressive language innate to the material, an extraordinary number of American artists experimented with some form of fiber in their work. The year 1960 pinpoints the full maturity of the contemporary fiber movement in which artists—some trained as painters or sculptors, and some beginning from a textile discipline—found fiber, thread, and textile-based construction to be their materials and processes of choice. As a result, woven textiles were no longer designed to be utilitarian, but rather unequivocal aesthetic objects. Object makers began to self-identify as artists rather than as craftspeople.

From the 1960s through the 1980s, artists trained as weavers paved the way for textiles to enter the world of sculpture by placing collective pressure on the dominant definition of art. For example, well-known artist-weavers such as Lenore Tawney, Sheila Hicks, and Claire Zeisler used fiber to create three-dimensional forms that liberated the medium from the loom and released their work from the confines of fiber's historically subordinated position in the art world.

Meanwhile, fiber sculpture was being shaped internationally by the French initiative—"art tapestry"—a project of the Centre International de la Tapisserie Ancienne et Moderns (CITAM), which sought to legitimize fiber as a medium of fine art in Europe. Founded in 1961, CITAM was at the heart of the textile industry's attempt to revive the art of tapestry by entering into collaboration with well-known artists such as Joan Miró, Fernand Léger, and Henri Matisse. CITAM initiated the Lausanne Tapestry Biennial in Switzerland in 1962 to showcase these collaborations.

By the third biennial in 1967, works were constructed generally off the loom using techniques such as knotting, knitting, braiding, and crocheting, among others. A preference for rough, natural fibers that facilitated hand manipulation, and an embrace of an experimental attitude toward form further distinguished entries to the Biennial. The work of many artists, including Polish artist Magdalena Abakanowicz and Romanians Ritzi and Peter Jacobi, challenged the conventions of traditional tapestry CITAM was attempting to enshrine by using nontraditional materials such as sisal, and creating monumental work and innovative imagery. By 1988, the twelfth Lausanne Biennial was titled Textiles as Sculpture, at which point the definitions of all media had blurred and the realm of sculpture opened up to include any material and form.

Historically, fiber was considered merely "women's work" by the western fine art canon. However, artists who used fiber and were part of the 1970s feminist movement in the United States challenged this designation, providing another important influence on fiber sculpture. This "second wave" of feminism followed the mid-19th-century women's suffrage movement and had as its aim the expansion of female political and cultural recognition and efficacy. Before feminism, most female artists were denied exhibitions and gallery representation based on their gender, but feminist movement artists created alternative venues and worked to change established institutions' policies to promote female artists' visibility and credibility within the art world.

The leaders of the movement, Judy Chicago and Miriam Schapiro, are known for harnessing the anonymous handiwork of women in the domestic sphere. By using the beauty of traditional crafts to subvert the dominant historic narrative that had excluded women, they formulated and disseminated a new understanding of art based on women's social experience. It rocked the art world. Their reformulation continues to affect how we think about contemporary art today.

Many of today's artists associated with fiber sculpture come out of an academic background. However, there is an equally vibrant group who do not have formal art training from an academic program. For example, during the latter half of the twentieth century, an environmental movement—a reaction to the ever-increasing mechanized world in which we live—encouraged citizens to pursue self-sufficiency with a then-nascent concern for the environment. Throughout the years, it has evolved into the philosophy of "recycle, reuse, and reduce waste."

Many artists, including fiber artists, began to subscribe to this notion of preserving the natural world. Some learned their skills and love of fiber from a family member, whereas others attended local, regional, or national workshops. Still others learned by attending textile conferences or by combining all these nontraditional methods. Like artists from academic backgrounds, such artists have continued to push the boundaries of art and the expressive qualities of their materials, techniques, and conceptual ideas.

The other current influence on fiber sculpture is the do-it-yourself (DIY) movement, established by the "millennials" during the 1990s. These self-proclaimed artists have taught themselves crafting skills that were not common during their youth. They have become the newest generation of "makers," which is continuing to grow and gain popularity.

These groups of artists—and their contributions—are celebrated in this book. Their work demonstrates the range of sculptural forms, materials, and processes used to further artists' intent and poetic ideas. They continue the traditions established by earlier generations of artists, while simultaneously pushing the boundaries of the role fiber plays in contemporary art during the twenty-first century.

Josephine Stealey, Chair, Department of Art
University of Missouri

JOSEPHINE STEALEY is a professor at the University of Missouri-Columbia, where she is chair of the Department of Art and former head of the fiber program. She has been part of the contemporary sculptural fiber and contemporary basketry movements since the 1980s, and has written articles and curated exhibitions on basketry and contemporary fiber as well. Currently, she is curating the traveling exhibition *Rooted, Revived, Reinvented: Basketry in America,* at the University of Missouri. She teaches workshops, lectures on contemporary fiber, and exhibits her work nationally and internationally.

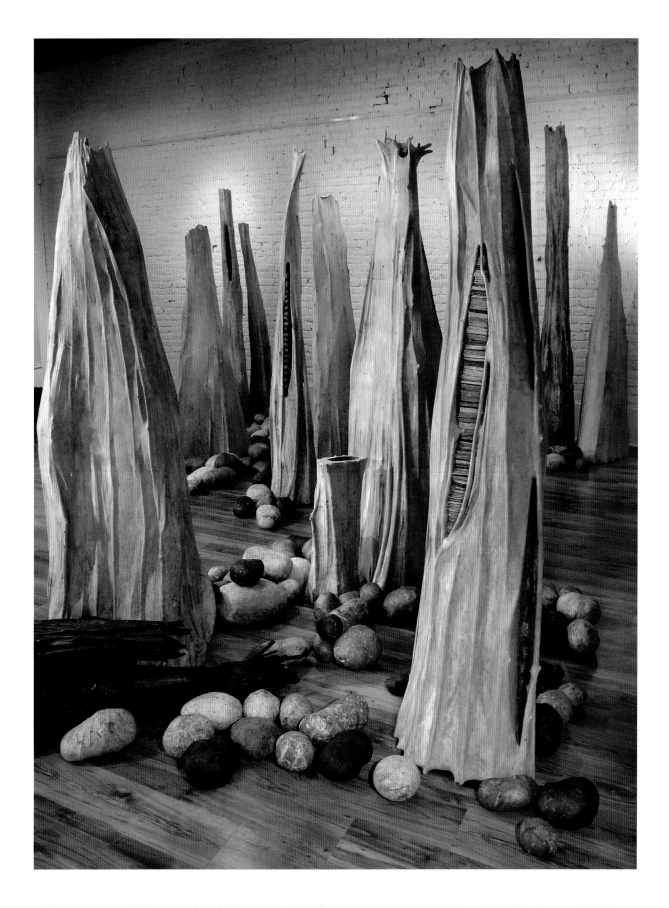

Josephine Stealey. *Forest*, 2009–2016. Variable size. More than 850 cast-paper rocks, more than fifty cast-paper trees and tree parts. River willow, handmade abaca paper, handmade cotton paper. Courtesy of Josephine Stealey.

ACKNOWLEDGMENTS

A heartfelt thanks to all the artists included in this book, who generously shared their lives, wisdom, and work. Thanks to Martha Sielman, Mirka Knaster, Sandra Sider, Michaele Ignon, Nancy Mambi, Linda and Laura Kemshall, Nancy Bavor, Rebecca Stevens, Carol Ann Waugh, Leesa Hubbell, and Joe Pitcher for recommendations and suggestions. Thanks to Cat Ohala for copyediting the manuscript. Thanks to Kay McDonald, Jody Berman, and Laura Goodman for their love, help, and support. Thanks to Brenda Gael Smith for designing my website. Finally, thank you to Nancy Schiffer, who recognized the beauty and importance of the artwork I brought to her attention.

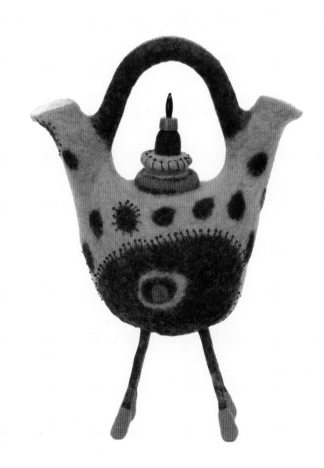

INTRODUCTION
WHAT IS DIMENSIONAL FABRIC ART?

A revolutionary movement during the 1960s and '70s turned the art world—in the United States and internationally—on its head. It was during this time that formerly flat, decorative, or utilitarian objects made of fibers leapt off the wall and floor and propelled themselves into space. Not on their own, of course. Groups of textile artists—weavers, knitters, knotters, crocheters, plaiters, and sewers—got the notion to re-imagine traditional forms as sculpture. Freestanding or suspended, these dimensional works invited a different kind of inspection. All at once, the viewer had access to all sides, surfaces, and contours of a piece, creating a more dynamic, physical engagement with and emotional connection to it.

Traditionally, the use of dimensionality was reserved only for artists who sculpted more established materials—stone, metal, or clay. When introduced to fiber sculpture, art critics initially turned up their collective noses. This work and its eclectic materials stood in opposition to conventional aesthetic definitions of fine art.

Such transgressive art appeared less than a handful of times during the twentieth century, including Picasso's use of cloth in his Cubist collages, and during the Surrealist period in the 1930s when Meret Oppenheim's fur-lined teacup and spoon became an icon of that movement's disdain for realism in favor of the fantastic. Granted, fur is not a fiber, but its use was a break with customary sculptural materials. Finally, between 1945 and 1960, when Abstract Expressionism came to the fore, Louise Bourgeois's sewn, sexually explicit forms symbolizing the feminine psyche lit up the nascent feminists and prefigured the installation art that would become a hallmark of early textile sculpture.

So what did this revolutionary sculpture look like? For one, it often entailed the flow of fiber—lots of it—as in Sheila Hicks's *Pillar of Inquiry/Supple Column*, in which cascading cords of brilliantly colored thread dominate; her *Banisteriopsis*, a pile of bound gold linen that becomes a low, soft wall; and *Mandan Shrine*, skeins of long linen tails bundled with vibrant yarns.

Sheila Hicks. *Mandan Shrine*, 2016. 118.5" × 53.5". Linen, cotton, synthetic fibers. Courtesy of Joslyn Art Museum.

Jagoda Buic's *Fallen Angel,* a woven brown object suspended from a metal ring, resembles a space capsule, whereas Françoise Grossen's twenty-foot-long *Inchworm* uses pale knotted cords to form five humps, with ropes running out from its sides, suggesting abundant legs. Although representing no specific image, all these objects were formed meticulously, creating tension between a sense of randomness and deliberate conception.

Besides teeming threads and cords, other artists used fabric in heretofore unprecedented ways. Polish weaver Magdalena Abakanowicz used panels of cloth, labeled *Abakans* by an art critic, to evoke skin, hides, and organs as a reflection of the violence the artist witnessed during World War II. Her later work, during the 1970s and '80s, consisting of human figures of burlap and gauze, later cast in bronze, represented her critique of the conformity enforced under communism.

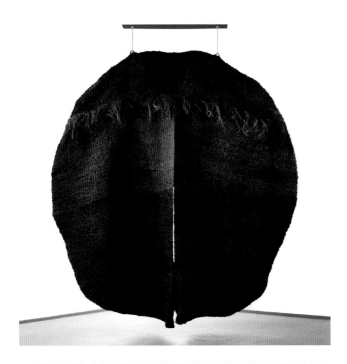

Magdalena Abakanowicz. *Red Abakan III*, 1970–1971. 9.8' × 9.8' × 1.4'. Sisal. Courtesy of Fondation Toms Pauli, Lausanne, Switzerland. Photography: Arnaud Conne, Lausanne.

At the same time that fibers were moving away from the wall, stuffed fabric sculpture also came into prominence. The main innovator was Claes Oldenburg, who produced, during the 1960s, soft objects rooted in popular culture—typically many times their usual size. Examples include a canvas electric plug the size of a sofa and a massive bag of overflowing, fried shoestring potatoes. By morphing their scale, he imparted a mystery and power to these commonplace objects, which he associated ultimately with the growing and destructive consumer culture he observed. Probably because his work was based on recognizable and trendy objects, Oldenburg's work was accepted readily by the art world and came to epitomize the Pop Art movement.

But that was then and this is now. These days, any technique and any material is fair game for artists. Fiber is used like any other material in the artist's studio—a tool with which to make art. The proof is in the refusal of many artists to be defined by the components of their work. The important question regarding any work today is not "What media does it use and how?" but "Is it good?"

Yet, fiber continues to attract a multitude of artists seeking to explore the technical concerns unique to it. In fact, decades after the textile revolution of the 1960s, sculptural textile art is seeing a revival as older artists mature and find their oeuvre, and younger ones begin to examine abstraction and dimensionality.

In this book I focus on a subset of sculptural textile artists: those whose work uses fabric as the primary element of their sculpture. I define fabric as a tightly woven web of natural or artificial fibers such as cotton, silk, flax (linen), wool, polyester, or nylon, among others. Because it is well represented elsewhere, I have not included art that is comprised mainly of jute, sisal, bamboo, or other basket-making materials, or hand-cast or commercial paper. Also, in some cases I have included two-dimensional art, although my original aim was to showcase three-dimensional work only. It was too hard to resist.

In the sculptures you see within these pages, the fabric is manipulated to form representational or fabulous configurations that are meant to stand conceptually—and often literally—on their own. Manipulation includes a multitude of methods, such as hand- and machine-sewing, embedding, coiling, embroidering, piling, stuffing, painting, waxing,

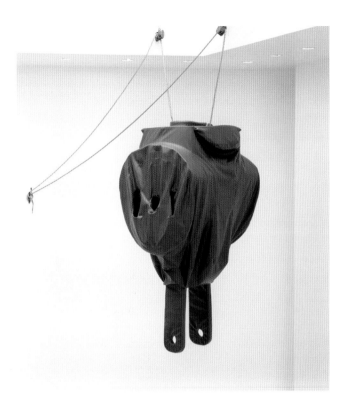

Claes Oldenburg. *Three-Way Plug—Scale A, Soft, Brown*, 1975. 12' × 6'5" × 4'11". Vinyl, polyurethane foam, Masonite, wood, wire mesh, metal, rope. Courtesy of Walker Art Center, Minneapolis. Gift of the T.B. Walker Foundation, 1966.

burning, discharging, twisting, rusting, bonding, wrapping, and so on, and may call for a system of visible or invisible supports, or armature, made of metal, plastic, wood, or the sturdy fibers of stiff interfacing, for example. The fabric might be embellished further with found, handmade, or manufactured objects. The artists are limited, it seems, only by their imagination and the skills they can garner to translate their ideas into reality.

These ideas run from the prosaic to the phantasmagorical, from a lacy teapot to a dense population of outlandishly colored felt coils, from a soft rendering of a collection of fortune cookies to a monumental pillar of words. One artist reproduces myriad bird species whereas another turns fabric tubes into painterly compositions. A room-filling installation incorporates forty ambulating silk and cotton figures to convey the psychological alienation experienced by refugees as they flee violence and seek asylum in strange lands. A work by a different artist also uses suspended chiffon panels, but these are embroidered with words to convey the themes of memory, mortality, and personal legacy.

For some of the seventy-eight artists included in this book, it is the very nature of the fabric to which they have devoted themselves that drives their work—the light-reflecting qualities of silk, the fragility of cotton gauze, the diaphanousness of chiffon, the sense of decay accompanying rusted cotton. Or, it might simply be a swath of white or black cloth that entices and moves them into action. One such artist described this process as "bringing fabric to life."

For other artists, a fascination with the natural world inspires them—in particular, the eternal processes of germination, growth, deterioration, and extinction. Ideas about remembering the past and anticipating the future figure largely in many works. For so many, dimensional fabric art is art that communicates, advancing views that go beyond the literal meaning of the materials pressed into service.

That these artists specialize in fabric is a given, but one might ask *why*. A primary reason is that fabric affords both the artist and the art lover the opportunity to explore texture—that is, the tactile feel of its surface. Although it is true that paint, for instance, can be textured with brushstrokes, built up into rough peaks called *impasto*, or even elaborated with sand or other additives, paintings—by and large—remain relatively smooth surfaces. In paintings, visual texture, then, is an illusion.

With cloth, on the other hand, we do not have to imagine hills and valleys, bumps and dips; we can see and feel them. We see the exact direction of the weave and weft, feel the prickliness of a natural fiber. We can trace a stitched line and follow it over an entire surface, even through holes and gaps of light. In this way, the object becomes a kind of landscape along which our eyes travel with a sense of movement, space, and time passing.

In other ways, too, cloth connects us to the natural world. In modern times, in which we are surrounded by technology and manufactured goods, we often feel removed from nature. In the same way we are sometimes starved for a patch of grass or a shady tree, we often experience an undefined

yearning for organic textures and the irregular forms of Earth's rustic elements. With fabric, there is the sense of the haptic, a satisfaction of the demand for physicality and the call to touch.

Moreover, the look and feel of cloth evokes deeply held somatic memories synonymous with physical engagement. Fiber has an alliance with human flesh and is bound up with corporality and transcendency, life, and death. The soft blanket slept under, the cozy sweater donned in cold weather, the fluffy stuffed animal of one's childhood—all are comfortable visual and tactile images embedded in our psyches. As Polly Ullrich tells us in *Material Difference: Soft Sculpture and Wall Works* (Seattle, WA: University of Washington Press, 2006), because the body and mind are connected,

[f]ibrous materials recall what our bodies feel like from the inside and also from the outside as we reside in space—an intertwining of physical and psychological unity. And because they irrefutably remind us of our modest place—as just one among many perishable beings—in the material world, they are radical, a far cry from classical Western philosophy which locates aesthetics and perception as a singular discourse of the "higher" abstract mind, not within the totality of the "lowly" body and the physical world in which it resides. (p. 11)

In fact, it was this argument the proponents of the 1960s textile movement put forward to refute the notion by art critics that textile art was not art at all, but craft—meaning, an extension of the handiwork mostly women (mostly poor women) learned to run a household. In other words, it was deemed merely an extension of "women's work" as opposed to an art form that required a formal, rigorous set of skills and, most important, a higher level of thought and conceptualization, such as those used by painters, sculptors, and architects. The work of the early fiber artists was dismissed as purely decorative.

Decades later, this distinction is, in large part, no longer an issue, with fiber artists the victors. It is useless to dispute the idea that the artists of yesteryear who dissembled weaving by emphasizing the space between crossed threads, and hanging these grids in space, were anything other than mavericks whose work proved textiles can, indeed, be used as an expressive rather than utilitarian or decorative force. Then

as now, fiber artists do not seek assimilation into traditional art forms, but rather find in fiber's physicality an intriguing alternative aesthetic modality.

That very materiality leads naturally to explorations of dimensionality. One might say fabric sculpture is fabric's textural qualities on steroids. If one can create a small pucker with a stitch, why not go further and create a fist-size pucker or, larger still, one to fill a room? Although "sculptural" is not always better than "flat," cloth manipulated into dimensional space affords the artist opportunities for a fuller exploration of the medium along with the ideas intended to be communicated with those manipulations.

Objects composed of cloth contrast with the hard-edged sculpture made from traditional and, therefore, one might say "masculine" sculptural materials such as stone, although cloth sculpture can also be monumental like stone. It possesses the potential, then, to be either massive or delicate, weighty or ethereal. Its inherent malleability provides the artist with choices.

Cloth sculpture shares with traditional sculpture the same expressive vocabulary; rectilinear shapes suggest stability; angular shapes, instability; and curved surfaces, organic forms, for instance. Yet, fiber's fragile individual threads transformed into freestanding art objects convey both a kind of strength and structure that traditional sculptural materials do not. Fiber is therefore unique in its symbolic power, its potency for abstraction and interplay of conceptual meanings. An example is the dichotomy of empty holes defining a space, empty holes connecting one side of the object to another side by directing the viewer's eye, and holes that stand as a metaphor for making the invisible visible—all issuing from a single thread.

Many of the artists in this book seek to transmit through their art ideas that are of great import to them. For some, though, their work signifies nothing other than itself—an object that simply exists in the world.

Art is enjoyed by many people for many reasons. Its purpose has changed throughout the millennia. Probably the oldest purpose of art was as a vehicle for spiritual and religious ritual. Think of the prehistoric cave paintings of Lascaux, France, or the many religious figures portrayed in the art of the Middle Ages. Art has also served as the recording of a specific event or place, or as social or political commentary about those events and places. Norman Rockwell's paintings

reflect small-town American life, for example. And art is an agent of beauty, in whatever form the artist finds it.

But, the primary reason the textile artists in this book make art is to contribute to the story of humanity, of what it feels like to be alive in this time, in this place. Whether their contribution describes the passage of time shown through images of decay or the beauty of a single, warbling bird, all artists have a vision to proffer a feeling that might resonate with their audience. Each piece becomes an opportunity for an empathic knowing, a mutual understanding, a kind of communion between the artist and the viewer. Even for those artists who mean for their work to represent nothing other than what they literally describe, their creations can be interpreted as a form of communication: "This is what I see."

With their art, these artists offer up what they observe and understand of the natural world or of the world of ideas, and challenge viewers to see what they see, feel what they feel. Yet, they also leave room for observers to make their own decisions about what is being seen and how to feel about those images. Thus, the objects created by these artists ask receivers to enter into a relationship with the artist. It is as if we, the audience, are witnessing one individual's emotional response to life and are being asked to experience what she or he is experiencing and wonder about it.

Real art, as it is shown here, is infectious. Receivers of true artistic expression are so united to the creator of that artwork that they feel as though the work is their own, as if what is being expressed is what they have longed to express themselves. A sincere work of art destroys the barrier between artist and audience, and hence makes room for a sense of union.

As the artists represented in this book bring their inner lives into consciousness, they also enter the consciousness of their viewers, and in so doing, invite all of us to shed our psychological isolation and come together for one moment to observe the world with another human's heart.

Claes Oldenburg. *Shoestring Potatoes Spilling from a Bag*, 1966. 108" × 46" × 42". Canvas, kapok, glue, acrylic paint. Courtesy of Walker Art Center, Minneapolis. Gift of the T.B. Walker Foundation, 1966.

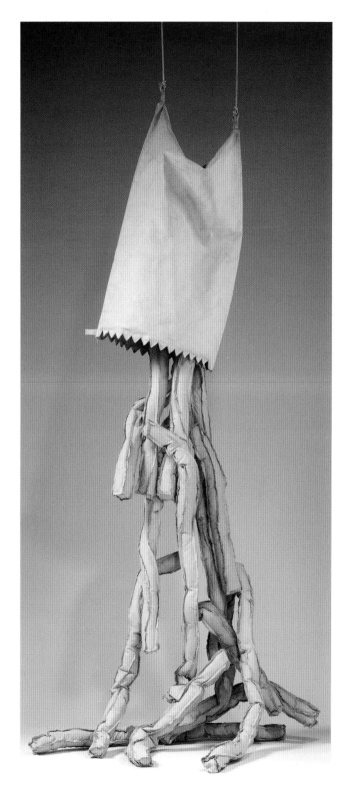

CHAPTER ONE
INVESTIGATING NATURE

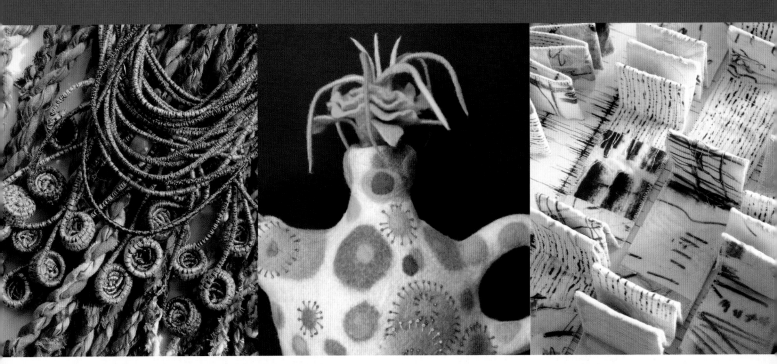

Creativity leads artists down many paths, and for many the natural world itself is the well from which they draw their creativity. To be able to express the joy of living, to explore the smallest fraction of the planet's wonders, provides the inspiration that propels artists to express their most genuine and heartfelt sentiments.

No wonder, then, so many textile artists seek to testify to their deep and abiding love of nature. Sometimes it is the performance of natural light as it plays off of objects, creating movement and rhythm even as it remains constant. Sometimes it is the flow of water over an object, shaping and ultimately destroying it. Sometimes imitating nature as closely as a medium allows, as when a textile artist recreates a bird or a flower, provides the satisfaction desired.

Most artists who use nature as their creative wellspring concentrate on their immediate surroundings. The details of that environment bring purpose and character to their work. Melody Money, for example, lives on a mountain in Colorado and her works often depict the way sunlight or moonlight dances along its stony ridges, pine groves, and waterfalls. Debbie Lyddon lives in a cottage by the coast of Great Britain's North Sea and her works explore what happens to cloth when exposed to the environmental elements there.

Debbie Lyddon
United Kingdom I www.debbielyddon.co.uk

Debbie Lyddon. *Tarpaulin Cloth No. 3*, 2014.
1.5' × 1.7'. Linen, wire, wax, rainwater.
Courtesy of Debbie Lyddon.

Debbie is a mixed-media artist whose first career was as a flutist in professional orchestras. When she began having children, though, it became difficult to continue to pursue her orchestral work. She chose to leave it behind and, as she did, she started taking art courses. She got hooked.

Lyddon says, "My work explores landscape and place. My inspiration comes principally from the art produced by the St. Ives artists, a group working in Cornwall from World War II to the 1960s. They explored ways to apply modernist abstraction in their paintings and sculptures to what they saw in their surroundings. These artists didn't want to create a literal reproduction of the landscape; instead, they wanted to present ideas founded on their experience of the landscape using light, space, and movement." Thus, in her work, Lyddon strives not to represent the actual scenes she observes, but, more important, to convey how each feels, so the viewer intuits the experience of actually being there. In this way, she tells a story in an abstract and ambiguous way, leaving room for observers to create their own narrative.

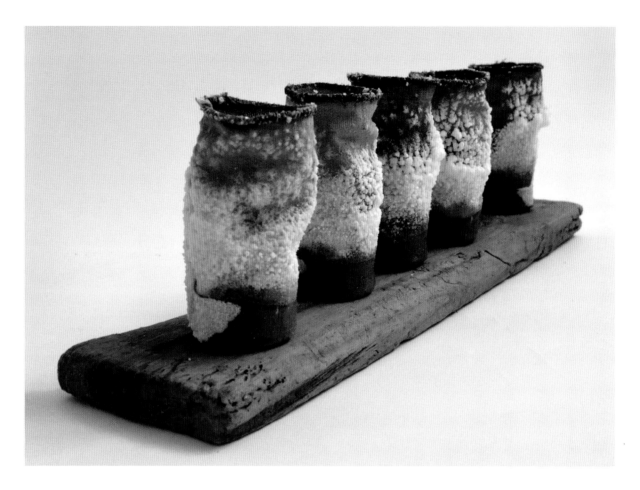

Residing near a coastline, Lyddon is exposed constantly to the natural phenomena there—birdsong, for instance, and the wind and the waves. These sights and sounds form a repetitive and rhythmic pattern like music for her. She is also acutely aware of this landscape's continuous mutability, because nothing is the same from moment to moment.

In her work, Lyddon explains, "I use cloth because we all have a fundamental and intimate relationship with cloth. It's found in every culture. Besides serving as clothing and protection, I like to think of it as a memory keeper whose natural qualities talk to us, narrating ideas about the environment from which it came, in an abstract way."

Lyddon sometimes submerges her cloth in seawater, letting it rust and disintegrate as it would if it had been subjected naturally to the elements. She might coat it with the materials used typically to protect seaworthy cloth, such as wax, bitumen, and varnish. These efforts represent ideas of process and change.

Her work *Tarpaulin* "hints at lost or discarded flotsam and jetsam, paraphernalia dragged in by the tide, the use of which has been undermined. It could be an old canvas casing, a disintegrating covering, or a fragment of a ripped sail; it is suggestive of a former utilitarian function. As you look closer, clues to its identity are revealed. Although purposely ambiguous, it aims to encourage viewers to create stories around it: how it was used, how it got to the shoreline, and what it means that it did."

For that work, Lyddon sewed iron-wire eyelets into a strip of linen, pleated the cloth, then stitched it to a larger piece of linen. The entire piece was dipped into the sea to rust the wire and mark the cloth. After stitching around the eyelets, she waxed some of the cloth and dragged it on the sea bottom, where the mud there could stain the unwaxed areas. In this way, Lyddon notes, "Using the sea to rust metal, and mud to mark cloth, connects the piece to the environment it is evoking."

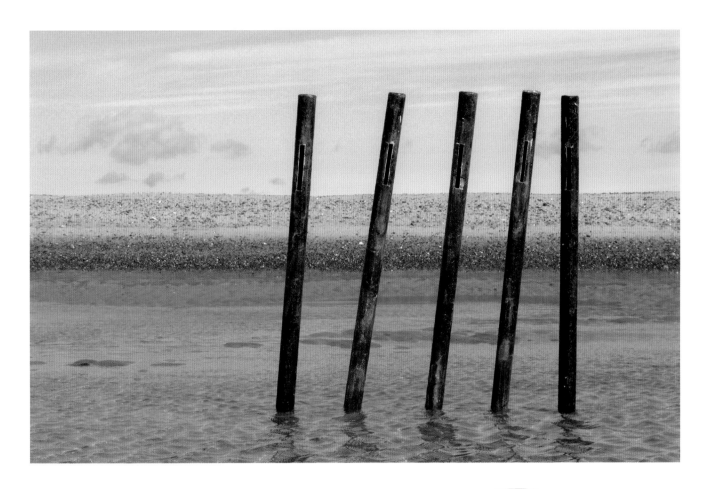

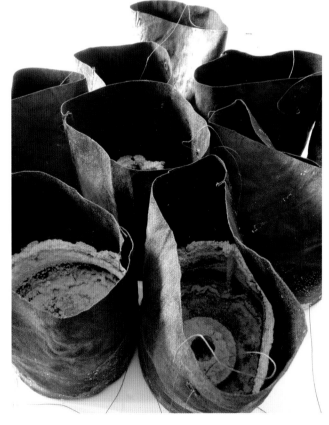

In another work, *Blue Salt Pots*, Lyddon also explores
the idea of passing time and the changes that accompany that
process. The pots are made of linen and are turned upside
down in a container saturated with salt solution so they be-
come soaked. They are then left alone as the water evaporates.
Debbie says, "The process takes time—in this case, ap-
proximately one month. The ephemerality of the medium
and the resulting salty deposits and encrustations express,
for me, the transformation of matter into time."

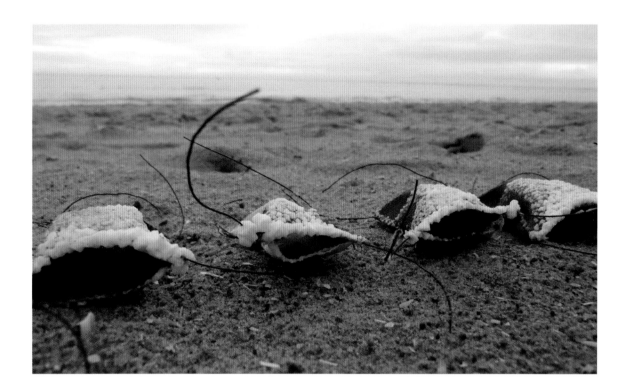

The objects that comprise *Aeolian Pipes* are made of felt stiffened with paraffin wax and Damar Resin. Lyddon explains, "*Aeolian Pipes* explores the connection between the visual and aural landscapes of the North Norfolk coast. The wind is the principal material in this work named after Aeolus, the ruler of the four winds in Greek mythology. As a flutist I am used to the idea of breath passing through a tube and making a sound, so it's a short step to using the natural phenomenon of the wind, an element very much in evidence in this bleak but beautiful landscape, to bring cloth alive by making it sing. And the pipes do sing. The pitch rises and falls as the wind strengthens and subsides."

For her piece, *Bitumen Buckets*, Debbie coated canvas buckets with bitumen paint and filled them with saltwater. They were left alone for a few weeks until the water evaporated and left a salt crust. A found rubber fishing float rests in the bottom of each one.

Lyddon's *Sea Purses* and *Sluice Creek Clot Masts and Halyards* are part of a series that further explores the artist's process of collecting and documenting. She says, "Inspired by a week-long project to collect and document actual objects from the beach, I created new objects from my imagination. They could well have been found on the strand line—the threshold between land and sea. The aim of this series is to evoke a coastal landscape through the use of naturally occurring materials, such as salt, without exactly describing it."

TOP
Debbie Lyddon. *Sea Purses*, 2016. 5" × 5" × 1.7". Linen, wire, saltwater. Courtesy of Debbie Lyddon.

ABOVE
Debbie Lyddon. *Sluice Creek Clot Masts and Halyards*, 2016. 7.8' × 1.5'. Linen, wire. Courtesy of Debbie Lyddon.

Denise Lithgow is a textile artist specializing in wool felt, possibly, she says, because she grew up on a merino sheep farm in Australia. When she was a child, her mother taught her dressmaking and knitting. Lithgow attended local community courses in photography and ceramics, as well. As a young adult, she pursued fashion design and eventually established her own label. But, once she was introduced to textile art at an exhibition at Sydney's Royal Botanic Garden, she knew her destiny. Today, she exhibits regularly throughout Australia and internationally. With support from her abstract expressionist husband, she is now teaching textile art, too.

Lithgow's aim when designing her pieces is to create splendid objects that relate to the landscape around her. She says, "I hope to convey a message of my strongly felt connection to natural beauty."

For *Red Rising Vessel*, Lithgow found inspiration in the countryside. The lakes and fallen logs she observed are represented by circles and lines, and the color red symbolizes the earth. In a way, these shapes are the artist's secret code, suggestions rather than hard facts, gestures rather than words. Yet, her minimal visual elements resonate with the viewer; one may not know the code, but one senses the creative impulse behind it—the unadulterated joy of constructing simple although powerful representations of nature.

Felt is believed by many scholars to have been our first textile, and the survival of nomadic cultures depended on this fabric for their clothing and gear. Thousands of years later, the basic principles of making felt from wool remain the same because of the fiber's unique physical and chemical components. When subjected to friction, moisture, and pressure, wool hairs intertwine and matt. The longer they are manipulated, the denser and stronger the consequent felt becomes.

Lithgow understands this process and it guides her work. She uses it to construct vessels such as *Tracks* and *Pebbles*. *Sea Anemone*, a black-and-white sculpture with strong, simple lines, is meant to impart strength to the image and the suggestion of a beach landscape. She created the black spikes by layering wool in two directions and rolling it over a piece of thick foam until very thin, leaving one end fluffy. The spikes were attached to the body by meshing the fluffy ends into the white fiber of the body.

Denise Lithgow. *Red Rising Vessel*, 2015. 2.6' × 1.3'. Merino wool. Courtesy of Denise Lithgow.

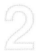

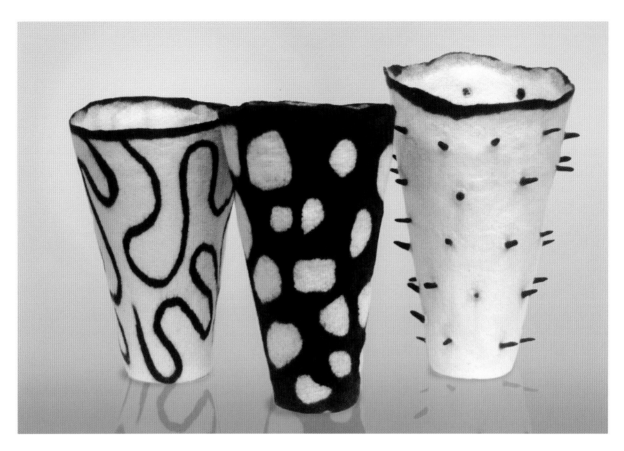

Lithgow explains, "The felting process starts by rubbing warm soapy water into the wool fibers with a synthetic cloth. For this piece, I worked around the spikes so they stayed upright. Then I rolled the entire sheet until it was fulled, or thick. At that point, it was shaped over a mold to create a uniform vessel. Before drying I painted an acrylic varnish over the entire interior, which helps it to hold its shape during shipping."

Regarding Lithgow's *White Ribbed Shell Vessel*, she says, "The inspiration for this vessel was the seashells I found in the littoral zone on the beach. I deconstructed the raised ridges of the shell to create the ridges of the vessel. With this piece, I'm looking for an emotional response by the viewer, and so a connection to the viewer."

ABOVE
Denise Lithgow. (Left) *Tracks*, 2015. 1.6' × 1' × 1'.
(Middle) *Pebbles*, 2015. 1.8' × 1' × 1'.
(Right) *Sea Anemone*, 2015. 1.7' × 1' × 1'.
Merino wool. Courtesy of Denise Lithgow.

RIGHT
Denise Lithgow. *White Ribbed Shell Vessel*, 2016. 1.9' × 1.3' × 1.3'. Merino wool. Courtesy of Denise Lithgow.

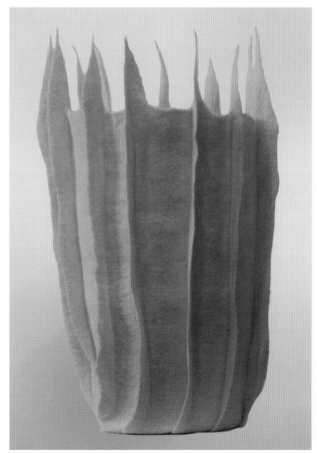

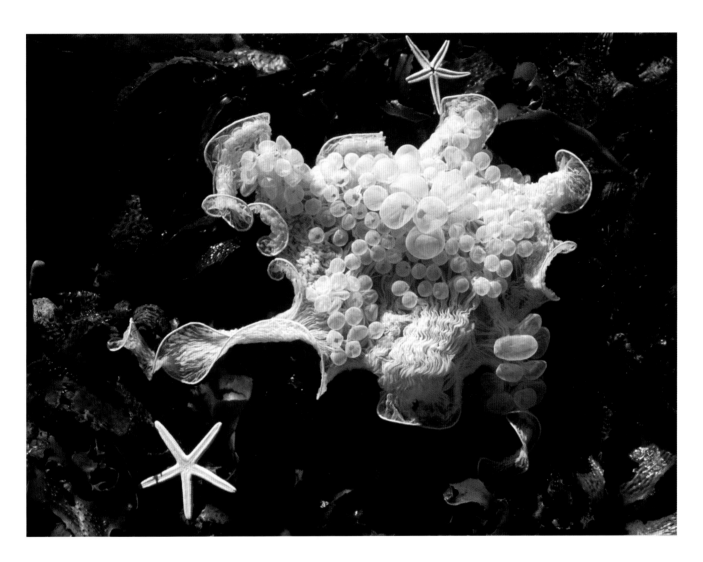

Maureen Locke-Maclean is a textile artist who lives on the coastline, north of Sydney, Australia, where acres of bushland are legislated nondevelopment areas to retain the area's ecosystem. With pristine beaches, a coastline brimming with abundant sea life, and lush farming land beyond the water, it is an artist's paradise.

Taught to knit and sew at the age of five by her grandmother and mother, who were Fair Isle knitters and tatting enthusiasts, Locke-Maclean knitted and sewed clothes for herself and, later, for her children.

While working in real estate, she was introduced by a friend to silk painting, and her appreciation for textile art began. She went on to create wearable art as well as to explore the Japanese art and craft of dyeing with indigo, and using shibori, Japanese resist-dyeing, and dimensional shaping. She learned Japanese and studied shibori in Japan from a leading sensei, or instructor.

Maureen Locke-Maclean. *Coral Amongst Seaweed*, 2014. 1.3' × 1.9'. Polyester organza, hand-stitching, shibori techniques. Courtesy of Maureen Locke-Maclean. Photography: Barry Walsh, Australia.

OPPOSITE
Maureen Locke-Maclean.
Prawns Caught in a Net, 2014.
27 pieces (Large 7.8" × 1.3";
small, 5.9" × .75") attached
to net. Polyester organza,
hand-stitching, embellished
metallic thread, beads, sequins,
shibori techniques. Courtesy
of Maureen Locke-Maclean.
Photography: Jenny Barker.

RIGHT
Maureen Locke-Maclean.
Pink Anemone/Coral Cluster,
2015. 4.1' × 4.1'. Polyester
organza, hand-stitching,
various shibori techniques.
Courtesy of Maureen
Locke-Maclean. Photography:
Jenny Barker.

BELOW
Maureen Locke-Maclean.
Prawns Caught in a Net, 2014.
Detail. Courtesy of Maureen
Locke-Maclean. Photography:
Jenny Barker.

Locke-Maclean uses shibori techniques to construct gossamer sea creatures—a project she calls Designed by Nature. Shibori comes from the word *shiboru*, meaning to "wring, squeeze, and press." The process developed along two paths in feudal Japan: (1) as a method of decorating textiles for the Daimyō ruling class and (2) as a way for the poor to repair and recycle used garments.

Using shibori, fabric is folded, stitched, twisted, knotted, clamped, or plaited, then dyed. The areas of cloth that have been compressed tightly do not pick up color when the fabric is immersed in dye because the dye cannot penetrate the folds, resulting in unique patterns. For today's artists, shibori offers a way not only to create visual texture, but also to form permanent shapes resulting in dimensionality.

Locke-Maclean notes, "After experimenting with methods of binding and compressing designs into fibers, I found that by steaming wrapped and bound variegated dyed silk for three hours, pleats stay in place after the binding is removed. I also use synthetic fibers, including polyester, nylon, and other thermoplastic man-made materials." She incorporates these dimensional shapes into the corals, anemones, bluebottle dolphins, and humpback whales of her Designed by Nature series.

After enormous storms swept an unheard-of amount of seaweed onto shore, Locke-Maclean placed one of her organza corals among them, creating *Coral Amongst Seaweed*. She says, "It nestled down amid the seaweed and seemed as if it belonged there."

Locke-Maclean's other works include *Prawns Caught in a Net* and *Pink Anemone/Coral Cluster*, both of which attest to the artist's fascination with the coastline by which she feels lucky to reside.

Fiona Rainford is a mixed-media textile artist. Much of her work is inspired by the natural world and the passage of time. A retired pharmacist, she began her art career as a stitcher and embroiderer, then moved into felting as a way to explore dimension.

This artist fashions wool into stunning biomorphic forms she calls *seed pods* using the process of needle-felting. Almost bursting with seeds, their beauty lies in their universally engaging rounded and oval shapes. In these shapes, we recognize the notion of the beginning and ending of life; ripe fruit, now at its apex, readies to morph into what will become its next iteration.

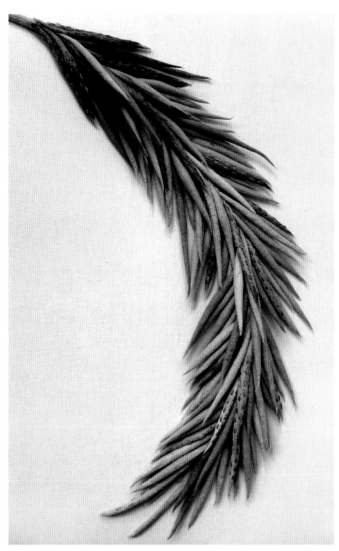

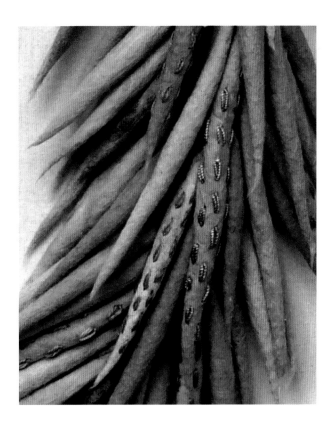

ABOVE
Fiona Rainford. *Seed Pod Chain*, 2011. 2.4' × 7.8".
Merino wool, cotton thread. Courtesy of Fiona Rainford.

LEFT
Fiona Rainford. *Seed Pod Chain*, 2011. Detail.
Courtesy of Fiona Rainford.

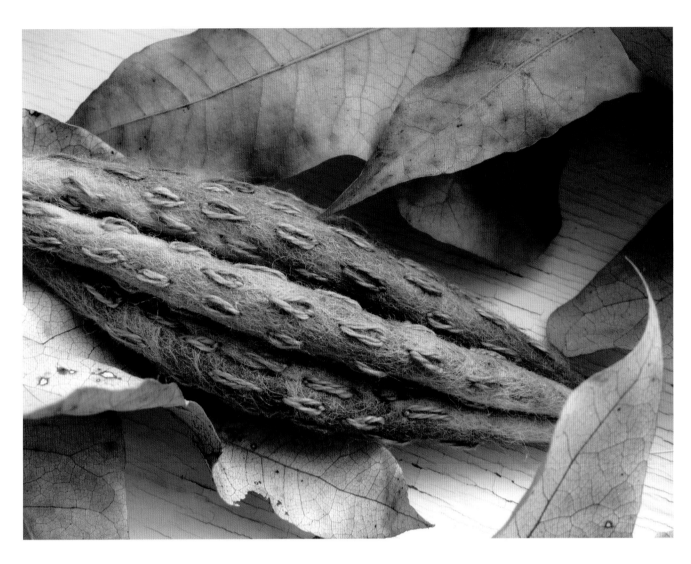

ABOVE
Fiona Rainford. *Purple Seed Pod in Leaves*, 2011.
6" × 1.25". Merino wool, cotton thread. Courtesy of Fiona Rainford.

RIGHT
Fiona Rainford. *Seed Pod Collection*, 2011.
7.8" × 1.4' × 1.4'. Merino wool, tapestry wool, hemp yarn. Courtesy of Fiona Rainford.

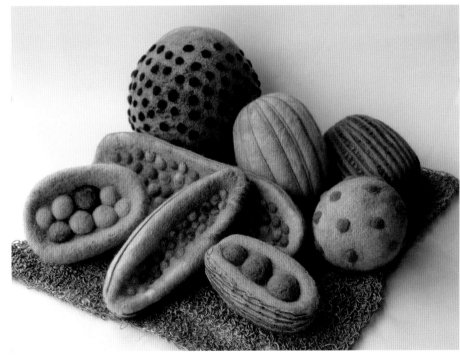

Rainford depicts what she understands to be the transitory nature of life, showing decay and death as an opportunity for future revelations. The psychological life of humans can be seen from that perspective, as well, as this artist's works suggest. In life, our emotions shift and evolve continually so that we, too, are forever in a state of flux.

Furthermore, Rainford is interested in how time affects man-made objects, especially clothing. She says, "I like taking garments left behind or discarded—unloved objects—and giving them new life." Because she is concerned about the health of the planet, she worries about waste straining the capacity of landfills with these objects that do not necessarily need to be thrown away. She notes, "The availability of cheap clothing has led to an enormous amount of textiles being cast aside."

As an expression of her concern, she created the installation *Yesterday's Must Haves*. Comprised of skirts, dresses, and shirts torn into strips, coiled into cords, and hung on old coat hangers, it is a testament to the artist's wish to challenge the status quo. She urges us to question how we live, what is important to us, and how we should prepare for the generations to follow.

Finally, Rainford's felted hand grenades hold a special meaning for her. Developed for a World War I project organized by a UK historical archive collection, it is meant as a memorial to her grandfather, who died during the war a few days before the Armistice of 1918. She imagines her grandfather, a truck driver, transported explosives and other military equipment. The title of the piece, *It Is with Deep Regret*, alludes to the letter her grandmother received informing her of her husband's death. Fiona repeats these words over and over, alerting us to the vast number of similar letters written during that period in history.

Fiona Rainford. *Yesterday's Must Haves*, 2014.
3.5' × 1.5'. Recycled clothing, synthetic cord,
machine thread, old family coat hanger. Courtesy of
Fiona Rainford.

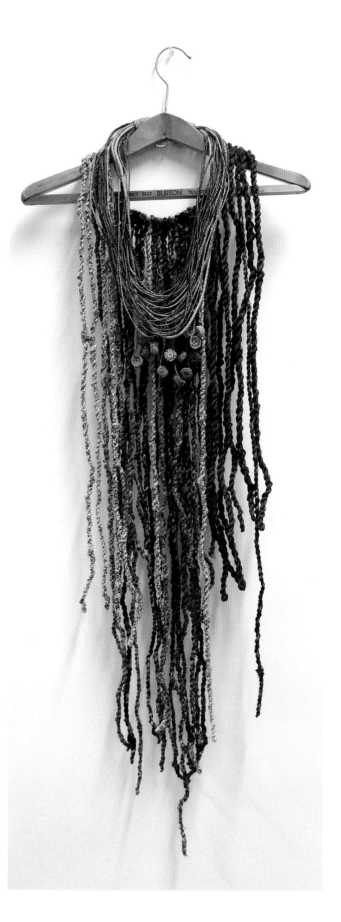

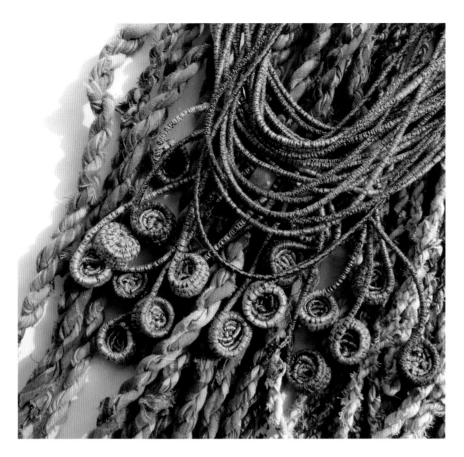

LEFT
Fiona Rainford. *Yesterday's Must Haves*, 2014. Detail. Courtesy of Fiona Rainford.

BELOW
Fiona Rainford. *It Is with Deep Regret*, 2014. 7.8" × 11.8". Merino wool. Courtesy of Fiona Rainford.

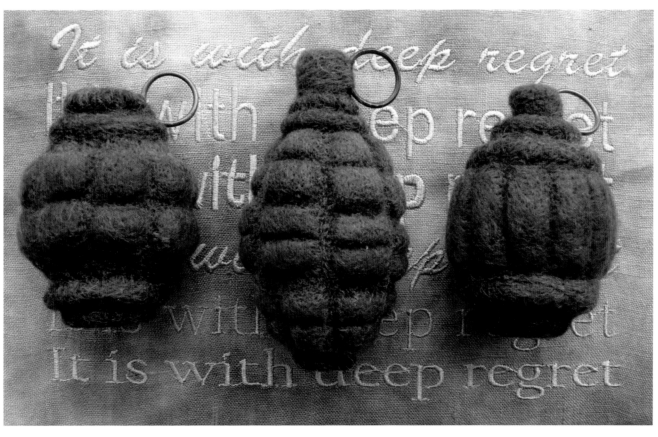

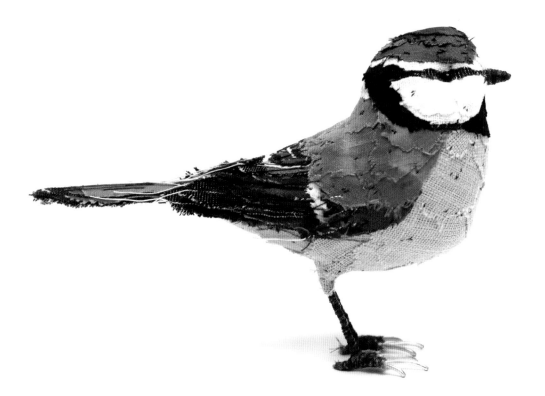

As a girl, Abigail Brown spent a lot of time with her grandmother, who was a seamstress. Ever since, she says, "I had confidence making things with fabric and thread. It became very natural for me. Making art makes me truly happy, and I've never found anything that comes even close to it. Making three-dimensional art is where I'm happiest."

Brown studied art while in college, and surface design and printing textiles at university. She went on to design and illustrate children's books and clothing. Her interest in creating bird sculptures first arose when her roommate was learning about decorative artifacts. Brown recalls, "When she started to bring home projects that called for the new techniques she was being exposed to, I was so excited by them that I wanted instantly to study them, too. As soon as I graduated, I began to make textile art in the form of dolls, plush toys, and wall art."

Although Brown states there is no inherent message behind her current work, her love of nature is evident in the delicacy and accuracy of her depictions of birds. She notes, "I make them because of a love for the medium and for the animals themselves. I make them because it makes me happy to do so. I have no other intentions than to satisfy my

Abigail Brown. *Blue Tit*, n.d. 4.3".
Cotton fabric, wire. Courtesy of Abigail Brown.

need to create and my joy in learning. I hope my enjoyment spreads to the viewers of my work, too."

Each of Abigail's birds are made from both new and used materials that she hand-stitches together and then hand-embroiders. Each design replicates carefully the specific colors and markings of the particular species she is depicting. Working from photographs, she first draws a pattern onto fabric. When it is machine-stitched nearly closed, she turns it inside out and inserts a wire through the beak to form the legs. She stuffs the shape and stitches it closed, and solders and wraps the feet with fabric. Last, she attaches fabric feathers, first with glue and then via hand-stitching. Her finely rendered creations include *Blue Tit, Woodcock, American Flamingo, Whooping Crane, Yellow and Green Budgerigar*, and *Puffin*.

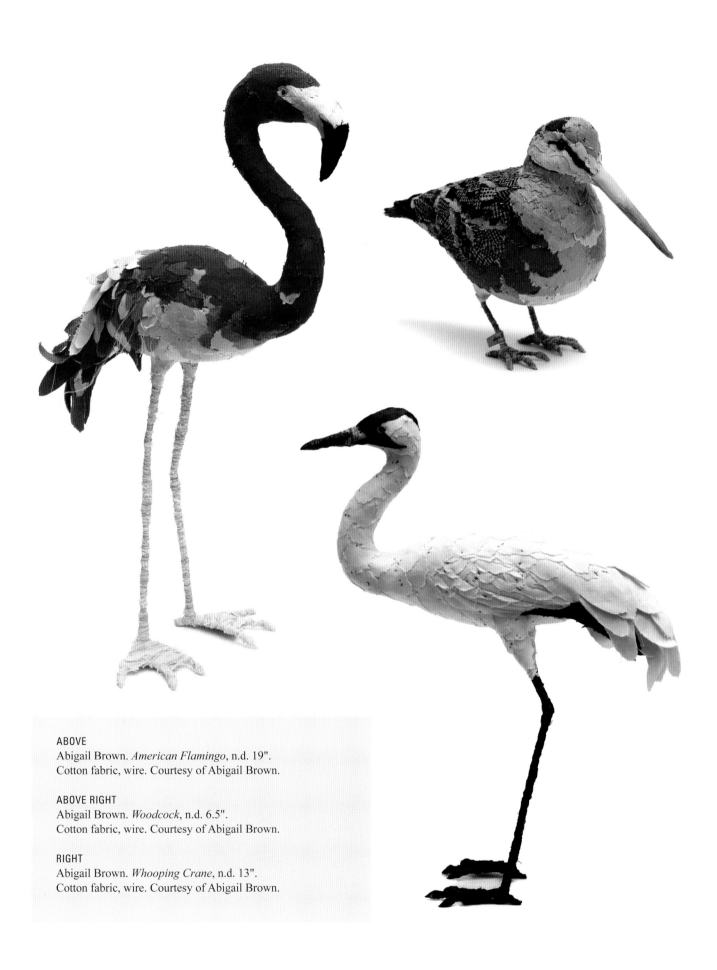

ABOVE
Abigail Brown. *American Flamingo*, n.d. 19".
Cotton fabric, wire. Courtesy of Abigail Brown.

ABOVE RIGHT
Abigail Brown. *Woodcock*, n.d. 6.5".
Cotton fabric, wire. Courtesy of Abigail Brown.

RIGHT
Abigail Brown. *Whooping Crane*, n.d. 13".
Cotton fabric, wire. Courtesy of Abigail Brown.

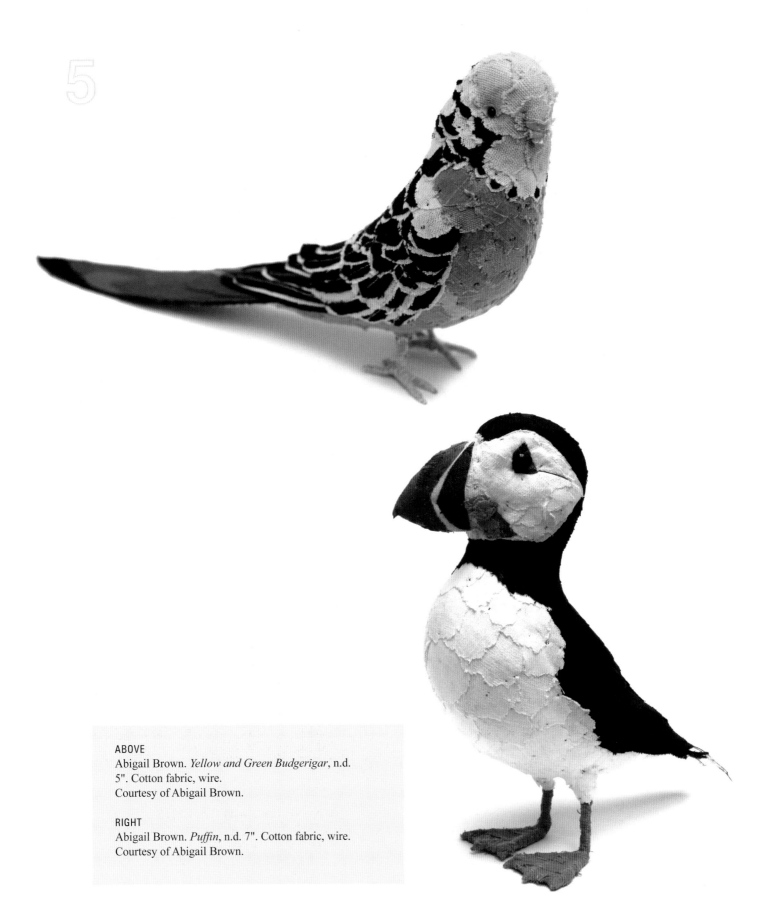

5

ABOVE
Abigail Brown. *Yellow and Green Budgerigar*, n.d.
5". Cotton fabric, wire.
Courtesy of Abigail Brown.

RIGHT
Abigail Brown. *Puffin*, n.d. 7". Cotton fabric, wire.
Courtesy of Abigail Brown.

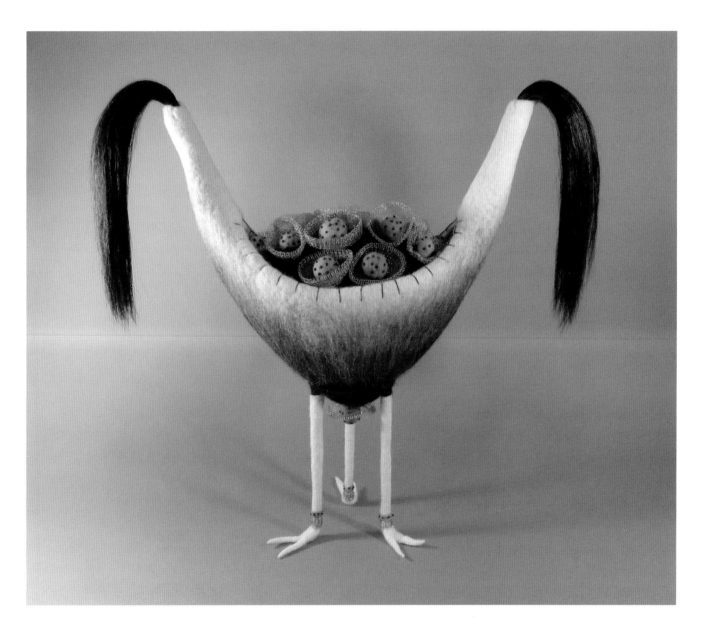

Pamela MacGregor is a felt artist who earned her bachelor's degree in art education and subsequently became a middle school art teacher. When she retired, she took a felting workshop and was smitten. She recalls, "In college I had pursued pottery and clay sculpture, and later found dimensional fabric art to be much like it. I even use many of the same tools I used with ceramics."

Pamela A. MacGregor. *Nesting Dreams*, 2015.
20" × 20" × 7". Finnish wool, horsehair, steel lint trap.
Courtesy of Pamela A. MacGregor.

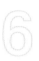

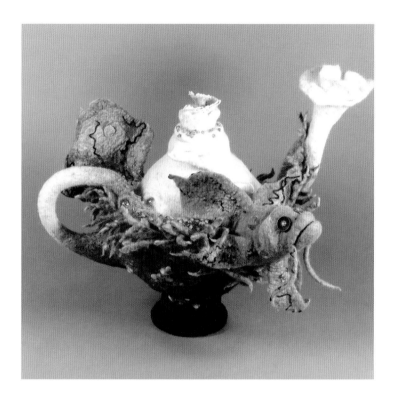

RIGHT
Pamela A. MacGregor. *On the Reef*, 2015.
10.5" × 14" × 9". Finnish wool, shell, glass
beads, glass stones, merino yarn. Courtesy
of Pamela A. MacGregor.

BELOW
Pamela A. MacGregor. *Carnival*, 2012.
13" × 12" × 10". Finnish wool, merino
wool, hand-dyed monofilament, glass
beads. Courtesy of Pamela A. MacGregor.

A love of nature has prompted MacGregor to visit many rainforests throughout the world, and her observations often inspire her to create work that not only depicts the beauty contained within this terrain, but also her awe at the relentless growth and unstoppable drive of nature.

After having been commissioned to create a teapot for a show, MacGregor came to favor the teapot as the basic form for many of her sculptures. She embellishes them in fanciful ways that surprise and delight.

For *On the Reef*, MacGregor was inspired by her deep-sea dives in Hawaii, and her intention for *Carnival* was to create an object that evoked a festival-like feeling. For *Nesting Dreams*, MacGregor used hair from her horse's mane as well as stainless steel lint-trap mesh and Finnish wool. She remembers, "My horse was a longtime friend and companion for more than 20 years and it felt right to immortalize her in this way."

Tea for Two, *Fish Vessel*, and *Flowering Teapot* showcase the playful, spirited attitude this artist adopts when interpreting nature's creations.

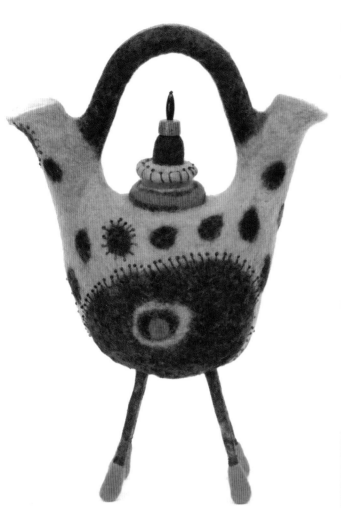

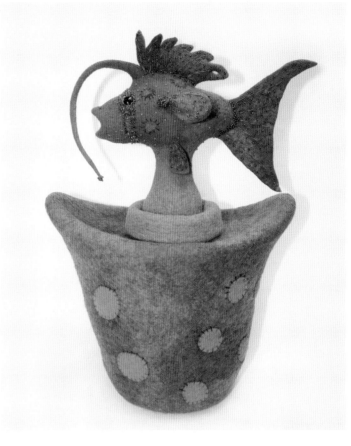

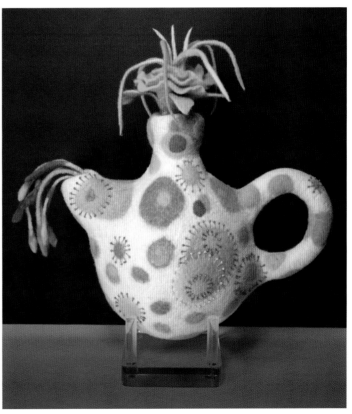

ABOVE
Pamela A. MacGregor. *Tea for Two*, 2015.
12.5" × 8.5" × 4.5". Finnish wool, glass beads,
hand-stitching. Courtesy of Pamela A. MacGregor.

ABOVE RIGHT
Pamela A. MacGregor. *Fish Vessel*, 2011.
18" × 13" × 6". C-1 Pelsull wool, glass beads,
plastic eyes, merino wool, hand-stitching.
Courtesy of Pamela A. MacGregor.

RIGHT
Pamela A. MacGregor. *Flowering Teapot*, 2011.
12" × 10" × 5". Finnish wool, merino wool, glass
beads, hand-stitching, Plexiglas stand.
Courtesy of Pamela A. MacGregor.

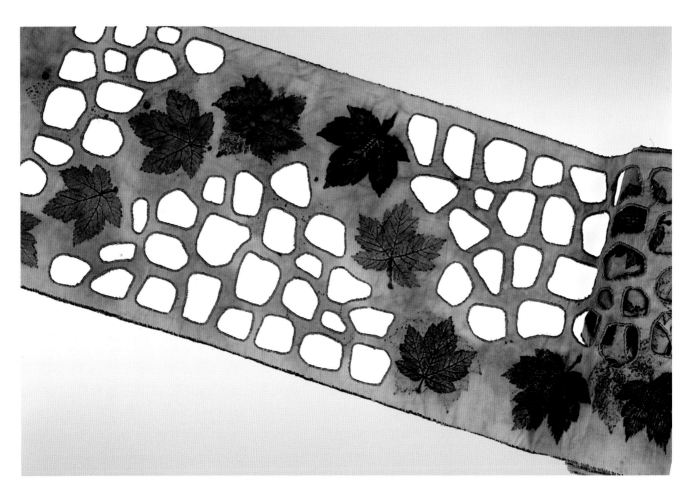

Caroline Bell is a mixed-media artist whose grandmother was a skilled seamstress who exposed her to sewing, knitting, and embroidery during Caroline's childhood. However, Bell came to the world of art much later in life, after a career in social work and after raising her children. She set up a small business selling hand-dyed threads and fabrics, but this left her with no time to satisfy her own need to create. Eventually, Bell enrolled in a textile program and her artistic life took off.

For Bell, the natural world is the central element in her artwork. She is concerned about the degradation of the environment and therefore uses only natural dyes and primarily secondhand fabric or "offcuts," which would ordinarily go to waste. She stitches by hand and enjoys eco-dyeing—a contemporary application of the tradition of natural dyeing. When eco-dyeing, plants are enclosed in textiles and steamed or immersed in hot water to extract the pigments and produce a print. Leaves, stems, flowers, buds, seeds, roots, and even bark can be used. At different times of the year, pigments concentrate differently in the various plant parts so that color from the same plant varies.

Caroline Bell. *Metamorphosis 2*, 2015. 9.1' × 9.8".
Printed Egyptian cotton fabric, silk thread.
Courtesy of Caroline Bell.

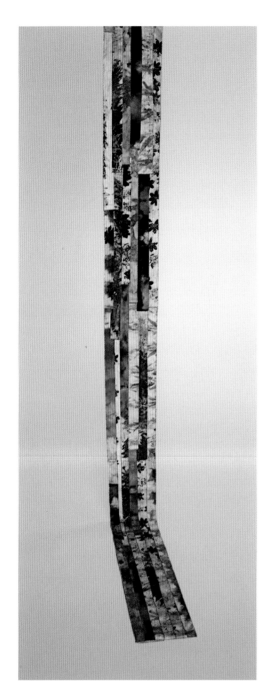

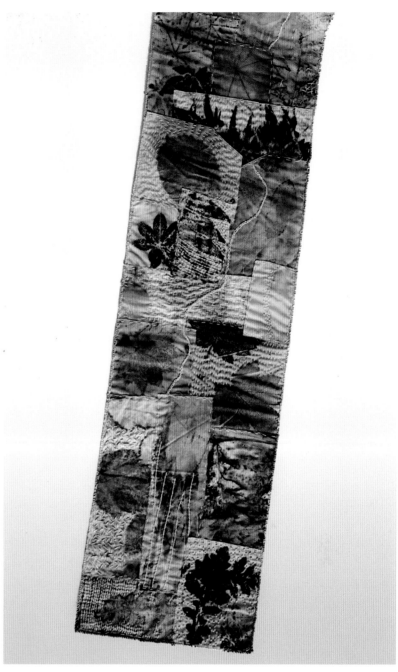

Indeed, the subtle variations in color and images produced by eco-dyeing characterize Bell's work. She cedes control to nature. Although she begins with known materials, the way they interact and what they reveal are always unknowns until the process is complete. In this way, Bell incorporates the cycle of the seasons into her work, allowing new life to generate certain colors and decayed life to generate others. For Bell, nature in all its states is both temporary and long-lived, in the same way the life span of a leaf is short, but the tree grows for years. Bell's series, titled *Metamorphosis*, demonstrates her love of, and fascination with, nature through leaf-printing, natural dyeing, and stitching.

ABOVE LEFT
Caroline Bell. *Metamorphosis 1*, 2015. 9.1' × 9". Printed Egyptian cotton fabric, silk thread. Courtesy of Caroline Bell.

ABOVE RIGHT
Caroline Bell. *Metamorphosis 1*, 2015. Detail. Courtesy of Caroline Bell.

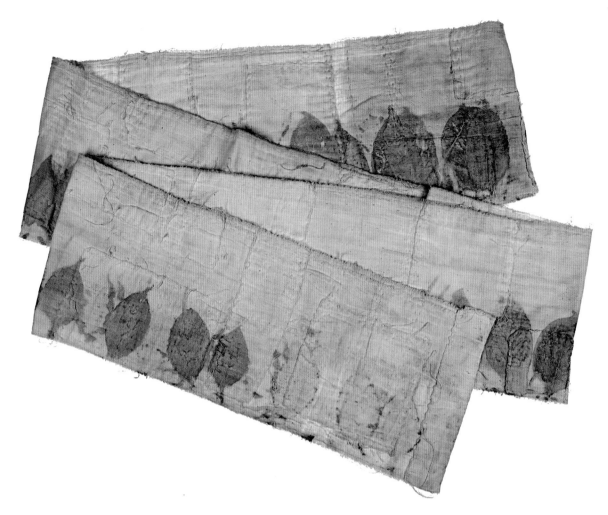

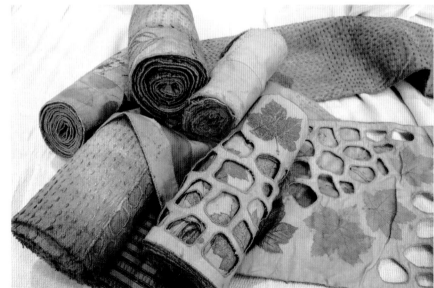

ABOVE
Caroline Bell. *Metamorphosis 3*, 2015. 9.1' × 10.2". Printed Khadi cotton fabric. Courtesy of Caroline Bell.

RIGHT
Caroline Bell. *Metamorphosis 4*, 2015. Various dimensions. Printed cotton fabrics, madder dye, silk thread. Courtesy of Caroline Bell.

George-Ann Bowers

United States | www.gabowers.com

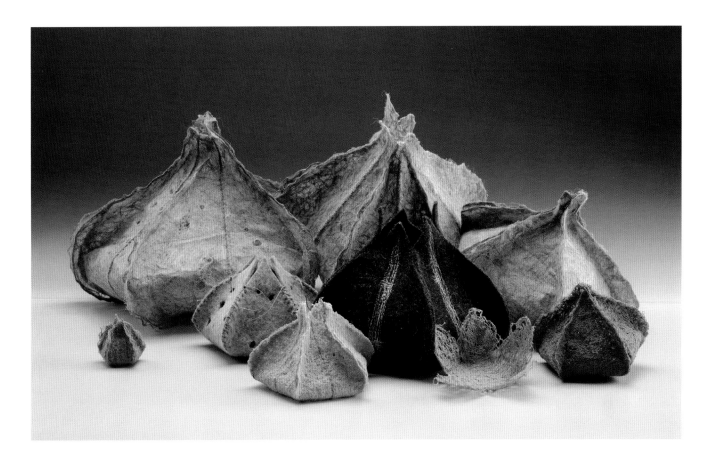

George-Ann Bowers was lucky enough to grow up in a family that encouraged her artistic endeavors and provided materials and instruction for her art exploration. After a hiatus from art during her college and postcollege years, she recalls, "The impetus to pursue art again was the result of a personal epiphany in which I felt called to find out what I might be passionate about by listening to my deeper self. When I followed that path, what I found was a strong urge to explore my creativity."

This artist identifies the 1960s fiber art movement as a catalyst for her work. She remembers exhibitions from that era, especially a show in 1971, Deliberate Entanglements, in which many well-known international fiber artists introduced

George-Ann Bowers. *Mallow Pod Cluster*, 2015.
26" × 20" × 10" (variable). Flax fiber, industrial felt, sewing thread, waxed linen. Courtesy of George-Ann Bowers. Photographer: Dana M. Davis.

their work, convincing her that her textile art studies should shape the next stages of her life. Since then, the preponderance of her work has been based on multilayer weaving, and she uses stabilized fibers to construct some of her sculptural work.

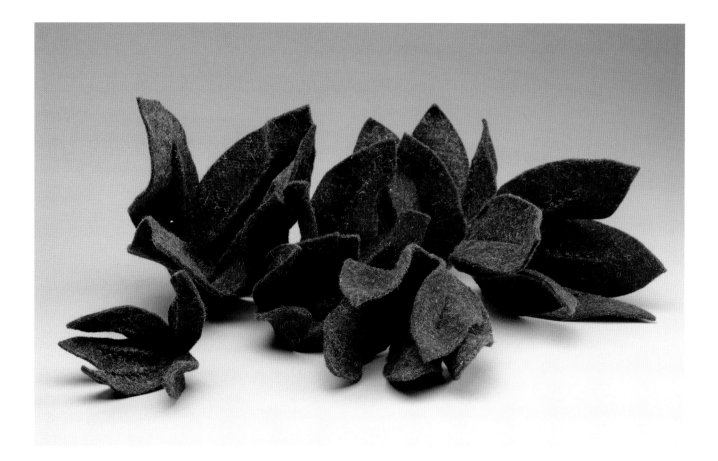

Although Bowers tells us she does not create her art with an expressed intention of communicating a particular message, she nevertheless means to share her love of nature. She notes, "My work celebrates the infinite intricacies of the natural world. I'm drawn to see how I can use fiber to create 'snapshots' of what I see, such as the patterns of trees, lichens, rock formations, and a myriad of other natural phenomena."

Bowers goes on to relate, "With my pod pieces, such as *Mallow Pod Cluster* and *Not Far from the Tree*, my inspiration was the discovery of a plant that had lacy seed pods with a five-segment structure. I enjoyed the challenge of analyzing the form and figuring out how to recreate it."

With this goal of echoing the delicate quality of the pods, Bowers layers and glues flax or hemp fiber into shaped sheets, which she then stitches together to build a five-sided structure. For smaller pods, she machine-stitches the shapes densely onto a water-soluble substrate, creating an interlocked web of sewing thread that holds together as fabric after the substrate is washed away. This fabric can then be stitched into a three-dimensional form. Other pods are constructed of industrial felt, cut into five-pointed patterns, and hand- and machine-stitched to shape the pod further and to add embellishment.

Bowers says, "If there is a message in my pieces, it is to encourage people to look carefully at nature. One can't help but marvel at the way the natural world is 'put together.' I also want to share some of the endless possibilities of working with fabric and other textiles."

9 Wendy Moyer

Mexico | www.textileartistmx.com

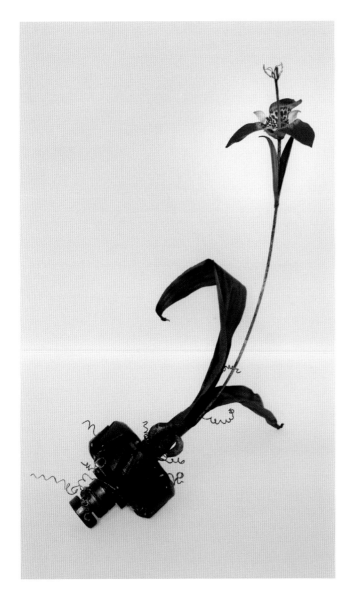

Moyer went on to create dimensional objects, eventually teaching herself a technique she calls *fire-sculpting*, in which the soft, flowing nature of fabric is molded into sturdy, permanent shapes. *Una Tigridia de un Paisaje* (*rojo*) / *A Tiger Flower for an Urban Landscape* (*red*) exemplifies this technique.

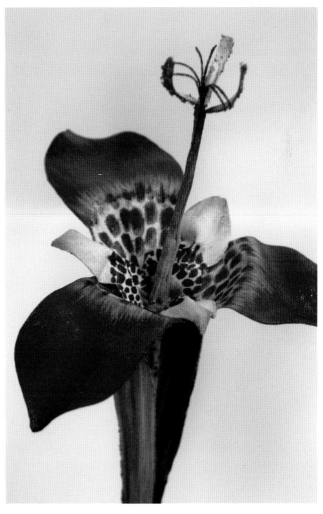

Wendy Moyer. *Una Tigridia de un Paisaje Urbano* (*rojo*) / *A Tiger Flower for an Urban Landscape* (*red*), 2013. 12" × 15" × 6". Copper wire, Ultrasuede, silk, metal gear base. Courtesy of Wendy Moyer.

Wendy Moyer is a mixed-media artist who grew up in a family of seamstresses, quilters, and crafters. She learned hand- and machine-sewing early in life, studied fine art in college, and received her degree from the Fashion Institute of Technology in New York. While pursuing a career initially in marketing and advertising, she continued to hone her textile skills through mural and trompe l'oeil commissions.

Moyer moved to Mexico and, after a time, when moving did not lessen her dissatisfaction with her commercial work, her partner suggested she turn to textiles as her artistic medium. She says, "It was an aha moment."

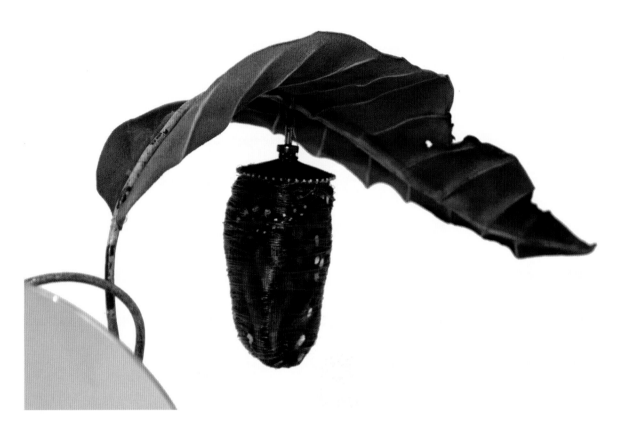

It took Moyer years to perfect her technique. She recalls, "I came upon fire-sculpting by accident. I had been singeing the edges of an Ultrasuede leaf to prevent the fabric from fraying, holding the leaf over a candle flame. I held it there too long and it caught fire. That's when I discovered that the edges had become moldable and retained their shape when they cooled."

Moyer continues, "To make a petal, for *Yucca Bouquet*, for example, I hold the flower-shaped fabric over a flame to the point when the fibers begin to melt, making them pliable. I then quickly sculpt the heated area into the desired form. It's a protracted, back-and-forth process. For a flower, I need to do this procedure about ten times. Although it's time-consuming, I believe it brings an organic suppleness to my work that I couldn't achieve through stitching alone."

As Moyer honed fire-sculpting, she was disappointed to learn it did not work well with the natural fabrics she prefers. Natural fibers do not melt, so she investigated other ways to obtain this effect. She explains, "I started to experiment with treating natural fabrics with a clear coating, such as transparent liquid glue. Sealed between layers of meltable compound, the natural fibers responded more like synthetics." Thus, she found the answer to her dilemma.

Moyer is practical and an inventor. She says, "I call upon a host of tools not usually associated with fabric sculpture. For example, I search for products that can change the weight or finish of a fabric, and I've been known to use spackling compound, plumbers' supplies, a soldering iron, and the occasional torch. Paintable silicon is one of my go-to materials. I've brushed it onto a fabric's surface, working it into the weave to give flowers like the yucca's their thin, plasticlike finish. Likewise, its long drying time allows me to add layers of dimensional details, such as scales on a lizard or thin veins on leaves. The results look quite natural."

ABOVE
Wendy Moyer. *La Crisalida / The Chrysalis*, 2013. 5" × 6" × 5.5". Copper wire, Ultrasuede, silk, clear thread, small clock gear, recycled computer disk, casted glass base. Courtesy of Wendy Moyer.

OPPOSITE
Wendy Moyer. *Yucca Bouquet*, 2015. 47" × 39" × 10" (entire sculpture). Metal frame, Ultrasuede, synthetic fabrics, agave wood, polymer clay. Courtesy of Wendy Moyer.

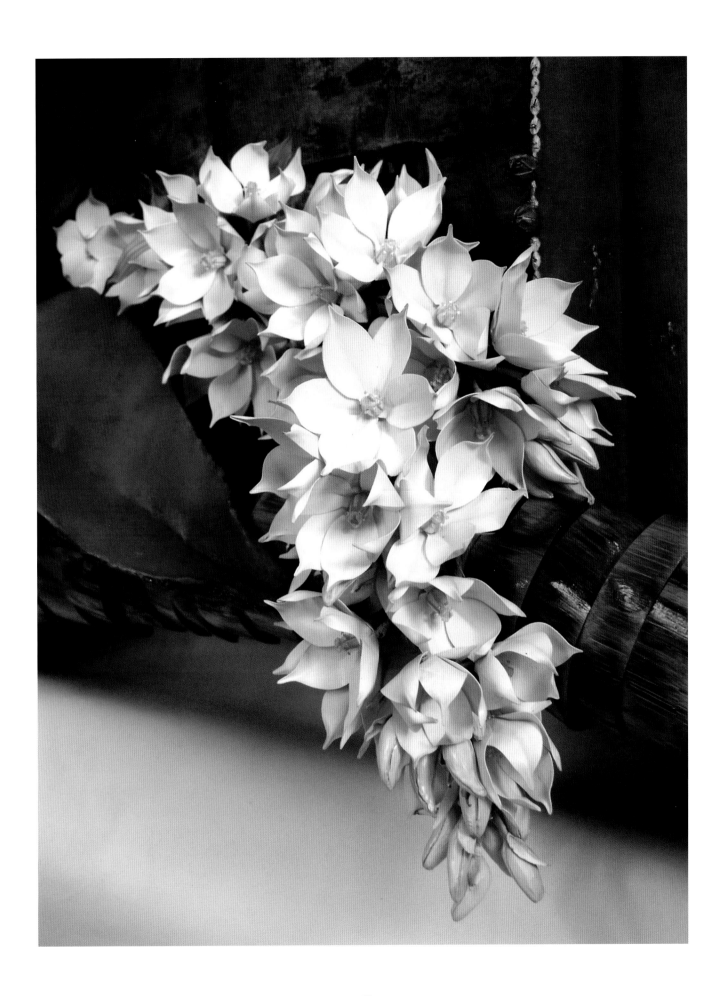

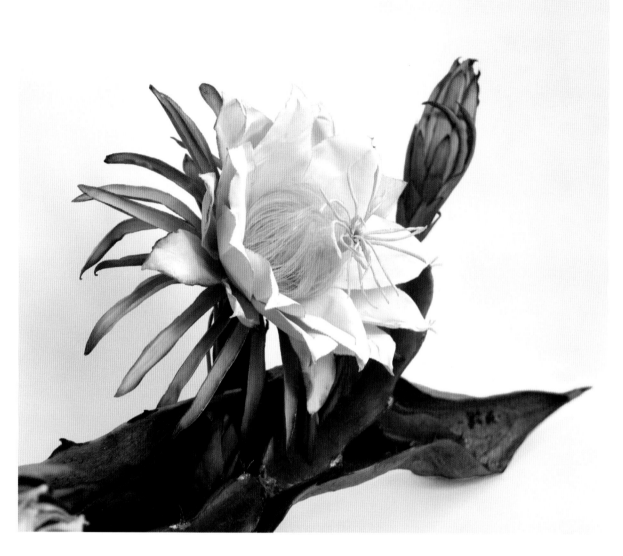

At the beginning of her art career, she was praised for her proficiency as a painter of realism, but Wendy did not find her artistic voice until she discovered a way to create her intricately composed fabric sculptures. "I wanted to shed light on nature's often unseen moments in time. Each moment is a vignette, a depiction of how an entity existed in that one singular moment. And I'm inspired especially by the indigenous flora and fauna of central Mexico's high desert, where I live."

Her sculpture *Flor del Dragon / Dragon Flower* is an example of such a vignette. Moyer notes, "Few people get to witness the blooming of the flower because it occurs at midnight, then wilts and dies before dawn."

With another sculpture, *La Crisalida / The Chrysalis*, Moyer sought to communicate her concern about the health of the natural environment. "Throughout leafless urban terrain, littered with castoffs of our ever-changing technologies, nature defiantly leaves its mark. Here, a chrysalis awaits, promising a new beginning, standing as a testament to the enduring miracle of nature."

Wendy Moyer. *Flor del Dragon / Dragon Flower*, 2014. 39" × 11.5" × 7". Lacquered agave leaf, Ultrasuede, silk, synthetic fibers, wire mesh frame, copper, solder, wire bristles, small gear part. Courtesy of Wendy Moyer.

Sue Walton

United Kingdom | www.suewalton.co.uk

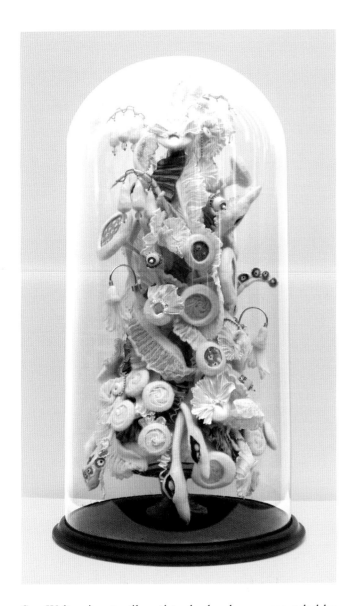

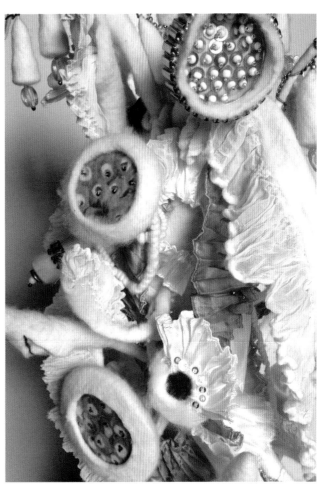

side near her home. She was influenced, also, by the intricate floral wood and stone carvings of the eighteenth-century Dutch–British sculptor Grinling Gibbons. Working in *Tilia* wood and stone, he produced Baroque garlands made up of life-size fruit, flowers, and foliage, often decorating the walls of churches and palaces.

ABOVE LEFT
Sue Walton. *Victoria*, 2010. 36" × 15". Glass cake stand, glass dome, handmade and hand-shaped felt, wire, glass, mirrors, synthetic materials, silk, beads, found objects. Courtesy of Sue Walton.

ABOVE
Sue Walton. *Victoria*, 2010. Detail. Courtesy of Sue Walton.

Sue Walton is a textile artist who has been surrounded by fabric since childhood, because her mother was a seamstress. She did not follow her creative inclinations until after her own children grew up. It was then, after she attended courses in textile art, that she was motivated to create a world of realistic and imaginary flora using felt, silk, and other fabrics, inspired by her love of gardening and roaming the country-

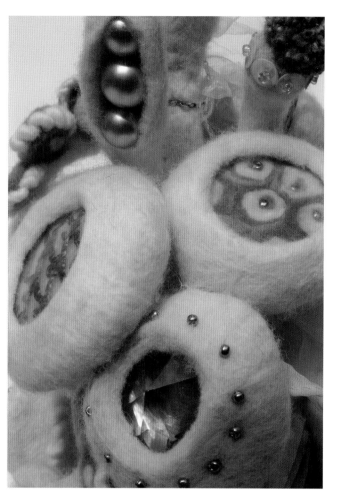

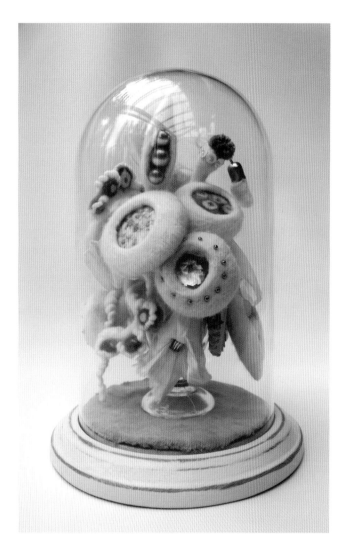

Walton relates, "The goal of my art is to create textile sculptures that are intriguing, both visually and in their construction. By using diverse materials, I form bizarre and unanticipated arrangements."

The methods of containing and displaying her floral creations are also important to Walton. She uses glass primarily for this aspect of her work, especially the *Globe de Mariée*, or French marriage dome, and the Victorian-era glass parlor dome.

The tradition of *Globe de Mariée* display pieces began in France during the 1800s to preserve wedding souvenirs. Throughout the years, special items were added to them by the married couple, such as photographs, locks of their baby's hair, or jewelry. Each item was pinned to a velvet or silk cushion, which was usually red.

Regarding the Victorian-era domes, during the late nineteenth century, these blown-glass forms were referred to as *shades*, and they graced nearly every parlor. These glass parlor domes held a variety of treasures, natural history specimens, and taxidermies of exotic birds. Walton remarks, "The general extravagance of that era—the over-the-top sensibility—appeals to me."

Walton uses Victorian-era domes for her pieces, including *Victoria* and *Louisa*, in which she composed a mix of forms reminiscent of arrangements of the time.

For *Chandelier*, drinking glasses—felted and embellished—hang from a metal framework consisting of five tiny baking tins filled with arrangements, including a spoon, mirrors embedded in handmade felt, beads and sequins, manipulated synthetic fabric, and tiny pom-poms. *Vase* is part of Walton's *Jabberwocky* installation, which she created with artist Ann Small for an exhibition in London. Walton tells us, "The installation consisted of a triangular table that appeared to be much longer because of its shape and placement, with many quirky, surreal arrangements inspired by Lewis Carroll, all meant to be a depiction of a very strange tea party. I wanted it to be a feast for the eyes." *Woodland Boudoir* was meant to be displayed on a mantelpiece.

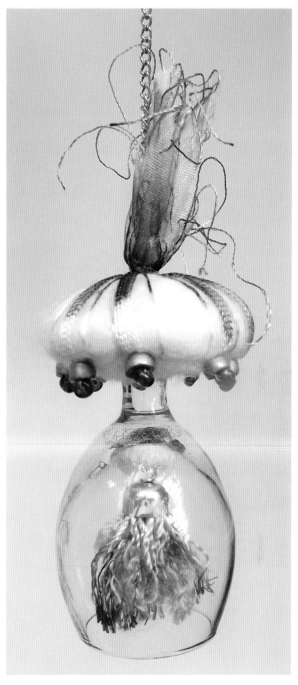

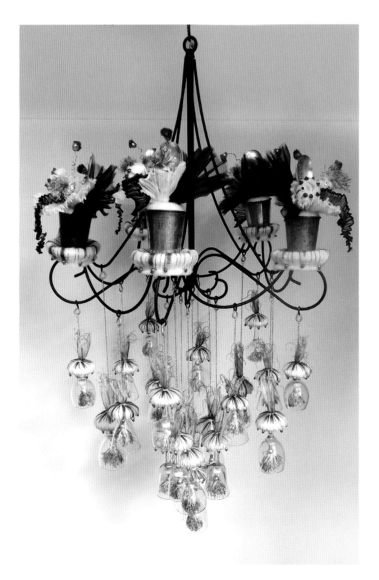

LEFT
Sue Walton. *Chandelier*, 2012. 20" × 30". Handmade felt, drinking glasses, metal chain, beads, bead caps, hand-dyed thread, metal framework. Courtesy of Sue Walton.

ABOVE
Sue Walton. *Chandelier*, 2012. 3". Detail. Courtesy of Sue Walton.

Walton's overriding goal is a study of the preservation of memories, real or imagined. Her works represent, in part, the ways in which, throughout the centuries, people have attempted to capture the most meaningful moments of their lives by objectifying them and turning them into tableaux to share with loved ones—or perhaps to impress their neighbors. More important, they helped their creators feel more substantial than the fleeting spirits they were. They are proof that they once existed—and mattered.

LEFT
Sue Walton. *Vase*, 2011. 12" × 6". Detail. Handmade felt; stitched, manipulated, and hand-dyed synthetic fabric; beads; bead caps; tiny handmade and hand-dyed pompoms. Courtesy of Sue Walton.

BELOW
Sue Walton. *Woodland Boudoir*, 2012. 20" × 10". Handmade and hand-shaped felt; wire; dyed silks; manipulated, dyed polyester fabrics; beads. Courtesy of Sue Walton.

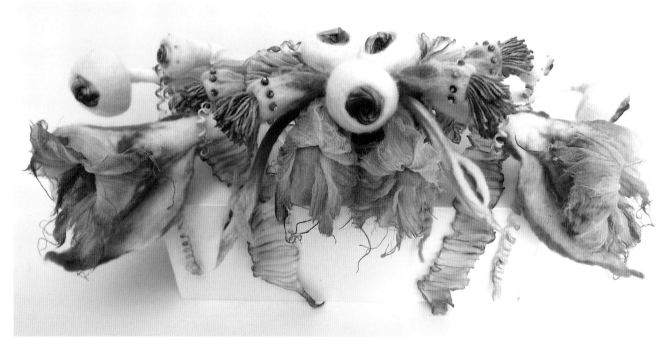

Eileen Doughty
United States | www.doughtydesigns.com

Eileen Doughty began her textile career as a traditional quilt maker until she was introduced to art quilting. At that point, she says, "I realized that quilts could be art, could be expressive, even abstract." From there, she developed thread-painting skills and realized ultimately that she wanted to try dimensional art with that technique. Some of her work is made entirely of machine-stitched threads, which she calls *thread sculptures*.

These pieces start as paper models, then the components are machine-stitched with cotton threads onto a water-soluble stabilizer. The stabilizer is rinsed away, leaving the threads somewhat stiff. Finally, she does more stitching, shaping, and joining of components to complete the sculpture.

Doughty has always been tuned in to the landscape around her, and her work is often based on her observations and impressions. Her sculptures become a "tactile memory" of a place or event in which she took part or witnessed.

For *Mountain Teapot*, for example, she notes, "I was inspired by an image of a forest on steep cliffs with a hazy mist behind the trees. It was so beautiful that I had to see if I could transfer it to my teapot design." The teapot pattern she uses is one she developed based on the traditional method of using gores to construct a globe, remembered from her college courses in cartography.

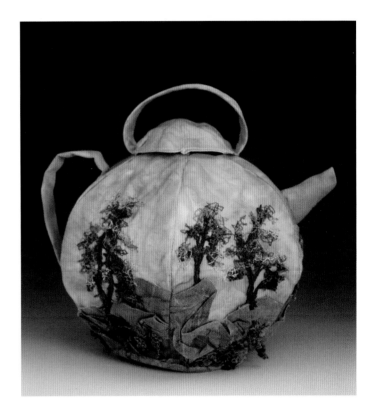

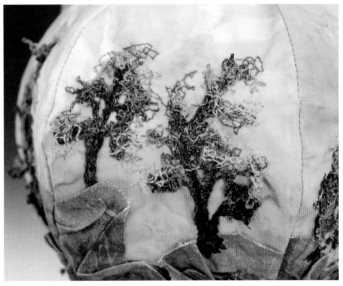

ABOVE RIGHT
Eileen Doughty. *Mountain Teapot*, 2015.
8" × 8" × 7". Cotton fabric, cotton threads, cotton batting, buckram. Courtesy of Eileen Doughty.

RIGHT
Eileen Doughty. *Mountain Teapot*, 2015.
Detail. Courtesy of Eileen Doughty.

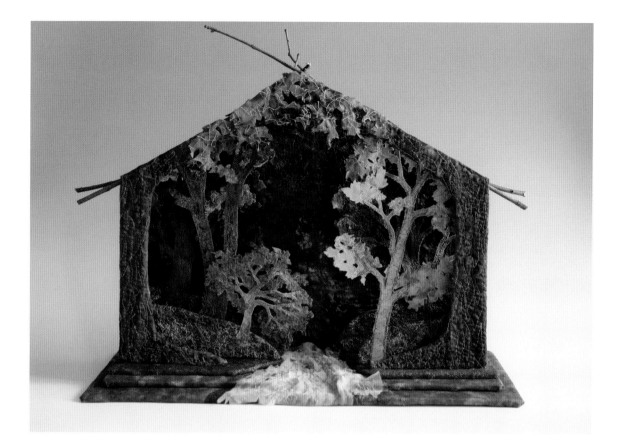

The scene that *Furl* represents shows the view from a footbridge in the woods near the artist's home. She explains, "High runoff from impermeable surfaces causes the water level of a stream there to rise rapidly. Over several years, it had seriously eroded the embankment, undercutting the trees—particularly a huge oak. In this scene, the oak's roots dangle below the disappearing soil. Two weeks after I made the piece, the tree fell."

Doughty created *Furl* using stitched and quilted fabrics on a foam-core armature. The stream is hand-painted organza and the twigs hail from an elm tree in her yard. She remarks, "My intent with this shrinelike piece was to show a beautiful place that, when you look closer, isn't what it seems. It's actually a depiction of an unhealthy environment. It implies that something is coming to an end, and this has a very personal meaning for me. A dear neighbor, who was a caretaker of the woods, passed away. His name was Earl. The real name of this piece is *For Earl*.

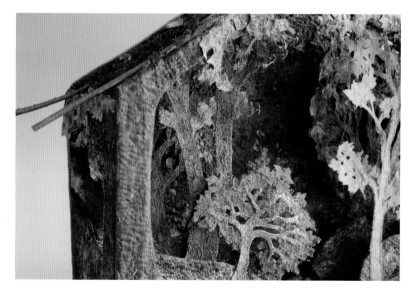

TOP
Eileen Doughty. *Furl*, 2014. 14" × 19" × 7". Cotton fabrics, foam core armature, hand-painted organza, elm twigs. Courtesy of Eileen Doughty.

BOTTOM
Eileen Doughty. *Furl*, 2014. Detail. Courtesy of Eileen Doughty.

Joy Stocksdale

United States | www.joystocksdale.com

Joy Stocksdale remembers her father being a well-respected woodturner and a member of the American arts and crafts movement. A campaign that began during the early 1900s, this movement stood for simple designs rather than highly embellished ones, and advocated for economic and social reforms. Its influence continues among today's makers, architects, and designers.

Stocksdale recalls, "I witnessed my father working his craft and making a successful business, so I knew it was possible to do." Subsequently, she pursued embroidery and, when her stepmother (a well-known textile artist) introduced her to the idea of teaching textiles, Joy signed on and is still teaching today.

Joy Stocksdale. *Black Rectangles*, 2015. 53" × 35". Polychromatic screen-printed silk. Courtesy of Joy Stocksdale.

During Stocksdale's early artistic career, she designed and printed silk banners, but eventually she wanted to add complexity and dimension to them. She notes, "Layering came to mind, but I had to confront the problem of the viewer being able to see through all the layers. I saw that I could solve the problem by using sheer fabric or cutting away areas of fabric. I adapted a lace technique I'd learned in England to keep fabric from unraveling, but instead of that process of intensive stitching, I found a stiffener. It did the job and also gave the fabric structure. I also designed and had fabricated acrylic mountings that allow for space between the fabric panels. In this way, all the layers show through."

Stocksdale also developed a variation of screen printing for her work. She says, "I came up with polychromatic screen printing. It allows for the same flexibility and spontaneity as painting, with the added advantage of allowing me to make more than one print. I color the entire image on a silk screen, then pull a squeegee through it. In this way, I can get four to eight pulls, or prints, from the original image. I teach the technique in my book *Polychromatic Screen Printing* (Corvallis: Oregon State Press, 2006)."

For her *Rectangles, Triangles, and Curves* series, Stocksdale overlapped various colors. *Circle Flowers* allowed her to design a trellis pattern that mimics trellises she has seen in many gardens. Stocksdale's aim with all her work is to "design interesting, unusual, and beautiful pieces."

OPPOSITE
Joy Stocksdale. *Striped Triangles*, 2015.
58" × 57" × 3". Polychromatic screen-printed silk. Courtesy of Joy Stocksdale.

ABOVE
Joy Stocksdale. *Striped Triangles*, 2015. Detail. Courtesy of Joy Stocksdale.

ABOVE RIGHT
Joy Stocksdale. *Triangles and Right Angles*, 2012. 30" × 52". Polychromatic screen-printed silk. Courtesy of Joy Stocksdale.

RIGHT
Joy Stocksdale. *Circle Flowers*, 2010.
30" × 48". Polychromatic screen-printed silk. Courtesy of Joy Stocksdale.

Barb Forrister

United States | www.barbforrister.com

Barb Forrister was introduced to art early in life. She says, "My uncle is an architect who encouraged me to draw and tap into my creativity. I also come from a long line of women who actively sewed and made clothes. I can still remember my great-grandmother working avidly on her treadle sewing machine. My family members passed along their knowledge to me—and for that I am most grateful."

Barb Forrister. *Amethyst Garden*, 2010. 21.5" × 17.5". Natural and synthetic fibers, acrylic textile paints, silk cocoon rods, Timtex, wool, floral wire, yarn, thread, batting. Courtesy of Barb Forrister.

After earning a bachelor's degree in biology and chemistry, Forrister pursued medical research, followed by a short stint as a cosmetic chemist and then a laboratory technologist testing blood for viral diseases. However, when she moved to Texas, she began her career as an artist creating art quilts, then progressed to dimensional fiber art.

Forrister tells us, "My first attempts at sculptural art began when I started attaching three-dimensional leaves and adding upraised trapunto elements to some of my painted and quilted artwork. I discovered that I really liked the concept of bringing dimensional elements off the wall such that they reach out to viewers."

Amethyst Garden was one of two pieces inspired by a photograph and presented so that the frame is integrated with the art. *Dimensional Flowers* is the second of these two small pieces. *Shangrila* features a hand-painted background with silk-screened surface design foliage. The flowers include tiger lilies, calla lilies, irises, lilac and tea rose bushes, as well as a variety of imaginary wild flowers.

Forrister learned to make her soft sculptures by experimenting with a variety of materials, including PVC piping, wire, packing materials, and Timtex, which is a stiff interfacing. She says, "Depending on the subject, I choose my media based on the amount of lift and stiffness that is required. It's always a new experience."

Mary McCauley
United States | www.maryhmmccauley.com

Mary McCauley is a mixed-media textile artist whose work includes imaginative vessels and botanical tableaux of exquisite detail. A self-taught seamstress who also makes theater props and costumes, and at one time created garments for disabled children, she moved into art quilting, learning through experimentation and from established art quilters. She then began to investigate dimensional artwork, again using self-taught techniques.

Many of McCauley's pieces are predicated on the same approach as that used for making pop-up greeting cards and books. She says she first learned of pop-up work when, as a child: "[M]y curiosity led me to take apart pop-up books and then put them back together before my parents saw what I had done."

With her sculpture *Hokusai's Wave*, the artist created a lively, rhythmic pattern that echoes swells of ocean waves approaching the shore. It is meant as an homage to the woodblock print by Japanese artist Hokusai, depicting an enormous wave. Lines of iridescent panels appear to be tumbling forward, invoking the ever-changing aspect of life. McCauley's sensitive response to nature can also be seen in her work *Flower Box*. She notes, "I wanted to create a pop-up sculpture that folded up into a cube for easy shipping. Easy shipping was key. I was told my three-dimensional work would not be accepted by galleries and textile shows because the organizers were worried a dimensional piece could be damaged more easily than a flat piece. What started as a defiant act, however, turned into a fun project and I didn't want to stop. For this project, I included as many three-dimensional techniques as I could."

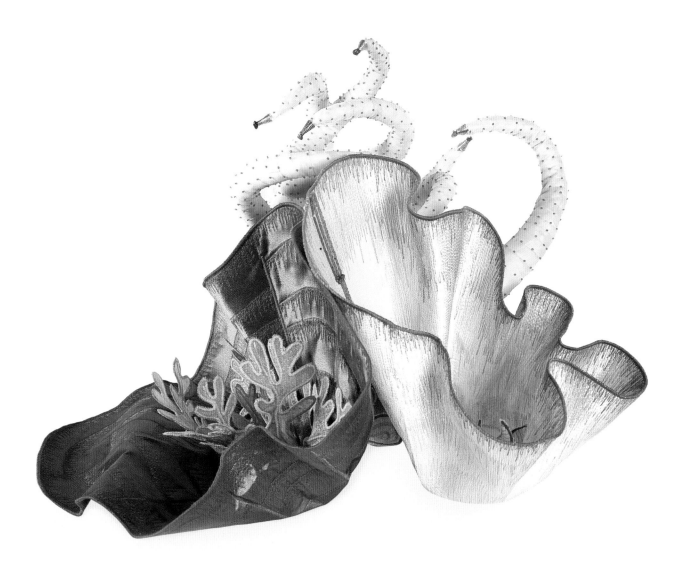

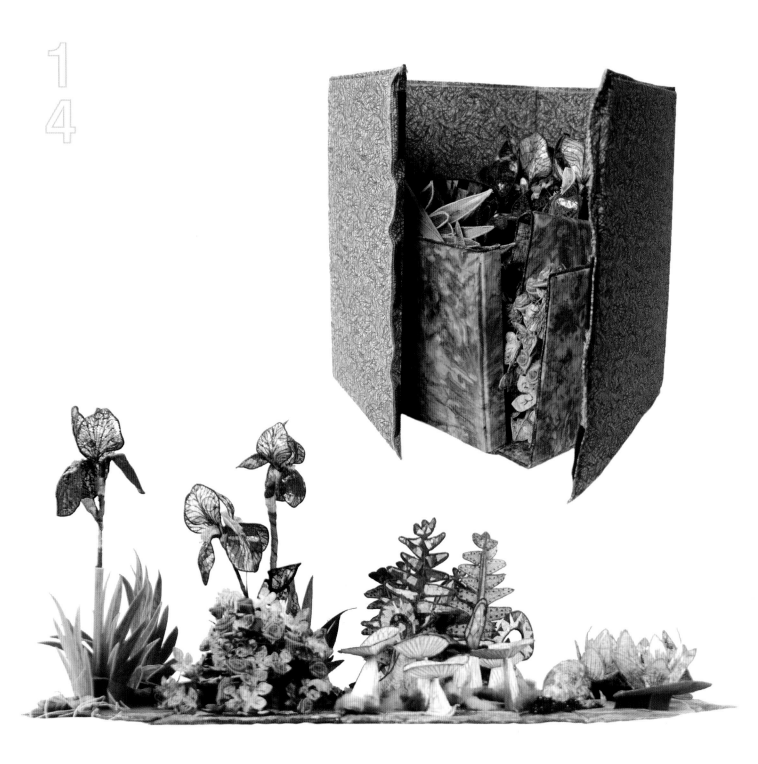

Indeed, the garden does fold up onto itself, like origami, to form a cube; but, when opened, a glorious miniature landscape delights the eye. Look closely and you see delicate orchids, butterflies, mushrooms, ferns, and water lilies, all stitched from organza and other fine fabrics, richly embellished with stitched veining so that the petals and butterfly wings appear as translucent and elegant as stained glass.

Mary McCauley. *Flower Box*, 2013. 16" × 14" × 12"; opened, 18" × 44" × 33". Cotton, satin, and organza fabrics; rayon and metallic threads; jewelry wire; corrugated vinyl armature; Velcro closures. Courtesy of Mary McCauley.

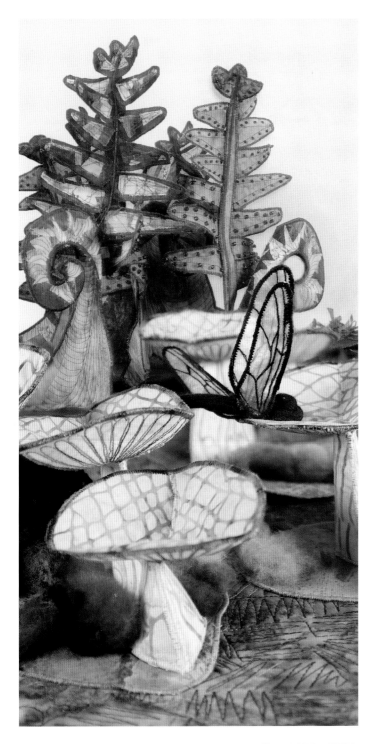

That same diaphanous quality suffuses *Reef Forms*, a sculpture of satin, organza, and beads. An arrangement of three enjoined vessels with smaller vessels nestled within them, this piece, too, simulates a living landscape. For all her work, McCauley embraces the concept of Wabi-sabi, a way of thinking promulgated by Sen no Rikyū, a figure in a fifteenth-century Japanese legend, according to which beauty can be found in imperfection and authenticity. Wabi-sabi was a reaction to the prevailing aesthetic of lavishness, ornamentation, and rich materials—a time that can be likened to today's consumer-driven culture. Wabi-sabi teaches that we are all temporary beings, that we and the world around us are in a continual process of returning to dust, and that we must embrace both the joy and grief found in this evidence of passing time.

ABOVE
Mary McCauley. *Flower Box*, 2013. Opened, mushroom detail. Courtesy of Mary McCauley.

RIGHT
Mary McCauley. *Flower Box*, 2013. Opened, orchids detail. Courtesy of Mary McCauley.

Melody Money

United States | www.melodymoney.com

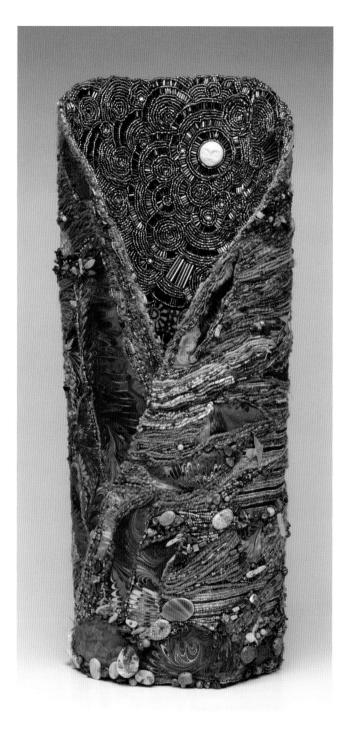

Melody Money is a mixed-media artist who lives in the mountains overlooking the city of Boulder, Colorado. Her pieces, comprised mostly of art quilts in addition to her three-dimensional work, are a wonder of precisely placed beads and threads that depict her unique view of natural landscapes—in particular, those currently around her and those she came to know when she lived near the California coastline. Money is an artist who works with a mixture of abandon and self-control.

Money learned quilting and needlework from her mother and grandmother, and as an adult earned a degree in fine arts, specializing in silk-screening. She then studied prismatic color theory at a design school. She worked as a graphic artist, children's book illustrator, and art teacher. With her children grown and off to college, she began to devote all her time to art. That was when she started translating the beauty of the Point Reyes National Seashore into beaded wall-hangings that portray the ocean, dunes, aquatic birds, and shimmering skies—all done with self-taught stump work embroidery, pleating, and painting techniques. Money remarks, "There are moments in life that are magic: sunlight on new snow, moonlight reflected on water, birds in flight, wind-swept grass. I think everyone recognizes such moments. I work to recreate them in my quilts." These moments are evident in *17 Cranes*.

Each of her pieces usually begins as a drawing in Money's sketchbook. Once she decides on a design, she works either directly from the drawing or uses it as a jumping-off point. She then paints her backgrounds, often on silk, using swathes of mottled color to create depth and movement. Then, she dips into her stash of treasured fabrics and embellishments she has been collecting for years.

Melody Money. *Canyon Wrapped in Starlight*, 2016. 18" × 7". Hand-dyed and hand-painted cotton fabric; silk tapestry fabric; marbled silk habotai; wool felt; beads; sequins; crystals; rocks; carved bone; yarn; hand-cut and hand-embossed copper; and hand-wrapped cotton, rayon, silk, wool, and metallic thread. Courtesy of Melody Money. Photography: Wes Magyar.

It takes extraordinarily focused attention to create the intricate patterning Money presents. The physicality of her work strikes the viewer immediately; we intuit her process of construction as exacting and intense, such as that seen in *Wildflowers*.

For her fabric sculpture *Canyon Wrapped in Starlight*, Melody says she studied sculpture in school and brought that knowledge to its construction. Here, again, this artist shows us her belief in engaging the viewer directly, focusing on elemental images, both simple and extraordinarily complex.

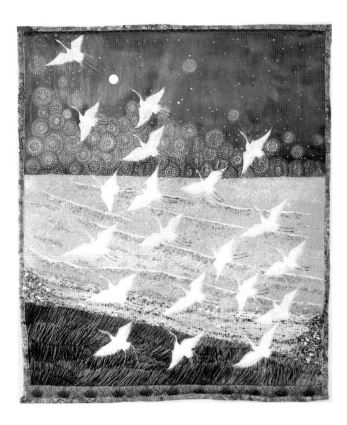

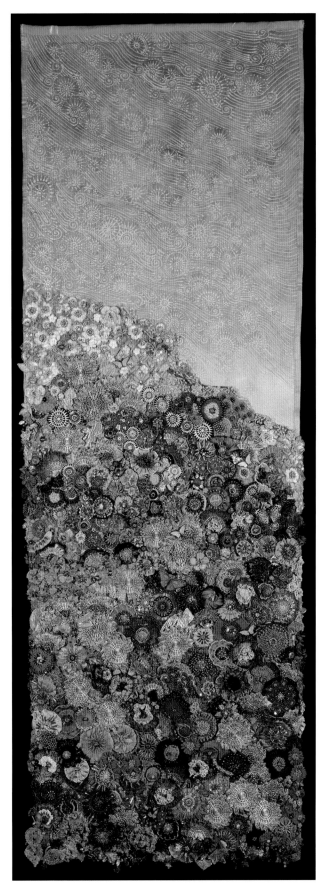

ABOVE
Melody Money. *17 Cranes*, 2013. 40" × 45".
Hand-dyed and hand-painted whole-cloth cotton; tulle; hand-dyed chiffon; lamé; silk; cotton batik; silk dupioni; beads; sequins; shells; carved bone; feathers; and cotton, rayon, and metallic embroidery thread.
Courtesy of Melody Money.

RIGHT
Melody Money. *Wildflowers 2*, 2015. 57" × 30".
Hand-dyed and hand-painted whole-cloth cotton; tulle; hand-dyed chiffon; lamé; silk; silk dupioni; beads; sequins; shells; carved bone; cotton batik; feathers; and cotton, rayon, and metallic embroidery thread.
Courtesy of Melody Money.

Wilma Butts

Canada | www.wilmabutts.com

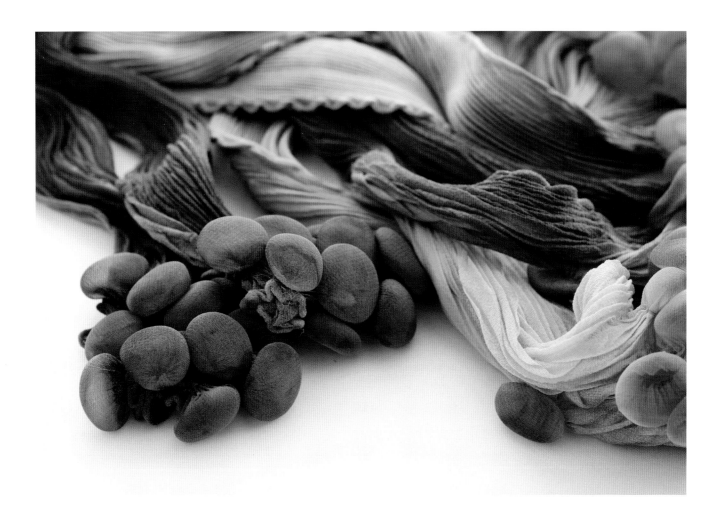

Wilma Butts worked in creative professions and pursued art as a hobby before she made the decision to commit to art full time in 1998. She discovered three-dimensional fiber sculpture through a process of experimentation with traditional Japanese shibori dye-resist techniques. She notes, "I became fascinated with the textures that folding, pleating, stitching, and binding create, and I've been exploring these techniques for almost twenty years."

Butts firmly believes that contemporary fiber artists, regardless of whether they are aware of it, have been influenced by the work of the innovators of the 1960s, such as Lenore Tawney and Sheila Hicks. Butts says, "Those artists broke ground for future artists by introducing fiber as an abstract sculptural medium. That era also saw the documen-

ABOVE
Wilma Butts. *Anemone*, 2007. Detail. Courtesy of Wilma Butts. Photography: Perry Jackson.

OPPOSITE
Wilma Butts. *Anemone*, 2007. 3.6' × 4.9'. Shibori pleated silk. Courtesy of Wilma Butts. Photography: Perry Jackson.

tation and appreciation of ancient fiber crafts, like shibori, that had been practiced for millennia by many cultures. That information provides an invaluable resource for today's artists."

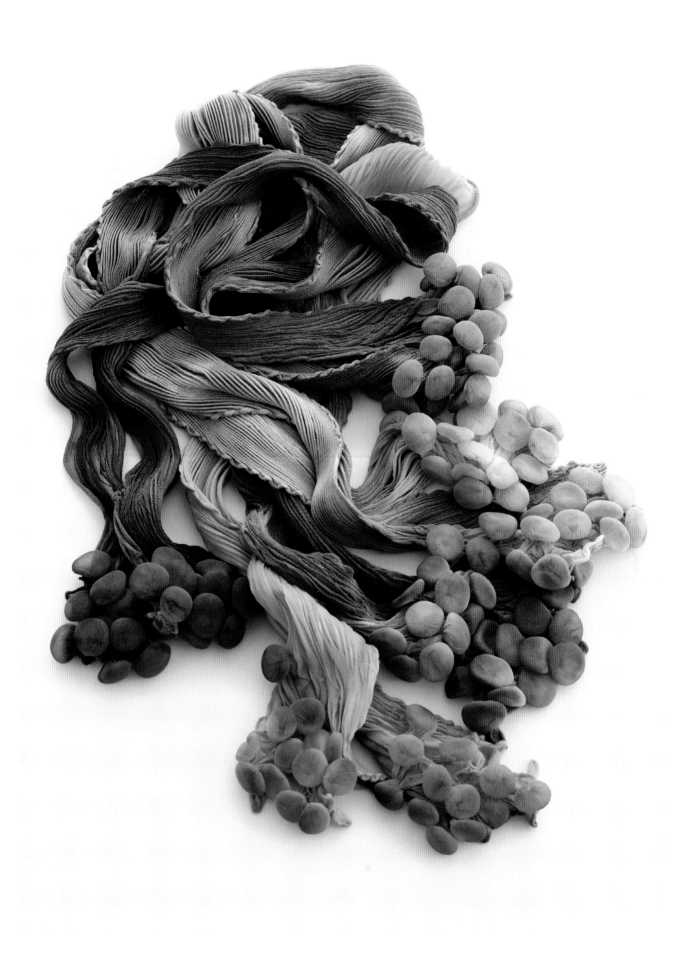

Nature is the theme that runs through Butts's work. "My work expresses my appreciation of nature and the joy it gives me. All around us we see examples of nature's amazing sculptural creations. I'm inspired by the transience of sand on a beach, the permanence of rock formations, the unfolding of flowers."

For her work *Anemone*, Butts bound semitransparent silk fabric over stones to form orbs that evoke sea anemones. She says, "*Anemone* explores the ethereal beauty of a magical undersea world. This piece is alive with texture, dimension, and movement. Sea anemones are being threatened by the effects of human activity. I wanted to create an awareness of their existence and the need to preserve their natural environment."

Butts was inspired by the sculptural beauty of mushrooms when she composed *Amanita #5*. "The earthy shades and sharply pleated silk I used references the genus *Amanita*, which contains 600 species of mushrooms. The texture was created by thread-binding pole-wrapped silk, resulting in thousands of tiny, knife-edged pleats. The incredible memory of silk makes this possible."

Daisho #1 was also made of shibori-pleated silk as well as forged aluminum in collaboration with metal artist Brad Hall, and was part of an exhibition that called for the interplay of diverse media and techniques. Butts explains, "Metal and silk may seem vastly different, but they have in common the qualities of strength, resilience, and memory. Both are shaped by intense energy. This piece is a balance of light and dark, transparency and opacity. The weightless, floating quality of the silk is grounded by the solidity of the metal. Just like nature, it's a study of balance."

Butts tells us, "My work is influenced by the patterns, textures, and quality of light I encounter on the Atlantic coast. Shibori-resist patterns can be seen everywhere in nature. They are created by the energy of the sun, rain, wind, and fire. In the same way that nature's energy imprints on the environment, shibori techniques record the energy of the creative process on fiber."

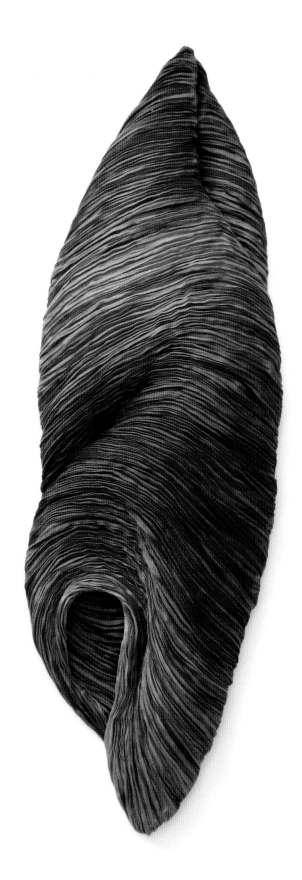

OPPOSITE
Wilma Butts. *Amanita #5*, 2013.
6" × 19". Shibori-pleated silk.
Courtesy of Wilma Butts.

LEFT
Wilma Butts. *Amanita #5*, 2013.
Detail. Courtesy of Wilma Butts.

BELOW
Wilma Butts. *Daisho #1*, 2010.
1.9' × 6.5' installation. Shibori-pleated
silk, forged aluminum (Brad Hall).
Courtesy of Wilma Butts.
Photography: Chris Myhr.

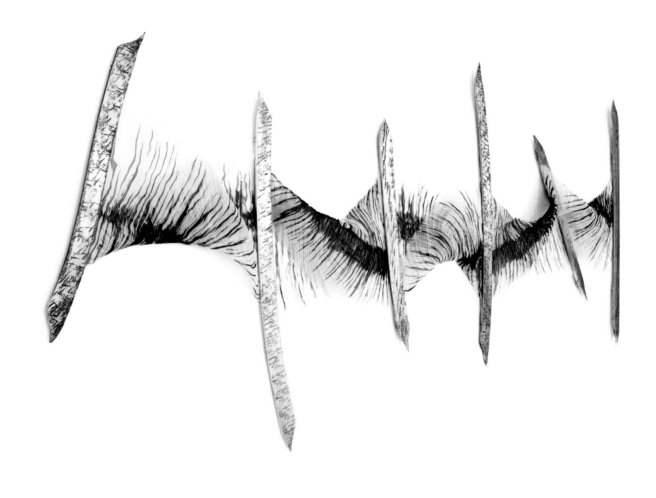

Cameron Anne Mason

United States | www.cameronannemason.com

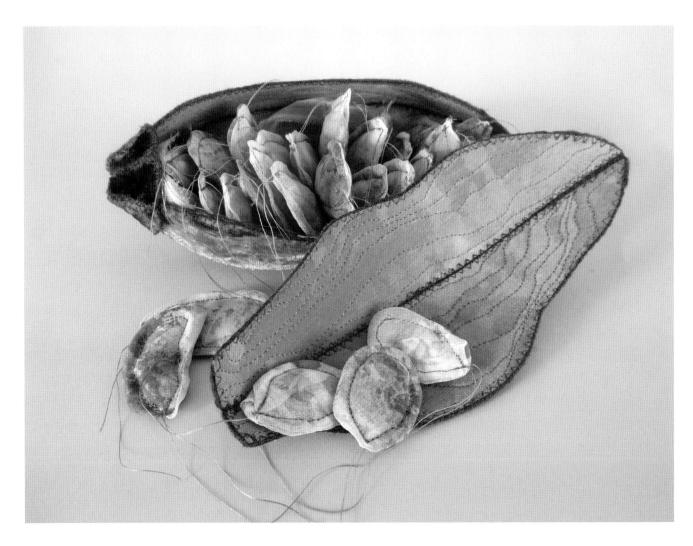

Cameron Anne Mason's path to her current art career as a sculptor working with hand-dyed textiles was a long and circuitous one. She studied theater, poetry, and collage, and got her degree in graphic design. After graduating, she worked as a book cover designer as well as created festival art, including giant puppets, floats, masks, and costumes. In 2000, she took a batik workshop and fell in love with surface design on fabric. Cameron began making quilts with her hand-dyed fabrics and soon extended her work into the third dimension. It was in this combination of surface, form, and stitching that Cameron found the artistic voice for her deep connection with and inspiration from nature.

Cameron Anne Mason. *In the Beginning Seed Pods*, 2014. 3.5" × 8" × 5" (variable). Hand-dyed and printed silks, cotton, rayon, silk/rayon velvet, nonwoven polyester interfacing, polyester, rayon, and cotton threads. Courtesy of Cameron Anne Mason.

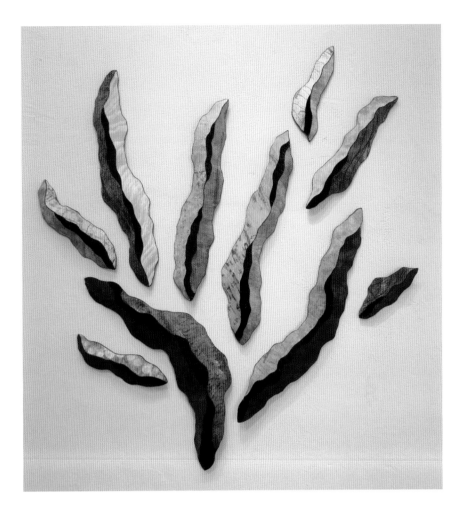

Regarding her *Soft Coral* installation, Mason relates, "On a trip to Mexico's Yucatan Peninsula, I snorkeled through an underwater garden of corals and sea fans under blue skies. Days later, a storm blew in with strong winds and rain. Snorkeling in these choppy waters after the storm, I saw these same sea fans undulating dramatically with the waves but still intact. These fragile structures were stronger and more flexible than they appeared. Like all corals, sea fans are made up of tiny polyps that form colonies, one building upon another to create larger forms over time. Their ecosystems are fragile and threatened by factors including climate change, ocean acidification, and agricultural runoff."

For her piece *In the Beginning Seed Pods*, Mason used the seed pod shape to represent "the original building block of a plant. Inside, these seeds are leftover strips and scraps of hand-dyed fabrics I'd used in other artwork. They represent the bits of the plant's precious DNA."

About her work, Cameron notes, "I like the object-ness of sculpture. I like the way that it is in space with the observer. I like the way someone can see it from multiple viewpoints. Working with fabric gives my work a connection to the body. There is an inherent commonality in the fact that we are wearing clothing. It has a sensuality that people respond to."

Kath Danswan

United Kingdom | www.danswandesigns.co.uk

Kath Danswan. *Chameleon*, 2012. 6" × 10" × 7". Dyed silk caps, painted felt, thread. Courtesy of Kath Danswan.

Kath Danswan was taught "all the lovely needle arts" by her mother and grandmother. She went on to immerse herself in embroidery instruction in college and, when she was asked to create three-dimensional pieces for her final exams, she found there was no looking back. She recalls, "Once I had learned the basics, I started to push the boundaries to see how far I could go."

Danswan's career in art took off with the publication of her book *Beautiful Bowls and Colorful Creatures* (Melbourne: Linen Press, 2006). She continues to favor images from nature. "I see beauty in the most unlikely of places. A good example of this was when I was on a choir tour of Tuscany. While my friends were admiring beautiful buildings, I was getting excited about the ground beneath me. The paving was worn and dirty and had the most wonderful textures and colors."

Danswan designed her piece *Chameleon* for her grandson. She explains, "I'd taken him to a local reptile shop and he liked the chameleon there. I made up a story to go along with the sculpture and the story evolved into a moral tale: The creatures on the log laugh at Chameleon because she has lost her long tongue. When she is told that it's just stuck, she figures out how to set it free—and she eats all the creatures who had made fun of her. I wrote a book to go with the sculpture." The chameleon is made of hand-painted and

hand-stitched quilt batting. The log is comprised of dyed silk cap sandwiched between two pieces of water-soluble fabric, which was then machine-embroidered. Later, the water-soluble fabric was washed away. Danswan then formed it over a tube and left it to dry.

Danswan created *Bug Eating Plant* after watching a television program about a well-known garden show in the United Kingdom: the Chelsea Flower Show. She had already been making beetles and other bugs, but recalls, "I decided to make a vessel for them to hang out on. The beetle was made of Fantasy Film with an overlay of organza that was then machine-embroidered. Wrapped wires make up the legs."

Monarchs Resting depicts monarch butterflies dozing on a tree trunk after their long migration. The trunk is a hand-dyed silk cap, which was machine-embroidered then formed over a cylinder. The butterflies are machine-embroidered fabric, and the leaves are made from silk. The lichen is of puff paint.

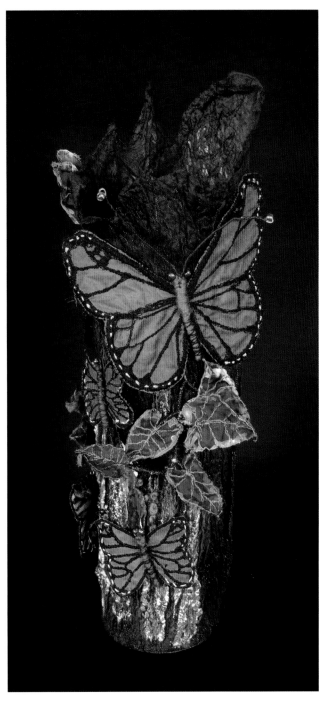

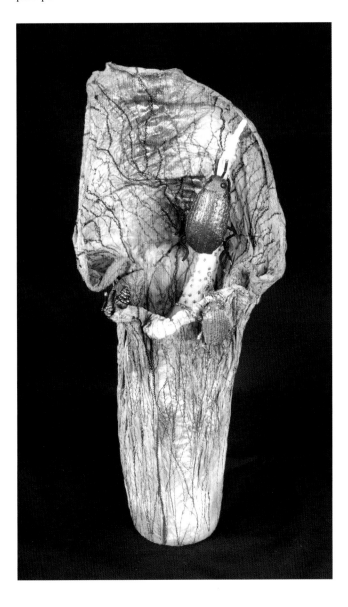

ABOVE
Kath Danswan. *Monarchs Resting*, 2014.
13" × 12" × 6". Dyed silk caps, cotton fabric, thread.
Courtesy of Kath Danswan.

LEFT
Kath Danswan. *Bug Eating Plant*, 2010.
15" × 7" × 6". Dyed silk caps, polyester organza, Fantasy Film, thread. Courtesy of Kath Danswan.

Jane King

United States | www.longmontquiltguild.org

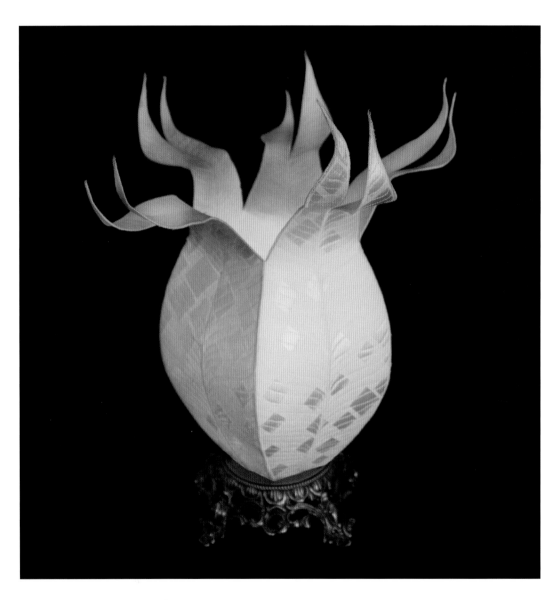

Art has been an intrinsic part of Jane King's life since childhood. She admired her older sister, an artist, and pursued instruction in high school and college. Eventually, she turned to quilting and, more recently, to three-dimensional fabric sculpture. Her primary instructor has been Mary McCauley, another artist represented in this book, from whom she learned to construct vessels using stiff interfacing.

King believes it is human nature to want to communicate feelings and ideas with others. She says, "We all have a story to tell, and art is the visual language we use to tell it. I have a great need to make things, to express myself. The main idea I want to get across is that the natural world is beautiful, created for our pleasure and enjoyment. My work is a way to share what I love."

Jane King. *White on White*, 2015. 14" × 8" × 8".
Cotton fabric, organza, interfacing, wire. Courtesy of Jane King.

For *Tulip*, King found inspiration in a bouquet. "The exterior fabric, including the six petals, is painted silk. The base has three sides that form a pedestal, and these are covered with painted organza. What I learned from this piece is that the grace and balance found in nature is not so easy to achieve. The image reflects the universal eternal hope for spring—for good weather and good spirits."

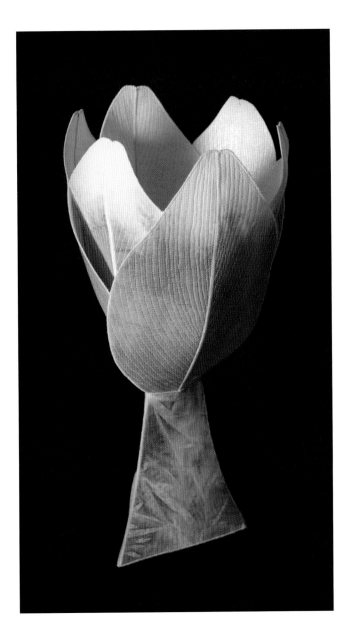

The sculpture *White on White* was King's first three-dimensional piece. She recalls, "It began with a simple shape repeated five times, creating a pentagon-shaped base. The top of each panel was split, and wires were stitched inside to form fingerlike projections. I wanted to create a vessel that looked like a blooming flower. I used white-on-white commercial fabric fused to heavy-weight interfacing. The interior is a sheer, sparkle organza. The light reflects off the satin diamonds of the fabric so they seem to be constantly moving as the light changes in the room."

Her sculpture *Dragonfly* is constructed of four panels. King notes, "I used hand-printed silk organza and sheer commercial fabrics to give the impression of stained glass. The dark 'lead' lines are satin-stitched, and beads were added to the top for a nice effect when the interior light is turned on. I used a metal base with an electric bulb."

ABOVE LEFT
Jane King. *Tulip*, 2015. 10" × 21" × 10". Hand-painted silk, hand-painted organza. Courtesy of Jane King.

ABOVE
Jane King. *Dragonfly*, 2015. 8" × 14". Hand-printed silk organza, commercial cotton, beads, metal base, electric bulb. Courtesy of Jane King.

Marjolein Dallinga
Canada | www.bloomfelt.com

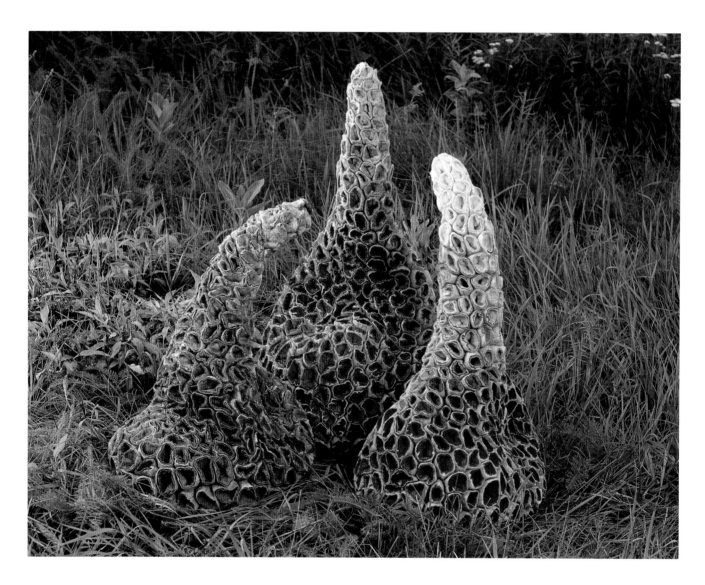

Marjolein Dallinga taught herself the felting techniques she has used throughout the years. She attended art school, where she studied painting and graphics, but always found paper and canvas limiting. She says, "I started sewing, quilting, and patching my paintings during those early years."

As a young woman, Dallinga was very active in the women's movement. She studied feminist art and feels it influenced her own artistry profoundly. She believes there is still a split between what is considered art and craft, although fiber artists have gained respect in the art scene. It does not bother her, however, because she loves the wool medium. She explains, "I don't mind if there are prejudices against this medium. I feel very drawn to it. It is close to the skin, protective, and present in our daily lives."

Marjolein Dallinga. *Three Swans*, 2016.
1.9' (height). Wool, cotton. Courtesy of Marjolein Dallinga. Photography: Philippe Doucet.

All of Dallinga's felted pieces are wet-felted by hand and most are of hand-dyed wool. *Tongue* is an example of this technique; it depicts the top of a tongue. Dallinga notes, "I had in mind the idea that the tongue enables us to taste, talk, and love, but also express aversion." *Three Sisters*, *Tubes*, and *Waves Gray* portray imaginative vessels and wall hangings made of hand-dyed felted tubes and pleats. Each is animated by its graceful form and intense colors.

ABOVE
Marjolein Dallinga. *Tongue*, 2016. 1.6' (height).
Hand-dyed wool. Courtesy of Marjolein Dallinga.

ABOVE RIGHT
Marjolein Dallinga. *Waves Gray*, 2013. 1.8' (height).
Wool, cotton. Courtesy of Marjolein Dallinga.

RIGHT
Marjolein Dallinga. *Tubes*, 2013. 2.4' (height). Wool.
Courtesy of Marjolein Dallinga.

Jan R. Carson

United States | www.janrcarson.com

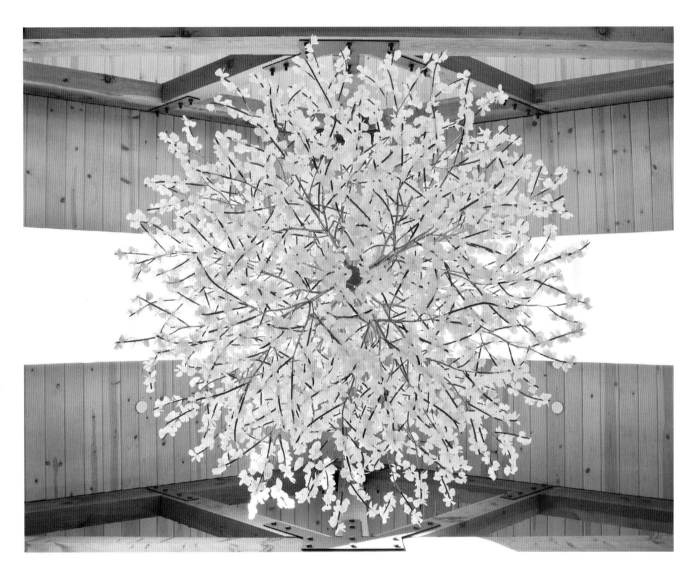

A textile artist, Jan Carson was aware from a young age that she had artistic talent, but she did not pursue a career in art until her third year of college. After graduating, she worked at a fabric store and used her spare time to experiment with sewing soft sculpture and clothing. Later, in a fine arts master's program, Carson's former interest in anatomy and physiology led her to compose paintings based on histological micrographs, and she ultimately turned to making anatomic recreations using fabric. She understood intuitively there was no other path for her but fiber art.

ABOVE
Jan R. Carson. *Flowering Almond Mobiles*, 2012. 7' × 7'. Aluminum, steel, silk, resin tubing. Courtesy of Jan R. Carson. Photography: Keith Sutter.

OPPOSITE
Jan R. Carson. *Winter*, 2011. 8' × 7.5'. Aluminum, steel, hand-dyed silk. Courtesy of Jan R. Carson.

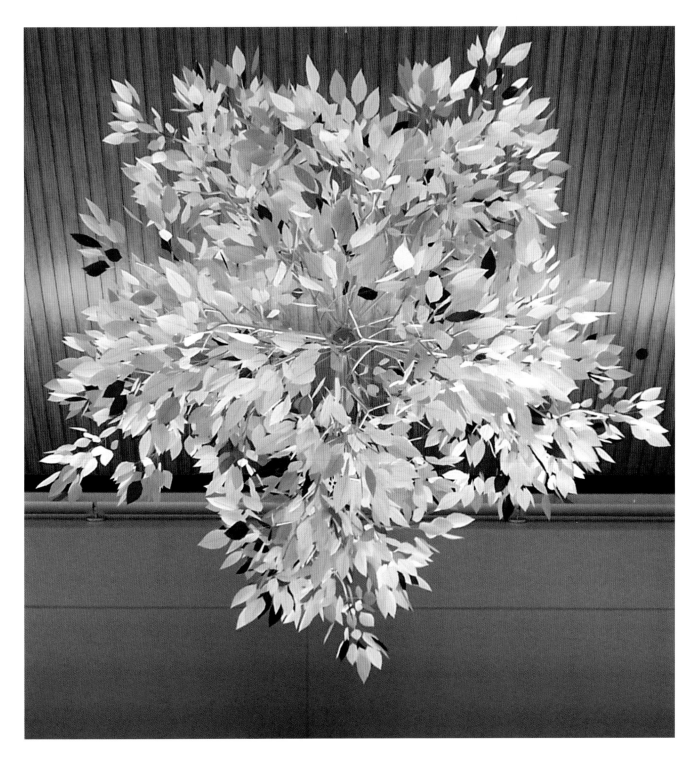

Carson came to create leaf mobiles, many of which were commissioned by large organizations. For example, *Flowering Almond Mobiles* was conceived for a cancer center in California. Carson says, "The central infusion bay was a cavernous space and I wanted to preserve its airy expansiveness while simultaneously providing a sense of sheltering intimacy. I wanted the mobiles to have a near-perfect, spherical shape, balanced by the organic sticklike projections of the flowering twigs. My thought was to express a sense of beautiful chaos within a balanced form as a metaphor for the push and pull—the challenges—we encounter in life."

For *Winter*, a white-leafed mobile, Carson used starched silk because of its luminosity and delicate appearance. The leaf clusters were created by using fine-gauge wire with a silk leaf at each tip. The artist used a laser cutter to create the leaf shapes. *Red Maple Vertical* uses similar techniques.

Similarly, Carson used laser-cut starched silk for *Yellow Flowering Tree Mobile*. The leaves were attached to heat-shrunk painted tubing; when the tubing shrunk, the paint created a lightly textured surface. Both of these mobiles, *Winter* and *Yellow Flowering Tree Mobile*, were a collaboration between Carson and metal sculptor Michael Gutzwiller. Gutzwiller chose aluminum for its light weight and durability.

The common theme running through Carson's work is her observation of the fragility and ethereal nature of the ever-changing environment. She notes, "My work focuses on the cycle of life, on the transitions we see occurring in nature—from the emergence of life through its seasonal changes to its death and resurrection. I'm interested in the impact of the flow of time."

ABOVE RIGHT
Jan R. Carson. *Red Maple Vertical*, 2006. 10' × 7' × 3'. Silk, stainless steel wire. Courtesy of Jan R. Carson.

RIGHT
Jan R. Carson. *Yellow Flowering Tree Mobile*, 2013. 5.5' × 5.5'. Detail (full-size rendering unavailable). Aluminum, steel, silk, resin tubing. Courtesy of Jan R. Carson.

Gwen Turner

United Kingdom | www.diverse-threads.co.uk

Gwen Turner is a textile artist who chose to pursue a career in science over her love of art. When she retired, though, she turned to art, earning degrees in fine arts and visual arts. She painted, etched, and drew, but yearned to make dimensional art. She came upon cloth sculpture and has since devoted her creative life to it.

Gwen Turner. *Seaweed Bowl*, 2011. 11.8" × 6.6". Silk dupioni, thread, dissolvable stiffener. Courtesy of Gwen Turner.

Turner recalls, "My first sculptural piece was a cup and saucer in the Matisse–Fauve style. I found I'm interested in creating work that, from a distance, appears two dimensional, but on closer inspection reveals an unexpected depth. Working with textiles allows me to move from realism into a more impressionistic, textural, and abstracted interpretation of nature."

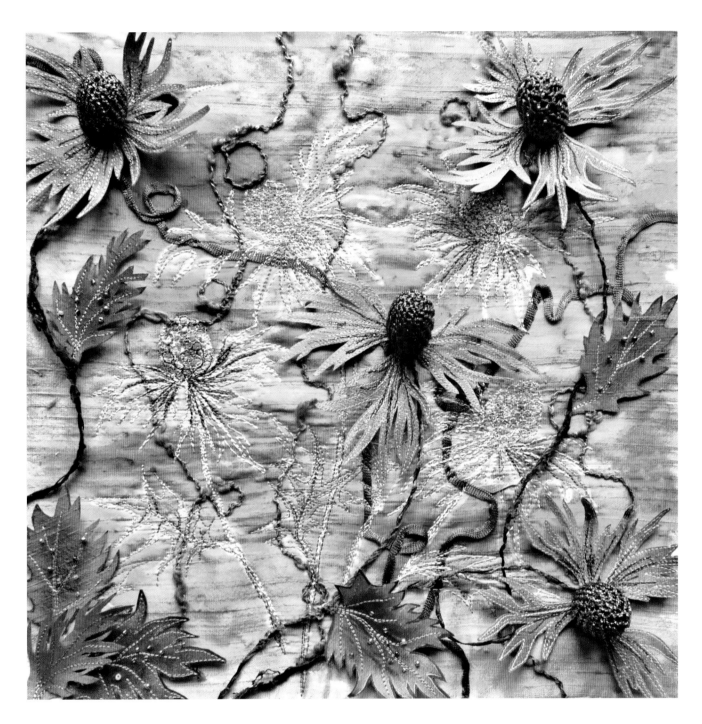

Turner's recent work—*Water Irises*, *Miss Willmott's Ghosts*, and *Seaweed Bowl*—is a series of dimensional plant-inspired scenes using hand-painted silk dupioni, habotai, and other silk fibers embroidered with free-motion and hand-stitching. She says, "As a scientist and artist, I find all natural things fascinating—from DNA to single-cell organisms, to the evolution of plants and animal life. Besides representing what is conventionally beautiful, like flowers, I also like to portray the often neglected, such as the thorny twig rather than its full-blown rose."

OPPOSITE
Gwen Turner. *Water Irises*, 2016. 12.5" × 12.5". Silk dupioni, hand-painted habotai silk, silk fibers, thread, dissolvable stiffener, beads. Courtesy of Gwen Turner.

ABOVE
Gwen Turner. *Miss Wilmott's Ghosts*, 2016. 12.5" × 12.5". Hand-painted silk dupioni, silk fibers, ribbon, thread, stiffener, dissolvable, beads. Courtesy of Gwen Turner.

Sandra Meech

United Kingdom | www.sandrameech.com

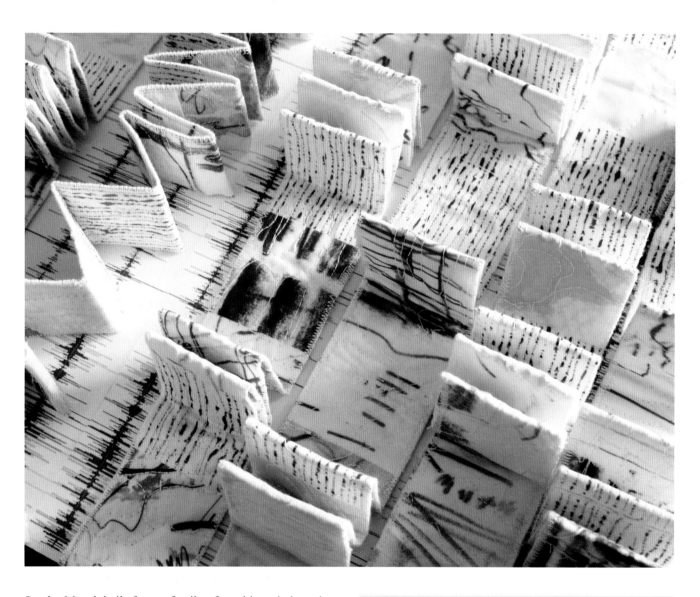

Sandra Meech hails from a family of machine stitchers; her aunt was a tailor and her mother made all the family's clothes, for example. Although she, too, learned these skills, art was Meech's "lifelong passion." She attended the Ontario College of Art, after which she worked as a graphic designer and magazine illustrator, eventually turning to textile art.

Sandra Meech. *The Last Silence*, 2014. 12" × 12". Image transfer on cloth, thread, wire. Courtesy of Sandra Meech.

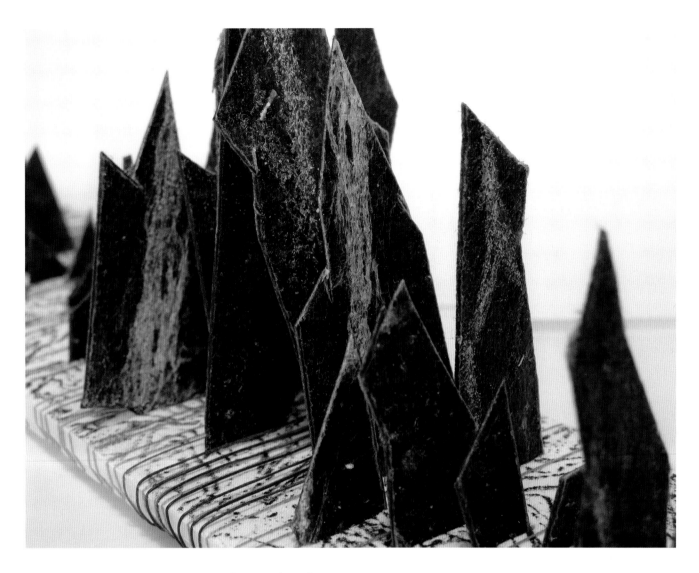

On her own, Meech developed skills to produce dimensional sculpture. She tells us, "I bought some sculptor's wire mesh and thought if I layered it with a thin wadding to soften the wire, it could be stitched and manipulated into a three-dimensional piece, or at least off-the-wall dimensional work. I also experimented with stiff interfacings I had learned about when attending the program Diploma in Stitched Textiles in the United Kingdom, which opened up a new range of materials and practice for me. It was an exciting time."

Meech notes, "Working with any subject in three dimensions is a challenge. The final work has to be interesting from every angle. In stitched textiles, there is the added limitation of some fabrics. Will they be rigid enough to stand on their own? Will the material last over time? If it is to be a hanging installation, will it float too much and set off security alarms? Will it be handled by the public? I like on-the-wall dimensional work, as well—stitched art that can be wall mounted.

Sandra Meech. *The Last Silence 2*, 2014. 12" × 4" × 9". Stiffened fabric, threads. Courtesy of Sandra Meech.

It sometimes casts an interesting shadow. These pieces don't require a special stand or plinth, and canvas-mounted textile art can give a great illusion of dimension. I recommend this as a first approach for the new fiber artist."

The Last Silence and *The Last Silence 2*, image transfers on cloth, machine-stitched through wire, were inspired "by a walk on a frozen lake in Arctic Canada on a visit to Inuit communities many years ago. There was not a sound to be heard. Total silence. Just the occasional cracking of ice beneath me. This small piece includes wavelength 'marks' from the sound of the ice."

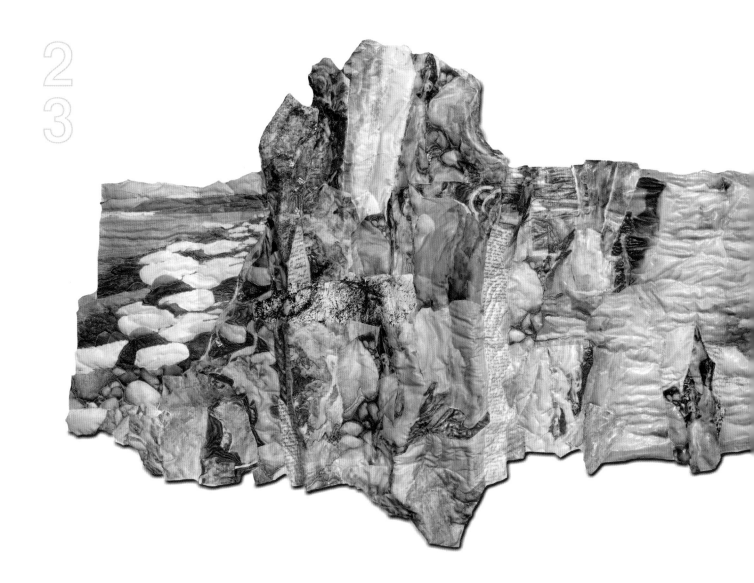

Continuum is a collage of images of marks, writings, and photographs transferred onto cotton, stitched through a wire form, and manipulated for dimension. Says Meech, "Conscious of the speed at which many glaciers are retreating, as well as complete ice shelves that have broken away in recent years, I am interested in the effects of global warming in these remote areas and how it affects all of us. The *Meltdown* series, which includes *Continuum*, addresses these issues."

ABOVE
Sandra Meech. *Continuum*, 2013. 6' × 2'.
Collage of photos, writings, and marks transferred onto cotton; thread; wire. Courtesy of Sandra Meech.

OPPOSITE
Sandra Meech. *Continuum*, 2013. Detail.
Courtesy of Sandra Meech.

Jennifer E. Moss

United States | www.jenniferemoss.com

Jennifer Moss's mother knits and embroiders, and taught her daughter those skills. However, it was just before she completed her undergraduate degree in art that Moss first considered fiber art as a mode of expression. She always knew she wanted to be an artist; initially, she studied traditional sculptural media as well as metals and jewelry. When she took a weaving class during a semester abroad in Florence, Italy, she fell in love with the technique.

After receiving her undergraduate degree, Moss developed a line of jewelry that featured silver and fiber elements, but she was dissatisfied with running a commercial business. She notes, "At the same time I was managing my own business, I was continuing to make conceptual, three-dimensional work and it was then that I taught myself felting. I liked that it was a technique I could use without specialized tools I no longer had access to after graduating from and leaving school. I also loved the way felt allows for large-scale sculpture and installations that are still lightweight and affordable to create."

ABOVE
Jennifer E. Moss. *Propagation*, 2011.
6' × 4' × 6". Felted wool, wax, oil color. Courtesy of Jennifer E. Moss.

OPPOSITE
Jennifer E. Moss. *Transient Structures*, 2013.
30" × 72" (each panel). Cotton, steel wire, saltwater. Courtesy of Jennifer E. Moss.

Moss went back to school for a master's degree in fibers, during which she focused on using computer-aided weaving in fine arts application. Since then, she has explored many different fiber techniques, including knitting, embroidery, coiling, and knotting. Currently, she often uses several of these techniques when creating her textile-based sculptures.

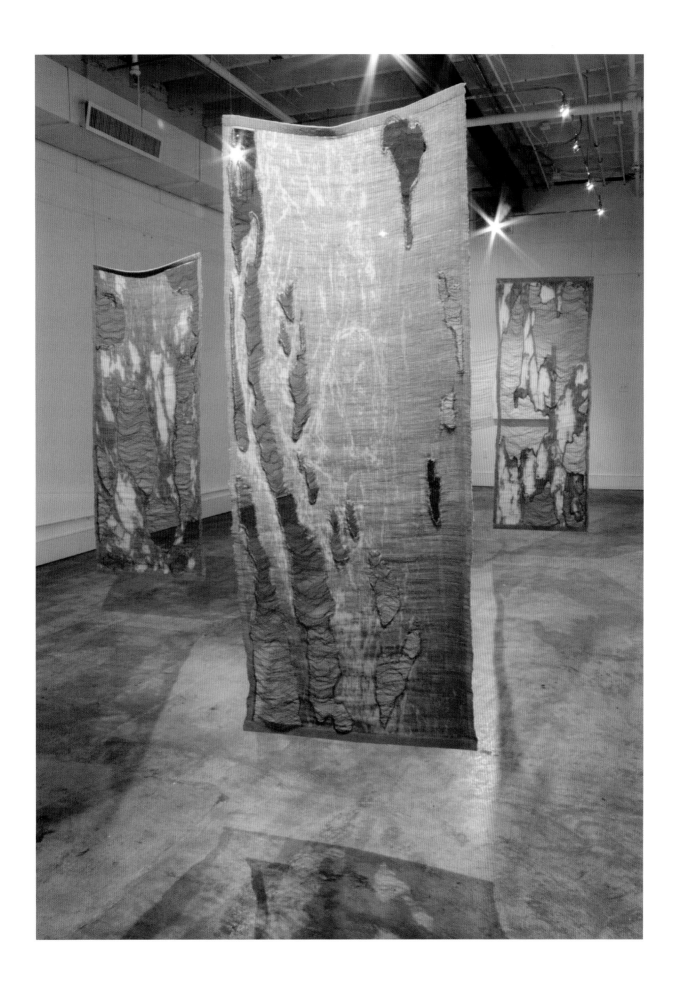

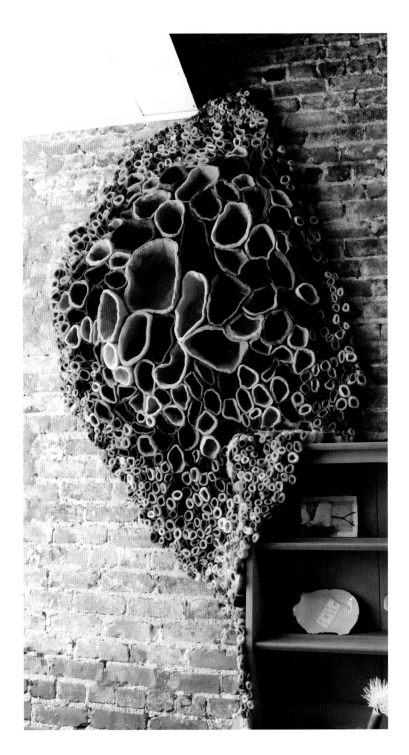

Moss was inspired to compose *Propagation* after she saw electron scanning microscope images of plant pollen emitters. She recalls, "By magnifying the forms, I invite the viewer to have a personal experience with these usually unseen systems." The piece is made of wool, wax, and oil pigments.

Transient Structures represents a series of weavings "that push the idea of impermanence to the extreme. The distinctive shades of rust you see were achieved with varying weave structures, which resulted in different levels of interaction between the metals and fibers I used. The wire was sprayed with saltwater to start the rusting process."

Originally created as a site-specific installation, *Overgrowth* was inspired by the notion of "urban decay and nature's ability to reclaim the built environment. Besides depicting nature overcoming adversity imposed by human hands, it also invites contemplation of one's own mortality."

Jennifer E. Moss. *Overgrowth*, 2013. Variable dimensions. Hand-dyed and hand-felted wool. Courtesy of Jennifer E. Moss.

CHAPTER TWO
CAPTURING THE EPHEMERAL

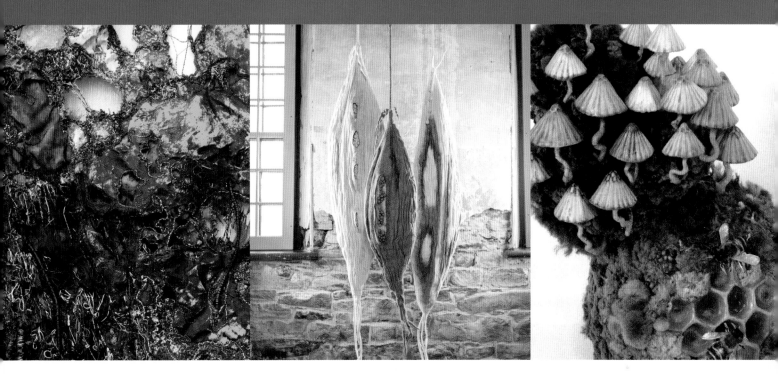

The dictionary defines *ephemeral* as lasting a very short time, short-lived, transitory. All living things can be considered ephemeral, but so are the moments of our lives—the second-to-second, minute-to-minute thoughts, feelings, sensations, and observations we register mentally or viscerally.

For the artists who seek to capture the ephemeral in their work, this concept also connotes the bridging of those moments as they pass through time—specifically, as they form our memories. Such memories then become our narratives, the stories we tell ourselves to help us understand what we have experienced and how these experiences make up the essence of who we are.

The exploration of time passing, of the process of birth to maturity, to decay and death, in some ways represents an attempt by the artists to leave a mark, a parcel of proof of having had once walked the earth. Furthermore, it reflects the artists' unique point of view about what was witnessed during their personal journeys. Their art expresses a wish to communicate this information with their contemporaries, and also preserve it for future generations—a pitch for fundamental human connection and perhaps a kind of immortality.

Katy Drury Anderson

United States | www.fiberdimensions.com/anderson

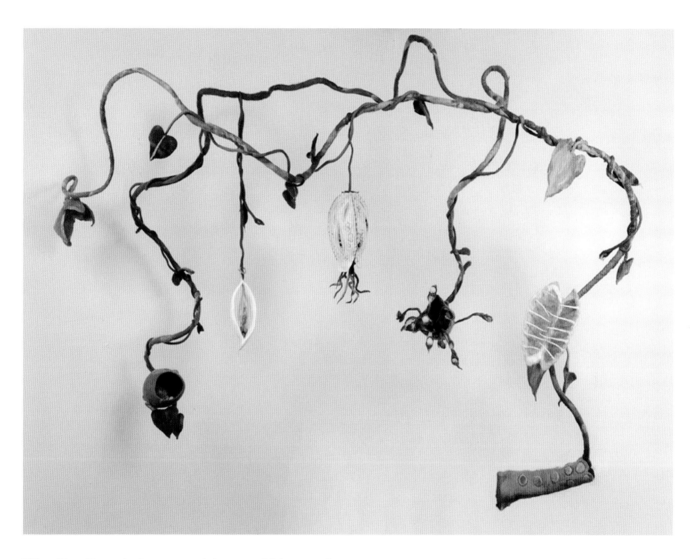

Katy Drury Anderson. *Womb with a View*, 2010.
6' × 8' × 3.5'. Needle-felted wool. Courtesy of Katy
Drury Anderson.

When Katy Drury Anderson was eight years old, her grandmother came to live with the family. Anderson says of her grandmother, "Her hands were constantly busy, sewing, beading, and creating heirlooms that I now treasure. Her industry and creativity inspired me. Becoming an artist was never a conscious decision. I make art because I must."

Although Anderson started her career at University of California, Berkeley, as an art major, she graduated college with a degree in sociology, which developed her social consciousness. She went on to become an obstetric nurse for more than thirty years.

Anderson continued to pursue her artistic interests in her spare time and became intrigued with Japanese papermaking. This became her artistic focus for the following eight years. At that point, she began taking courses in fiber sculpture, which opened her eyes to an endless array of dimensional

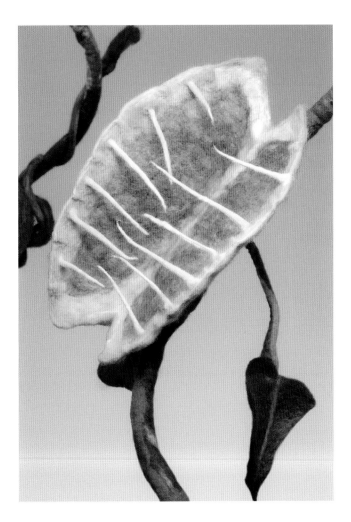

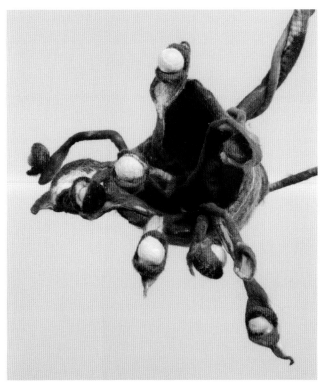

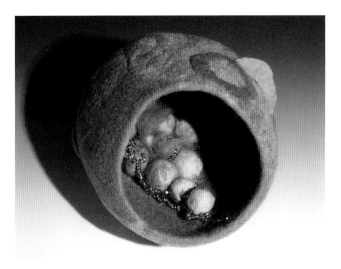

materials and techniques. She recalls, "I was motivated to take my art 'off the wall' and began to explore three-dimensional design. I realized it was much more fulfilling. Although it posed more challenges, it pushed my work to a new level."

For her series *Womb with a View*, the artist blends and felts wool roving to create a variety of podlike forms. She tells us, "As in the process of creating life, felting requires strength, calculation, patience, and a sensitive connection to the subtle transformation of the material. By using wet, dry, and hybrid felting techniques, I designed an array of pods ranging from fertile and ripe ones to overly productive and distressed pods. My intention was to emphasize the connection between human and botanical reproduction, and to demonstrate the patience and dedication required for creation. I hope to convey, especially, my deep appreciation for the life force."

Working with high-risk pregnant women, Anderson says, "I am fascinated by the similarity between the protective womb and the botanical pods I encounter on my frequent hikes. From coastal trails, too, I witness the mighty power and hypnotic rhythm of the ocean, and am reminded of the awesome forces of labor and delivery. Life in all its forms is miraculous."

Phillippa K. Lack

United States I www.pkldesigns.com

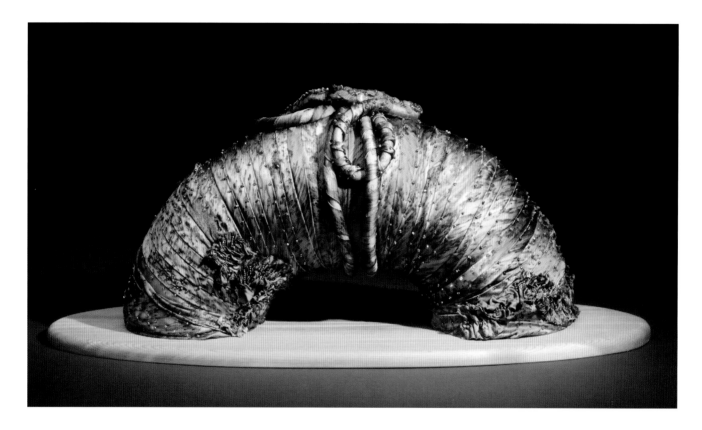

Phillippa K. Lack describes herself as a fiber and mixed-media artist. Before incorporating fiber into her pieces, Lack worked with watercolors, and pen and pencil on paper. On a trip to France, however, where one of her daughters was studying abroad, she was given a beautiful hand-painted silk scarf. Thus, her addiction began, especially to vibrantly colored pleated-silk sculptures.

These textiles remind her of her mother's pleat-work at home in Jamaica, except that her mother made her pleats by hand whereas Phillippa uses a machine. She recalls, "My mom laboriously put in rows and rows of fine basting stitches by hand. My work is more organic. I just pin a pleated piece to a backing and see where the twists take me." For *Fandango*, she manipulated smocked shibori silk ribbons, beads, and peacock and pheasant feathers.Lack also creates silk-wrapped sculptures. "*Portal* was done on a piece of

ABOVE
Phillippa K. Lack. *Portal*, 2012. 15" × 9". Polished wood base, 30". Hand-painted silk, aluminum tubing, beads, and sequins. Courtesy of Phillippa K. Lack.

OPPOSITE
Phillippa K. Lack. *Fandango*, 2003. 23" × 19". Manipulated silk, organza, beads, peacock feathers. Courtesy of Phillippa K. Lack.

leftover flexible aluminum tubing [a dryer vent hose]. I covered it with batting and then wrapped bias strips of hand-painted silk over the batting. Then, I beaded the entire piece along the seam lines as a decorative and practical way to keep the strips in place."

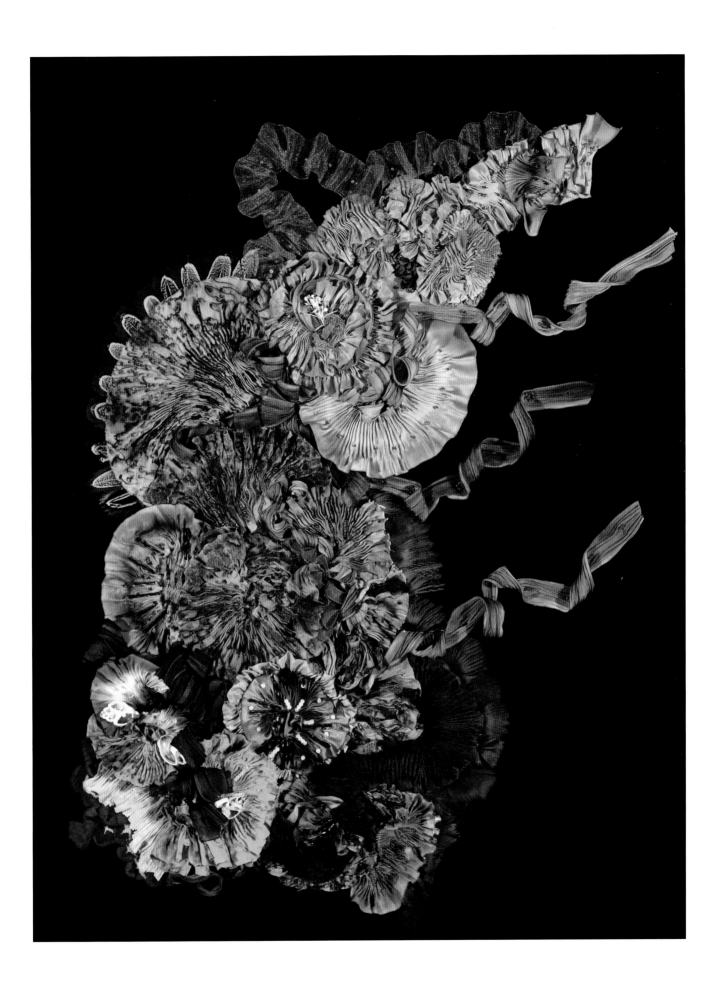

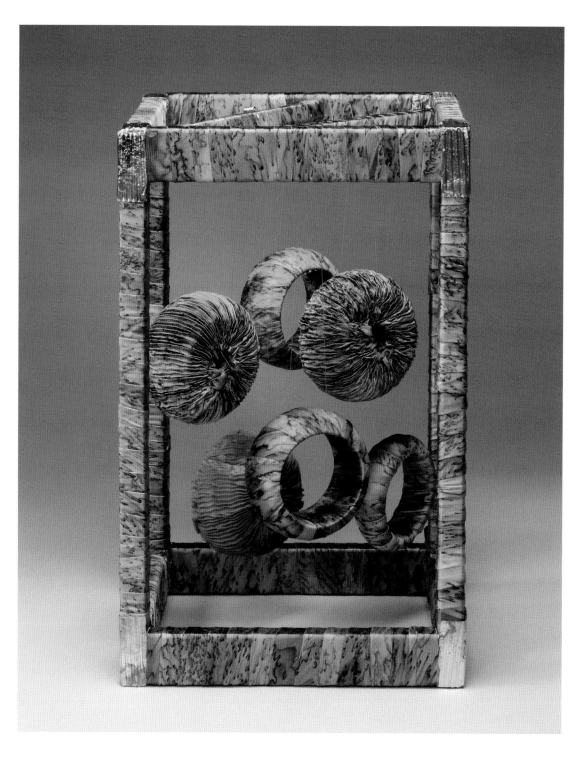

For *Spheres*, the artist suspended circle shapes from bars placed across the top of an open cube frame she made from wood slats. Lack notes, "I used a nonstretchy jewelers' string with a hidden magnetic clasp on the inside of the individual circles so that they can be moved by the owner, making it a kinetic sculpture."

The pure joy of coloring and manipulating silk fabric inspires Lack as she explores what forms her materials are capable of taking and her own unbridled motivation to bring her imaginative ideas to fruition.

Phillippa K. Lack. *Spheres*, 2012. 16" × 10".
Wood armature, hand-painted silk, pleated copper sheeting, nylon cord. Courtesy of Phillippa K. Lack.

Katherine D. Crone

United States | www.katherinedcrone.com

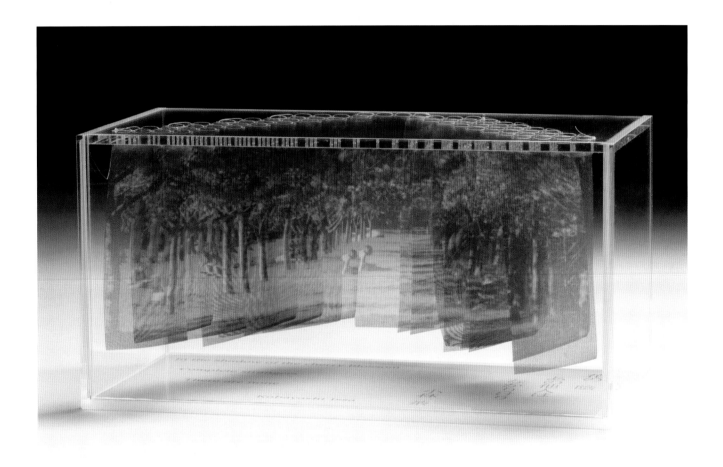

After having attended a graduate program in theatrical costume design, a program in digital images and printing at a fashion institute, and courses in bookbinding and photography, Katherine Crone pursued a practical career in design. When her husband became ill, and a major client of hers closed up shop, she decided life was too short to put off following her dream. It was then that she began to make art full-time.

Crone describes her work as visual journals viewers can interpret for themselves. "The images are transparent and ephemeral, captured in photographs in a book form, forming sculptural dimension. My subject matter is quotidian—light and shadow, water, reflections, architectural details, and panoramic landscapes. And like a written journal, it represents

Katherine D. Crone. *In the Shadow*, 2009.
6" × 12" × 6". Acrylic, silk organza, nylon monofilament. Courtesy of Katherine D. Crone.

accumulated ideas and emotions. Yet even though each piece may have a personal backstory for me, the viewer's reaction will be personal and unique, validating my intent."

For all her pieces, Crone turns photographs into digitally altered images that are then printed onto fine silk organza and mounted with bookbinding stitches, producing a second projected image.

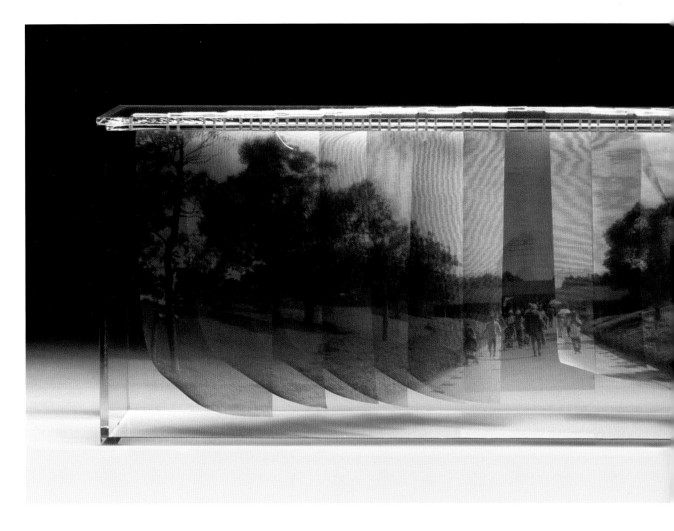

In the Shadow was inspired by a haiku. Crone recalls, "I saturated the colors using a computer program, and then the image was cut into segments, or pages. With clear nylon monofilament, I bound the pages to a lid of a clear Plexiglas box using a saddler's harness figure-eight bookbinding stitch. I treated the lid as the spine of the book. The holes were laser-drilled by a fabricator using a template I had made. In such works I am exploring the best marriage of form and image."

Other works created in a similar fashion include *Garden in the Rain* and *Tokyo Sunday*, but using an alternating-hitch bookbinding stitch.

For Crone, her artwork is a way of documenting memories—repositories of moments in her life she has chosen to record. Now tangible and permanent, they are physical evidence for her and others that she was a participant in the rhythm and flow of her life.

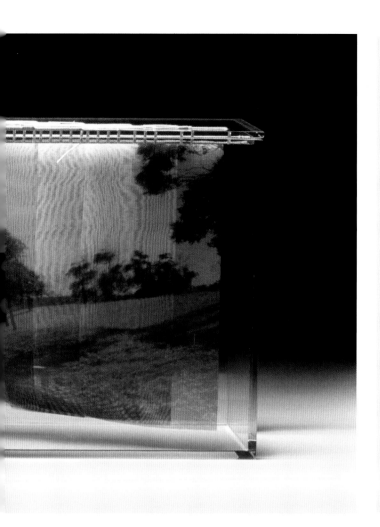

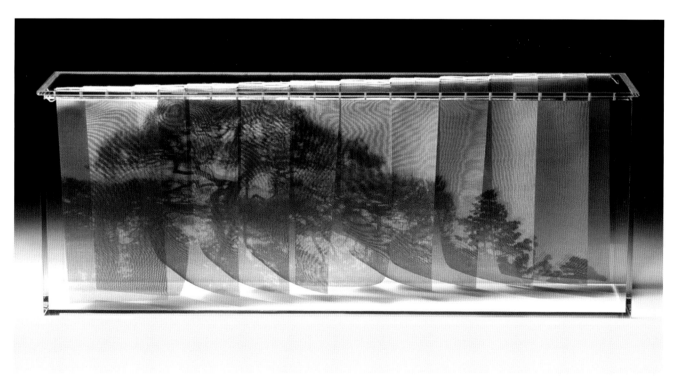

Susan Hotchkis

United Kingdom | www.suehotchkis.com

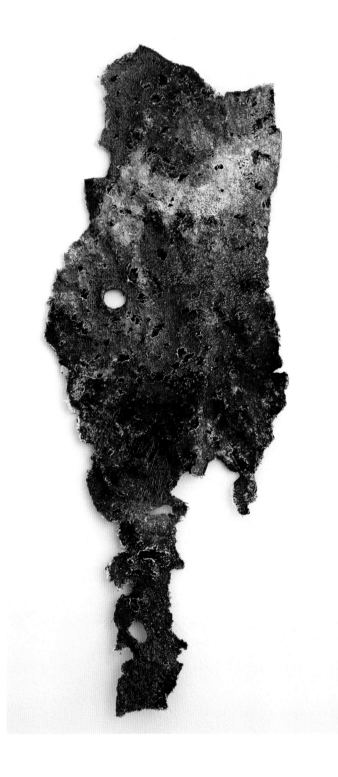

Surrounded by family that was "always knitting and sewing," Sue Hotchkis has long had an affinity for cloth. As an adult, though, she worked in an office. However, after nine years, she says, "I knew I didn't want to spend the rest of my life trapped behind a desk. I'd always regretted not pursuing art and so, at 28, I enrolled at university and eventually graduated with a bachelor's degree in embroidery and a master's degree in textiles. I went on to teach until 2007, at which point my circumstances changed and allowed me to focus on developing my art full-time."

For Hotchkis, the core focus of her work is texture. She is strongly influenced by the Japanese aesthetic of Wabi-sabi, or the beauty of imperfection. She notes, "I'm interested in the activity between the natural and man-made. Nature has a way of reclaiming the artificial. The altered surfaces and marks created in the process of this transformation are ephemeral—always in a state of flux—fleeting and beautiful. I try to capture that transient beauty."

RIGHT
Susan Hotchkis. *Once*, 2012.
3.4' × 1.3' × 1.6'. Felt, cotton organza, wadding. Courtesy of Susan Hotchkis.

OPPOSITE
Susan Hotchkis. *Metamorphosis*, 2014.
4.6' × 3' × 2". Voile, paper, transfer foils, thread. Courtesy of Susan Hotchkis.

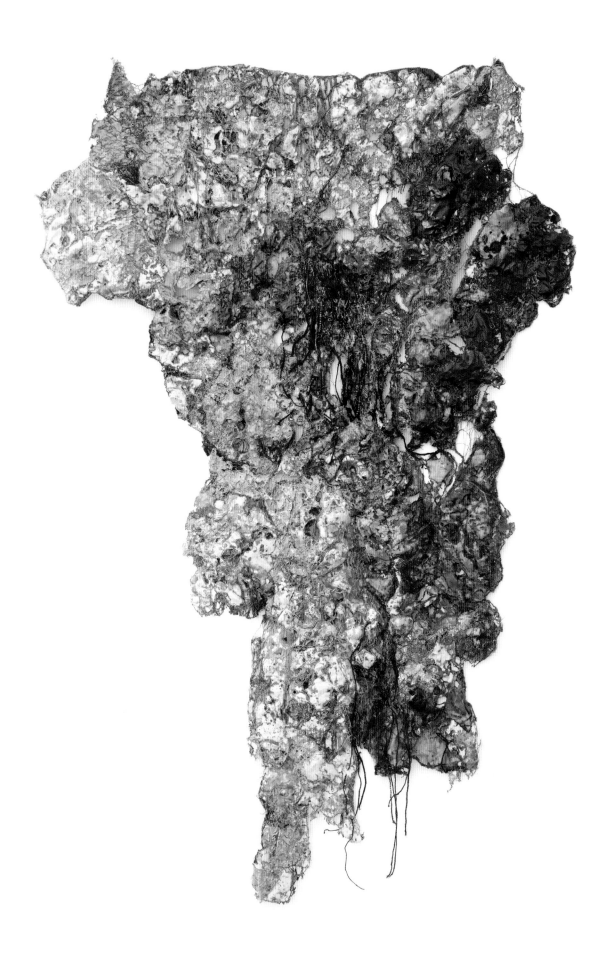

Made from felt and cotton organza, Hotchkis's sculpture *Once* was heat-distressed, discharge-printed, and trapunto-quilted by the artist. Hotchkis explains, "*Once* is an object that exhibits the process of natural transformation. Nature has edited its shape, leaving us to guess its original shape and function. Its past is forgotten and untraceable; its patina only hints at its history. Fire and oxidation have eaten away too much of it. Unable to perform the task for which it was originally constructed, it must take on a new purpose—an object of beauty."

Metamorphosis, composed of the artist's manipulated photos that were printed on an inkjet printer and laminated onto voile with matte medium, represents the decay of a man-made object. Hotchkis tells us, "The process of decay is not yet complete. The object is a hybrid suspended in time, neither new nor old. Traces of bright yellow and metallic blue are the only indications of what it might have once been, but now it is slowly being transformed into a delicate, lacelike structure."

Again reflecting the artist's curiosity about surface transformation, *Rust-Rose* "speaks of the process of erosion, a celebration of asymmetry and the random imperfections found in nature. The process creates a new visual and tactile landscape."

ABOVE RIGHT
Susan Hotchkis. *Rust-Rose*, 2016.
3' × 9' × 2". Felt, voile, paper, silk, digitally printed satin, wadding. Courtesy of Susan Hotchkis.

RIGHT
Susan Hotchkis. *Rust-Rose*, 2016.
Detail. Courtesy of Susan Hotchkis.

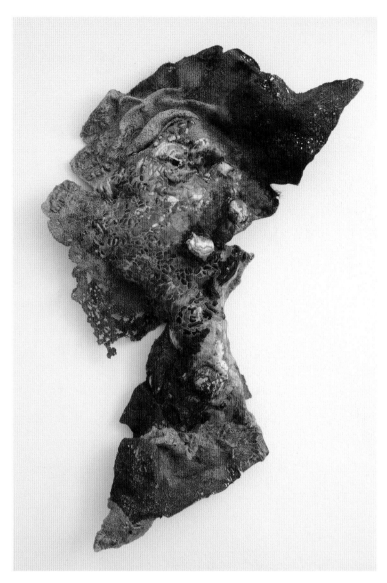

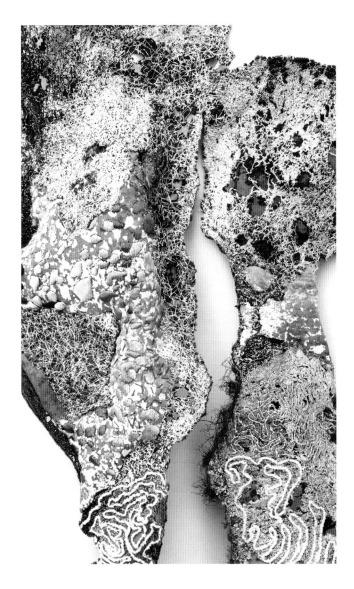

With *Embrace*, Hotchkis hoped to challenge the viewer's perception of beauty. She says, "The work is quite literally two forms embracing and it stands as a metaphor for the change that occurs as a result of nature's ongoing and opposing interaction with the man-made. The surfaces of the two forms are at different points in the process of erosion. Once they were whole, but are now dividing—permanently altered, permanently separated."

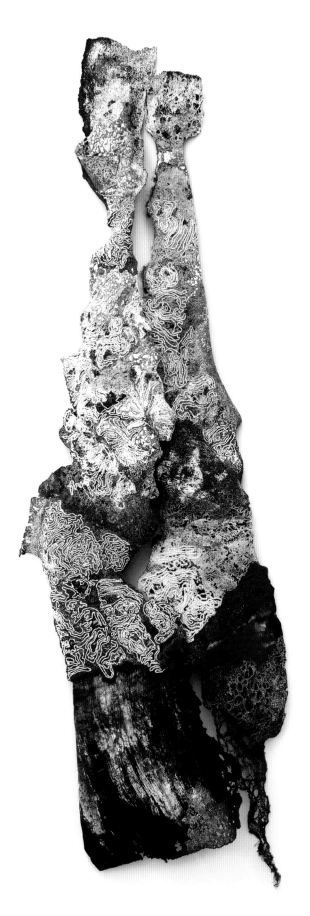

Amy Gross

United States | www.amygross.com

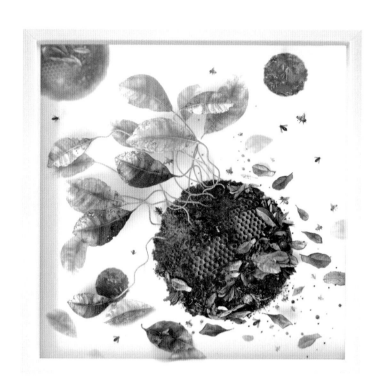

Amy Gross studied graphic design and painting in college. Because her father had raised the family first as a muralist's assistant, then as a textile designer and art director, she learned it was possible to support oneself with one's creativity. Therefore, soon after graduating, she pursued a career as a freelance surface designer, which led to working for more than twenty years in that field.

Sitting at a computer all day, Gross designed and colored fabric patterns but never actually got to work with cloth itself. She reintroduced herself to making things by hand by creating embroidered jewelry. Her first fabric sculptures began as trapuntolike shadow boxes. She recalls, "These were like framed illustrations sprouting their own vegetation. They began growing more and more three-dimensional, but I think I approach my dimensional work as a kind of painting, using thread and beads and yarn instead of pigment." *Bee Drift 2*, *Cross Pollinators*, and *Marsh* are examples of this work.

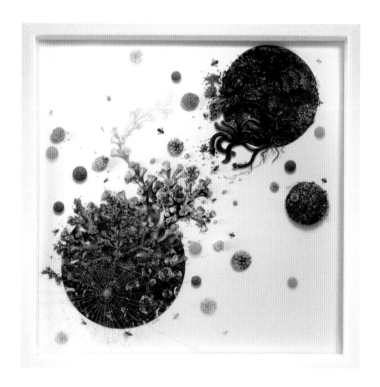

ABOVE RIGHT
Amy Gross. *Bee Drift 2*, 2014. 21" × 21" × 2".
Embroidery thread, beads, paper, wire, fabric transfers on cotton fabric, shadow box.
Courtesy of Amy Gross.

RIGHT
Amy Gross. *Cross Pollinators*, 2014.
21" × 21" × 2". Embroidery thread, nylon thread, beads, polymer clay, fabric transfers on cotton fabric, shadow box. Courtesy of Amy Gross.

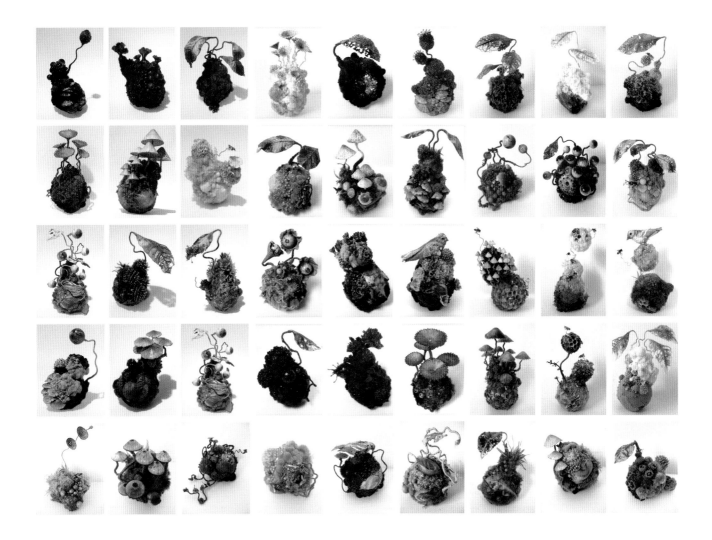

Gross feels she was destined to be a hands-on artist. "I have to make things. I have stories I need to tell—at least to myself. I feel a very deep need to leave a trail of breadcrumbs to mark my time here."

Unlike many of her contemporaries, Gross states, "I'm a descendent of the 1960s fiber art movement simply because the artists of the '60s legitimized the medium, expanded it beyond the 'women's work' idea, abstracted it, and turned it expressive and monumental. I can do what I'm doing now because they rocked the boat."

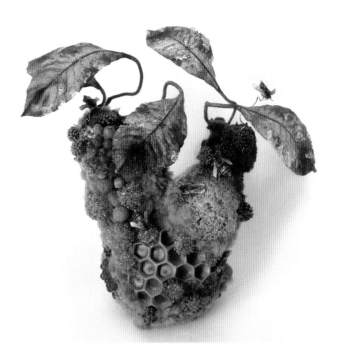

ABOVE
Amy Gross. *Amy's Biotope Collection 3*, 2011. 8" (variable). Embroidery thread, yarn, beads, paper, wire, polymer clay, fabric transfers. Courtesy of Amy Gross.

RIGHT
Amy Gross. *Amy's Biotope Collection 3*, 2011. Detail 1. Courtesy of Amy Gross.

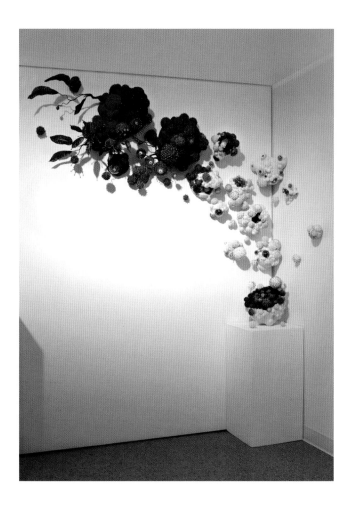

Gross particularly admires the work of Louise Bourgeois, a 1970s artist who was renowned for highly personal fiber sculpture involving the unconscious, sexual desire, and the body. "Her work was sad and angry and brittle and tough. I love the way she manipulated fabric to imply both the delicacy and durability of skin. I'm more interested in depicting nature than the human body, but fabric suggests to me the skin of all things, the surface that both reveals and conceals what is underneath. 'Skin' made of fiber can be extremely imitative of roots, fruit, seeds, spores—the tiny elements we can see with the naked eye, and those that require a microscope." These facets of her work are evident in *Amy's Biotope Collection 3*.

In fact, Gross has always been fascinated with the natural world. Since childhood, she recollects, "I've been preoccupied with the intricate and complicated environments underfoot, and with the poignancy of life on the edge of ruin. My fabric objects cluster and combine, tangle and compete, and ultimately adapt to survive."

She adds, "We have so little control over the temporality of life. I like to play with the idea of having control, of stopping time, of freezing my organisms in the midst of their growth and decay. And thousands of beads and stitches leave a trail of the past, evidence of an actual life lived, of breaths taken." *Spora Mutatus* and *Inconstancy* typify these concepts.

Regarding her work *Silver Bees*, Gross explains, "I've been fascinated with geodes, the glittering result of unrelated geologic time. The dull outer shell is the perfect disguise for a beautiful chalcedony inside—a hidden seduction. I wanted to explore the idea of interior things. In this sculpture, the silver bees burrow underground, adapting to a hard life aboveground. The crystal spheres become nurseries for their larvae, their hope for the future."

In creating *Silver Bees*, Gross has given symbolically our planet's endangered honeybees a way to survive in a toxic world. It is a story that comforts her, as do many of her pieces. "It's a way of taking terrible news about the environment out of my head. Life is constant, erratic; but, unintentional beauty can come from a changing, volatile world."

ABOVE
Amy Gross. *Spora Mutatus*, 2015. 90" × 70" × 14".
Beads, embroidery thread, yarn, plastic, velour, fleece, paper, wire. Courtesy of Amy Gross.

OPPOSITE TOP
Amy Gross. *Spora Mutatus*, 2015. Detail.
Courtesy of Amy Gross.

OPPOSITE BOTTOM
Amy Gross. *Inconstancy*, 2009. 31" × 22" × 5".
Beads, embroidery thread, yarn, fabric transfers, paper, wire. Courtesy of Amy Gross.

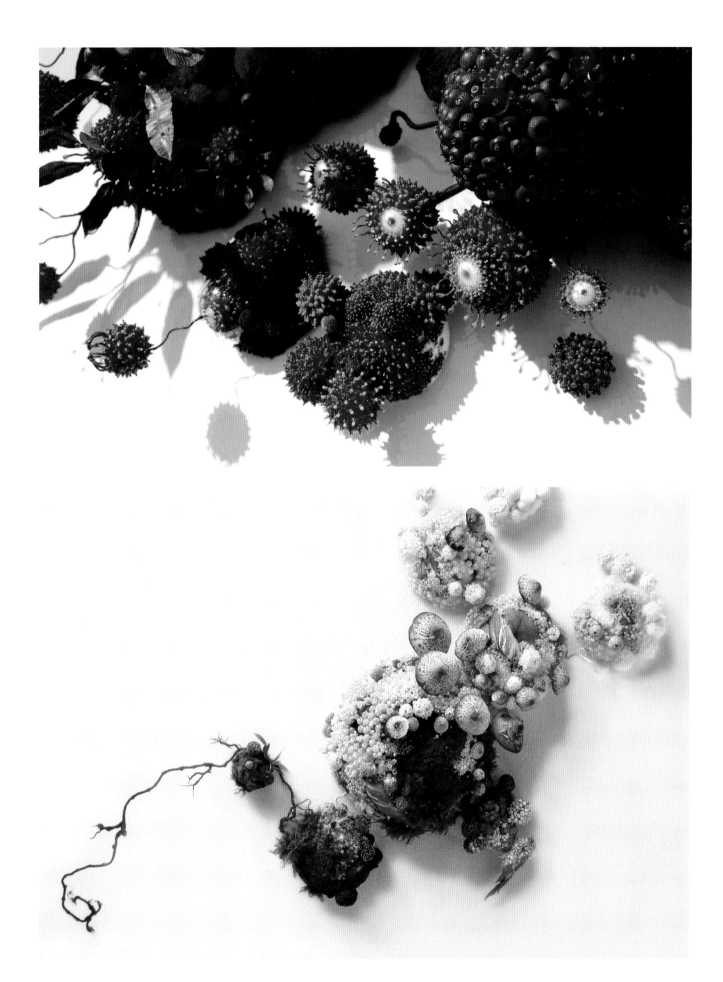

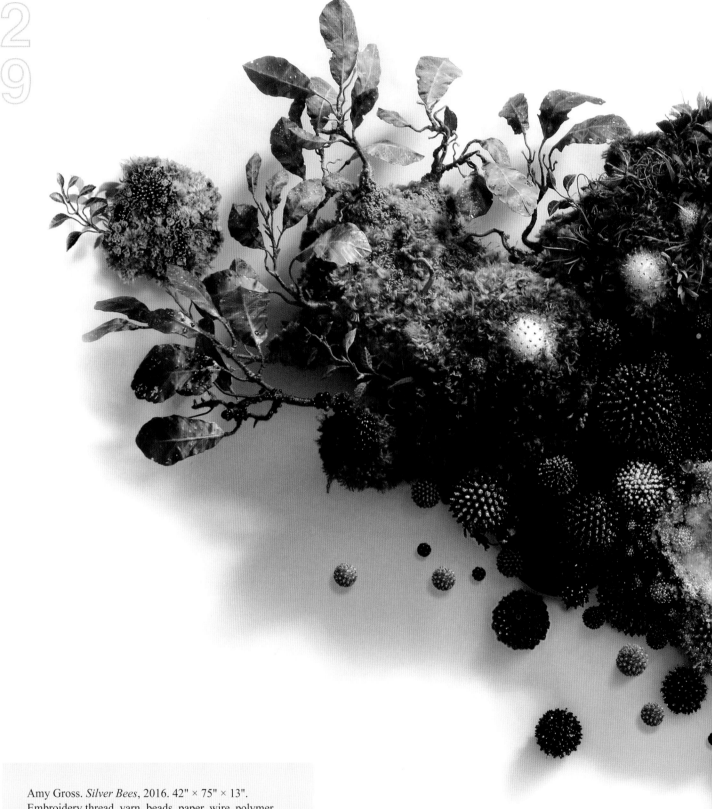

Amy Gross. *Silver Bees*, 2016. 42" × 75" × 13".
Embroidery thread, yarn, beads, paper, wire, polymer
clay, velour, acrylic spheres. Courtesy of Amy Gross.

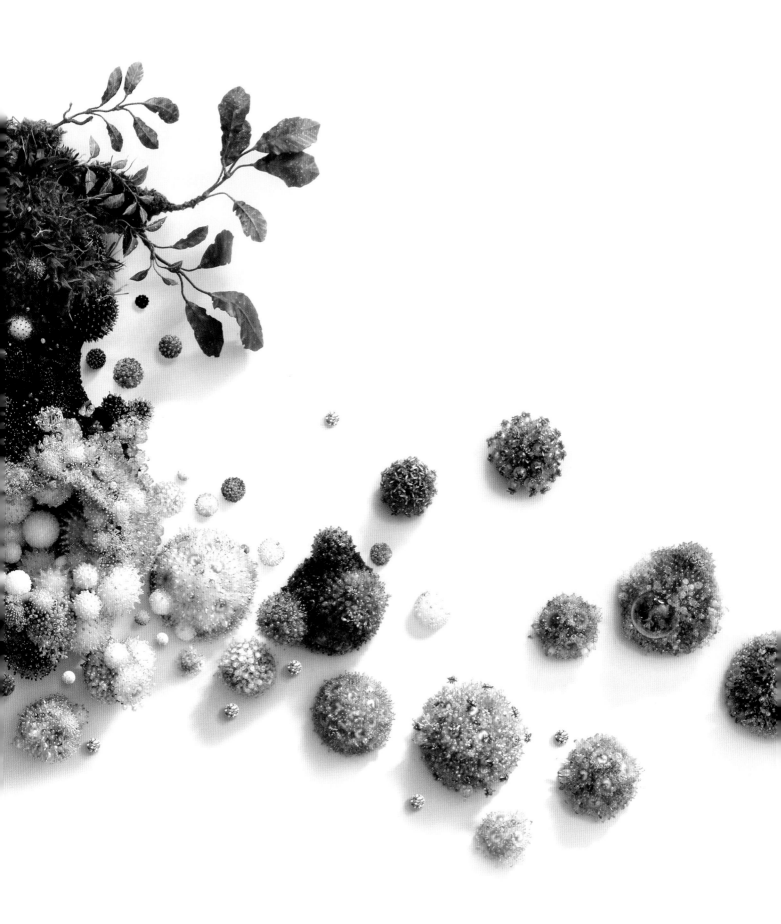

Karen Margolis

United States | www.karenmargolisart.com

For Karen Margolis, the circle, or Ensō, provides inspiration for her magical sculptures. The Ensō is a sacred symbol in Zen Buddhism; it embodies enlightenment, infinity, and perfection. Karen is particularly interested in the mystical symbolism of the circle as well as the idea of its paradox of imperfection. She works with positive and negative space to capture this dual nature. "I work with interruptions in continuity of matter, form, and space. I'm interested in how negative space intersects with the concrete to create blockages and openings that, like our thoughts and emotions, interfere with perception."

ABOVE
Karen Margolis. *Omphaloskepsis*, 2015.
26" × 32" × 15". Cotton-covered wire.
Courtesy of Karen Margolis.

OPPOSITE
Karen Margolis. *Containments*, 2012.
36"–15' (height). Cotton-covered wire.
Courtesy of Karen Margolis.

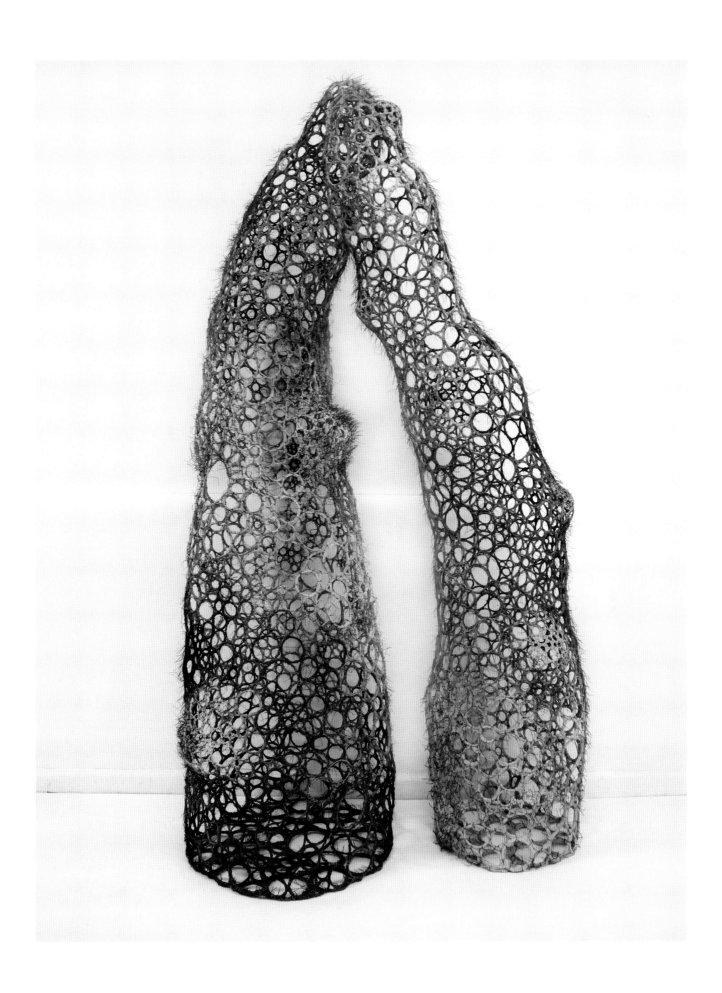

Margolis's pieces, including *Omphalo-skepsis* and *Containments*, are comprised of cotton-covered wires that are rolled, colored, and attached with annealed wire. Architecturally, the sculptures are built up as columns through successive layers and then pieced together in jigsaw fashion. "Each sculpture's form," she says, "evolves through an absurd collaboration, a struggle between my determination to contain the work and its endeavor to swell out of my control. The marks of this conflict reside in the consequential bulges and indents that viewers see." She likens her process of creating to the natural cycling of nature as it builds, adapts, self-destructs, and rebuilds itself through the ages.

Margolis created *Continuum* as a three-dimensional mandala. Composed of handmade linen and abaca laminated onto wire, it references the idea of continuous transformation within the endless cycles of nature. Initially, she was inspired by physicists' superstring theories about time—namely, "that all of creation is made up of vibrating strings and membranes as well as six-dimensional spaces that continually mutate their shapes as they repair the fabric of the universe. It's an ongoing process beyond anyone's understanding or control."

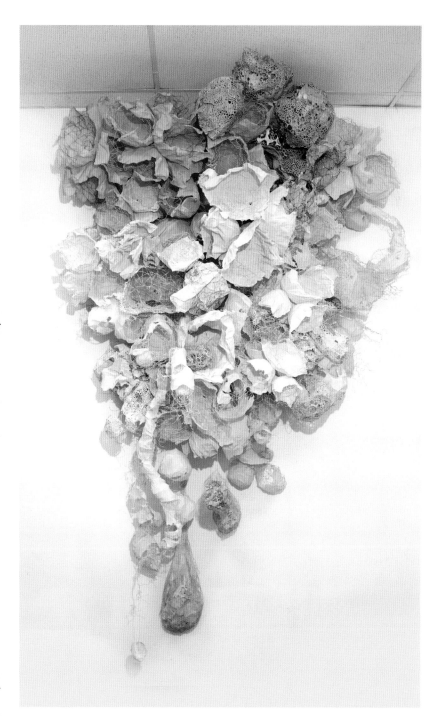

Karen Margolis. *Continuum*, 2000–. 8.5' × 4.5'. Handmade linen, wire. Courtesy of Karen Margolis.

Cecilia Heffer

Australia | www.ceciliaheffer.com

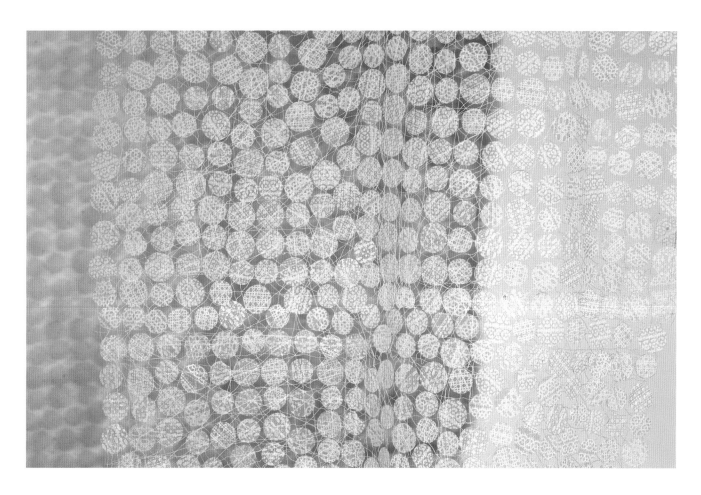

Cecilia Heffer. *Reticella Series—White Shadow Lace*, 2006. 24" × 9'. Hand-printed silk organza, soluble substrate, thread. Courtesy Cecilia Heffer. Photography: Paul Pavlov.

Although she tried to "be sensible" and pursue economics in school, Cecilia Heffer "lasted about five weeks without art. I realized I needed to express myself through it." She then trained in visual communication and visual arts, specializing in abstract painting, and eventually pursued a career in the textile industry. Her career provided her many opportunities to work with cloth, including using surface embellishment.

For the past ten years, Heffer has concentrated on contemporary ways to redefine lacework after completing a mentorship in bobbin lace-making with textile historian Rosemary Shepherd. Shepherd defines lace as an openwork structure whereby the pattern of spaces is as important as the motif. This definition has, conceptually, underpinned Heffer's practice as she pursues the notion that narratives can never be complete. And instead of traditional techniques, she uses dissolving substrates on which she machine-stitches to compose lacelike structures. In these ways she presents to us lace that is—and is not—as we typically think of it.

The intention behind Heffer's work is "to inspire and move people through the social narratives I embed in my work. Hopefully, these stories connect and resonate with viewers." For example, with her piece *Reticella Series—White Shadow Lace*, Heffer's intent is "to express how ephemeral art is and how inexact its meaning. What does its translucency and ethereality signify to each viewer? Does the viewer respond to the artist's wish to make it graceful and joyful?"

When we observe *Ebony Lace*, we are aware of its darkness and mystery. In constructing this piece, Heffer means to give physical substance to feelings of loss, grief, and impermanence.

Small works such as *Passport Lace* tell of the artist's personal story. She says, "This piece is about the cultural assimilation of a seven-year-old child from Santiago de Chile into the culture of Australia during the 1970s. Each space symbolizes a memory from childhood."

In *Drawn Threads*, Heffer transformed the unique qualities of the Australian landscape into lace. "The work was meant to embody my observations and experiences of the natural world here, in my adopted home."

For Heffer, "[s]torytelling is an essential part of the way humans make sense of the world around them. Over time, textiles have been embedded with meaning and story, passing from one generation to another. The qualities cloth embodies resonate with people and help to convey narrative and enrich our lives."

OPPOSITE TOP
Cecilia Heffer. *Ebony Lace*, 2011. 21" × 52". Detail (full-size rendering unavailable). Silk, screen-printed organza, eucalyptus natural dye, soluble substrate, thread. Courtesy Cecilia Heffer. Photography: Paul Pavlov.

OPPOSITE BOTTOM
Cecilia Heffer. *Passport Lace*, 2010. 6' × 4.5'. Silk, cotton, linen, digital photographic transfer, soluble substrate, thread. Courtesy Cecilia Heffer. Photography: Paul Pavlov.

RIGHT
Cecilia Heffer. *Drawn Threads*, 2013. 2.2' × 7.2'. Digitally printed satin organza silk, soluble substrate, thread. Courtesy Cecilia Heffer. Photography: Paul Pavlov.

Anna van Bohemen

Netherlands | www.annavanbohemen.nl

As a mixed-media artist, Anna van Bohemen has been working with "textiles, paper, and other materials people throw away" for more than thrity-five years. Her father was fond of drawing, and as a child she found she liked to "make things with my hands, too." However, she wanted to try a different career—acting—and attended drama school. After deciding that career was not for her, she studied pedagogy. Finally, at age twenty-five, she enrolled in an art academy and worked for many years as an art teacher. These days, however, she devotes her time to making art.

Van Bohemen says she was inspired by Magdalena Abakanowicz, a Polish artist of the fiber revolution of the 1970s, whose work explored the confusion of the individual's presence in the mass of humanity, as well as Dutch artist Krijn Giezen, an artist whose themes focused on environmental and personal health and well-being.

RIGHT
Anna van Bohemen. *Cocoons*, 1979. 13.7"
× 7.8". Fabric, twigs, wire, wooden frame.
Courtesy of Anna van Bohemen.

OPPOSITE
Anna van Bohemen. *Untitled 1981*, 1981.
5.2' × 1.3" × 1.3". Paper, fabric, bamboo
sticks, clay silt, acrylic paint, charcoal.
Courtesy of Anna van Bohemen.

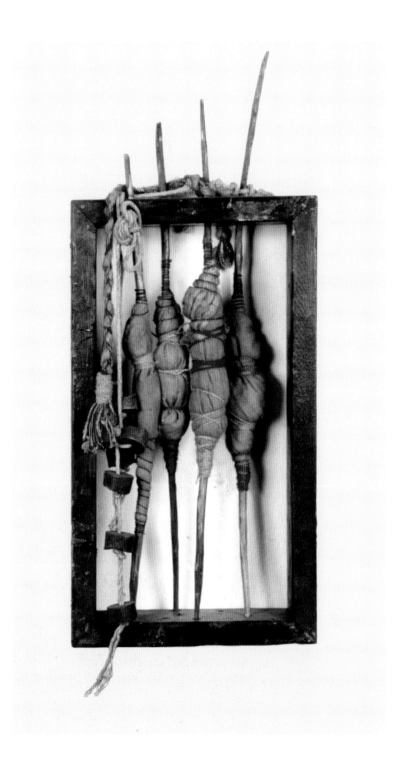

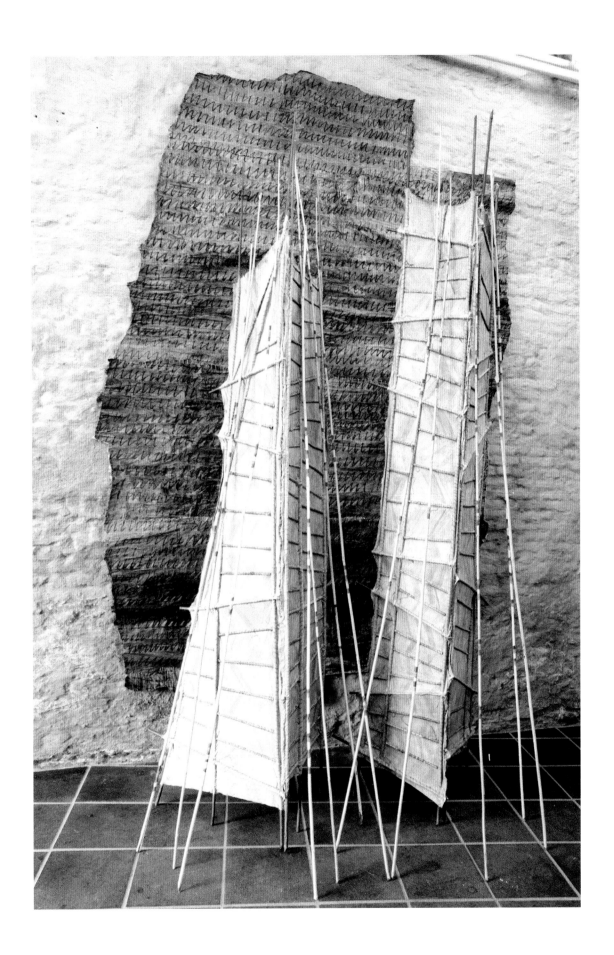

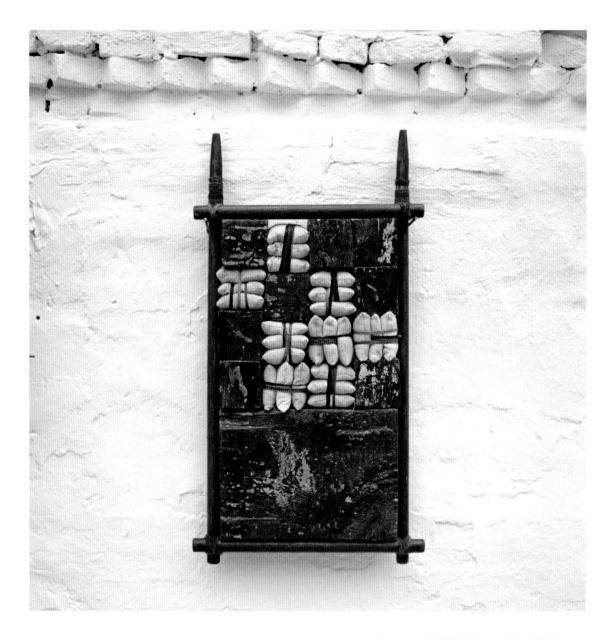

With those ideas in mind, van Bohemen began experimenting with dimensional design. The main theme of her art, she notes, "is to convey the idea of the fragility, vulnerability, and transience of matter, and the beauty of decay. My materials are natural, from the earth, and my methods are both traditional and process oriented, but also direct and emotional."

Many of van Bohemen's pieces, such as *Cocoons*, *Untitled 1979*, and *Untitled 1981* reflect, too, her fascination with relics and objects that represent cultural memories and are sometimes said to grant magical powers to their owners.

Anna van Bohemen. *Untitled 1979*, 1979. 2.62' × 1.3'. Fabric, painted wood, wool threads. Courtesy of Anna van Bohemen.

Ellen Schiffman

United States | www.ellenschiffmanfiber.com

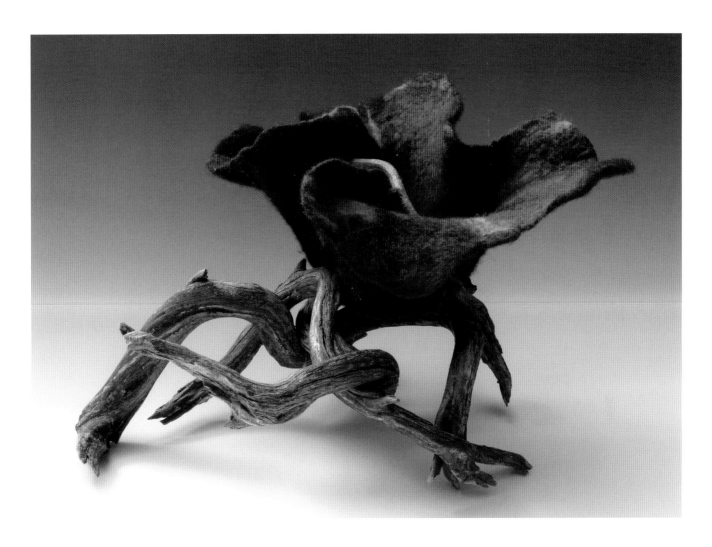

From an early age, Ellen Schiffman admired artists but never imagined she would someday become one. Although she played with crayons and construction paper as a child, art was never especially valued in her home, and her family did not recognize her creativity. Despite this, she went on to develop a love of woodworking in high school, and quilting after college. For her career, however, she chose to channel her artistic interests into a consulting business, in which she placed the work of other artists, as well as architects and designers, in corporate collections. Ten years later, she finally began to indulge her own need to "make."

Ellen Schiffman. *Irene 1*, 2011–2013. 11" × 14".
Handmade felt, branches, found objects. Courtesy of
Ellen Schiffman.

Schiffman notes, "I'm interested in exploring the sculptural possibilities of each fabric I work with. What can this material do? How far can I push it? I'm drawn to dimension, texture, shadows, and layering, and have always admired the media that traditionally addressed these qualities: wood,

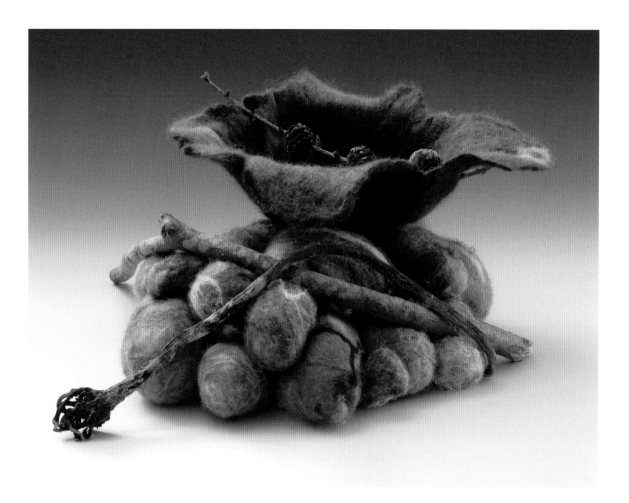

glass, clay, and metal. Fiber has not been used much for three-dimensional work, but it turns out the possibilities for dimension are endless."

Through her work, Schiffman hopes to convey her belief that we should look beyond the surface of objects and ideas. "Nature is my muse. I don't attempt an exact replication of nature; rather, I use the images, sensations, colors, and moods of the natural world as springboards for my creations. With my materials, I offer direction, but respect the ways fabrics and the processes I use conspire to manifest in their own way, much the way nature does. For me, my work becomes a metaphor for the unexpected occurrences in life, and both the challenges we face and the growth we experience as we make our way through them."

The *Irene* sculptures that belong to Schiffman's *Basket* series were created in the aftermath of Hurricane Sandy. They are composed of debris from the hurricane and handmade felt. Schiffman recalls, "We lost power for over a week and debris was everywhere. I spent a lot of time cleaning up my yard. The beauty of some of the debris caught my eye and I brought it to the studio to incorporate into my work. I wanted to create pieces that had movement and evoked the energy of the storm, and the great beauty of nature even when it's destructive."

Schiffman's sculpture *Remnants of Forgotten Joy* is made of recycled, brilliantly colored saris wrapped around rods. The artist says, "As I repeatedly wrapped the silk fabric, I wondered what each said about the life of the woman who once wore it. It was a way for me to connect with people I'll never know."

ABOVE
Ellen Schiffman. *Irene 3*, 2011–2013. 10" × 12".
Handmade felt, branches, found objects. Courtesy of Ellen Schiffman.

OPPOSITE
Ellen Schiffman. *Irene 6*, 2011–2013. 7" × 11".
Handmade felt, branches, found objects. Courtesy of Ellen Schiffman.

OPPOSITE BELOW
Ellen Schiffman. *Irene 9*, 2011–2013. 8.5" × 18".
Handmade felt, branches, found objects. Courtesy of Ellen Schiffman.

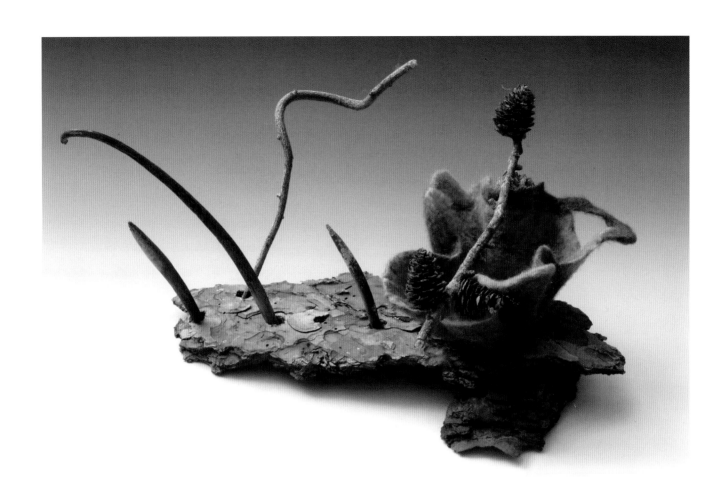

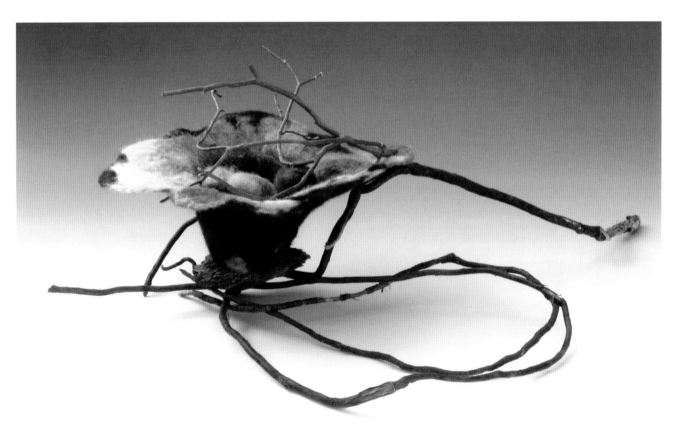

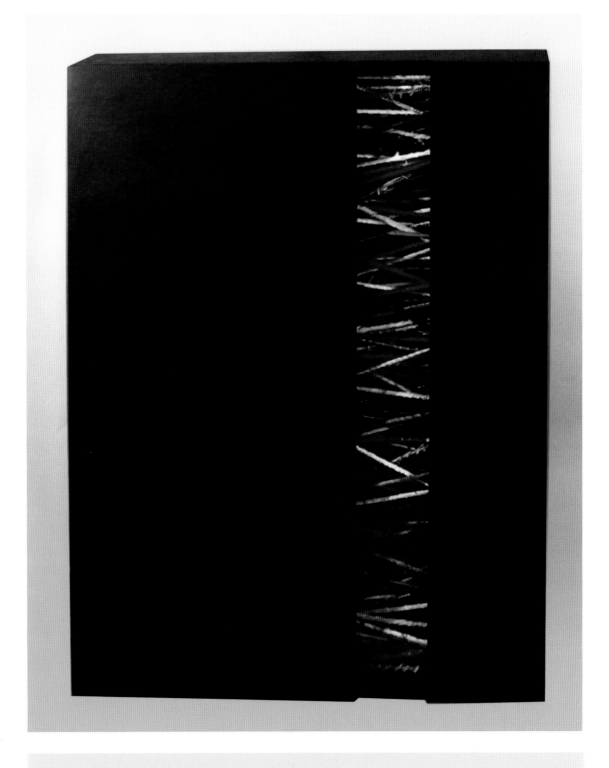

Ellen Schiffman. *Remnants of Forgotten Joy*, 2014. 32" × 32".
Metal rods, recycled silk from old saris. Courtesy of Ellen Schiffman.

Renato Dib

Brazil | www.flickr.com/photos/renatodib

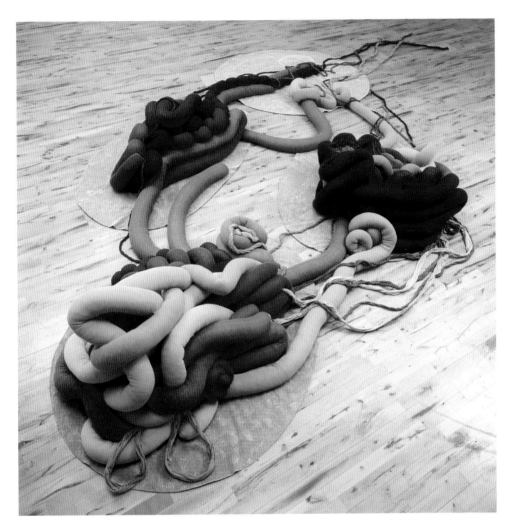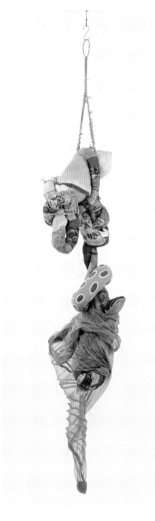

As a youngster, Renato Dib was fascinated with the work of a seamstress who came weekly to his family's home to make and repair clothing, although neither the seamstress nor Renato's mother taught him to sew. Instead, he taught himself, and his work was first shown at an exhibition when he was only fourteen years old. He pursued a formal education in a fine arts program in Sao Paulo and additional instruction in several ateliers. Since then, he has continued to teach himself sewing techniques such as embroidery and tricot, a warp-knitting process.

Dib was drawn initially to painting on canvas. Yearning for a more tactile composition, however, he began to glue fabrics and other materials onto the canvases. In time, he replaced the glue with stitching. Once comfortable working with sewn fabric, he noticed the fabric reminded him of human skin. He notes, "Textiles can represent skin, including spots, wrinkles, grooves,

LEFT
Renato Dib. *Intestinal Embrace*, 2002. 17.3' × 8.5' × 2.6'. Various fabrics. Courtesy of Renato Dib.

RIGHT
Renato Dib. *Air Embroidery*, 2013. 7' × 1.3'. Various fabrics. Courtesy of Renato Dib.

internal tissues, and organs. For example, folded in certain ways, fabric can be made to look like the folds of the brain. Fabric reminds me, too, of the clothing we wear to cover our skin, our second skin. I wonder what goes on inside people's clothes, and then inside their skin. My work is about the sphere of intimacy in an impersonal world."

This artist prefers certain fabrics because of their construction. Dib says, "I love the complexity of jacquard and the simplicity of organza. I love silk and its origins, the silkworm and its cocoon. I start my pieces by using mostly plain fabrics. My first technique is to cut and sew, do some patchwork and some appliqué, then use embroidery, tricot, crochet, and some painting, when needed."

Intestinal Embrace was part of a group project called *Socle du Monde* for a Danish museum. Each artist was assigned to a specific factory in the city where the museum was located. Dib recalls, "I worked in a socks factory and the 'tubes' you see in the piece are giant socks, made for me, in colors I chose. They are filled up with synthetic foam and sewn together as one piece. It references the interior of the human body as well as the body's relationship with clothes and the exterior environment around it."

Air Embroidery was created with fabrics the artist collected from many places throughout the years. The structure was then filled with synthetic foam. Dib says, "This piece is also based on the human body. The title refers to the fact that I sewed it together while it was hanging from the ceiling, in the air."

Another sculpture of fabric and found objects, *Lágrima—Prego / Teardrop—Nail*, is described by the artist as "a big drop hanging from a nail. It looks painful."

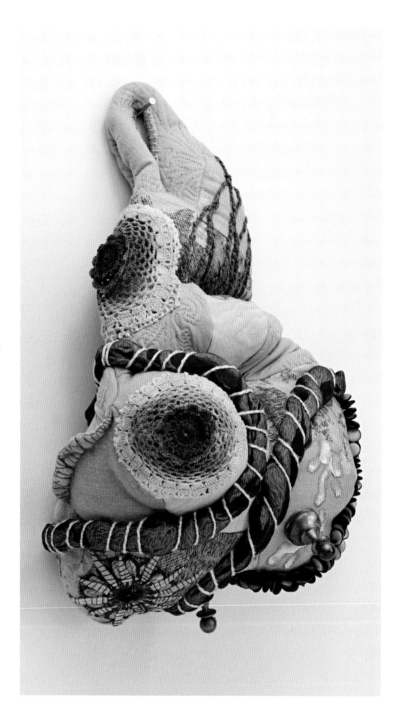

Renato Dib. *Lágrima—Prego / Teardrop—Nail*, 2010. 1.7' × 1.1' × 6.6". Various fabrics. Courtesy of Renato Dib.

Andrea Graham

United States | www.andrea-graham.com

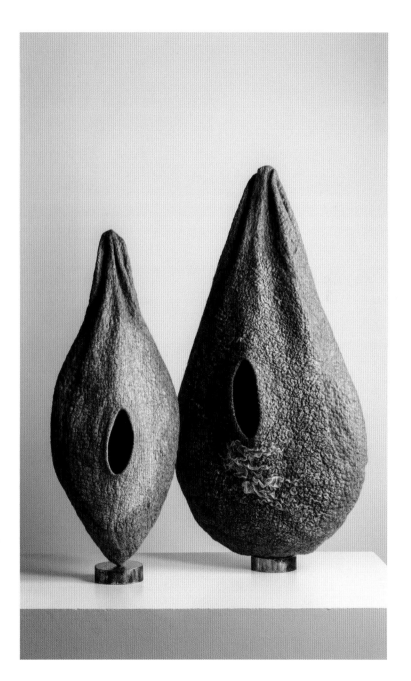

A felt artist, Andrea Graham remembers her family being steeped in creative endeavors; her grandmother was always a maker, and her father was an architect and draftsman. Although she painted as a youth, she did not pursue art professionally until she turned 30. That's when she discovered felt-making. It allowed her to create dimensional work, which had always appealed to her. She says, "I was never satisfied with paint on canvas. I wanted to stack it. I used *lots* of paint. In hindsight, these pieces were my first attempts at making sculptures."

Ideas for her work often come from conversations or a single word, such as *time*. When a work inspires her, Graham notes, "my hands and materials become the conduit to those ideas." Because she has been working with wool for years, she knows how different types will behave and she chooses specific kinds for specific projects. "My work is no longer experimental. The materials are predictable and my work is purposeful. I walk into my studio knowing what I am going to do."

For her monochromatic pieces *Magnum Vasculum* and *Grey Pods*, Graham chose to eschew "complexity and detail" and aim, rather, for an emphasis on the felt itself and the way its natural colors and organic texture picks up light and shadow.

Andrea Graham. *Grey Pods*, 2014. 4' × 6' × 2'. Felted wool. Courtesy of Andrea Graham.

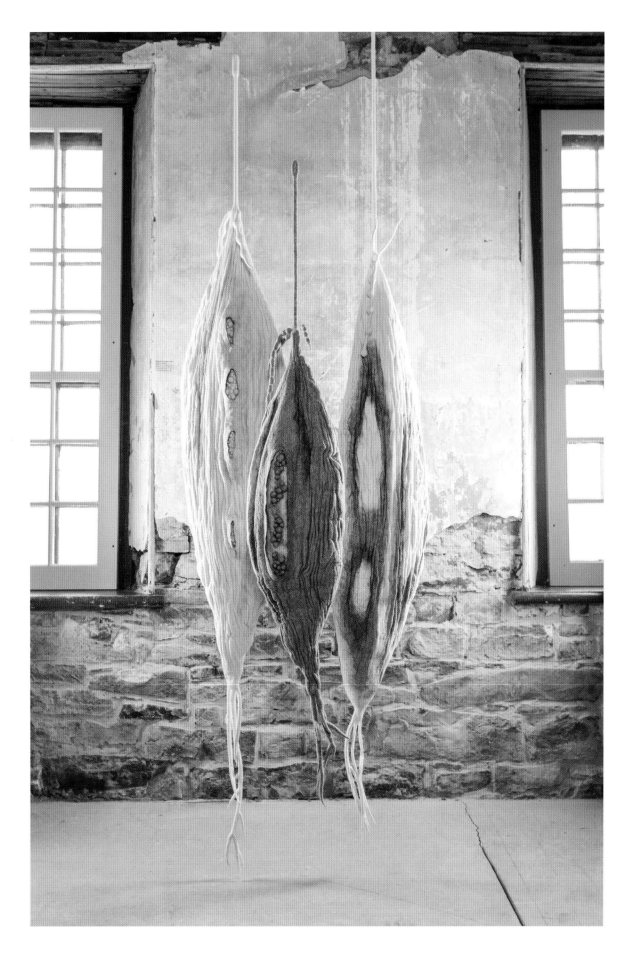

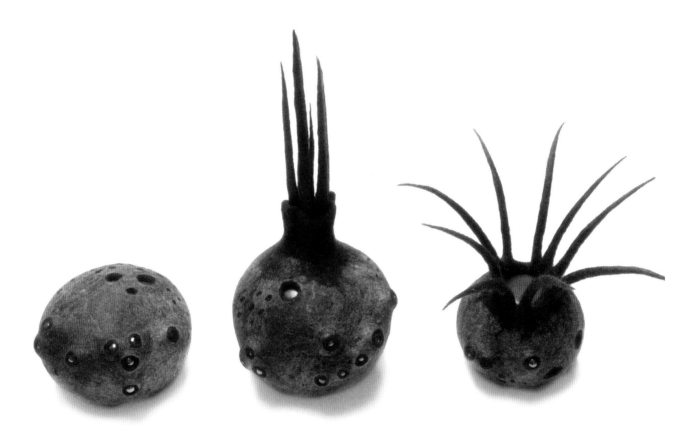

For *Colorful Pods*, on the other hand, she wanted to explore an important topic, but in a playful way. "When my children were little, I tried to find food in the store that was safe and nutritious. I was frustrated with what we as a society do to food—using toxic pesticides, for example—and I imagined what these unhealthy ingredients looked like. Do we really want to be eating food with my pods hidden inside? But then they became comical; they developed feet, they became expressive, they communicated with one another when they were in groups. Now people love them."

ABOVE
Andrea Graham. *Specimens*, 2013.
8" × 18" × 4" (as displayed). Felted wool.
Courtesy of Andrea Graham.

RIGHT
Andrea Graham. *Specimens*, 2013. Detail.
Courtesy of Andrea Graham.

OPPOSITE
Andrea Graham. *Magnum Vasculum*, 2014.
9' × 3' × 4'. Felted wool.
Courtesy of Andrea Graham.

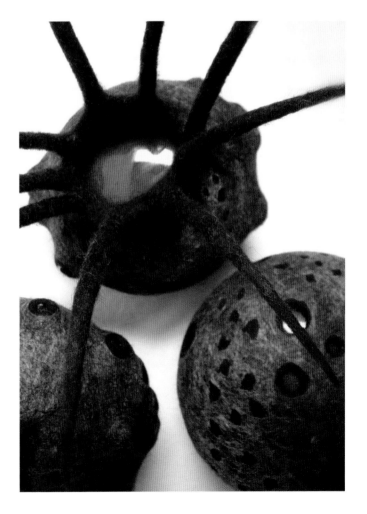

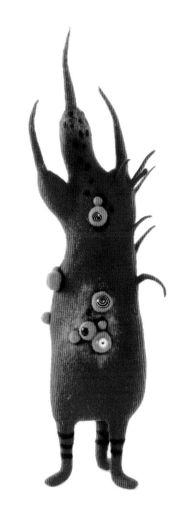 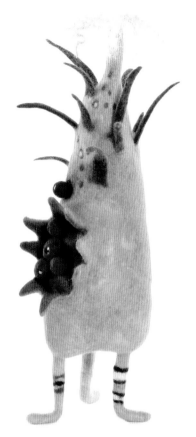 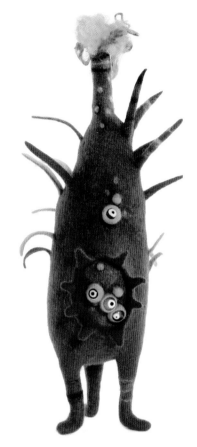

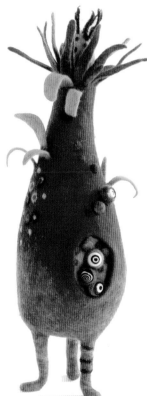

Using both traditional nomadic and modern felt-making techniques, Graham also magically transforms wool fiber into ambiguous sculptures such as *Specimens*, *Monument 7*, and *Monument 8* that "express the paradox of living organisms: strength and fragility, persistence and surrender, liberation and containment. Those that resemble open wounds with haphazard sutures serve as a metaphor for our consumer culture in which we're exhorted to buy things we don't need and eat food that's not good for us."

Andrea Graham. *Colorful Pods*, 2015. 15" × 4" × 4" (each, varies). Felted wool. Courtesy of Andrea Graham.

OPPOSITE LEFT
Andrea Graham. *Monument 7*, 2015. 24" × 8" × 4". Felted wool. Courtesy of Andrea Graham.

OPPOSITE RIGHT
Andrea Graham. *Monument 8*, 2015. 24" × 6" × 4". Felted wool. Courtesy of Andrea Graham.

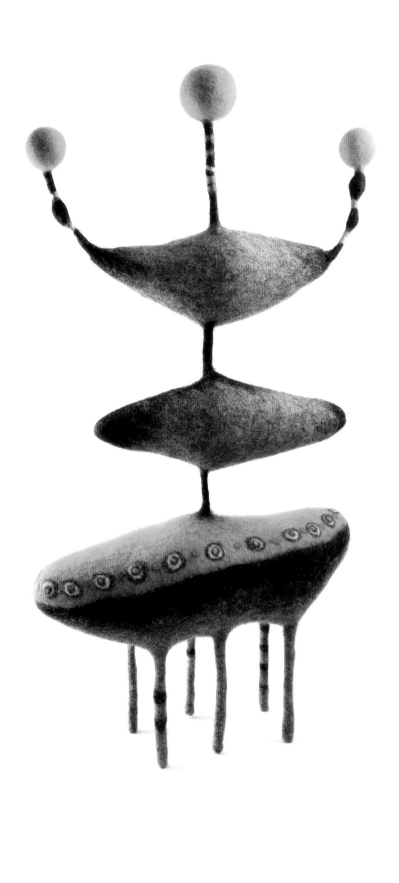
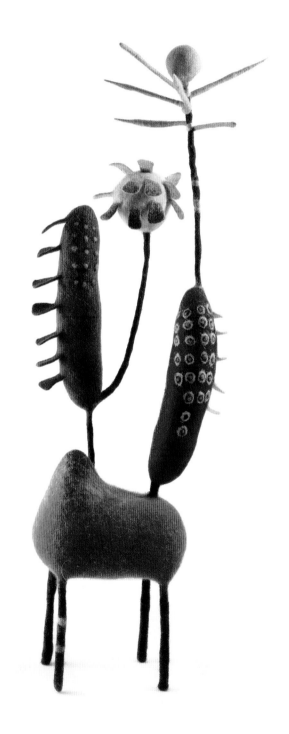

Charlotte Bailey

United Kingdom | www.hangingbyathreadembroidery.wordpress.com

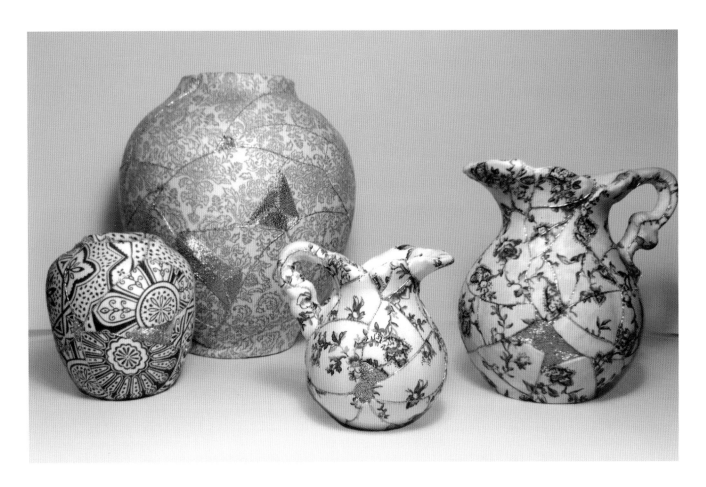

Charlotte Bailey has been sewing since she can remember. "My mother introduced me to simple stitching via a book from her own childhood and I worked my way through its projects—from glove puppets to egg cozies. I was also a keen cross-stitcher as a kid before my mother introduced me to more complex hand-embroidery. My grandmother is a talented dressmaker, as well. There is something infinitely fulfilling about making something with one's hands and continuing a centuries-old tradition, especially in this modern digital age. Although I always knew I wanted to make art, it wasn't until my teens that I knew that textiles—more specifically, hand-embroidery—would become my preferred medium with which to work."

Charlotte Bailey. *Kintsugi Collection*, 2016.
3.5" × 3.5" × 3.5" (small vase), 7.8" × 6.2" × 6.2" (large vase), 3.7" × 3.9" × 3.9" (small jug), 5.5" × 5.5" × 5.5" (large jug). Found porcelain objects, printed cotton fabric, metallic thread. Courtesy of Charlotte Bailey.

Bailey studied at the Royal School of Needlework, where she learned myriad complicated techniques. After graduation, she went to work for London–based ateliers, where she contributed to a number of projects, including London Fashion Week. Currently a freelance artist, she takes private commissions from individuals and companies along with continuing her own practice, which includes creating, exhibiting, and teaching.

The slow, steady rhythm of the piecing process, and the intimacy of interacting with fabric by hand, is what motivates Bailey. She says, "My three-dimensional fabric vases are built upon this principle. They are primarily of an approach I call *porcelain patchwork*, which is wrapping fragments of broken porcelain in fabric and hand-sewing the pieces back together. The couched gold thread is a technique from my favorite hand-embroidery discipline: goldwork."

Bailey's patchwork is based largely on Kintsugi, the ancient Japanese custom of repairing broken pottery with gold. According to this art form, rather than discard a cracked item, the object's wear and tear is celebrated, beautified, and treasured. In this way, Bailey tells us, "An object is more beautiful for being broken, a beautiful ethos to relate to both visually and metaphorically." Bailey's textile *Kintsugi* interpretation, however, uses no glue at all. She says, "It's very rewarding to see the jigsaw come together as the work progresses—a solid object materializing from a jumble of pieces."

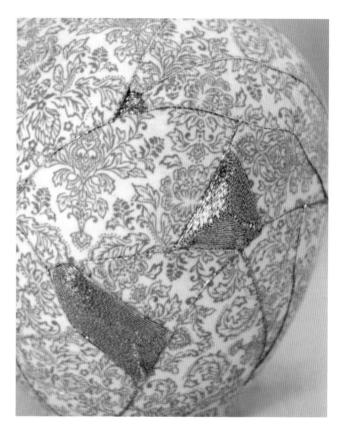

ABOVE RIGHT
Charlotte Bailey. *Large Vase*, *Kintsugi Collection*, 2016. Detail. Courtesy of Charlotte Bailey.

RIGHT
Charlotte Bailey. *Small Vase*, *Kintsugi Collection*, 2016. Detail. Courtesy of Charlotte Bailey.

Mo Kelman

United States | www.mokelman.com

Mo Kelman. *Two Eyes*, 2005.
10" × 24" ×42". Constructed
bamboo and reed, silk organza,
cotton cord, nails. Courtesy of
Mo Kelman.

LEFT
Mo Kelman. *Two Eyes*, 2005.
Detail. Courtesy of Mo Kelman.

OPPOSITE TOP
Mo Kelman. *Penumbra*, 2008.
35" × 29" × 17". Constructed
bamboo and reed, silk organza,
cotton cord, nails. Courtesy of
Mo Kelman.

OPPOSITE BOTTOM
Mo Kelman. *Bestia*, 2010.
36" × 11" × 14". Constructed
bamboo and reed, silk organza,
cotton cord, nails. Courtesy of
Mo Kelman.

Mo Kelman has taught textiles, sculpture, and three-dimensional design since 1981. As an art major in college, Kelman was building her skills, but her aha moment came outside her coursework. She recalls, "One night over a big pile of deadfall branches I'd collected, I started tying jute cord to the branches and hanging them on the wall. I continued to add branches, allowing their weight, size, and balance to direct me as I built the composition. My professors were unimpressed, but that piece contained all the seeds of everything I've produced since."

At a young age, Kelman learned crochet and embroidery from her grandmother, who "was from the old country, and trimmed every bed sheet and towel in our house with crochet." Kelman's father and uncles, all contractors, allowed her to walk through houses during the early stages of construction where, she says, "the beauty and clarity of those structures got stuck in my head."

Inspired by the works of architects Frei Otto and Vladimir Shukhov, who are known for breakthroughs in tensile structures, Kelman created a series of sculptures that includes *Two Eyes*, *Penumbra*, and *Bestia*. Compression and tension give form to each skeletal framework and tethered membrane. She also uses shibori, the shaped dye-resist technique, to transform silk organza into an elastic, translucent, patterned membrane.

Kelman tells us, "I've always been compelled to engage in the physical world. I like movement, using my muscles, dancing, gardening. It's not like I decided to work three-dimensionally. I suppose I've always had a hard time with two dimensions. If I can't bend it, tie it, or break it, I don't know where to start. I strive to make objects that are positioned in space using transient balance and tension." She adds, "Life is fragile; I hope my mode of engineering expresses that."

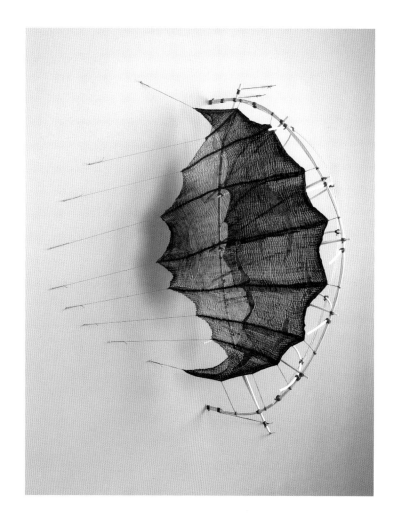

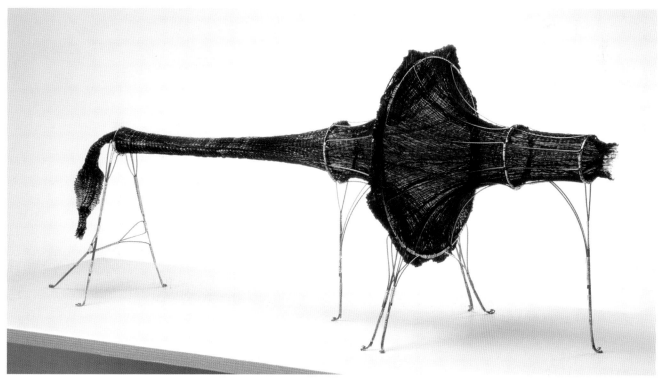

CHAPTER THREE
PLAYING WITH SPACE

Most visual art is nonverbal, although much of it represents something real: a person, a place, a thing, an idea. Yet, not all art aims to convey a message. Some art, in fact, serves as a joyful celebration of a strongly realized design and its elaboration; it is an appreciation of the object itself.

Object artists can be seen as accomplished engineers who approach the processes of design and construction as the central aspect of their work. They are physical artists who invite viewers in for a close investigation, even perhaps a tactile or manipulative survey of their art. Indeed, many of the sculptures described in this chapter are made to be taken apart or reconfigured by viewers to allow for a fuller recognition of their cleverness of form. In doing so, participants can sense the exquisite satisfaction the artist must have felt at having taken raw materials and transformed them into such mysterious and compelling sculptures.

Likewise, installation art, whether permanent or temporary, might also be considered a kind of object art. These works are usually created for a particular location. Typically, the artist observes the physical space, taking into account its dimensions, shape, and lighting, for example, and composes a piece of three-dimensional art that transforms the broader sensory experience of the space. The result is art that begs a dissolution of the line between art and life. You enter the world the piece occupies and, as you move within it, your personal response to the images and sensations surrounding you makes you a part of the artwork itself. Installation art is immersion art, an alternate reality.

Interestingly, although installation art has probably been around for centuries, it was only named an art form during the fiber revolution of the 1960s and '70s. Sheila Hicks, among others, became the standard-bearer when she moved from site-specific installations to so-called site-responsive ones. In other words, instead of simply installing a tapestry or other fiber piece, she took a more holistic approach and let the space inform the shape and content of her work. She would work for months to arrive at a visual language that reflected both the needs of the space and the message or sensibility of the patron who commissioned the work. Today's artists take their cues from her, although they may not always realize it.

Meghan Rowswell

Meghan Rowswell learned to sew and embroider while attending a youth development program, as well as from her mother's guidance. In fact, she says, "I come from a long line of homemakers and farmer's wives who made what they needed." She attended college for plant science, but it was not long before she realized, "I desperately needed art in my life. To me, art is like breathing. It's the core of my being." She eventually earned a bachelor's degree in art history and studio art.

Rowswell began making dimensional art after taking a class in large-scale outdoor sculpture. She remembers, "The students had to create a 20-foot inflatable sculpture out of

Meghan Rowswell. *Gaia*, 2011. 30" × 30" × 10".
Mixed fibers, thread. Courtesy of Meghan Rowswell.

fused plastic. My group made a milk jug, and the ten of us had to stand inside it to keep it from blowing away." A second assignment, for which she developed a floor lamp out of woven microfiche, convinced her of the endless possibilities of dimensional sculpture.

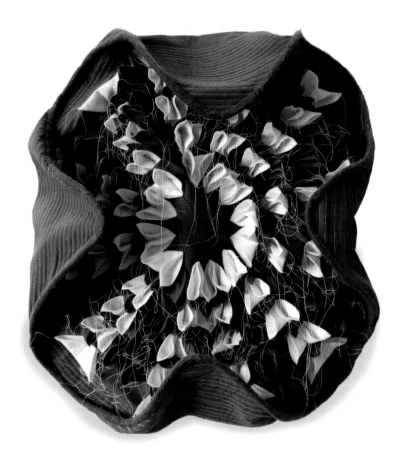

Currently, Rowswell is most interested in organic forms found inside plants and other cell structures. She says, "I enjoy transforming these forms into fiber because I like to experiment with the structural aspects of textiles."

For her sculpture *Gaia*, Rowswell wanted to evoke a mandala. "The felt pieces were sewn to a canvas backing and were quilted in circles. I thought the piece was too static, so I inserted a heavy wire inside the binding and bent back the corners. At that point it came alive; it was something between a plant and an alien form. It feels like it might devour you! I like the idea of creating art that has personality, motive, and its own essence—sculptures that breathe."

Growth was inspired by a ride on a high-speed train from Tokyo to Kyoto. "My scarf—silky, diaphanous, and brightly colored—was balled up and encapsulated in an elastic mesh pouch on the back of the seat in front of me. It was a very beautiful image and I've been working on ways of recreating the idea of confined, swirling energy."

Regarding *Growth*'s construction, Rowswell says, "Cutwork allows you to stitch and open up space without having to provide additional structure. Slashing and puffing are other traditional fabric manipulations as well. They come from the Tudor era, when sleeves for doublets and dresses incorporated them. The top layer is slashed in rows and then a lighter-color fabric that's underneath is pulled through the slashes, creating a puff. This technique takes me back to the time when I read my mother's costume history texts."

ABOVE RIGHT
Meghan Rowswell. *Gaia*, 2011.
30" × 30" × 10". Mixed fibers, thread.
Courtesy of Meghan Rowswell.

RIGHT
Meghan Rowswell. *Gaia*, 2011. Detail.
Courtesy of Meghan Rowswell.

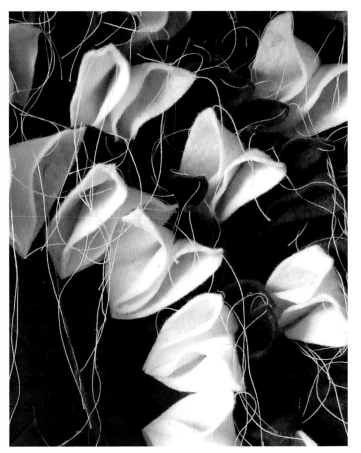

For *Morel*, the artist experimented with combining a hardened fabric with soft, organic flower bud forms. "While practicing Ikebana, Japanese flower arranging, I observed how plants adjust to their surroundings, even in the least-hospitable environments. That is what I meant to suggest with this sculpture. It began my exploration, too, about how limitations shape people's development. The work symbolizes adaptation and growth in the face of life's obstacles."

Amputee also began as an experiment. Rowswell explains, "I wanted to see what fur looked like through clear tubing. Because I've been exploring the ideas of boundaries and restrictions, it seemed natural to me to weave tubing around a fur sleeve, and to use hot pink string to bind it up."

For Rowswell, then, *play* is an operative word. With curiosity and wily imagination, she explores fabric manipulation with an eye toward objectifying her ideas about coexistence—with one another and with the natural environment.

RIGHT
Meghan Rowswell. *Morel*, 2015. 6" × 12" × 15". Mixed fibers, stiffener, thread. Courtesy of Meghan Rowswell.

BELOW
Meghan Rowswell. *Amputee*, 2015. 22" × 6" × 7". Fur, plastic, thread. Courtesy of Meghan Rowswell.

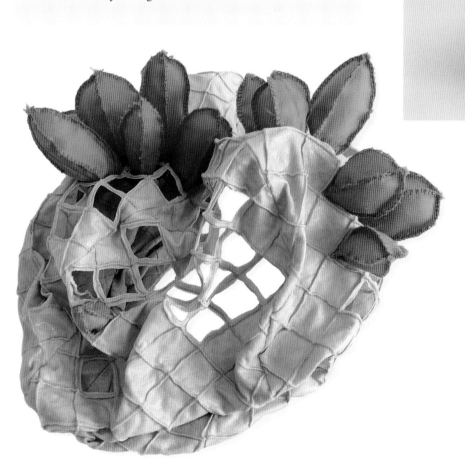

Diane Núñez

United States | www.dianenunez.com

Diane Núñez comes from a family of makers. Her mother is a weaver and her grandmothers taught Diane to sew, knit, crochet, embroider, and needlepoint. She took classes in jewelry, papermaking, quilting, ceramics, basketry, and felting, and pursued a career in landscape architecture. She says, "I think being a landscape architect has had the biggest impact on my textile work. Landscape architects design two-dimensionally and think three-dimensionally. While imagining what the design will look like, you have to ask yourself, 'What will the design look like when it's put in place in the real world? How will it look when it grows and matures?' When I tried to work flat with fabric, it just didn't feel right to me."

Núñez's work requires much mathematical accuracy, is labor intensive, and reflects the artist's interest in geometric shapes. She notes, "I enjoy playing with shadows and light. My work can be hung on a wall, suspended from the ceiling, or sit by itself on a pedestal. Its appearance changes depending on the time of day and how the light hits it, and it is even affected by the seasons and their changing quality of light."

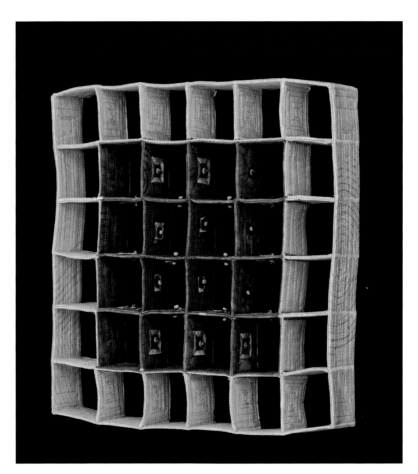

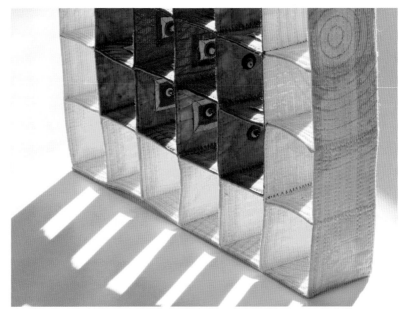

ABOVE RIGHT
Diane Núñez. *Two by Two*, 2009.
12" × 12" × 12". Commercial cotton, batik, batting, oil paint sticks, thread, beads. Courtesy of Diane Núñez.

RIGHT
Diane Núñez. *Two by Two*, 2009. Detail. Courtesy of Diane Núñez.

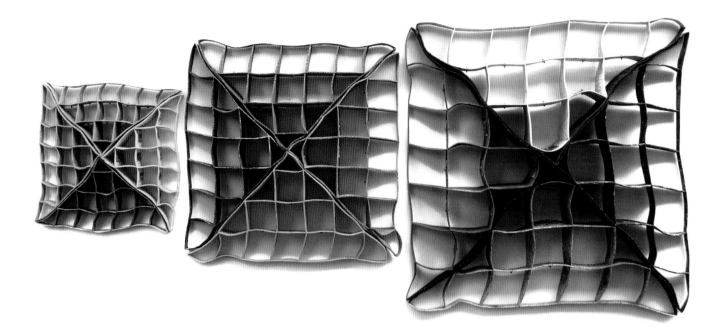

Two by Two was Núñez's first gridded, quilted fabric construction. She recalls, "I began by experimenting with paper and tape, thinking that if I could assemble the design with these materials, I could eventually make it from cloth and batting. I then made maquettes from cardboard and thread, and finally graduated to cloth. I found I enjoy working with solid-color batiks together with yardage embellished with oil paint sticks and colored pencils. This entire piece was further embellished with hand- and machine-sewing, and hand-sewn beads."

Núñez's *Six Squared* was made in much the same way. She explains, "This work is a variation of the grid form. As I was working on it, I was thinking of the Great Pyramids of Giza. It's more complicated than *Two by Two* in that its shape is not finite. Along the outside spines of each triangle there are snaps so that each section can be reconfigured or even taken apart to sit as a stand-alone piece."

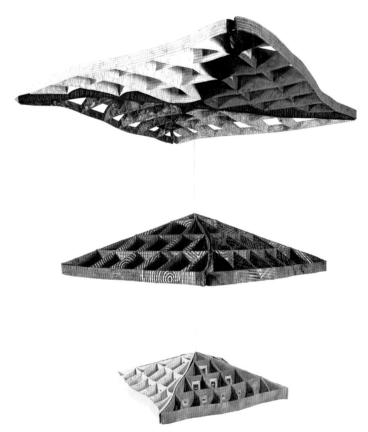

Diane Núñez. Two views, *Six Squared*, 2009.
47" × 27"× 27". Commercial cotton, batik, batting, beads, artist paint sticks, colored pencils, snaps, thread. Courtesy of Diane Núñez.

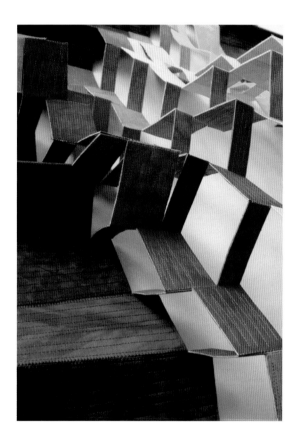

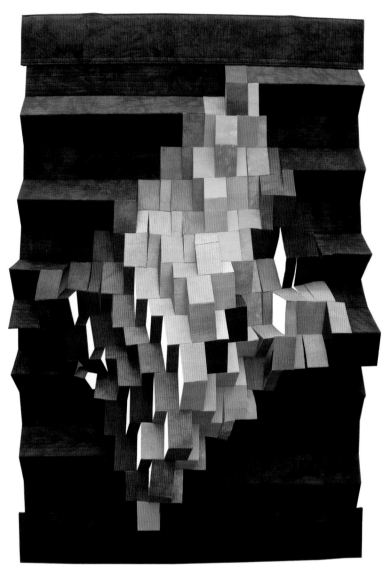

ABOVE
Diane Núñez. *Spaces*, 2011. Detail.
Courtesy of Diane Núñez.

ABOVE RIGHT
Diane Núñez. *Spaces*, 2011. 51"× 33" × 10".
Hand-dyed cotton, batting, thread, Ultrasuede,
stainless steel slat, stainless steel cable.
Courtesy of Diane Núñez.

For *Siamese Twins*, the artist says, "I took simple shapes and tried to make mirror images with my twin sons in mind. I wanted to see if I could work both flat and dimensionally. The center was ultimately made with Velcro so that the piece can be taken apart."

Spaces, composed of hand-dyed cotton, batting, Ultrasuede, stainless steel slats, and stainless steel cable, was inspired by pop-up cards. "Pop-up cards have always intrigued me. Here, I made a series of mistakes—learning opportunities—and I ended up creating a vertical piece rather than a horizontal one. The batting I was using was not strong enough to hold up the work horizontally. No amount of fiddling or stitching helped. My maquettes were of chipboard and were smaller, and I hadn't taken those factors into account. The steel slat I embedded into the top gave it needed stability. The final piece has a static exterior frame, and the interior moves independently, depending on how it is arranged. It works really well as a room divider."

Twisted, made of hand-dyed cotton, batting, aluminum tubing, and rubber O-rings, is another grid form. The artist tells us, "It is an interpretation of traditional quilting called *strip piecing*. While conceiving it, I wondered, 'What happens if I twist the strips? What happens when the light hits them? What shadows form?' Ultimately, the completed piece was created in five sections that can be hung separately or together, horizontally or vertically. It is the first art I created introducing visible metal rods. I enjoy the contradiction of soft fabric and hard metal."

RIGHT
Diane Núñez. *Siamese Twins*, 2010.
81.5" × 25.3". Hand-dyed cotton, batting, Velcro, thread. Courtesy of Diane Núñez.

BELOW
Diane Núñez. *Siamese Twins*, 2010. Detail.
Courtesy of Diane Núñez.

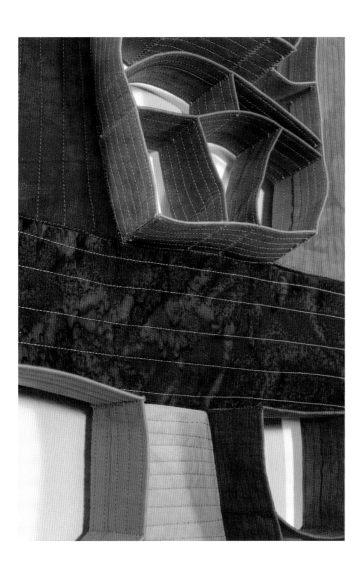

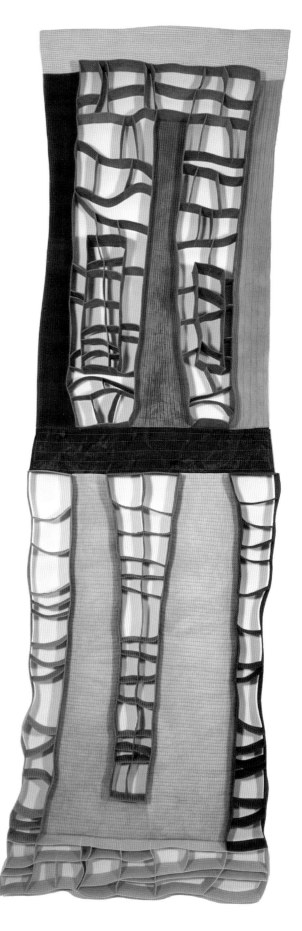

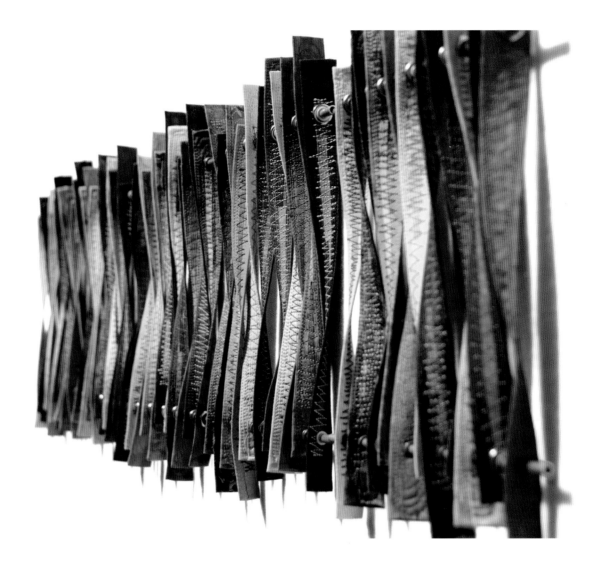

Human minds naturally crave order, and grids are the most common examples of an ordered system. Yet, Núñez's grid-based art is so much more than a rational, objective composition. Each describes a complex linear creation that invites the viewer in through its colors, textures, and intricacy of form.

TOP
Diane Núñez. *Twisted*, 2011. Detail. Courtesy of Diane Núñez.

BOTTOM
Diane Núñez. *Twisted*, 2011. 15" × 60" × 1".
Hand-dyed cotton, bedding, thread, aluminum tubing, rubber O-rings, eyelets. Courtesy of Diane Núñez.

Susan Avishai

United States | www.susanavishai.net

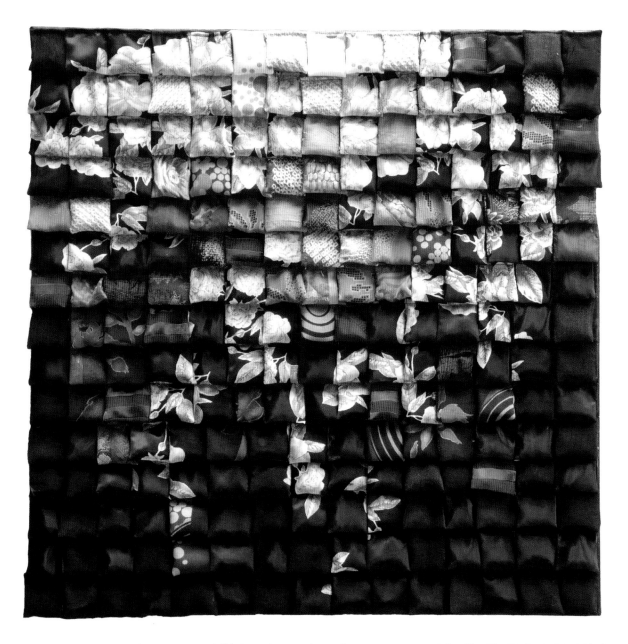

Susan Avishai learned to sew as a child from her mother, who was an artist, but she also vividly remembers at age two, "when my father's ballpoint pen slipped from his breast pocket as he kissed me goodnight. I discovered the joy of scribbling all over my sheet into the night."

As a young woman, Avishai studied drawing and printmaking in schools in Canada, during a year in France, and on her own. She also earned a master's degree in creative writing later in life. She found she admired the work of artists "who incorporated the debris and castoffs of our manufactured world" into category-defying sculpture, wall art, and installations, prompting her to embark on just such a path. She says,

Susan Avishai. *Homage*, 2012. 24" × 24". Assorted textile pockets, corn kernels, canvas. Courtesy of Susan Avishai.

"The first clothing I deconstructed was as a daughter in mourning after my parents had died. I'd held on to some of my mother's dresses and my father's shirts, imbued as they were with memory and poignancy. I eventually decided to leap boldly, cut them up, and create homages to them." The result is *Homage*.

Afterward, she began her sculptural fabric work in earnest. "I had worked and exhibited in drawing, print-making, egg tempera, oil, and collage for many years, but I was seeking a new medium, one that could allow me to express my distress over the vast quantities of clothing we throw into landfills, how quickly we decide its usefulness is over and its value gone. Americans alone generate more than thirty billion pounds of textile waste each year—about eighty-two pounds per person."

Avishai wanted to insert herself into "this para-doxical cycle of the exploitation of garment workers in Third World factories and the huge problem of waste" by focusing on used garments for her sculptures. She began bringing home armfuls of shirts from thrift shops; men's shirts—cut, resewn, quilted, or stiffened with glue—became the raw material for her art. "I wanted to show the possibilities for inspired reuse, demonstrating an appreciation of the dignity of labor, respect for mate-rials, and for the unexpectedly beautiful or whimsical results."

For *Blue Jellyfish*, Avishai composed a collection of seams and hems, shirt plackets, and quilted shapes left over from her other projects, which she let cascade from an embroidery hoop. She recalls, "My intent was to cre-ate an original and imaginative piece of art made only from upcycled, deconstructed shirts that might have otherwise ended up being thrown away."

ABOVE RIGHT
Susan Avishai. *Rapunzel, Rapunzel*, 2014–2015.
29.5' × 1'. Deconstructed men's shirts, thread, glue.
Courtesy of Susan Avishai.

RIGHT
Susan Avishai. *Rapunzel, Rapunzel*, 2014–2015.
Detail. Courtesy of Susan Avishai.

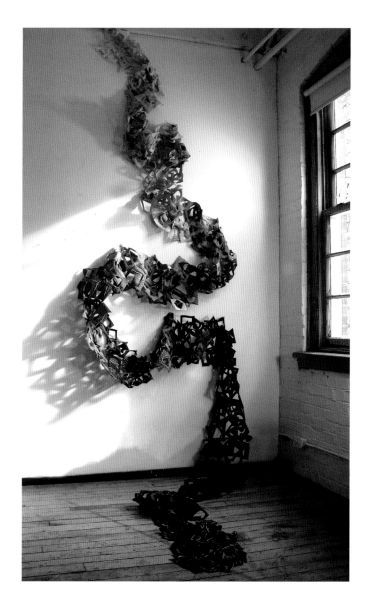

Rapunzel, Rapunzel is Avishai's largest piece to date: a thirty-seven-foot ribbon of quilted elements cut from more than fifty shirts. She notes, "It can be wall-mounted or suspended from the ceiling. Its color flows from white and lavender to deep purple and black hues. Fairy lights shine through the piece, creating a magical effect."

For *Garden Without Seasons*, Avishai composed shirt seams into tiny loops that seem to undulate, as if being pushed and pulled gently by ocean waves.

Cuff'd was made from deconstructed men's shirt cuffs stiffened with medium and glued. *Tulip Row* is comprised of shirt collars.

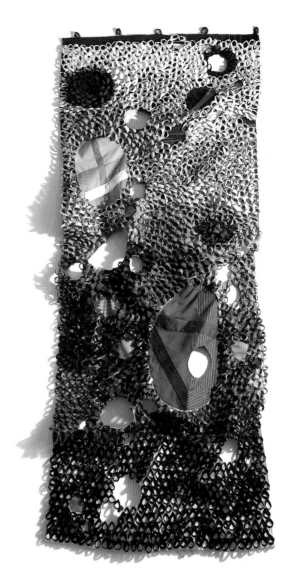

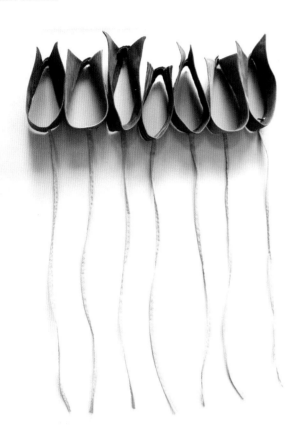

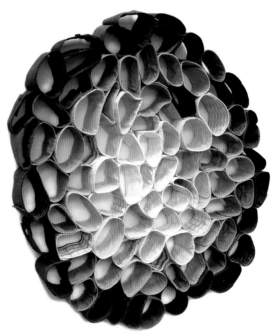

ABOVE
Susan Avishai. *Tulip Row*, 2013. 34" × 25".
Deconstructed men's shirt collars, medium, glue.
Courtesy of Susan Avishai.

ABOVE RIGHT
Susan Avishai. *Garden Without Seasons*, 2014.
70" × 28" × 4". Deconstructed men's shirts, thread, glue. Courtesy of Susan Avishai.

RIGHT
Susan Avishai. *Cuff'd*, 2013. 27" × 24".
Deconstructed men's shirt cuffs, medium, glue.
Courtesy of Susan Avishai.

Pippa Andrews
United Kingdom | www.pippaandrews.com

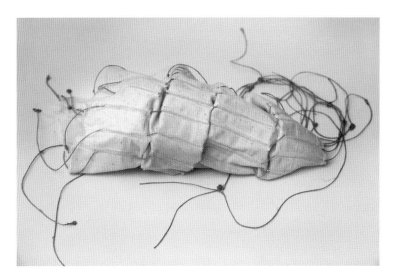

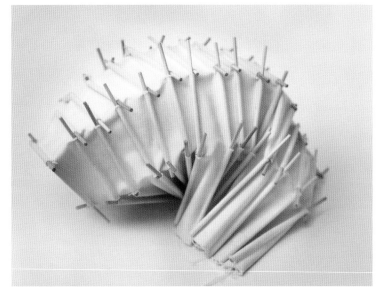

Even as a child, Pippa Andrews relished attending art exhibitions and knew she wanted to be an artist. She earned a teaching degree in English and art but, because pursuing art seemed like a precarious way to earn a living, she decided to become a journalist for a local newspaper. Yet, she always made art, taking evening classes in painting, ceramics, stone-carving, and weaving. She earned certificates in hand- and machine-embroidery, and eventually attended a fashion and textiles program, earning a bachelor's degree. She says, "When I discovered textiles, my courses in ceramics and carving had already helped me develop a three-dimensional way of thinking."

Andrews's work tends not to be literal. Rather, she notes, "My work relates to shapes and patterns found in nature, and also the built environment. I then abstract these shapes. For example, some of my work is based on grids relating back to city streets. I get my ideas in one of two ways—either I see some kind of pattern I want to try to adapt or I play around with all sorts of materials in a random way. Often, just twiddling with them in my hands, such as folding a piece of paper, results in an idea that I decide to develop with cloth. If my work is at all literal, it usually reflects an emotion I'm trying to convey, such as vulnerability."

For *Cone Cloth*, Andrews was exploring the possibility of making a flat cloth three-dimensional by incorporating mechanisms inside the structure. She says, "I wanted to be able to pull or twist it so that it became dimensional. It's made of two pieces of fabric, one a lightweight gauze and the other a

TOP
Pippa Andrews. *Cone Cloth*, 2004. 12" × 8" × 5".
Cotton muslin, cotton gauze, cotton thread, linen thread, plastic-coated wire. Courtesy of Pippa Andrews.

BOTTOM
Pippa Andrews. *Shell Cloth*, 2004. 9.5" × 4.5" × 3.5".
Cotton muslin, cotton thread, bamboo sticks. Courtesy of Pippa Andrews.

stiff calico. Linked channels were stitched between them and long linen threads were inserted through the channels. A stiffening wire was put in each section of channel to keep it rigid when the threads were pulled, forming pleats. The piece was then twisted to form an organic shape—perhaps a shell or cocoon. I like the idea that people can handle and arrange these cloths into a shape. Thus, the shape is vulnerable to change and, in fact, can never be the same twice."

Shell Cloth, a sculpture in the same series, is formed from stiff fabric with stitched rows of pintucks. Andrews says, "For *Shell Cloth*, the tucks were snipped to form five irregular columns with overlapping bamboo sticks inserted into them. The cloth was then rolled up and twisted into shape. Once again, the form it takes is organic—a crustacean, perhaps."

For *Carnival Cloth*, instead of sewing pintucks, stiffening sticks were attached with zigzag machining. *Spikes and Spots* is a larger sculpture made of short fabric-covered tubes joined using a bead-weaving technique, with painted bamboo sticks inserted through the tubes.

BELOW
Pippa Andrews. *Carnival Cloth*, 2005. 7" × 5" × 3.5". Acetate rayon, nylon organza, transfer dyes, fabric crayons, rayon thread, acrylic paint, bamboo sticks. Courtesy of Pippa Andrews.

BOTTOM
Pippa Andrews. *Spikes and Spots*, 2006. 63" × 9.5" × 9.5". Commercially printed fabric, double-sided adhesive tape, plastic beads, fishing line, emulsion paint, bamboo sticks. Courtesy of Pippa Andrews.

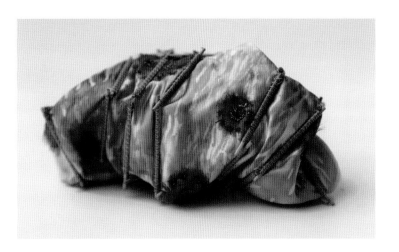

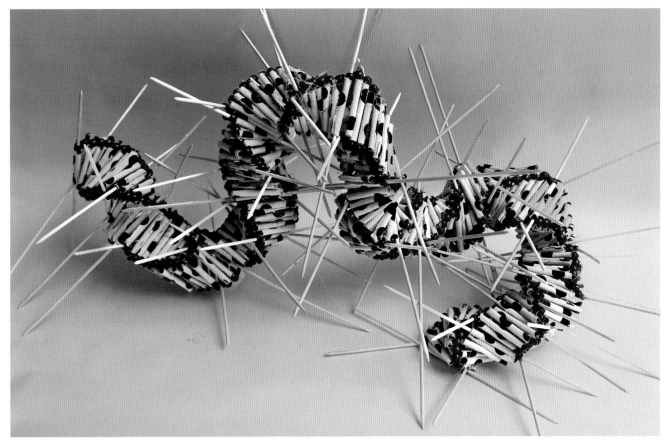

Sooo-z Mastropietro
United States | www.mastropiece.com

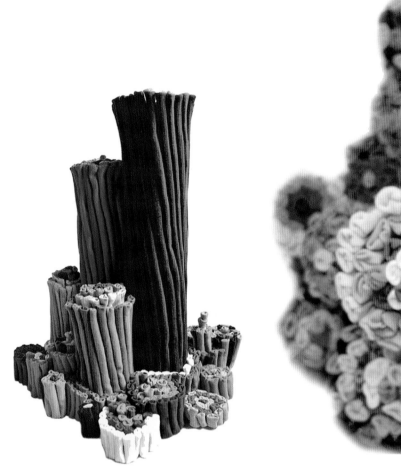

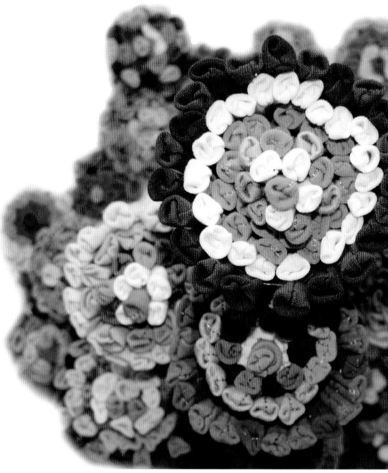

Sooo-z Mastropietro learned the essentials of sewing from her mother, and she has been experimenting with new uses of fabric ever since. Beginning in fashion design and clothing construction, she came to create hand-sewn fabric tubes attached to garments as adornment or functional closures. She says, "Many years later I discovered I could take this design to a different level, and I began making fine art compositions. I use my tubes as the basis for mosaics, paint strokes, millefiori, and upright shafts."

VeKNITzia was inspired by the Murano technique of Venetian glass fabrication in which glass rods are fused together and sliced, creating flower patterns. Mastropietro notes, "Despite the fact that fabric tubes are soft and pliable whereas glass rods are hard and breakable, and fabric has a

matte surface whereas glass is shiny, both media can achieve a defined shape beyond their natural inclinations." *VeKNITzia* is made of individual tubes turned inside out, grouped meticulously in radial patterns of varying sizes, and hand-stitched together. An internal vertical armature supports the sculpture.

According to Mastropietro, *Aquanomy* is meant to illustrate the power of the South Pacific Gyre, part of Earth's system of rotating ocean currents, the center of which is the site on Earth farthest from any continents and productive ocean regions. It is regarded as Earth's largest oceanic desert. Mastropietro explains, "This piece is comprised of fabric remnant tubes standing upright in a radiating configuration. It serves as a reminder of the danger of overconsumption and waste, which leads to destruction of the planet."

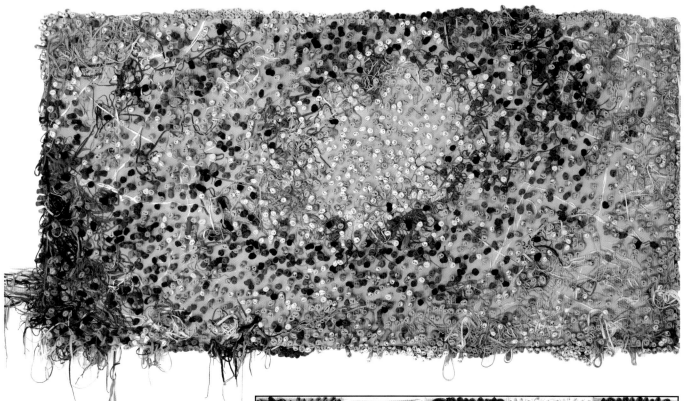

OPPOSITE LEFT
Sooo-z Mastropietro.
VeKNITzia, 2014. 11" × 12" × 14".
Cotton–Lycra knit, dowel armature,
cigar box. Courtesy of
Sooo-z Mastropietro.

OPPOSITE RIGHT
Sooo-z Mastropietro. *VeKNITzia*,
2014. Detail, top view. Courtesy of
Sooo-z Mastropietro.

ABOVE
Sooo-z Mastropietro. *Aquanomy*,
2015. 25.5" × 53". Cotton–Lycra
knit, painted board, resin. Courtesy
of Sooo-z Mastropietro.

CENTER
Sooo-z Mastropietro.
*Materialization: The Social
Collection*, 2014. 8" × 10" (each).
Cotton–Lycra knit, board. Courtesy
of Sooo-z Mastropietro.

RIGHT
Sooo-z Mastropietro. *Mo*, 2015.
16" × 20". Cotton–Lycra knit,
canvas. Courtesy of Sooo-z
Mastropietro.

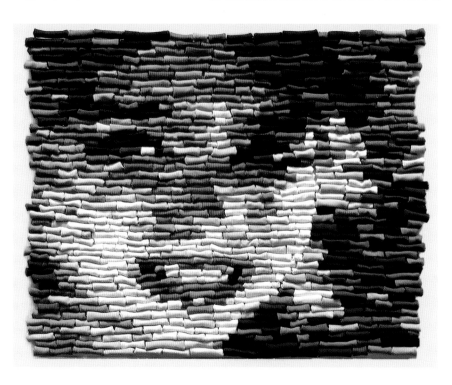

The intention behind Mastropietro's sculpture *Materialization: The Social Collection* was to illustrate the superficiality of social media. "Popularity on social media has become a measure of a person's worth. It's become another form of overconsumption, superficiality, and waste."

Many of Mastropietro's other pieces, such as *Impudent Flumpet* and *Mo* are equally inventive and compelling. They exemplify the artist's strong beliefs and innovative techniques.

RIGHT
Sooo-z Mastropietro. *Impudent Flumpet*, 2015. 11.5" × 11.5" × 4.5". Cotton–Lycra knit, frame. Courtesy of Sooo-z Mastropietro.

BELOW
Sooo-z Mastropietro. *Impudent Flumpet*, 2015. Detail. Courtesy of Sooo-z Mastropietro.

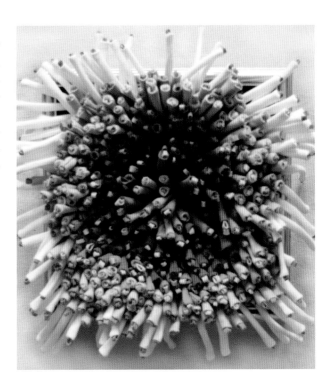

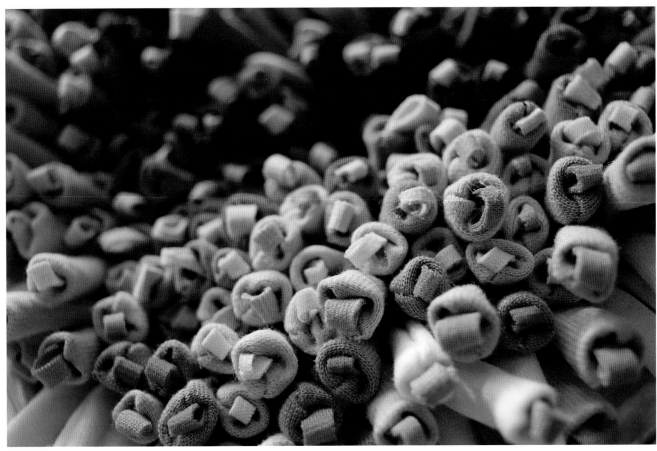

Mariko Kusumoto

United States | www.marikokusumoto.com

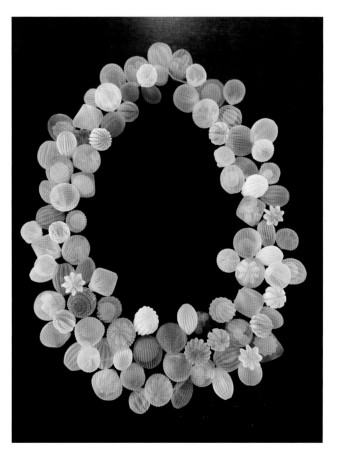

Mariko Kusumoto is a textile artist who grew up in Japan and now lives in the United States in Massachusetts. She creates ethereal flowers and baubles of extraordinary translucency and elegance, exemplified by her piece *Blue and Green Necklace*. Many hold within them another equally exquisite formation. Kusumoto is a physical artist—someone who makes the process of construction central to her creativity—but she's also a dreamer; her works are fantastical reinterpretations of natural phenomena.

Kusumoto was inclined toward art from a young age and majored in art in high school. As an adult, her early sculptures were of metal, as evidenced by *Hinamatsuri* and *Tokyo Souvenir Exterior/Interior*. She recalls, "[I]n 2013, after completing a very involved and technically challenging metal piece, I felt the need to move away from representational imagery and do more abstract and organic work, and with a different material. The result is my fabric sculpture. I like the softness and atmospheric qualities of the fabrics I use."

When Kusumoto returned to Japan for vacation, she discovered tsumami zaiku, a fabric-making technique developed during the country's Edo period, from 1603 to 1867. "The flowers were made into hair ornaments that women would wear with kimono. I was fascinated and inspired by this simple origami-like technique that transforms small fabric squares into complex and beautiful patterns." She now uses this set of techniques to devise her flower sculptures, as seen in *Blue Flowers* and *Red Flowers*.

Mariko Kusumoto. *Blue and Green Necklace,* 2014. 16" × 12" × 2". Polyester, monofilament. Courtesy of Mariko Kusumoto and Mobilia Gallery.

Mariko Kusumoto. *Blue and Green Necklace,* 2014. Detail. Courtesy of Mariko Kusumoto and Mobilia Gallery.

Although one day she might use metal again in her work, today Kusumoto enjoys focusing on composing airy and enigmatic fabric orbs, and orbs within orbs. Her *White Object 1* and *Necklace 2: Seascape with Coral* illustrate such shapes. She does this using heat-set techniques she has perfected during the past few years. Kusomoto notes, "Many of my pieces come from accidental discoveries. During the construction process, there is sometimes a breathtaking moment when something unexpected happens. I catch those moments and develop my ideas from them."

Kusumoto has been inspired by the work of other artists—in particular, Japanese avant-garde artist Yayoi Kusama, whose work showed alongside Andy Warhol in New York galleries during the 1960s and who favored eye-popping colors and over-the-top design, as well as Finnish designer Maija Isola, who helped produce the bold fabrics of Marimekko. Yet, Kusumoto's own sensibility could not be more different. Where those two artists went big and aggressive, she aims for the personal and quietly revelatory.

OPPOSITE
Mariko Kusumoto. *Hinamatsuri*, 2001. 22" × 12" × 12". Nickel, silver, copper, brass, sterling silver, steel, mirror. Courtesy of Mobilia Gallery. Photography: M. Lee Fatherree.

ABOVE RIGHT
Mariko Kusumoto. *Tokyo Souvenir Exterior*, 2008. 7.5" × 9.5" × 8.5" (closed). Nickel silver, sterling silver, brass, copper, resin, decal, found objects. Courtesy of Mobilia Gallery. Photography: Dean Powell.

ABOVE
Mariko Kusumoto. *Tokyo Souvenir Interior*, 2008. 7.5" × 35" × 20" (open). Courtesy of Mobilia Gallery. Photography: Dean Powell.

RIGHT
Mariko Kusumoto. *Blue Flowers*, 2014.
4.5" × 4.5" × 3". Silk, metal. Courtesy of
Mariko Kusumoto and Mobilia Gallery.

BELOW LEFT
Mariko Kusumoto. *Red Flowers*, 2014.
4.5" × 4.5" × 3". Silk, metal. Courtesy of
Mariko Kusumoto and Mobilia Gallery.

BELOW RIGHT
Mariko Kusumoto. *Necklace 2: Seascape
with Coral*, 2015. 12" × 12" × 4".
Polyester, monofilament. Courtesy of
Mariko Kusumoto and Mobilia Gallery.

OPPOSITE TOP
Mariko Kusumoto. *Wall Piece*, 2016.
4.5" × 4.5" × 2" (each). Polyester,
monofilament. Courtesy of Mariko
Kusumoto and Mobilia Gallery.

OPPOSITE BOTTOM
Mariko Kusumoto. *Brooch 1*, 2016.
4.5" × 4.5" × 2" each. Polyester,
monofilament. Courtesy of Mariko
Kusumoto and Mobilia Gallery.

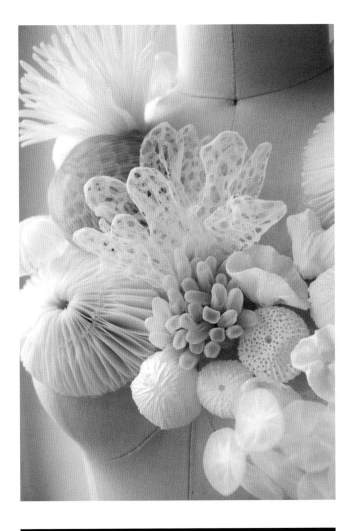

For Kusumoto, art is a way to take observable natural phenomena that stimulate her and reconceive them. "I like to reorganize these images and transform them into objects that are surrealistic, amusing, or unexpected. And I like the idea of layers. When objects are embedded inside created space they generate a mysterious effect." Indeed, her work presents us with magical microcosms—complete imaginary worlds—such as those that can be detected in *Brooch 1* and *Wall Piece*. Kusumoto says, "I'm challenged to see how far I can go. I have so many ideas and I'm anxious to see the pieces in real life. They will be formations never seen before."

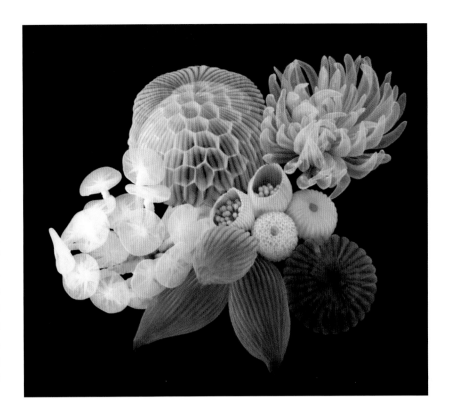

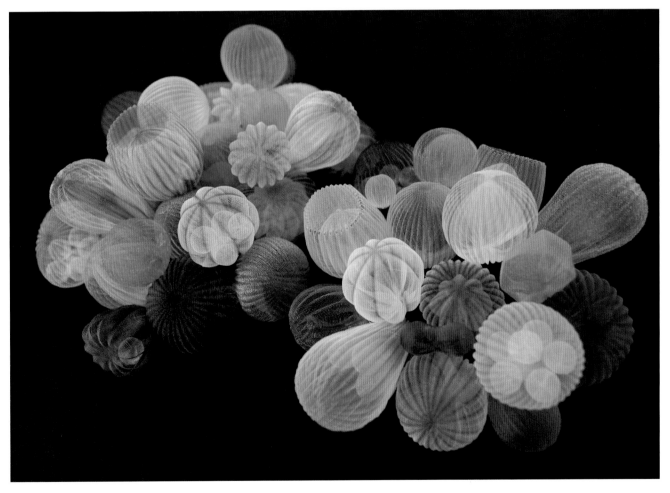

Sara J. Schechner

United States l www.altazimutharts.com

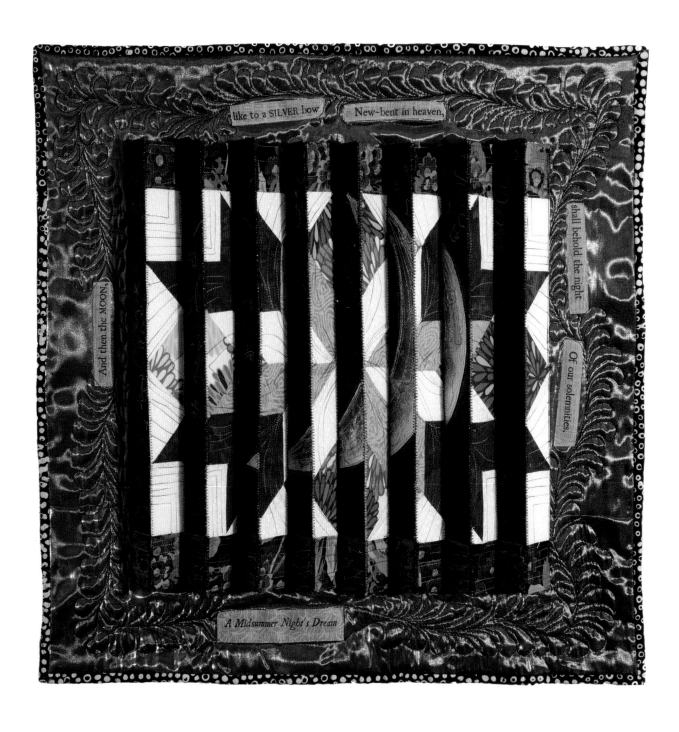

As a young girl, Sara Schechner learned painting and needlework from her grandmother. She recalls, "By day, we traipsed around the shore with sketchbook and paints, setting up our easels side by side in marinas, on beaches, and by historic buildings. At night, I joined her in embroidery, needlepoint, and other needle arts. Sewing with a machine came later, when I was 11; I was taught by my friend's mother."

"As a teen, I sewed clothes and fixed camping gear. I set sewing aside in college and my adult life, except for making the occasional set of curtains or costumes, until I received a new sewing machine for my fortieth birthday. That's when I took up quilting. My first quilts were traditional bed quilts, but soon after I was making art quilts and fiber art."

Schechner taught herself the dimensional techniques she uses for her metamorphosing quilts. She was inspired by sixteenth- and seventeenth-century optical devices, and also by tabula scalata preserved in European art collections. She notes, "In each of these, the witnessed scene evolves and comes to be as the viewer changes his or her position."

For *Metamorphosis II—Like to a Silver Bow, New-Bent in Heaven*, Sara drew inspiration from a line in Shakespeare's *A Midsummer Night's Dream*, in which a character announces the date of an upcoming wedding:

And then the moon, like to a silver bow

New-bent in heaven, shall behold the night

Of our solemnities.

As the viewer moves from left to right, the image of the crescent new moon metamorphoses into a traditional quilt star block.

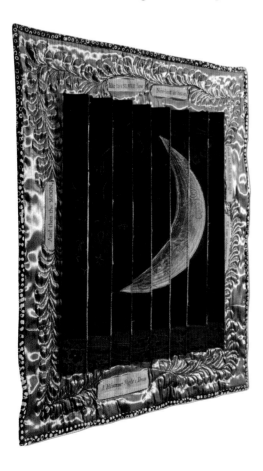

Leslie Pelino

United States | www.howlingspiders.com

Leslie Pelino is a mixed-media artist whose complicated sculptures are an amalgam of used materials and found objects, including clothes, faux furs, wire, ribbon, yarn—anything that is colorful and textured. Her work is spontaneous and whimsical, elaborate and exuberant.

Pelino's first foray into three-dimensional art was inspired by a beautiful rag rug she saw in a store; she imagined making one herself using her children's clothes. She borrowed a loom from a friend and, with the friend's help, taught herself to weave. Pelino says, "But I wasn't interested in acquiring perfect weaving skills; rather, I was totally enamored of the instantaneous thrill of combining colors and textures. I developed my own unconventional way of weaving using many different materials, including miscellaneous yard-sale treasures. I wanted a lush fullness and vibrancy, and lots of dimension. Eventually, I began to apply these abstract weavings to armature that I make, lashing everything together with discarded electrical wire I've found in my husband's electrical shop."

Most of all, Pelino wants her art to express her personal joy and wonderment. "I especially hope my sculptures make people smile and inspire them to ponder what's before them. Maybe they will understand my message that it's alright to have fun, to play, to transform objects they love rather then discard them. Maybe they'll feel motivated to find a passion of their own."

Pelino was brought up with three tight-knit brothers and often felt like an outsider in her own family. She became a sensitive loner who enjoyed exploring the woods and swamps near home. Perhaps because of this, she became "infatuated with nature" and bases many of her sculptures on natural imagery.

For example, *Anemone* was meant to be an "homage to the sea." Actually, it was the result of an upsetting event in which Pelino accidentally wiped out the fish in her beloved

Leslie Pelino. *Anemone*, 2013. 8' × 4' × 3'. Upcycled clothing, velvet, silk, rubber bands, blanket fringe, fake fur, rugs, artificial grapes, pom-poms, ribbons, barstool, tomato cages, plant basket, hula hoops. Courtesy of Leslie Pelino.

saltwater tank. "I was devastated and felt so guilty. My feelings led me to create a series of sculptures representing ocean scenes. They were a way of asking forgiveness for my ignorance. The effect of humans on the environment is one of my most heartfelt concerns, and it shows up in my art a lot."

Anemone is made from recycled materials such as blanket fringe, artificial grapes, pom-poms, and ribbon. The artist wove the foot of the creature on her loom, hand- and machine-stitched the bloom, and used a barstool with tomato cages and hula hoops for the base.

Another sculpture, *Can't Take It with Her*, is based on Pelino's question, "Do we own our possessions or do they own us?" She explains, "My artwork will remain after I'm gone and I wonder what will happen to it. I love creating, but I ask myself, is my art worthy of posterity?" In this way, this artist's work interweaves its materiality with a conceptual preoccupation about the human condition: permanence and transience, life and death. It is also concerned with generational communication. She poses the question, "Will those who come after me know I've been here?" Although these may be sobering enigmas, Pelino addresses them with humor and a sense of celebration. "My sculptures are an expression of my love and gratitude for all the goodness in my life."

Leslie Pelino. *Can't Take It with Her*, 2008.
3' × 2' × 2'. End table, curtains, beaded dress,
upcycled fabrics, antique buttons, vintage fringe. Courtesy
of Leslie Pelino.

Marty Jonas

United States | www.martyjonas.com

A mixed-media artist, Marty Jonas was taught by her mother to knit, crochet, and sew. Her father showed her how to hammer, saw, solder, and drill. She recalls, "I can't remember a time when I wasn't doing something creative with my hands."

During the 1980s, Jonas constructed a Victorian dollhouse—one she could add to her family's beloved antique collection—and when she needed to create carpets for it, she discovered she loved textiles. Later, she took an embroidery class and was again smitten, leading her to study embroidery, first in the United States, and then in London for seven years. She remembers, "My first class was in a thirteenth-century abbey and I was housed in a monk's bedroom."

Marty Jonas. *Blue Succulent/Astrophyllum*, 2014.
4" × 8" × 8". Hand-dyed felt, batting, thread.
Courtesy of Marty Jonas.

Today, Jonas says, "My work is composed of five basic elements: color, line, composition, form, and texture. Whether my pieces are abstract, representational, or sculptural, I use these elements to achieve a cohesive compositional balance aimed at provoking an emotional response,

such as anxiety, energy, imbalance, tension, turmoil, comfort, ease, or pleasure. Take lines, for instance. I find thin lines create a feeling of fragility and elegance whereas thick lines suggest strength and importance. Diagonal lines might make you feel restless, and horizontal lines can bring a sense of distance, calm, and quiet. Color also imparts a mood or feeling, as do certain shapes. Circles give you a sense of completeness, but also of continuous movement."

In some cultures, the circle symbolizes strength, elegance, and universality. The Japanese, for example, practice drawing circles, or Ensō, as a way to achieve self-realization. For Jonas, "The circle is a recurring shape in nature, art, design, architecture, and engineering, and it is one of the oldest, most rudimentary forms created by humans. For me, it has symmetry and aesthetic and functional perfection. I like circles. They're friendly." Nowhere are her feelings for circles more evident than in *Blue Succulent/Astrophyllum* and *Green Buckyball*.

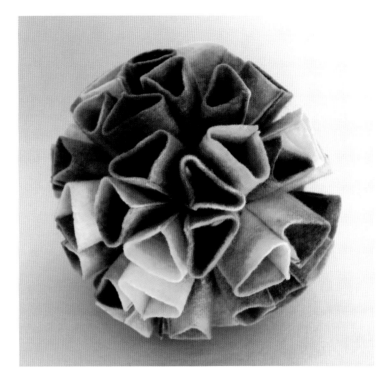

ABOVE
Marty Jonas. *Green Buckyball*, 2014.
6" × 6" × 6". Hand-dyed felt, thread. Courtesy of Marty Jonas.

LEFT
Marty Jonas. *Euphorbia Pulvinata*, 2014.
8" × 8" × 8". Hand-dyed felt, sheer fabrics, thread. Courtesy of Marty Jonas.

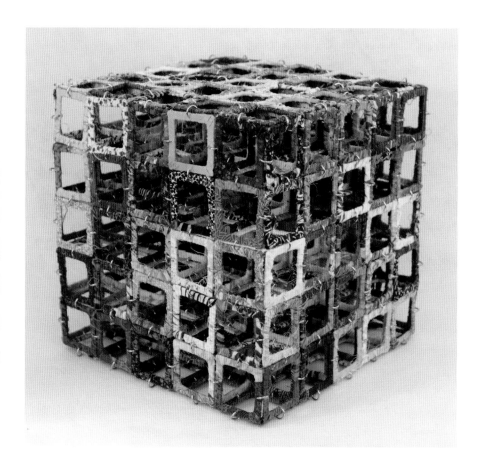

For her sculpture *Euphorbia Pulvinata*, Jonas made several panels of flat felt from various colors of wool roving combined with sheer fabrics, onto which she hand- and machine-stitched a geometric pattern. She initially left the project unfinished. Years later, she discovered modular origami, a form of Japanese paper-folding that involves folding multiple units and assembling them to create a larger and more complex shape. Using felt instead of paper, Jonas began to use this technique to create orbs. She remembers, "At the time, I was making abstract forms using metal window screen. I combined the metal screening with the modular origami, but eventually stopped using the screen and instead used stitches to maintain the shapes I created."

Jonas likes to choose unusual materials and techniques. For *Circle in a Cube*, for example, she used cardboard photographic slide mounts. She says, "I wrapped each mount in small cotton fabric strips. I used hundreds of them because there are 125 cubes made up of 450 mounts each. I fastened together each mount with metal jump rings, and the center of the cube forms a circle."

Pam Farley
United States

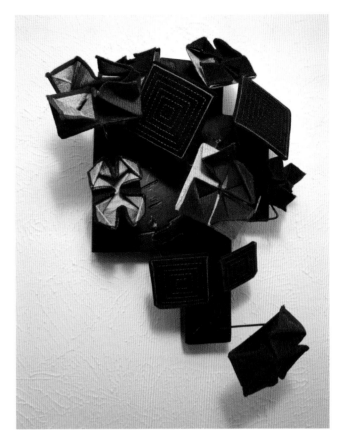

Pam Farley is a mixed-media artist who was a knitter and clothes-maker from the age of six, initially exposed to creativity—in particular, dimensionality—through her mother's career as a pastry chef. Years later, following retirement from a career in occupational therapy, Farley was drawn to the Japanese paper-folding art of origami. She recalls, "I was fascinated by how, with a few folds, a piece of paper could come to three-dimensional life. My desire to make fabric behave like paper became the driving force for my art. Through trial and error, I developed my own ways of stiffening fabric so that it would permanently maintain a fold. My techniques include applying clear polyurethane, fusing fabric to cardstock, and using a variety of interfacing products."

For this artist, expressing feelings about important relationships drives much of her work, as well as the idea that she is sharing those feelings with the viewer, even if the exact image she portrays remains mysterious. Connection is paramount.

Sonia, for example, is meant as a memorial to a friend. The friend had traveled to the United States from Chile to study and work. Soon after retiring, she was diagnosed with pancreatic cancer and died. Pam reflects, "Sonia was beautiful and compassionate. She wore elegant and colorful clothes. She was smart and full of wonderful energy. With my piece, I wanted to remind us that life can be cut short and we should look for beauty every day."

ABOVE RIGHT
Pam Farley. *Sonia*, 2009. 18" × 12" × 8". Silk dupioni, cotton, wool–nylon thread, polyester thread, stiff interfacing, wire, wood base. Courtesy of Pam Farley.

RIGHT
Pam Farley. *Sonia*, 2009. Detail. Courtesy of Pam Farley.

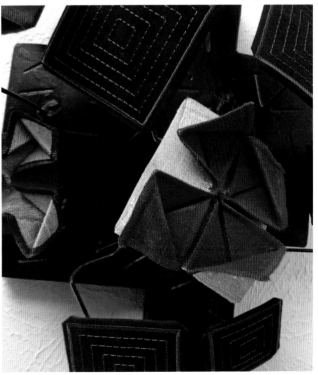

Emily Dvorin

United States I www.emilydvorin.com

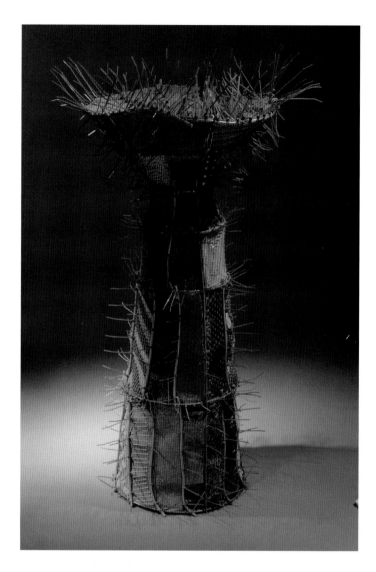

A mixed-media artist, Emily Dvorin enjoyed experimenting with many art forms before she came upon the basketry techniques she now favors. She says, "With a visual language, I like to tell a story by sculpting, weaving, sewing, assembling, and coiling. My use of ordinary, repurposed, and recontextualized materials are meant as a commentary on our cultural overconsumption, societal excess, and throwaway consumerism. My work references everyday life and our relationships with the urban environment."

Dvorin credits the 1960s textile revolution with giving her permission to make art about ordinary lives. She recognizes, as well, that the women's movement of the 1970s helped elevate fiber art to a respected pursuit, although she bemoans the fact that there are still those who consider it craft rather than art.

TOP RIGHT
Emily Dvorin. *My Universe*, 2013.
43" × 25" × 25". Tomato cage, fabric, plastic, zippers, embroidery floss, pencils, needlepoint canvas, cable ties. Courtesy of Emily Dvorin.

RIGHT
Emily Dvorin. *My Universe*, 2013. Detail.
Courtesy of Emily Dvorin.

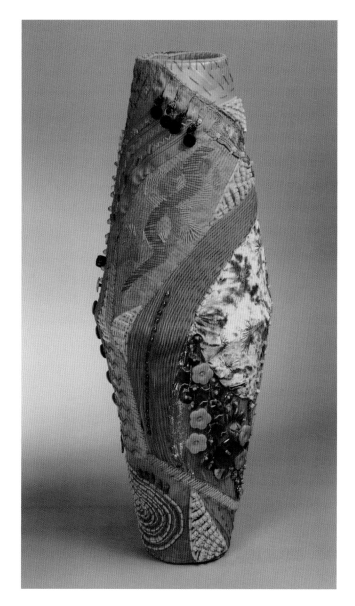

Macramé first sparked Emily's imagination and, from there, she created her own form of sculptural art, which she calls *sculptural basketry*. She enjoys constructing these vessels in large part because they "become a holder of a story I want to tell." For example, *My Universe*, made from an upside-down tomato cage, fabric, plastic, zippers, embroidery floss, pencils, needlepoint canvas, and cable ties, is representative of Dvorin's enthusiasm for the many materials she uses to tell her stories.

Tangerine Tantrum composed of lampshades, fabric, plastic, zippers, buttons, and cable ties was created to celebrate color. "I sewed together and embroidered objects that honor the color orange. This piece symbolizes the combination of colorful elements in my life that I so appreciate."

The sculpture *Terpsichore*, made of a lampshade, ballet slippers, lace, fabric, and cable ties, "talks about the beauty

ABOVE LEFT
Emily Dvorin. *Tangerine Tantrum*, 2014.
24" × 9" × 9". Lampshades, fabric, plastic, zippers, buttons, cable ties. Courtesy of Emily Dvorin.

ABOVE RIGHT
Emily Dvorin. *Tangerine Tantrum*, 2014. Detail.
Courtesy of Emily Dvorin.

and pain of dancing ballet. I took apart well-loved slippers to get at their construction and discovered metal and wood. In other words, the magic of ballet has an unseen layer that is tortuous for the dancers."

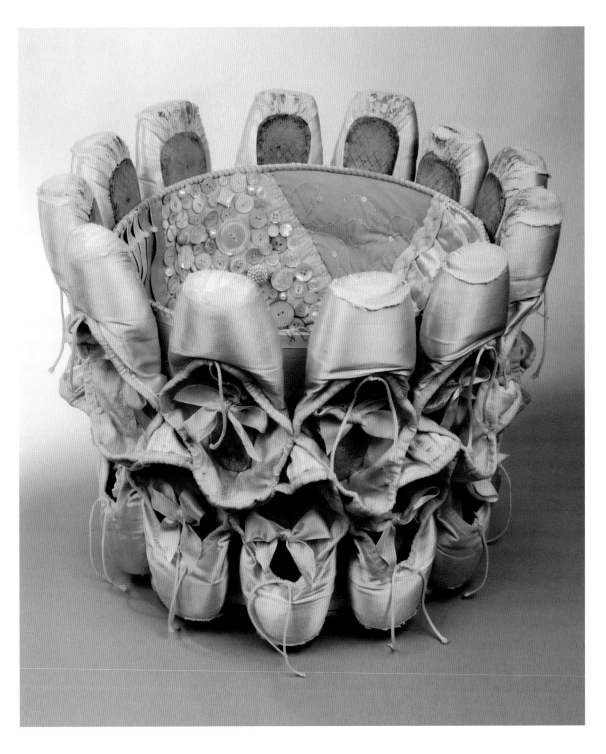

Dvorin's ability to create intricately com-posed—yet fantastic—sculptures demonstrates her confidence in her imagination to translate important messages into broad, transformative visual imagery. The joy of expression motivates this artist.

Emily Dvorin. *Terpsichore*, 2014.
15" × 18" × 18". Lampshade, ballet slippers, lace, fabric, cable ties. Courtesy of Emily Dvorin.

Richard McVetis

United Kingdom | www.richardmcvetis.co.uk

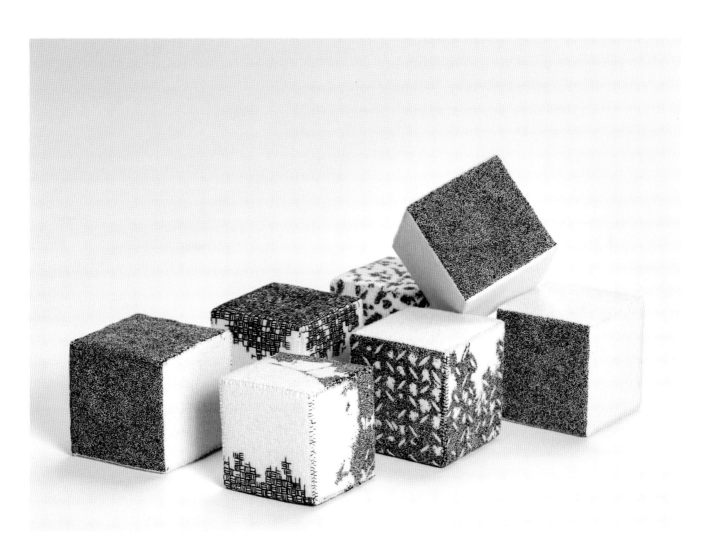

Richard McVetis remembers creating imaginary worlds with pen and paper as a youth, and his love of this simplest system of mark-making led him on his creative path. Although he was not encouraged to become an artist, his need—and passion—to create could not be denied.

McVetis began his career by studying traditional embroidery. Later, he became interested in shapes created by draped fabric, and he began to explore abstraction. "I enjoyed drawing, but the idea of creating sculpture was particularly exciting. The ability of sculpture to affect and interact with

the space it occupies can have a profound effect on the viewer. In fact, I find the way in which we interact with space in our daily lives is, in effect, one big interactive sculpture."

Richard McVetis. *Units of Time* Collection, 2015.
2" × 2" × 2" (each piece). Wool, thread, foam.
Courtesy of Richard McVetis.

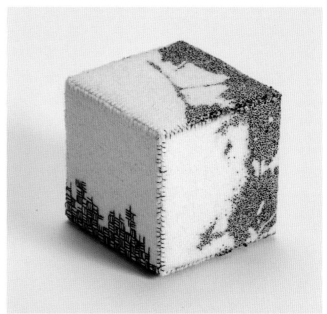

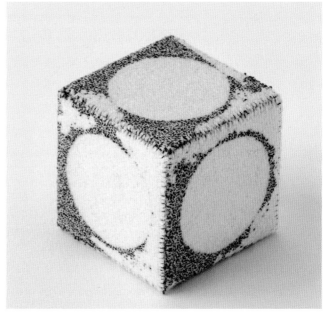

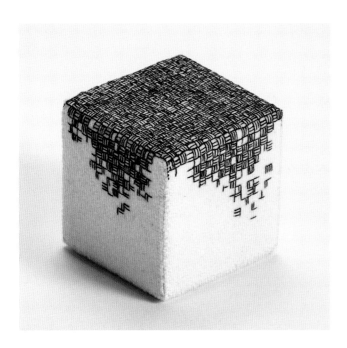

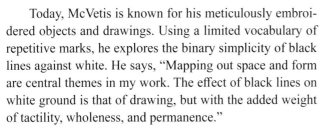

Today, McVetis is known for his meticulously embroidered objects and drawings. Using a limited vocabulary of repetitive marks, he explores the binary simplicity of black lines against white. He says, "Mapping out space and form are central themes in my work. The effect of black lines on white ground is that of drawing, but with the added weight of tactility, wholeness, and permanence."

This artist's recent project, a collection titled *Units of Time*, is a study of the way time and place are experienced and constructed. "Ideas are often developed in response to moments or a specific moment; it is the process of making that moment into a tangible object. I created this work to explore how objects bear witness to time passing. Collectively, the units are a diary and a timeline. Individually, the title of each one refers to the hours and minutes I spent stitching them."

For this artist, shape, line, contrasting color, and texture guide his creative flow. Each stitch he makes is a link to the next, and represents the beginning and course of his journey.

ABOVE LEFT
Richard McVetis. *Cube 1: 29:59*, 2015. 2" × 2" × 2".
Wool, thread, foam. Courtesy of Richard McVetis.

TOP
Richard McVetis. *Cube 2: 31:26*, 2015. 2" × 2" × 2".
Wool, thread, foam. Courtesy of Richard McVetis.

ABOVE
Richard McVetis. *Cube 3: 28:10*, 2016. 2" × 2" × 2".
Wool, thread, foam. Courtesy of Richard McVetis.

Betty Busby
United States | www.bbusbyarts.com

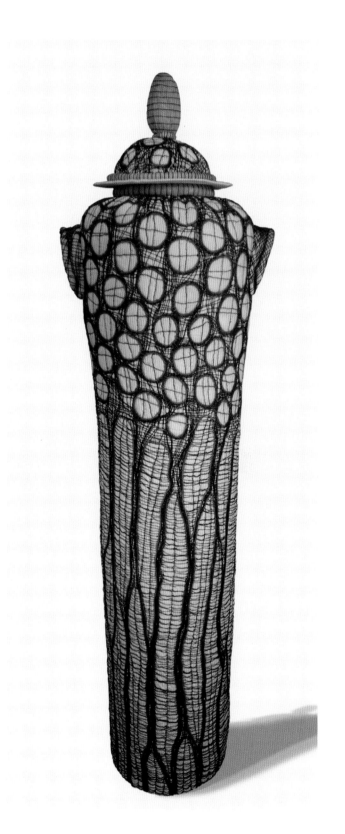

Betty Busby enjoyed arts and crafts with her two sisters and considered herself an artist even as a child. She graduated from a design school where she majored in ceramics, and founded a ceramic manufacturing business, which she ran for twenty years.

Today, some of the techniques she uses with fabric have a basis in clay sculpture, such as armature construction. Busby says, "With my fiber sculpture, I'm reflecting classical pottery shapes, but using textures and sizes that are unique to the medium."

With *Ginger Jar*, for example, Busby's intention was to pay tribute to several hundred years of Chinese pottery. She notes, "The forms are reinterpreted in fiber—exaggerating the size of the original—and with a surface texture unique to fiber. There is a saying, 'We stand on the shoulders of giants' and, with this piece, I am trying to convey my love of and respect for the ancient artisans." *Ginger Jar* is made of hemp overlaid with mesh, machine-quilted with corded yarn, and stretched over an interior armature. In addition, the traditional technique of gathering threads helps shape the jar.

Betty Busby. *Ginger Jar*, 2014.
63" × 21". Linen, mesh, corded yarn, hemp.
Courtesy of Betty Busby.

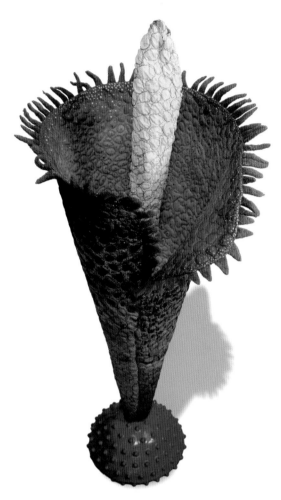

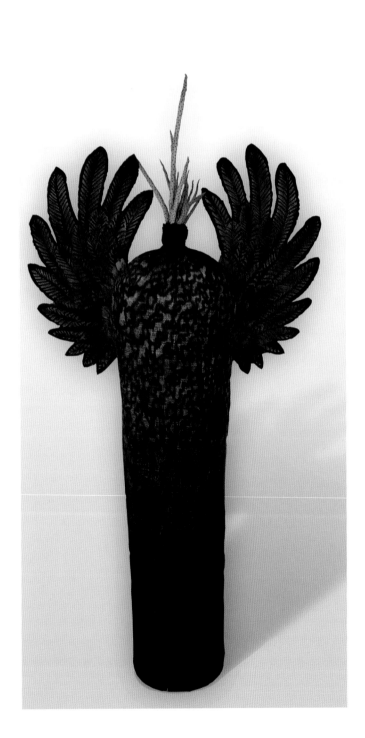

Busby conceived *Vengeance* as an expression of "those worries that overtake us as we try to settle in for the night. With its looming black wings and yellow felted locks sprouting from the top, it represents our worst nightmare." For the body of this sculpture, raw silk was machine-quilted then partially bleached with thiourea dioxide, lightly overpainted, and shaped over an interior armature. The wings are of heat-stiffened batting, quilted and bleached, and attached to the body with strands of wool. Beads help form the shapes at the top.

LEFT
Betty Busby. *Vengeance*, 2014. 66" × 36" × 16".
Silk, cotton string. Courtesy of Betty Busby.

ABOVE
Betty Busby. *Voodoo Lily*, 2014. 36" × 12" × 12".
Silk, felt, rubber. Courtesy of Betty Busby.

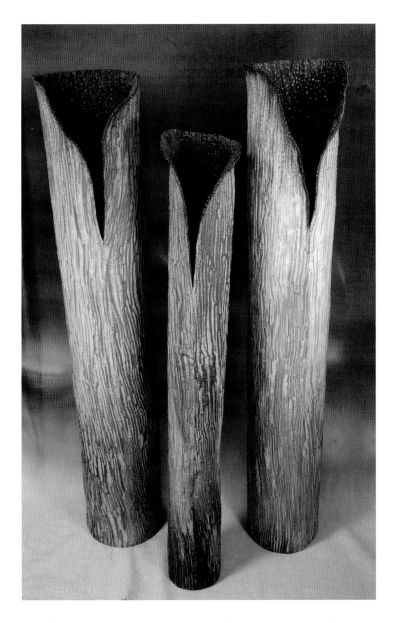

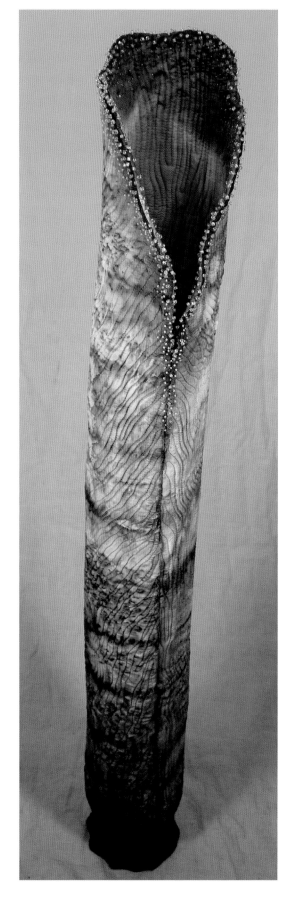

Of *Voodoo Lily*, Busby explains, "I adore jungles and tropical plants. This sculpture is a reinterpretation of a giant flower of the genus *Amorphophallus* that blooms only rarely. With it, I wanted to evoke the rainforest and its flashes of brilliant color."

Busby's many other vessels, including *In the Weeds* and *Ice Fall*, speak to this artist's exceptional sense of color and design. Her compositions pulse with life.

Serena Garcia Dalla-Venezia
Chile | www.serenagarciadallavenezia.com

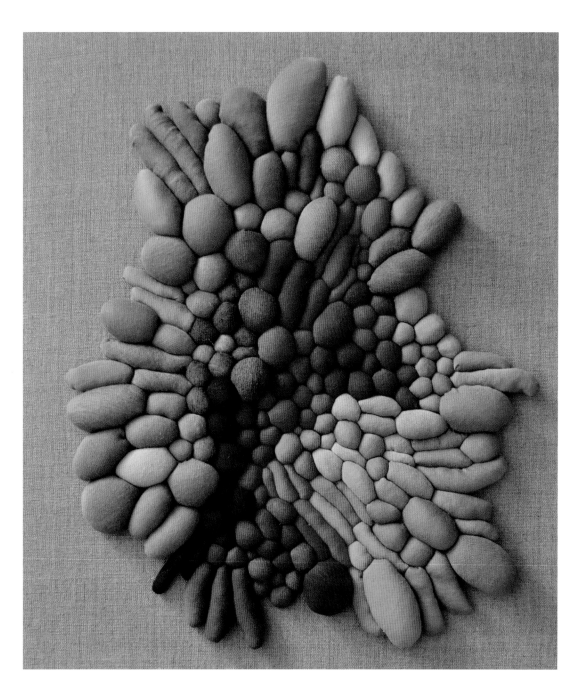

Both of Serena Garcia Dalla-Venezia's parents were artists and introduced her to the world of art. At eighteen, she attended a visual arts program in her native country of Chile. Although she worked with watercolors on canvas and embroidery on linen, she invented a technique years ago that has allowed her to explore dimensionality. "The technique involves hand-sewing small nodules of fabric, which are joined together, creating a volume as well as images and textures. My penchant for creating volume has to do with the characteristics of the material I work with. I like to modify and transform it, though always staying true to its possibilities and limitations."

168

Obra 1 and *Cresimiento Continua* illustrate the simplicity and beauty of the artist's work. Made of linen, they incorporate Dalla-Venezia's round and elongated nodules. She says, "I elongated the round shape so it's more of an oval in order to generate a different kind of rhythm in the composition." All of her pieces, she notes, reference connected organic forms to suggest the idea of community. "We're all connected," she remarks. "We are part of nature. Just as plants are interconnected, so we are with them and with each other."

For *Accumulacion, Orden y Caos*, Dalla-Venezia notes, "The central theme here is accumulation that leads to excess. I show it with not only the colors and shapes I used, but the way in which the work grew and came to invade both itself and the space around it. It represents growth patterns seen in nature that help organisms adapt to and then modify their environments."

In all her work, Dalla-Venezia's masses of individual nodules become an entity unto themselves and, as such, take on a greater degree of visual interest and power. Without each nodule, the entity could not exist. Therefore, the unit and the whole are dependent on one another for life and efficacy.

ABOVE RIGHT Serena Garcia Dalla-Venezia. *Acumulacion, Orden y Caos*, 2010. 11' × 6.5'. Fabric, thread. Courtesy of Serena Garcia Dalla-Venezia.

RIGHT
Serena Garcia Dalla-Venezia. *Acumulacion, Orden y Caos*, 2010. Detail. Courtesy of Serena Garcia Dalla-Venezia.

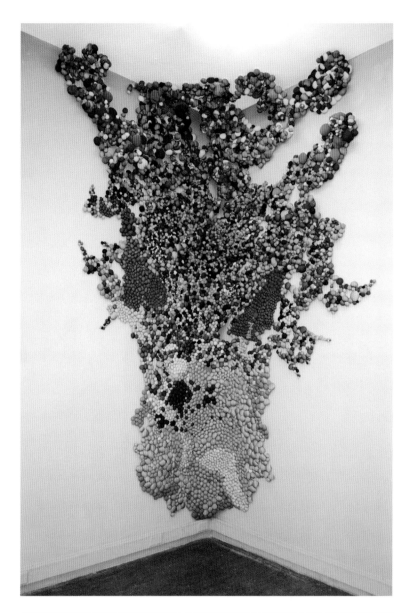

Marilyn Muirhead
New Zealand

Marilyn Muirhead was creative in childhood and, after she raised her own children, decided to pursue art full-time. She says, "A couple of cancer episodes made me realize we have to get on with what we love, not put it off for later."

Adventurous, Muirhead doesn't hesitate to experiment with many different styles of fabric art. She notes, "My good knowledge base means I can make it work even if I only have a vague idea of where I'm heading after I start. I love the idea of not restricting myself to two-dimensional forms. It's so exciting to go beyond traditional boundaries and borders."

For *White Island Ash*, the artist began with an abstract design with the intention of exploring varying textures. Muirhead used highly textured fabrics such as wool, cord, and linen, then laid them out on fabric, sometimes crisscrossing them. However, when she recognized branch shapes in her composition, she chose to portray the image of trees. The foliage was created by layering fabrics over a center wire stem and hand-sewing them into place. She recalls, "After six coats of paint, it occurred to me that this was how White Island—the only active volcano in New Zealand—off the coast where I lived, would have looked over the centuries."

Marilyn Muirhead. *Organic Evolution*, 2015. 1.9' × 3.9'. Organza, thread. Courtesy of Marilyn Muirhead.

After reading about the technique of burning synthetic organza, Muirhead was inspired to try layering chips of organza, sewing, and quilting them, then burning parts away as well as curling and twisting the chips to expose the colors beneath the top layer for her work *Organic Evolution*. A few strips of brown organza make up the ground. She says, "This imagery was from my imagination, but I later realized the piece represented nature's creation of new growth after fire and destruction. Here, burning is part of a metamorphosis."

Created for a national quilt show, *Living Copper* presented the artist with many challenges. She explains, "Copper is such a pretty, but also hard, material. I was keen to use it and saw that it was easy to manipulate. I kept coming back to a vessel shape. I used a sprinkle of beads emerging from the crevices of the fibers and wrapped and melted painted fibers to soften the look and feel of the ends of the wires. The final image depicts the process of growth emerging from the earth, seeking light and gaining sustenance from it."

RIGHT Marilyn Muirhead. *White Island Ash*, 2014. 2.2' × 6.8'. Textured fabrics, wire, yarn, thread, paint. Courtesy of Marilyn Muirhead.

OPPOSITE TOP
Marilyn Muirhead. *White Island Ash*, 2014. Detail. Courtesy of Marilyn Muirhead.

OPPOSITE BOTTOM
Marilyn Muirhead. *Living Copper*, 2014. 19.6" × 11.8" × 7.8". Fabrics, wire, beads, paint, yarn, thread. Courtesy of Marilyn Muirhead.

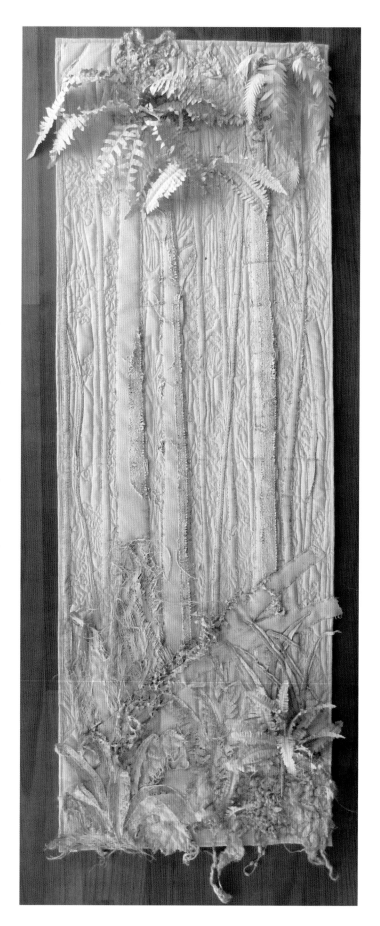

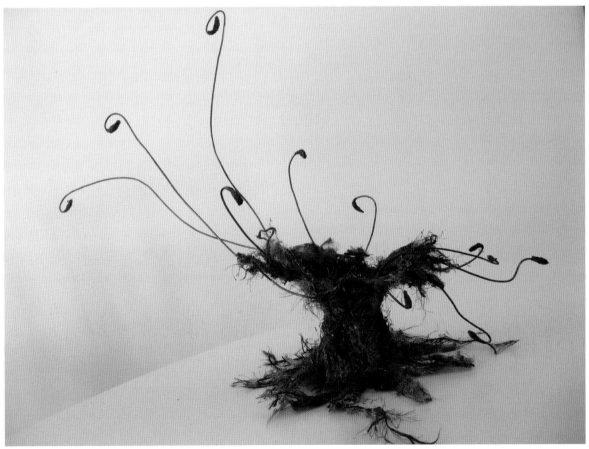

Beili Liu

China/United States | www.beililiu.com

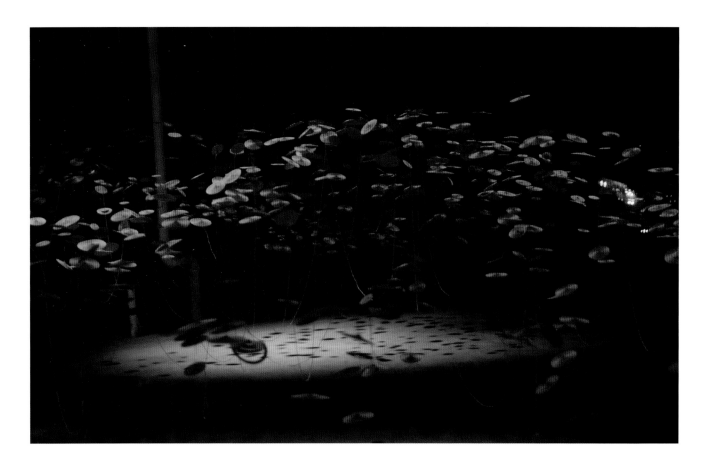

Since childhood, Beili Liu has been interested in "materials, space, and making. The first time I was exposed to installation art was when I saw images of Xu Bing's *Book from the Sky* at an exhibition held between 1987 and 1991 in Beijing's China Art Gallery. It was made up entirely of meaningless glyphs designed to resemble traditional Chinese characters. The hand-printed books were laid out on the floor and these were surrounded by ceiling and wall scrolls. The installation presented a radical challenge to current Chinese culture. I was an undergraduate studying graphic design at the time. I was in awe of the breadth and scale of the work, and the idea that art does not have to be attached to a wall or stand on a pedestal. It is a piece that greatly affected my understanding of the potential of contemporary art—how it starts with

tradition then breaks away from it, and how it embodies complex concepts that affect viewers on intellectual, psychological, and emotional levels. I came to see installation art as the most moving format an artist can use to communicate with viewers."

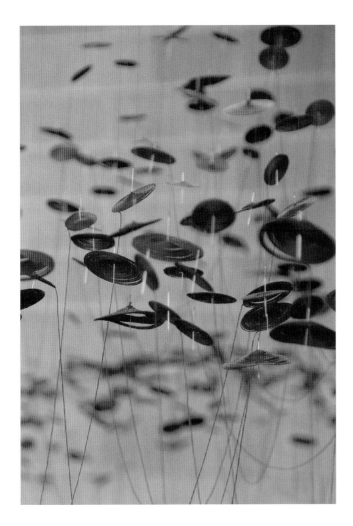

BELOW
Beili Liu. *Toil*, 2012. 2"–8" (each element).
Charred silk organza. Courtesy of Beili Liu.

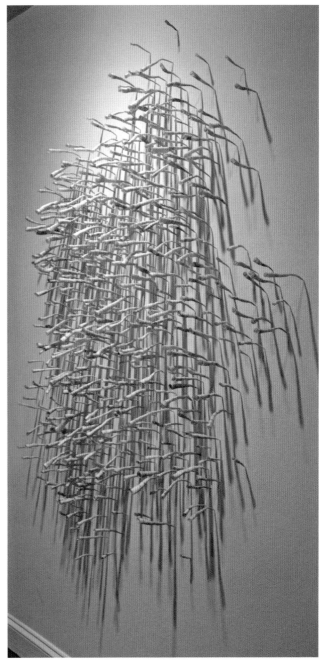

Above all, Liu is drawn to an experimental approach to her materials because it enables her to chance upon unexpected results, which she uses to inform the nature of her installations. She says, "During a first visit to a given space, I look at the structure and volume, then note the details: the mundane, the unusual, the light, temperature, sounds, the residue of memories, and the paths of those who have passed through it. I observe, stay alert to my responses, and then begin to envision the possibilities. Subsequently, I research the cultural and social history of the space. Once I begin the work, it is labor intensive, but I enjoy the long meditative process. I need the time to simply lose myself in the intuitive rhythms of my hands at work."

Liu finds that the themes of her work weave back and forth between cultural specificities and universal human desires. She explains, "My themes often touch upon the ideas of transience, fragility, and the passage of time. My work navigates two parallel paths: examining broad cultural narratives and my own personal history crossing the East–West cultural divide." These themes are never more apparent than in *Lure/Wave* and *Toil*.

Lizz Aston

Canada I www.lizzaston.com

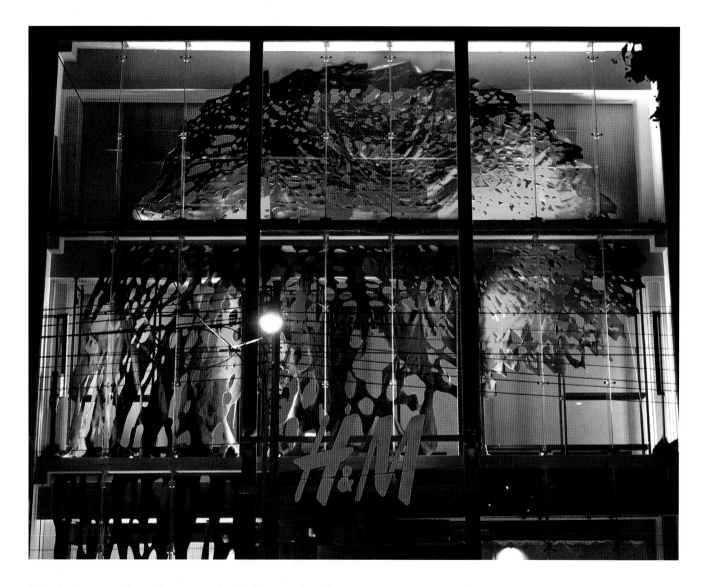

Lizz Aston remembers always wanting to be an artist. She was accepted into an art-based high school in Canada, then attended a craft and design college program in which she learned ways of thinking and working in three dimensions. She says, "I learned processes such as dye and print, knitting, crochet, weaving, papermaking, embroidery, and heat-setting, to name a few. They helped me understand how materials act and interact, and what their tolerances are. The program allowed me to take greater and greater risks as I began to work more sculpturally and explore my ideas on a much larger scale."

Lizz Aston. *Coalesce*, 2014.
55' × 44.9' × 1.9'. Discarded garments, canvas, hand-cut fusible interfacing. Courtesy of Lizz Aston.

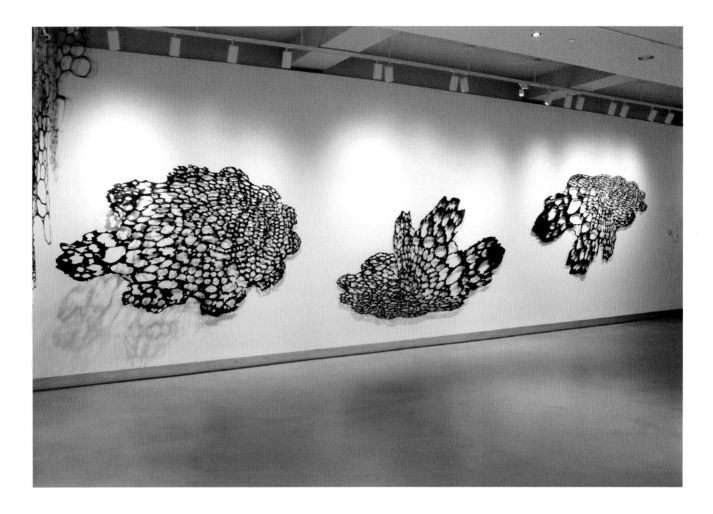

In general, this artist is interested in exploring how textiles trigger memories and associations. Aston explains, "By shifting traditional imagery and altering familiar forms—while also playing with material, scale, and context—I want to create new experiences for the viewer, whether it's on a delicate and intimate scale or an architectural and monumental scale."

Aston's installation *Coalesce* is a site-specific piece that explores the idea of the global exchange that takes place when garments are designed, manufactured, and purchased. She says, "Looking at lace as a metaphor for interconnectivity, this large installation transforms recycled materials into a monumental cascade of lacy fabric."

Lizz Aston. *Exploding Lace*, 2012.
10' × 26' × 1.9'. Hand-cut linen, fusible interfacing, fiber-reactive dyes. Courtesy of Lizz Aston.

The installation *Exploding Lace* is based on manipulated photographs of the artist's textile work taken by the artist. Aston explains, "With this work I am interested in expanding the textiles' patterns and forms. I deconstructed the original patterns in unexpected ways to create a three-dimensional, large-scale sculpture."

Barbara Shapiro

United States | www.Barbara-Shapiro.com

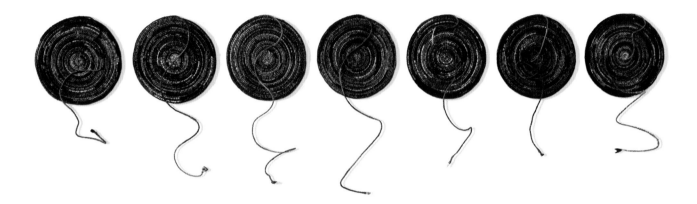

A textile artist for many decades, Barbara Shapiro grew up in a family of artists. Her mother was a painter and clay sculptor, and her grandmothers were seamstresses. She recalls, "I made textiles starting as a young girl in San Francisco, and first started weaving in 1975 in New York City. It was some time before I really considered myself an artist. The ability to express myself with textiles allowed me to accept myself as an artist."

Shapiro came to dimensional textile art after studying couture sewing in Switzerland during the 1960s. She says, "I started out weaving in New York and then created clothing, which is textiles in a three-dimensional format. During the 1980s, I shifted to woven artwork for the wall. Some of the pieces had a dimensional quality, with pleats bursting off the flat surface. I also made fabric kimono sculptures for a while and explored dimensional card weaving. Then, about sixteen years ago, I shifted my interest once again and delved into basketry. Both plaiting and coiling have allowed me to explore sculptural possibilities beyond the traditional basket format."

Themes that run through Shapiro's work include the passage of time and the persistence of friendship and love. She also notes, "The use of indigo is a theme, as well. The universality of this most amazing dye ties me to artisans across time and continents. That link ties us together as creative beings."

For her work *Testing Testing II*, Shapiro used test strips from twenty-five years of maintaining indigo vats. She says, "It includes seven coiled, recycled indigo cloth disks, each trailing its working element in a nod to dimensional technique. The installation speaks of the universality of indigo, with each disk enlivened by bits of multicolor fabrics that come from a particular part of the world where indigo has a presence. It also honors friendship; many of these bits were gleaned from the ragbags of willing friends."

ABOVE
Barbara Shapiro. *Testing Testing II*, 2013. 30" × 9' (installation view). Indigo-dyed test strips of cotton and linen, printed or woven fabric scraps from various countries, waxed linen thread, wired paper rush core. Courtesy of Barbara Shapiro.

OPPOSITE
Barbara Shapiro. *Testing Testing II*, 2013. Detail. Courtesy of Barbara Shapiro.

Rae Gold
United States

When she was a girl, Rae Gold was taught by her mother to knit, and by a neighbor to crochet, thus beginning her career in art. She went on to create one-of-a-kind wearables and was in business for thirty years. She says, "I always thought in three dimensions. Moving from producing clothing to creating felted sculpture seemed like a natural progression. With both, there's something exciting about working with texture and dimension."

Gold's sense of humor is evident with her sculpture *Witch*. She relates, "I love Halloween and it seemed like an appropriate name for this piece. It is one of my more complex forms." *Teapod* was created for a teapot gallery show. She created *Jester* "because the colors make me happy."

For *Dante*, Gold hoped to incorporate the elegance of the glass sculptures of Dante Marioni, whose elongated, sinuous shapes were made with bright and saturated colors. She explains, "I am actually collaborating with the Pittsburgh Glass Center in Pennsylvania for my next projects. They just

blew me three shapes that I'm hoping I will do justice to when I felt them."

Says Gold, "I simply want to make beautiful things. There is enough in the world that is disconcerting and upsetting, so I try to go the opposite way and create things that will hopefully make people smile."

ABOVE
Rae Gold. *Teapod*, 2015. 7" × 17" × 5". Wet hand-felted and hand-dyed Finnish, C-1 Pelsull, and/ or merino wool. Courtesy of Rae Gold.

OPPOSITE
Rae Gold. *Jester*, 2016. 22.5" × 7.5". Hand-felted and hand-dyed Finnish, C-1 Pelsull, and/or merino wool. Courtesy of Rae Gold.

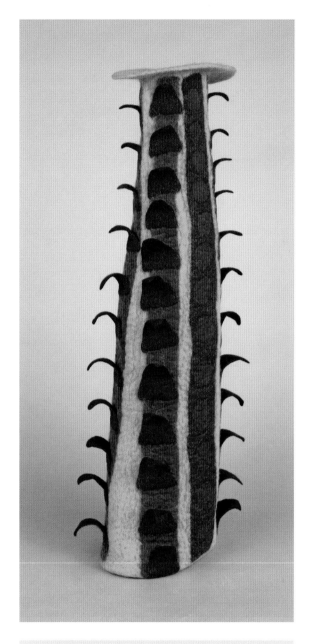

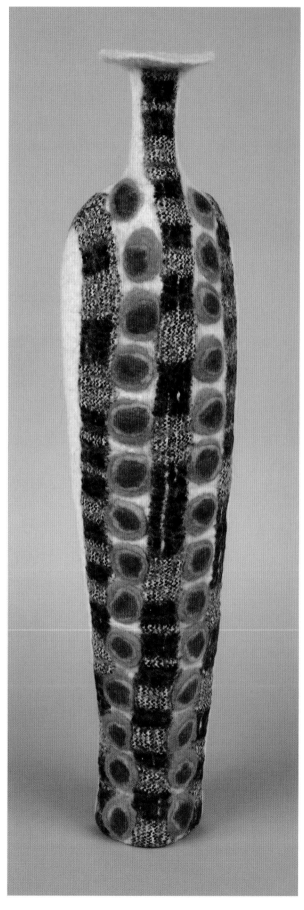

ABOVE
Rae Gold. *Jester*, 2016. 22.5" × 7.5".
Hand-felted and hand-dyed Finnish, C-1
Pelsull, and/or merino wool. Courtesy of
Rae Gold.

RIGHT
Rae Gold. *Dante*, 2015. 21" × 17". Hand-felted
and hand-dyed Finnish, C-1 Pelsull, and/or
merino wool. Courtesy of Rae Gold.

Kimberly Warner

United States | www.kimberlywarner.com

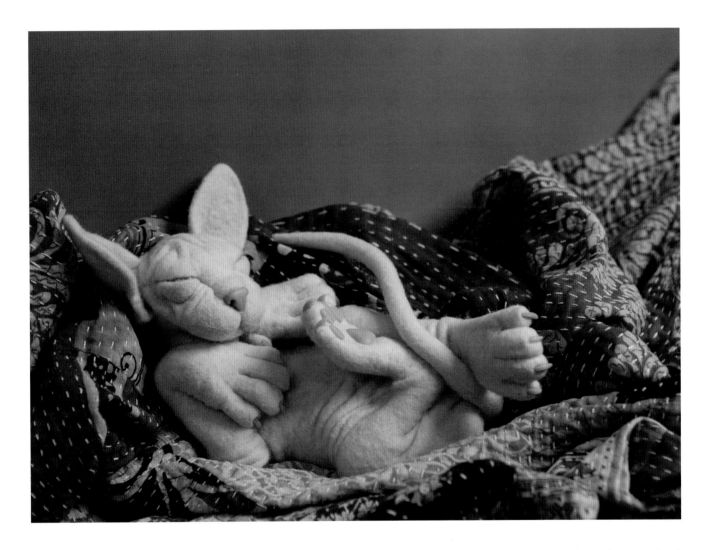

Kimberly Warner's mother was an enthusiastic potter when Kimberly was a girl, and she encouraged her daughter to join her. However, being an artist was never a true vocational option for Warner. She says, "I grew up in a family oriented toward wellness and medicine, so I pursued that path as well."

When Warner was thirty and in the middle of pursuing a career in acupuncture and Chinese herbology, she woke up one morning in the hospital after an adverse reaction to a medication. She recalls, "It was very scary and I knew I had

to change paths and pursue my passion: photography. I dropped out of school, picked up a camera, and taught myself photography and filmmaking. I never looked back."

Kimberly Warner. *UV Rex II,* 2016. 3" × 8" × 4.5". Wool batting. Courtesy of Kimberly Warner.

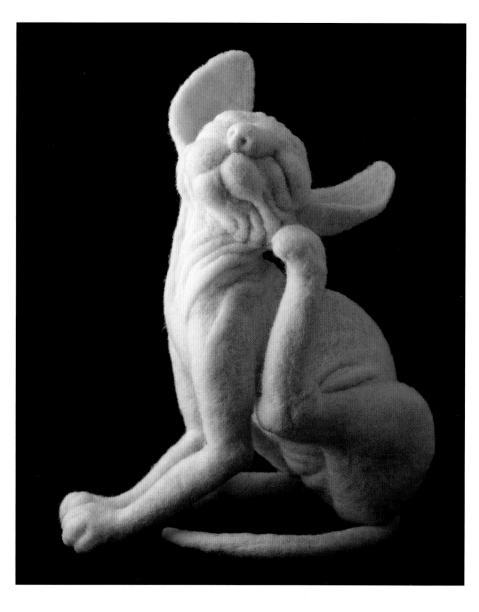

Kimberly Warner.
UV Rex III, 2016.
9" × 7" × 4". Wool batting.
Courtesy of Kimberly
Warner.

Working in a photography studio, Warner quickly realized she felt at ease. She remembers, "I started out shooting mostly fashion, but my heart was drawn to the spontaneity and vulnerability of street photography. I began to write screenplays, which eventually led me to my current career as a filmmaker."

However, Warner was in a bicycle accident, sustained a fractured pelvis, and needed two months of bed rest to heal. She explains, "I was just beginning to get back on my feet when I developed chronic vertigo. I found the only way to take my mind off the wobbling room was a technique I'd recently taken up: needle-felting wool. I devoted thousands of hours to it. These days I look back at that strange chapter of my life with great gratitude for having discovered that art form. Shaping a three-dimensional structure, especially something soft and tactile, touched a primal part of my nervous system and brought me a sense of peace. And although it appears that I have completely jumped ship from a healing profession, I believe—and continue to explore—the possibility that artistic expression can be profoundly transformative and healing."

Warner tells us, "My *UV Rex Hairless Cat* series, with their skinny limbs and exposed curves, expresses the vulnerability and raw, fragile aliveness I felt while recuperating. I love how their awkward, honest shapes hint at the truth of who we all are, especially when our 'protective fur' has fallen away." In *UV Rex II* and *UV Rex III* she used wool batting; polymer clay for noses, eyes, and claws; and a few pieces of stiff copper wire for limb support when necessary. She says, "The rest involves hundreds of hours of rolling, folding, needling, and shaping the wool."

Cathy Jack Coupland

Australia | www.cathyjackcoupland.com

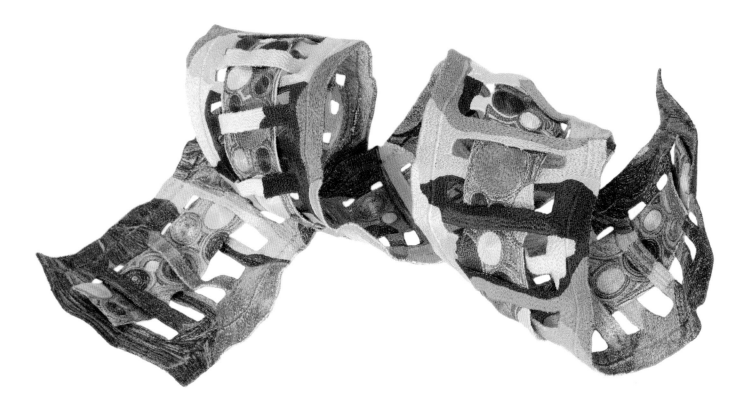

Cathy Coupland was introduced to sewing by her mother, a knitter and sewer. She became serious about her art about six years ago, after she retired from administrative work and began to focus on the embroidery techniques she learned in a master class offered by Alice Kettle of the United Kingdom. Today, Coupland stitches daily, using free-form embroidery to create her designs. She says, "There is a great sense of well-being and achievement in designing, then making a piece of artwork that you love. I don't always have success, but I just keep working."

Coupland enjoys exploring color and dimensionality. She notes, "Being able to walk around a piece of art is my inspiration. And I adore working with color and really pushing color combinations."

Cathy Jack Coupland. *The Wave*, 2014. 5.9" × 3.8'. Acrylic felt, cotton, rayon and polyester thread, beading wire. Courtesy of Cathy Jack Coupland. Photography: Julie Gianotis.

For her work *The Wave*, she explains, "I really wanted to show that quilts could be different; they could be more than wall-hangings. The idea behind the work was my response to Australia's fabulous beaches. The shape evokes the rolling waves. The cutout areas represent the sun bouncing off the water. I used a color palette that reflects the cool water and warm sunshine."

CHAPTER FOUR
TELLING A STORY

Although we are all part of our families and communities, we are also very much alone and isolated psychologically. This is not necessarily a bad thing. Everyone, at times, experiences great wonder and happiness, satisfaction and pride. We might find even greater happiness sharing those pleasurable experiences, but we certainly may choose to bask in good feelings by ourselves for a while before doing so. Yet, also, we all know suffering and heartache, and those emotions can be harder to bear in isolation. Whether joy or sorrow, humans seem to want to—or need to—communicate their feelings, to tell the stories of their lives to others, perhaps as a form of recognition, validation, or connection. We have the urge to prove to ourselves we are not alone.

For artists who embed stories in their work, art is not so much a way to deliver information, but rather an expression of the psychological facets of their lives. It is a subtle bearing of the soul, a covert act of intimacy. Using colors, textures, and shapes, one artist, for example, tells us about the loss of a loved one, another about her deeply felt reaction to a scene in nature that she once witnessed. The actual facts may not be readily accessible to viewers; nevertheless, for those viewers, a doorway has been opened into another's psyche. If the viewers are at first surprised, confused, or bewildered, then the artist has succeeded in pulling them through.

Leisa Rich
United States | www.monaleisa.com

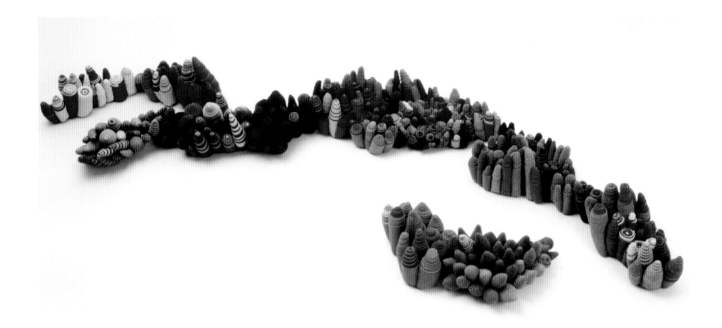

With her mother's help, Leisa Rich learned how to sew at age eleven. At age fifteen, she took her first weaving class. At that point she was "immediately enamored of its tactility. I found a bliss I had not known existed—a quiet meditative state. Then came the excitement of realizing a vision, of seeing how the ideas in my head could come to life! Art chose me."

The artist went on to earn bachelor's degrees in fine arts and art education, as well as a master's degree in fibers. Her career has spanned international fashion design and set design, and she developed and ran a wearable art business. In addition to exhibiting and selling her art worldwide, Rich currently teaches art, and writes for local and national art publications.

She remembers spending time in 1976 with famous dimensional fabric artist Magdalena Abakanowicz. Rich also owns an original copy of Abakanowicz's book *Beyond Craft* (New York: Kodansha USA, 1986), which some say is the most influential book on fiber art. Like

TOP
Leisa Rich. *Rhodocrosite*, 2007. 28" × 120" × 10". Wool, dye. Courtesy of Leisa Rich. Photography: Jonathan Reynolds.

ABOVE
Leisa Rich. *Rhodocrosite*, 2007. Detail. Courtesy of Leisa Rich. Photography: Jonathan Reynolds.

Abakanowicz, Rich's work always contains conceptual content. She says, "It may be of a personal nature or it may be a statement that addresses social concerns and topics of interest to me. My love of nature runs through my work, but it is nature reflected through my eyes."

For example, as a young girl, Rich owned a rock collection and loved going to museums that featured rocks and minerals. She notes, "I'm absolutely spellbound and in awe when I am surrounded by their extraordinary beauty. My piece *Rhodocrosite* is a fabric interpretation of that mineral. I didn't want to imitate it, but, rather, intimate it."

LEFT
Leisa Rich. *Hive Mind*, 2013. 38" × 30" × 24".
Industrial felt, dye, embroidery floss, Fosshape, resin, rubber, mixed media. Courtesy of Leisa Rich.

TOP
Leisa Rich. *Hive Mind*, 2013. Detail 1.
Courtesy of Leisa Rich.

ABOVE
Leisa Rich. *Hive Mind*, 2013. Detail 2.
Courtesy of Leisa Rich.

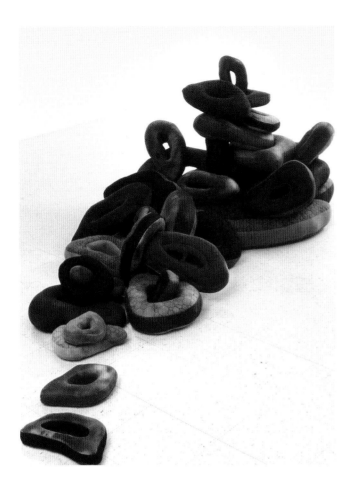

LEFT
Leisa Rich. *From the Ground Up*, 2006.
36" × 36" × 108" (indoor installation). Wool, thread.
Courtesy of Leisa Rich. Photography: David Wharton.

BELOW
Leisa Rich. *From the Ground Up*, 2006–2015.
36" × 36" × 108" (outdoor installation). Wool, thread.
Courtesy of Leisa Rich.

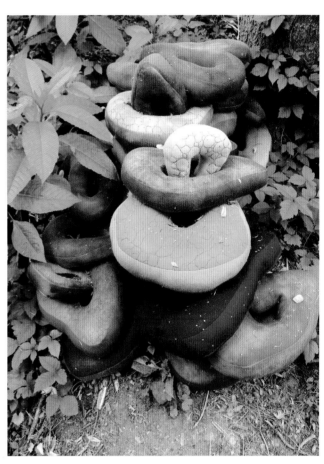

For *Rhodocrosite*, the artist rolled and sewed hand-dyed wool. She recalls, "At the time, I was exploring this rolled format and wanted to create a cluster of bright reds that seemed to glow to simulate the feeling I get when I see rhodocrosite."

Hive Mind addresses the collective unconscious. Rich explains, "This piece is about how it takes a 'village to raise a child,' or to assist a mother with dementia, and the importance of nurturing Earth and banding together for the greater good. The 'birch' teepee, made of hand-dyed felt, is a nod to my Canadian heritage in the form of native shelter. Inside is a hivelike nest that holds my mother's fleeting memory—in the form of small, cast brains that glow. The nest also references our fast-disappearing bees. We must care for all."

For the "brains" in *Hive Mind*, Rich used cast resin and rubber. She says, "I wanted them to glow with natural light, simulating the illumination others provide to light the path that those who can no longer navigate on their own need in order to continue their journey through life. To create the hive, I used Fosshape, a wonderful product that hardens with heat and steam."

Rich didn't originally intend for *From the Ground Up* to be an outdoor installation, but when an opportunity became available to take it out of a gallery and into nature, she took it. She recalls, "A nature preserve near my home hosted an art competition and I'd longed to put this sculpture into nature, so I submitted it. Although it was hard to see it disintegrate, it was very satisfying to document the worms and insects that insinuated themselves into the batting that was stuffed into each piece of the sculpture. The mold became new textures and painterly surfaces, and a scattering of woodland creatures rooted into it."

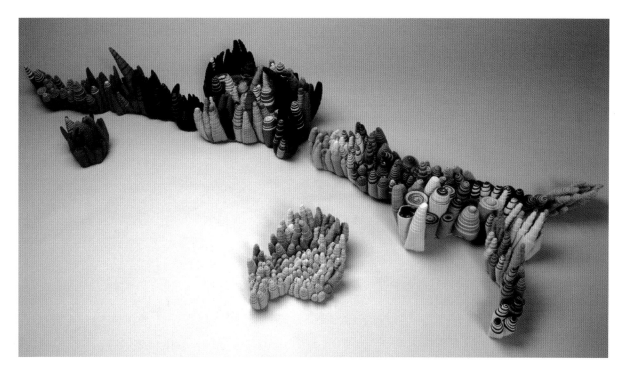

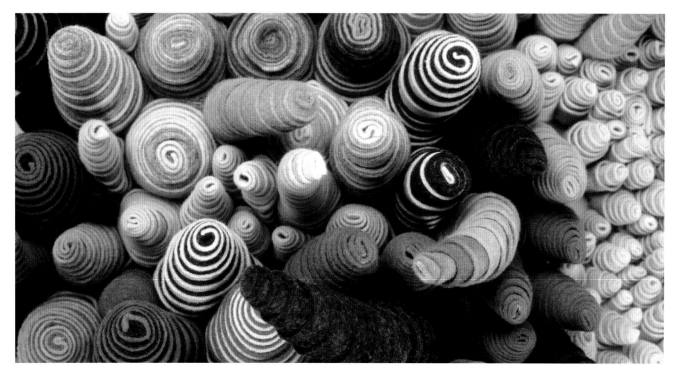

Leisa Rich. *Liquid Force*, 2016.
60" × 48" × 4". Wool, dye, thread.
Courtesy of Leisa Rich.

Leisa Rich. *Liquid Force*, 2016. Detail.
Courtesy of Leisa Rich.

Rich constructed *Liquid Force* of multiples that reference biological systems. She says, "*Liquid Force* hints at the different types of movement that can be seen in different bodies of water such as rivers, lakes, oceans, creeks, and streams. The colors of the piece appear to change depending on the light and the position in which it is hung. Hand-dyed wool, tightly wrapped into conical shapes, were hand-sewn together, and the piece was intended to cascade down a wall or undulate over an organic surface."

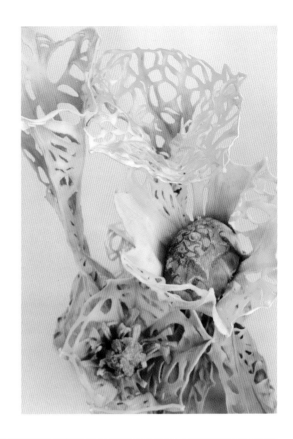

For *Put the Lime in the Lemon*, the artist continued to experiment with Fosshape. She explains, "I wanted to see how big I can make pieces with it. I am presently creating massive sculptures that people can walk through. I'm also trying out a variety of dyes and paints and achieving really vibrant colors."

Pushing through many medical hardships, including deafness from early childhood and paralysis in adulthood after a truck plowed into her car, Rich views life's challenges as avenues for self-discovery. Her stunning and dramatic work flows from her ceaseless determination to bring to light her thoughts about the pressing concerns of the day as well as her feelings about surviving in a harsh world.

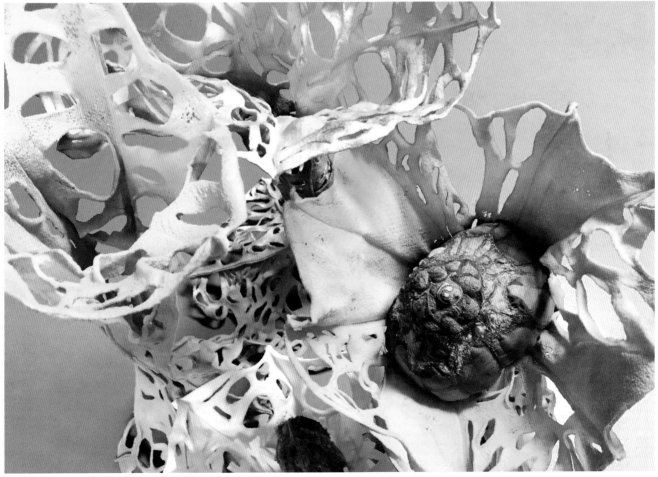

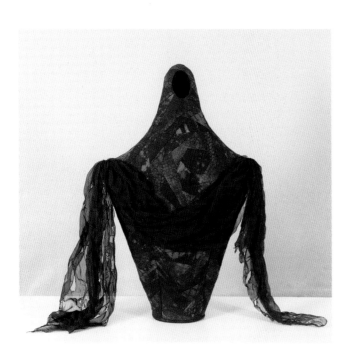

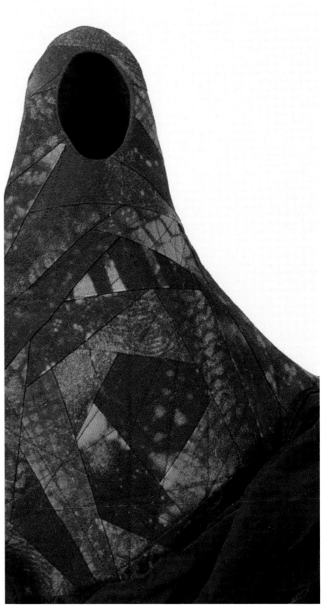

A textile artist, Linda Witte Henke remembers making her first "sculpture" when she was six years old. She tried to fashion a scrap of cotton, including a dart, into a bra. A few years later, she began making clothes for herself; in college, she created several dimensional installations. In seminary, she used textile art to create vestments for herself and classmates. After several years of service as a parish pastor, Henke cultivated a career as an artist specializing in commissioned projects for liturgical use, such as vestments and space installations. At the same time, she began experimenting with dimensional art.

Because there were few resources available on the subject of three-dimensional cloth art, Henke expanded her research to include sculpture, architecture, origami (the Japanese art of folding paper), and kirigami (the Japanese art of folding and cutting paper), pop-up-form and slice-form construction, packaging design, handmade book construction, coiling, and doll-making. She recalls, "Sometimes I'd check out so many books from the library, I'd have to carry them to the car in multiple trips."

ABOVE LEFT
Linda Witte Henke. *Pieta II*, 2006. 17" × 25" × 6".
Discharged black rayon fabric, burned synthetic organza, black cotton, heavy-duty synthetic stabilizer, miscellaneous threads. Courtesy of Linda Witte Henke.

ABOVE
Linda Witte Henke. *Pieta II*, 2006. Detail.
Courtesy of Linda Witte Henke.

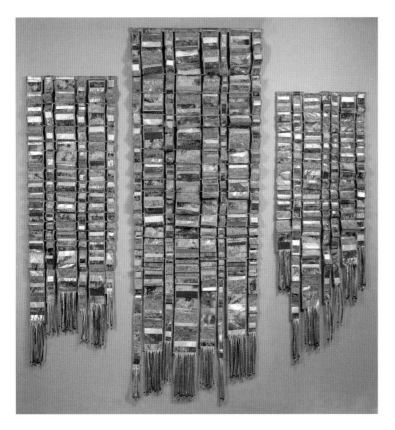

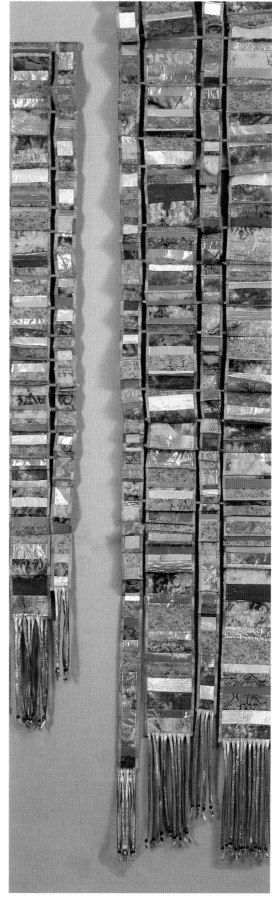

Henke's first successful three-dimensional cloth sculptures were
abstracted depictions of women in the Bible. *Pieta II*, comprised of
varying shades of black fabric, shows a grieving, spectral figure of
Mary, her arms open to carry a shroud, representing her son. It pos-
sesses an unmistakable monumental presence.

This artist also finds expression in large-scale works, such as *Let
Justice Roll*, a sculpture for a stairwell off a congregation's primary
worship space. Henke notes, "The congregation's commitment to
ministries of peace and justice helped define this piece. It brought to
mind the words of an ancient prophet whose expressions of longing
still resonate today: 'let justice roll down like water and righteousness
like an ever-flowing stream.' This, and the idea of creating a bright
light washing over the piece sparked the idea of a three-dimensional
waterfall from rich hand-dyed and commercial fabric interspersed
with jewel-tone metallic lamé."

Tina Maier
United States | www.tinamaier.com

An artist with a killer sense of humor and a penchant for storytelling, Tina Maier learned to sew from her mother and experimented with a variety of techniques including tie-dying, brass jewelry design, and basketry weaving, taught by the commune in which she lived during the 1960s. An out-of-print book, *Church of the Earth* by Robert S. de Ropp (New York: Delacorte Press, 1974), describes the commune, which disbanded during the '70s. Maier says, "This group was a creative bunch looking to do its own thing and defy the rules and conformity of the rest of society."

The artist went on to pursue a career in theater arts while raising her three children, supplementing her income by sewing for clients. Later, she returned to college and earned a master's degree in marriage, family, and child therapy, and is accredited in school counseling. This new career enabled her to continue to explore her artistic endeavors, and after her children grew up, she was able to focus more of her time on her art.

When Maier realized that clothing construction was a form of sculpture and that she could compose sculpture from fabric if she used wire supports, she turned her focus to dimensional cloth art. She began entering her work in shows and competitions, and found that many venues did not allow fabric-based pieces. She understood then that there still remains a bias against fabric art. For example, if her work was

Tina Maier. *Marshmallow Demon*, 2015.
39" × 17" × 10". Repurposed upholstery fabric (from FabMO, California, a company that rescues interior decorator textile samples from landfills), wire, marshmallows, found object base (vintage marshmallow tin). Courtesy of Tina Maier.
Photography: Don Felton.

accepted for exhibit, she found jurors judged it by quilting standards and ultimately rejected it. She recalls, "My work was rejected for being too traditional or not traditional enough. I've dreamed of quilting an autopsy scene and entering it in a state fair just to watch those jurors' heads explode—and then quilting that, too."

It might be fair to say that Maier approaches her work as a kind of diviner, a telepath who seeks to find the spirit within objects she finds, which she then incorporates into her sculptures. She notes, "I seek to find that spirit and give it life. With *Marshmallow Demon*, for instance, I felt like I finally set free an angry spirit who had been held hostage inside a tin of marshmallows since the 1930s. Now he's free and sends his regards."

Tina Maier. *B-Girl*, 2015. 24" × 24" × 23". Repurposed fabric (from FabMO, California, a company that rescues interior decorator textile samples from landfills), 1950s movie posters transferred onto fabric, 35-mm film, wire, found object (vintage film can). Courtesy of Tina Maier. Photography: Don Felton.

Marshmallow Demon is made of upholstery samples that have been cut, linked, and stitched together, producing long chains of fabric that were then wrapped around foam-board support rings attached to an old gooseneck microphone. The crown holds a painted foam ball to which roasted marshmallows have been attached; the marshmallows were dipped in glue, painted to look fiery, and sealed with clear resin.

For *B-Girl*, Maier says, "I cherish bad movies from the 1950s. They're so bad, they're good. When I found an old film can that had long acquired a beautiful brown patina, I imagined the spirit of a young actress trapped inside. She'd once had dreams of being a Hollywood star only to find herself objectified again and again in bad B films. Her youthful face is wistful, sad; she's had a disappointing life and perhaps she ended it by her own hand."

For *B-Girl*, Tina transferred old film posters onto fabric using an inkjet printer, then cut the fabric into shapes and sewed them onto black backing fabric. The body parts were wired using 15-gauge black wire, and the hair was made of leftover sheer drapery fabric sewed on to light wire. A piece of a 35-millimeter 1960s exploitation film depicting a woman being manhandled was woven loosely into the piece as well as an audition clip of Drew Barrymore. The sculpture sits on fabric so that it appears as if B-Girl is emerging from the film can.

Regarding *Sieve Amour*, Maier explains, "I purchased a beautiful old sieve at a junk shop and immediately imagined the sieve-imprisoned spirits of two lovers quickly embracing before their boss, the chef, came back from his cigarette break. I found the mate to the first sieve on the Internet. When I set the spirits free, they emerged with pointed heads after having lived so long in the sieves."

Tina notes, "Even though my family thinks my work is weird, my ideas are endless and I'm having a blast."

Tina Maier. *Sieve Amour*, 2016. 35" × 27" × 23". Repurposed upholstery and leather samples (from FabMO, California, a company that rescues interior decorator textile samples from landfills), wire, found objects (vintage canning sieves). Photography: Don Felton.

Susan Else
United States | www.susanelse.com

Susan Else's mother, a professional sculptor, taught her how to sew. Susan also learned to weave and later attended workshops in traditional quilting and art quilting. She says, "The surfaces of my pieces are all based on this kind of work. I primarily use free-motion stitched collage and quilting techniques. The substructures vary greatly from piece to piece depending on what I'm trying to represent, how strong the base needs to be, and whether the piece is mechanized. I'm entirely self-taught in terms of armature creation and attaching the surfaces to them. I collaborate with carpenters, metalworkers, and engineers when I need expertise outside my own skill set."

Else turned to three-dimensional work because, "I think I just got bored with two-dimensional work, the flat surface. I had to feel my way. I used to say it felt like swimming through rocks. I went by my intuition." Her first sculptures were cloth figures and she soon discovered that fabric sculpture had an unforeseen capacity for narrative. She notes, "This changed the work entirely, making it all about relationships, gestures, and the interaction between figures. I started telling stories with my work, and I discovered that viewers responded to it."

Many of Else's ideas for sculptures reflect actual experiences of hers or surreal riffs on those experiences. She says, "The theme that runs through all of my work is one of conflation—the merging of the wonder, beauty, tragedy, and misery of life into a single image that leads the viewer to divergent responses. The colored and patterned surfaces I use, in particular, tend to transport the pieces to an alternative universe: believable but not realistic."

ABOVE RIGHT
Susan Else. *Nothing to Fear*, 2008. 49" × 30" × 27". Collaged and quilted cloth over commercial plastic skeleton. Courtesy of Susan Else. Photography: Marty McGillivray.

RIGHT
Susan Else. *Nothing to Fear*, 2008. Detail 1. Courtesy of Susan Else. Photography: Marty McGillivray.

A great example of this is *Nothing to Fear*, one of a series of fabric-covered skeletons. Else explains, "This group represents the opposites we live with—joy and grief, skin and bones, the fleeting moment and the ultimate end. In this particular piece, the festive surface, covered with images of thriving plants, and the benign pose are welcoming, but the skeleton is also a frightening image of mortality." For this series, which also includes *Forever Yours*, *Family Life*, and *Dog Years*, Else purchased commercial plastic skeletons from a Halloween store. She recalls, "I took them apart, made a machine-quilted collage for each bone, and then hand-sewed each collage to its bone, taking tucks to make the flat surface hug the bumpy armature. Then, I sewed the bones back together in the pose I wanted, adding reinforcement when necessary."

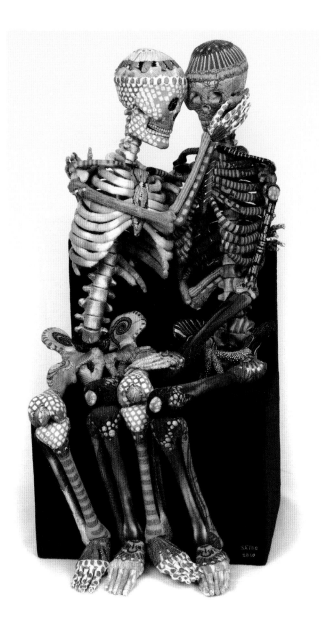

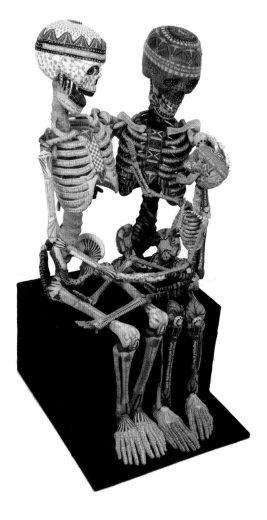

LEFT
Susan Else. *Family Life*, 2014. 38" × 20" × 20". Collaged and quilted cloth, commercial plastic skeletons. Courtesy of Susan Else. Photography: Marty McGillivray.

ABOVE
Susan Else. *Forever Yours*, 2010. 25" × 13" × 17". Collaged and quilted cloth, commercial plastic skeletons. Courtesy of Susan Else. Photography: Marty McGillivray.

OPPOSITE LEFT
Susan Else. *Dog Years*, 2015. 33" × 33" × 6". Collaged and quilted cloth, commercial plastic skeleton, tennis ball. Courtesy of Susan Else. Photography: Marty McGillivray.

Else's *Is There Any Hot Water?* was meant as a commemorative piece honoring an annual week-long quilting retreat she's been attending for years. She says, "Because it takes place in a converted army barracks, 'Is there any hot water?' is a frequently asked question in the mornings. I had great fun creating the facilities out of cloth, and the shower heads are made of thimbles. More of a joke than social commentary, I made this piece to evoke a shared experience with my fellow campers."

The architectural elements of *Is There Any Hot Water?* are constructed of polyethylene foam and plastic board covered with quilted fabric sleeves that are sewn together. For the figures, the individual body parts were cut, machine-sewn, stuffed, and hand-sewn together. "The gestures that bring the action to life were added as the last part of the process."

ABOVE
Susan Else. *Is There Any Hot Water?*, 2010. 18" × 18" × 6".
Collaged and quilted cloth, armature, wire, thimbles.
Courtesy of Susan Else. Photography: Marty McGillivray.

A recent sculpture, *Crossing Points*, was created partly in response to a call for entry on the theme of Diaspora. Else explains, "Envisioned originally as a large snarled knot made up of figures fighting, in two different colorways, the piece eventually became two lines of figures finally hitting the 'crossing point' of all-out war. The cracked-earth pattern of the ground beneath them reflects an increasing scarcity of resources (from green to brown) and eventually an inability to coexist (red). Refugees flee the conflict, heading for the literal 'crossing points' of the border. This piece does not represent one particular conflict, but includes the hallmarks of civil conflicts around the world. It was eerie to work on it because the current refugee crisis made it more relevant by the day." She adds, "Ironically, the colored cloth makes the image quite beautiful. Cloth is such a domestic, comfortable, and engaging medium that it can be used to snare the viewer into considering an otherwise difficult topic. I call this *stealth art*. I've heard people say, 'Oh, what cute figures!' and then, 'My God! They're killing each other!'"

Susan Else. *Crossing Points*, 2015. 47" × 47" × 12.5". Collaged and quilted cloth over armature. Courtesy of Susan Else. Photography: Marty McGillivray.

Roxanne Lasky

United States | www.roxannelasky.com

Taught to knit and sew by her mother, Roxanne Lasky has been steeped in art since early childhood. She recalls, "I was surrounded by creative people who loved working with their hands. My paternal grandfather was an ornamental bricklayer who participated in the construction of many buildings in New York City. My mother was a postwar housewife who beaded gowns as a part-time job. Her mother, my grandmother, was a masterful crochet artist."

As a teen, Lasky pursued embroidery and went on to study fine arts, including painting and sculpting, in both college and graduate school. She learned quilting and clothing construction by taking courses at local establishments and by reading. She ultimately opened a fabric shop and taught art, hoping to share her passion for textiles with others. She says, "There was no real decision to become an artist, simply a need to find expression through art. I consider myself a mixed-media fiber artist, with my work falling into the classification of 'slow stitching.' That means that I'm process oriented and enjoy the meditative quality of sewing, with the intent of letting a project unfold organically."

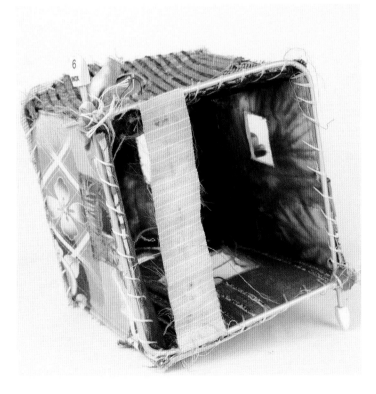

ABOVE RIGHT
Roxanne Lasky. *Word House: Persist*, 2006.
6" × 6" × 9". New and recycled silk,
deconstructed fabric, vintage upholstery tassels,
lace, buttons, beads, recycled woven place mat,
knitting needles. Courtesy of Roxanne Lasky.

RIGHT
Roxanne Lasky. *Word House: Persist*, 2006.
Interior. Courtesy of Roxanne Lasky.

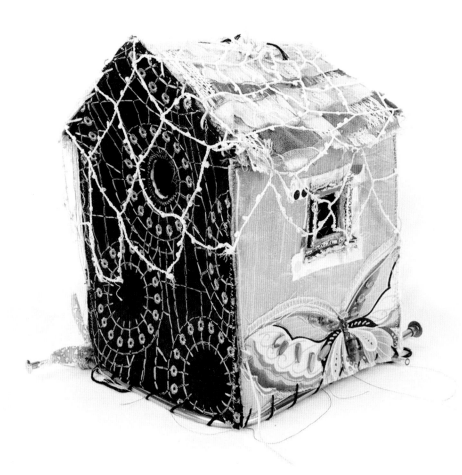

An important goal of Lasky's is to empower other artists to be independent problem solvers because she, herself, sees the benefit of discovering solutions to compositional challenges. She explains, "Fortunately, I'm good at figuring out how to engineer solutions, sometimes developing ideas with materials not generally used for my intended purpose. For example, the knitting needles I bend as a support for my house structures took several attempts and trips to the hardware store."

ABOVE
Roxanne Lasky. *Word House: Dance*, 2007.
6" × 6" × 9". Recycled machine-embroidered skirt fabric; vintage apron; dupioni silk; vintage, hand-crocheted haberdashery net; commercial print fabric appliqués; glass beads; buttons; knitting needles. Courtesy of Roxanne Lasky.

RIGHT
Roxanne Lasky. *Word House: Dance*, 2007.
Side view. Courtesy of Roxanne Lasky.

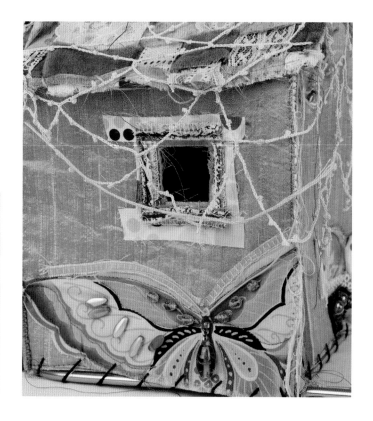

Lasky's work is in keeping with her desire to transform images of pain and trauma into objects of beauty. She says, "As someone sensitized to the plight of the oppressed, I rely on my own history to chart a universal message in my work. I focus on the house, because a home is a sanctuary and a refuge. My *Word Houses* series represent vessels for gathering healing energy. To start one, I find a word that inspires me, or I might be inspired by the materials and processes I use. I attempt to offer a sense of hope and encouragement through these sculptures."

Persist was created out of new and recycled silk, deconstructed fabric, vintage upholstery tassels, lace, buttons, a recycled woven placemat, and knitting needles. Lasky tells us, "My message with this house is to focus on your goals and move toward them with intention."

The artist composed *Dance* using recycled machine-embroidered skirt fabric; a vintage apron; a vintage, hand-crocheted haberdashery net; and glass beads, among others. Lasky explains, "My message with this piece is to be grateful and to celebrate."

Roxanne combined recycled and new hand-dyed cotton, Japanese wovens, Indian wovens, vintage lace, birthday ephemera, and zippers for *Climb*. Her message with this *Word House* is to "take the direction necessary to sustain your passion."

ABOVE RIGHT
Roxanne Lasky. *Word House: Climb*, 2016. 6" × 6" × 9". Recycled and new hand-dyed cotton, Japanese wovens and prints, Indian wovens, vintage lace, repurposed quilt piecing, stabilizer, vintage buttons, vintage knitting needles, zippers, glass beading, birthday ephemera, wire. Courtesy of Roxanne Lasky.

RIGHT
Roxanne Lasky. *Word House: Climb*, 2016. Side view. Courtesy of Roxanne Lasky.

Marianne Penberthy
Australia | www.mariannepenberthy.com

Marianne Penberthy. *Ferrous Solution,* 2013.
1.9' × 1.6' × 2.3". Salvaged woolen blankets, cotton,
cotton thread, iron sulfate dye, corrugated iron.
Courtesy of Marianne Penberthy. Photography:
Karl Monaghan.

From the time she was a child, Marianne Penberthy has loved making things. "I loved making something out of nothing. Making became a form of therapy and helped me to build self-confidence. My journey began as a self-taught potter and basketmaker in my early thirties. I formalized my career when I was forty by attending art school and university. I found that communicating through art was more comfortable than speaking or writing."

Penberthy strongly believes her artwork is related to the feminist movement of the 1970s, especially its fight against the notion that fiber art is not true art. She says, "I remember Judy Chicago's powerful *Birth* embroideries. Seeing those birthing images and references to earth-based spirituality, the power of female energy, was very influential. Choosing to work with stitch and fabric connects me to that earlier movement."

This artist's first three-dimensional work included paper and was an installation related to her connection to her childhood home. She recalls, "The work consisted of fifty-seven shoeboxes made of tracing paper. Each box was dyed with indigo and other natural dyes, and then machine-embroidered with stream-of-consciousness writing. The coffin-esque nature of the installation related to my father's death. This piece marked a transition to textiles as my primary medium."

As a textile artist today, Penberthy says she searches for a way to convey her responses to her natural surroundings. She explains, "My quest includes ideas about place, time, memory, and feelings. I work with shibori, quilting, and bojagi (traditional Korean wrapping cloth). Increasingly, I have been exploring issues related to isolation, particularly women in isolation. I want to explore my own sense of belonging to and connecting with a place. Through this process, my cultural identity relating to the postcolonial history of Australia is gradually rising to the surface."

Penberthy's piece *Ferrous Solution* consists of old blanket remnants machine-stitched together in layers, then rolled and hand-quilted into shape. The wool has been created using the dye-resist technique, shibori, then dyed in rust and tannin solutions. Woolen cores were placed in the grooves of a found piece of semirusted corrugated iron. Penberthy says, "In Western Australia, there is a rich iron ore mining industry, often located in remote areas. In order to develop these mines, workers are flown in and out of the area in a rotation system. This means workers are separated from their families and friends, often for long periods. There is no permanent community in the mining camps. My partner worked in this field for many years. This piece represents extraction, excavation, isolation, separation, and relocation."

Another of her sculptures, *Core Beliefs*, also consists of old blanket remnants machine-stitched together, rolled, and hand-stitched into shape. Penberthy explains, "I have always been interested in the idea of my own inner core beliefs and how they are often hard to change. This installation of forty-two core samples is an exploration of how sediment, rock, and minerals are laid down over time, just as belief systems lie in the subconscious layers of the mind. Mining the earth or mining the mind both require great respect and care."

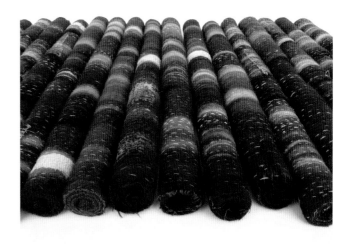

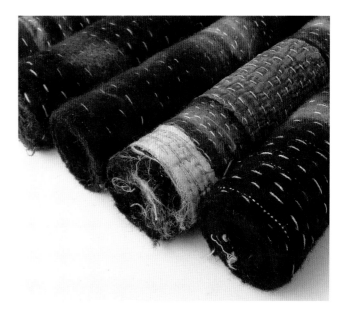

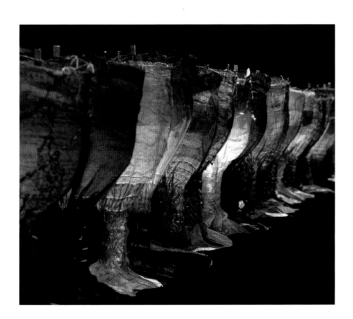

TOP
Marianne Penberthy. *Core Beliefs*, 2012.
2.2' × 1.6' × 1.3". Salvaged woolen blanket, cotton, cotton thread. Courtesy of Marianne Penberthy. Photography: James Thompson.

ABOVE
Marianne Penberthy. *Core Beliefs*, 2012. Detail. Courtesy of Marianne Penberthy. Photography: James Thompson.

LEFT
Marianne Penberthy. *A Still Life Now Breathing*, 2012. 3.1" × 7" (each, twenty-four textile goblets, installation variable). Silk organza, acid dye, printed maps, photographs, words. Courtesy of Marianne Penberthy. Photography: James Thompson.

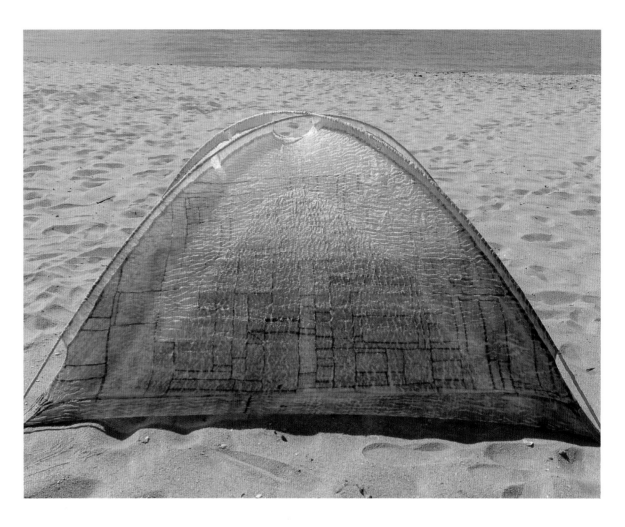

A Still Life Now Breathing is an installation that consists of twenty-four silk organza goblets. She tells us, "The goblets have a variety of images printed onto their surfaces, including early eighteenth-century Dutch maps depicting the rim of the Indian Ocean and the Western Australia coastline, personal photographs, and printed writing. The piece refers to early European navigation, shipwrecks, and a personal memory of seeing a 300-year-old undamaged drinking glass that divers had found at an underwater wreck site. I was amazed at how such a fragile object survived in the wild ocean for three centuries. For me, this points to the original contact between indigenous people and Europeans, a significant marker in our history."

Longing and Belonging is a life-size tent for two people, hand-pieced from intricately dyed silk organza fragments. It has a silk organza floor and non-functional door. Marianne says, "I chose the tent shape to represent the mobile nature of my life in different parts of Australia and the transient nature of life itself. The shape of the door and the tent itself echoes the powerful mountainous landscape of my childhood."

TOP
Marianne Penberthy. *Longing and Belonging*, 2003. 6.5' × 6.5' × 3.6'. Silk organza, indigo dye, metal poles, thread. Courtesy of Marianne Penberthy.

ABOVE
Marianne Penberthy. *Longing and Belonging*, 2003. Detail. Courtesy of Marianne Penberthy.

Naomi Weidner

United States

Naomi Weidner has been sewing for years—her own clothes and home décor—and pursued photography as well. After she retired, she became interested in creating art quilts. From there, she developed three-dimensional boxes she calls *shrines*. She explains, "They were inspired by Mexican shrines. I made my first one a few years ago, after a friend had died suddenly. These days I give them to friends for special occasions with the hope they will afford the recipient good health and protection from harm."

For her work, Weidner hopes "to convey a feeling of the sacredness of nature, and to create an awareness in the viewer that nature is precious and we must protect it."

With *No Place Like Home II*, for instance, she wanted to convey the insignificance she felt when the US spaceship *Apollo 8* passed behind the moon and traveled where no human had gone previously. She says, "When the ship emerged from the back of the moon, the astronauts saw Earth, 234,000 miles away, floating in space. The images they captured changed the way we view our home. For the first time, we saw ourselves living on a small and very finite planet in a vast universe—an oasis of life in the dark and cold of space."

To construct *No Place Like Home II*, Weidner created a small box with doors, using a stiffening product layered between cloth. She then painted the image of Earth on a separate piece of fabric and attached it. Inside, she depicted Grand Teton mountain and the Snake River using commercial hand-dyed fabric.

Naomi Weidner. *No Place Like Home II*, 2011.
12" × 17". Commercial cotton, stiff interfacing,
fabric paint, cotton and rayon thread, magnet.
Courtesy of Naomi Weidner.

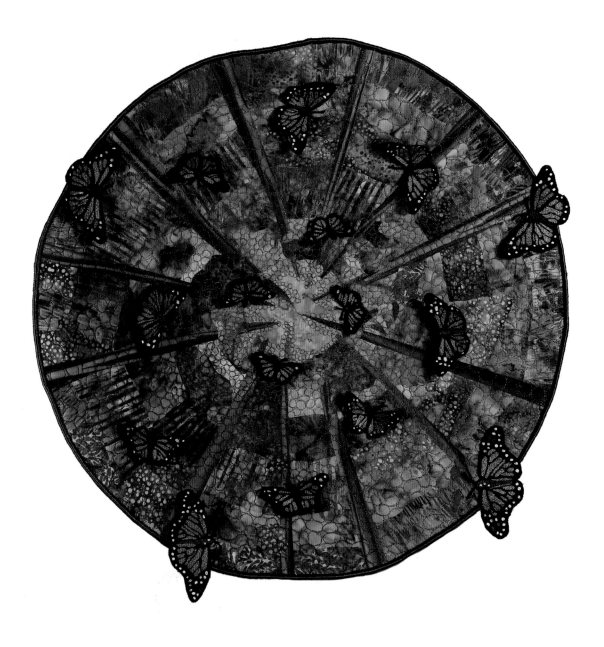

Weidner created *Bowl of Oranges* to bring attention to environmental breakdown and a culture that, by and large, disregards it. She notes, "In 1991, I visited a monarch butterfly wintering ground in the mountains of central Mexico. Seeking to conserve heat and energy, they had layered themselves upon the branches of the trees. There were so many butterflies that they actually weighed down the branches. As the day warmed up, they would gradually leave and ascend into the forest. Now their existence is being threatened by climate change." Naomi adds, "The indigenous Mexican people believe the butterflies are the souls of their ancestors because each year they arrive around the time of the Day of the Dead celebration."

Bowl of Oranges is comprised of a sandwich of heavy canvas between layers of fabric shaped into a bowl. Weidner explains, "I used commercial hand-dyed fabric to create the trees and sky, and created thread-painted butterflies using water-soluble fabric between two layers of tulle stitched with varying colors of thread."

ABOVE
Naomi Weidner. *Bowl of Oranges*, 2013. 17" × 17". Commercial batik, canvas, cotton and rayon thread, plastic. Courtesy of Naomi Weidner.

OPPOSITE
Naomi Weidner. *Bowl of Oranges*, 2013. Detail. Courtesy of Naomi Weidner.

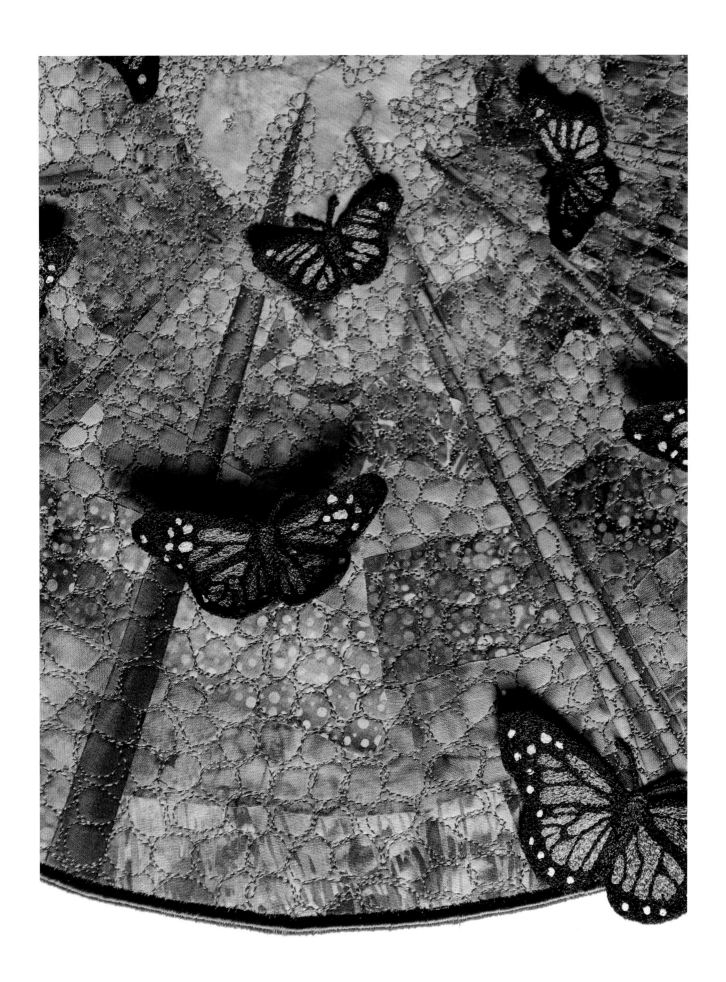

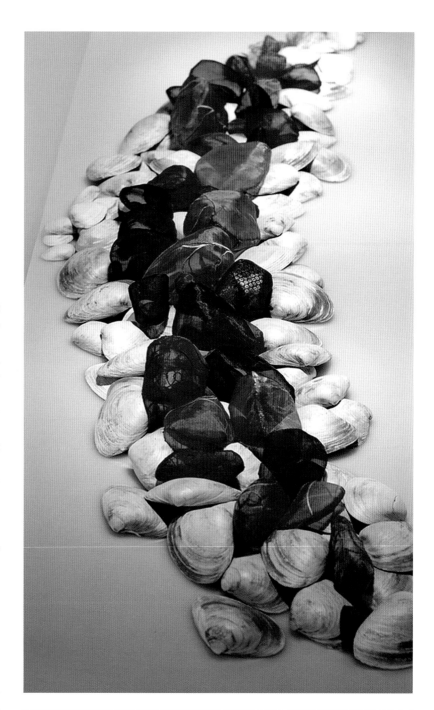

Saberah Malik

United States | www.saberahmalik.com

Saberah Malik creates ethereally transparent fabric forms that mimic natural and man-made artifacts. Although the artifacts themselves might be rough and weighty, such as rocks and stones, her pieces—paradoxically—appear smooth and weightless. Her work, she says, "grew out of a creative need to incorporate form and space. I experimented with fabric based on my knowledge of shibori by tying transparent cloth around marbles and permanently setting them before removing the marbles. My work is a meditation on the perfect and imperfect, on the beauty of the inconsistency of nature and the act of creating art. It's a search for the spiritual within matter as a divine presence."

As a child, Malik was thrilled by Mughal architecture, a style developed in sixteenth-century India and an amalgam of Islamic, Persian, and Indian architecture. Mughal buildings usually sport large bulbous domes, slender minarets, and delicate ornamentation. Malik dreamed of being an architect, but did not have access to such a school, so instead studied graphic and industrial design. After pursuing study in surface design and textiles, and after her children went off to college, she began creating and exhibiting her sculptural work.

Saberah Malik. *Red Line Moving*, 2013. 30" × 96" × 8". Polyester fabric, seashells. Courtesy of Saberah Malik.

The main message Malik hopes to get across with her art is the notion that "[w]e should honor each person's individual worth in communities and also honor the individual elements of nature. I am an immigrant, and one of my defining experiences was when a teacher I had worked with in the past did not recognize me, probably because, to her, all Asians look the same. From that experience, I felt a need to reclaim the idea of individuality, that an object at first glance might look very much like its neighbors, but on closer inspection, proves to be unique. I wanted to suggest to my audience that we should look not just at the forest, but also at each tree."

For her work *Red Line Moving*, Malik was inspired by an oncoming major winter storm as she stood on a beach. She says, "Undercurrents had already ripped up large clams from their beds and hauled them onto shore. I reflected on the moving red line that is climate change and how we mostly continue to ignore it. I believe artists observe their

surroundings intently and feel changes on a deep, emotional level. That makes it incumbent on us to give voice to what we see."

Although *Gardener's Bane* appears to be simply a pile of stones, Malik was intent on making each stone unique by giving it its own defining characteristics. For this, she enhanced the surface of her fabric with immersion dyeing, marbling, and ink spattering to create varying textures and colors.

Similarly, in *Copper Time*, bottles are presented as a homogenous whole, but if you look carefully, you see that each bottle has subtle variations. Malik explains, "For both works [*Gardner's Bane* and *Copper Time*], I pinned, basted, stitched, and sewed fabric onto natural stones or glass bottles. By boiling and cooling, I imprinted the memory of those shapes into the fibers so that the fabric was transformed. Each rock or bottle yielded a slightly different result based on temperature, fiber tension, and humidity. Each one is different, as we all are."

Saberah Malik. *Copper Time*, 2010.
36" × 18" × 12". Metallic polyester fabric, Plexiglas. Courtesy of Saberah Malik.

Judy Kahle
United States

Surface design was Judy Kahle's primary interest when she began taking courses at an arts and crafts center in Tennessee. She studied dyeing, printing, and free-motion quilting, at which point the sewing machine became an integral component of her creative process. She says, "I love the color interaction and the texture as layers of thread build up. Free-motion quilting provided me with the basis to move on to fabric sculpture."

RIGHT
Judy Kahle. *I Will Not Be Silent*, 2003.
12" × 9" × 5". Blueprinted and hand-printed cotton, canvas, thread. Courtesy of Judy Kahle. Photography: Jerry Anthony.

BELOW
Judy Kahle. *I Will Not Be Silent*, 2003. Detail. Courtesy of Judy Kahle. Photography: Jerry Anthony.

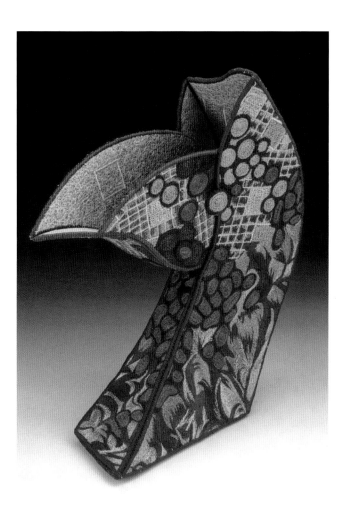

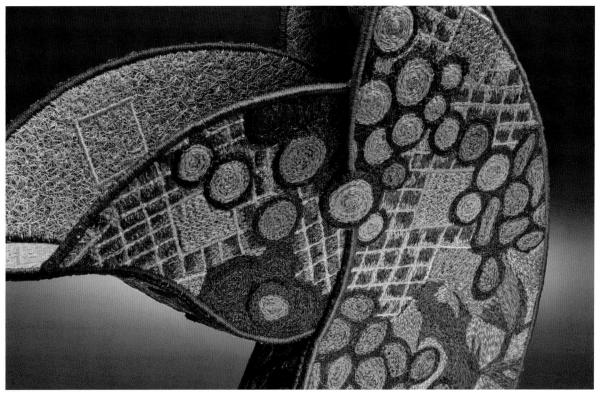

213

Kahle's vessels are autobiographical in that they represent her responses to specific events in her life. She explains, "Each sculpture directly reflects what is happening in my life at the moment. Themes are embedded in the hand-patterned fabrics I use and are reinforced with thread."

For example, Kahle wanted the shape of *I Will Not Be Silent* to sweep up in a dramatic curve that expressed the passion she felt about a particular issue she faced as an art educator. "I spent thirty-three years of my thirty-six-year career in the public school system. The longer I taught, the more I realized that too many decisions were being made with little regard to what was best for the students. It was very difficult to walk the fine line of maintaining a professional demeanor while also being a fierce advocate for my students. For this sculpture, I wanted the upper section to have a spoutlike feature similar to a pitcher; I wanted to suggest the possibility of inner turmoil escaping. The outer designs—with a grid pattern—reference grade books, rubrics, seating charts, and schedules. The students are represented as irregular, rounded shapes clustered together while I'm represented by all the circles bubbling to the top edge."

Emerging from Retirement addresses Kahle's response to retirement from teaching. She says, "I was excited about the possibility of having more time to create, but I'd been employed since the age of sixteen and wondered who I would be without a job. For this sculpture, I made a tagboard prototype that required many revisions in order to get its balance right. The wide base reflected the stability I felt being a teacher, and that base cradled the less sturdy curved section, which represented a period of time when I doubted my decision to end my teaching career. Out of that insecurity came growth: the fern unfurling."

For her work, Kahle prefers to construct vessels. "We have containers to hold everything. I wanted to create vessels that would act as repositories for the important intangibles in life—that is, feelings and ideas. I love the challenge of working around the whole object and considering the importance of details in the interior and exterior designs. These provide many opportunities for the viewer to interact with my artwork."

LEFT
Judy Kahle. *Emerging from Retirement*, 2013. Detail. Courtesy of Judy Kahle. Photography: Thomas A. Ethington.

OPPOSITE
Judy Kahle. *Emerging from Retirement*, 2013. 15" × 13" × 9". Hand-dyed and hand-printed cotton, canvas, thread. Courtesy of Judy Kahle. Photography: Thomas A. Ethington.

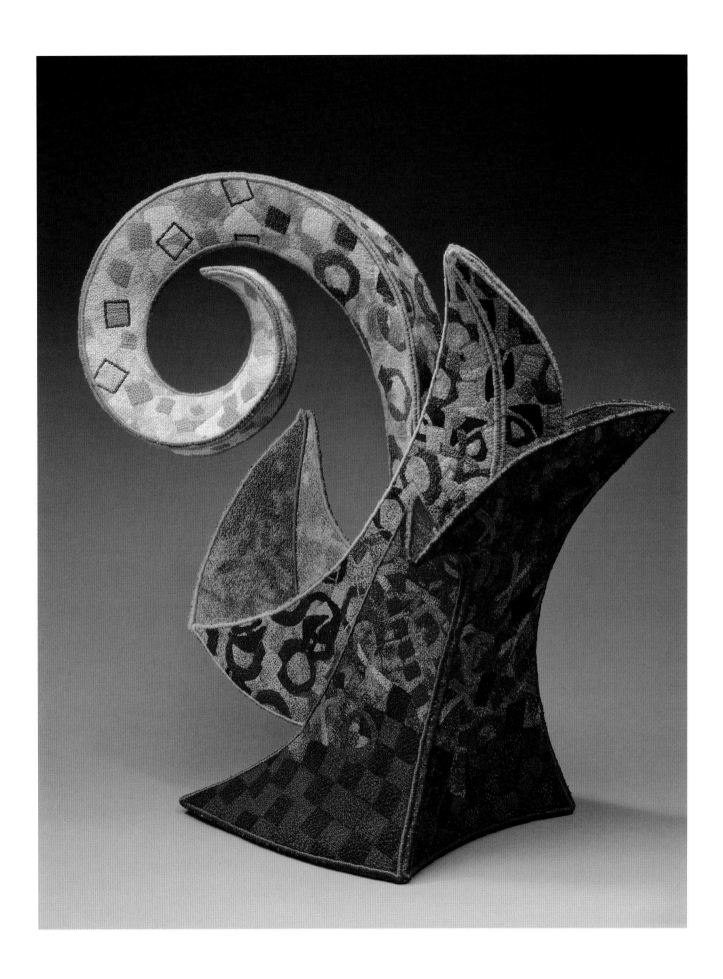

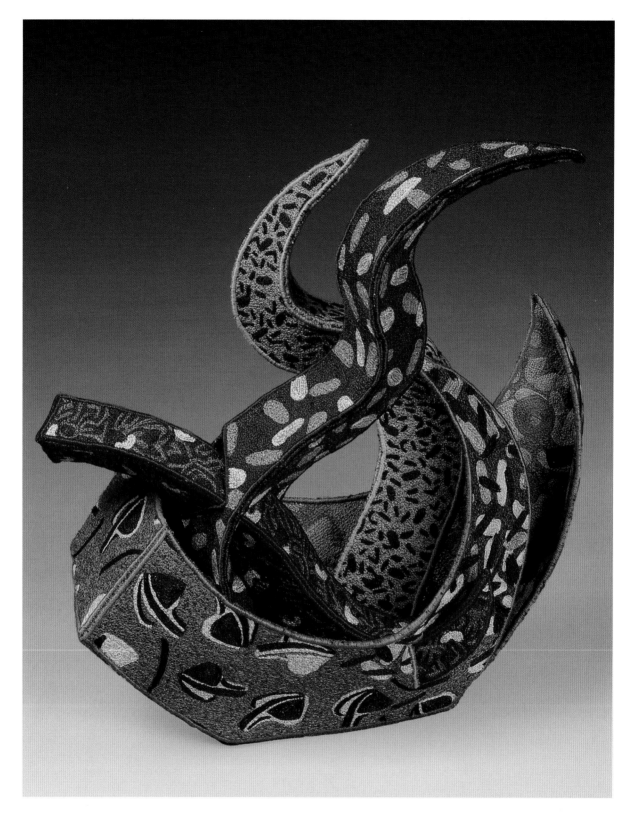

Judy Kahle. *Just Trying to Stay Afloat*, 2011. 13" × 12" × 6". Hand-discharged, hand-printed, and hand-painted cotton; canvas; thread. Courtesy of Judy Kahle. Photography: David Bewley.

Helga Berry

United States | www.fibercomposition.com

Helga Berry. *India in My Heart*, 2010.
25" × 25" × 10". Silk, silk brocade, metallic silk brocade, textile stiffener. Courtesy of Helga Berry.

Helga Berry believes she was an artist at heart "from as far back as I can remember and probably before." She started out as a tapestry weaver and pursued that art form for thirty years, including organizing international traveling tapestry exhibitions, and fundraising and networking with artists worldwide. While attending a workshop on sewing textiles, Berry was introduced to a fabric stiffener that enabled her to shape fabric, and she began to create baskets made from many of the textiles she bought—and still buys—when traveling to India.

Berry explains, "With my baskets, I create three-dimensional organic shapes from complementary or contrasting fabric pieces. Black serves as a good contrast to all of them, so I use black for the outside. I use two fabric stiffeners: a water-soluble fabric and a liquid glue product. I cover the black cloth with the water-soluble fabriclike stiffener and place this same stiffener between each of the multiple layers that make up the basket. By machine, I sew the layers together along an outline in the fabrics to minimize the appearance of the stitches. I immerse the basket in water to dissolve the fabriclike stiffener and, afterward, soak it in the liquid glue product, which dries clear. Now the fun part: I shape the basket, sometimes taking a hair dryer to certain areas while molding it."

Berry's love for the luster of hand-dyed, hand-loomed, hand-painted, and hand-printed silks as well as metallic silks, silk organza, and vintage silk brocade fabrics is evident in all her baskets, including *India in My Heart*, an homage to the country she loves. She says, "India owns a large part of my heart. No other place has influenced me as much—the people, culture, spirituality, sensibility, food, and fabrics. They nurture my heart and soul."Other works by Berry, including *Purple Passion*, *Seaweed*, and *Love in My Home*, are equally evocative and show us that the intrinsic message in a piece of art might be known only to its creator. The rest of us can only wonder at its consummate construction and beauty.

ABOVE
Helga Berry. *Purple Passion*, 2009.
19" × 19" × 6". Silk, silk brocade, metallic silk brocade, textile stiffener. Courtesy of Helga Berry.

OPPOSITE TOP
Helga Berry. *Seaweed*, 2009. 22" × 16" × 7". Silk, silk brocade, metallic silk brocade, textile stiffener. Courtesy of Helga Berry.

OPPOSITE BOTTOM
Helga Berry. *Love in My Home*, 2010. 33" × 33" × 15". Silk, silk brocade, metallic silk brocade, textile stiffener. Courtesy of Helga Berry.

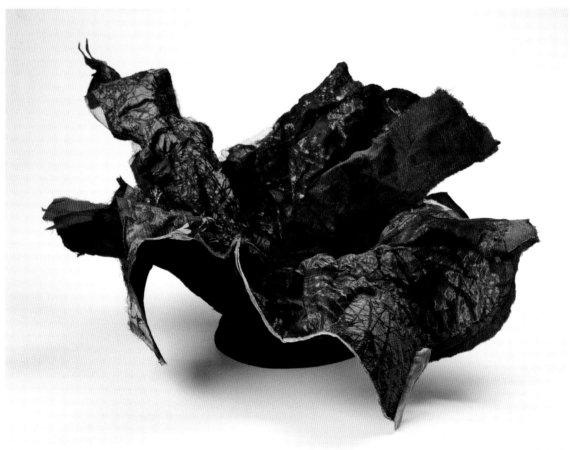

Dee Thomas
United Kingdom | www.deethomas.co.uk

Dee Thomas describes herself as having been a solitary child who loved drawing and reading. She hated sewing at school and only began to stitch when she wanted to create clothes that suited her own style. She attended art school, and her fascination with colors, textures, and even the "smells" of fabric and paint reinforced her desire to become an artist. She studied pattern cutting and fashion design before coming to specialize in printed surface design.

Thomas took on work as a studio artist in the audiovisual industry, drawing and producing presentations for a variety of clients. A chance meeting with an embroiderer introduced her to the world of modern textile design and she finally found the right outlet for her love of texture and color.

ABOVE RIGHT
Dee Thomas. *Circular Pathway*, 2015.
2" × 55" (with 6" fringe). Silk, wool, cotton.
Courtesy of Dee Thomas.

RIGHT
Dee Thomas. *Circular Pathway*, 2015. Detail.
Courtesy of Dee Thomas.

Thomas tells us, "My first installation was a collaborative project by a group of textile artists. I made from felt a life-size image of a monk, which was placed on the grounds of an ancient priory. Giant cowls were suspended from the treetops and these ghostly monk figures could be glimpsed throughout the gardens. It was a very satisfying and inspiring experience."

These days, Thomas describes her way of working as intuitive, although she always begins a project with a collage. She created *Circular Pathway* in response to the theme of "lines of communication." Printing, patching, and layering were used to create a background on which hand-stitching provided additional detail.

Regarding *Shoes for Emma*, Thomas explains, "Emma Hamilton, who was the mistress of Lord Nelson and the muse

Dee Thomas. *Shoes for Emma*, 2013.
9" (UK shoe size 5). Gauze, silk, tissue paper.
Courtesy of Dee Thomas.

for artist George Romney, was known for her great beauty and her theatrical performances. It was said she danced naked on tables to entertain at parties. I made these ballet shoes, nearly invisible, for her to wear. They are composed of gauze and silk organza meshed together with glue and are so delicate they will not leave a mark as Emma dances. Fragile shoes for a fragile girl."

Both of Kendra Dowd's parents were artistic; her father taught college theater and her mother was an expert seamstress. They encouraged their daughter to pursue her creative activities, so it is no wonder she began making her own clothes at an early age. As an adult, she sewed her daughters' clothes as well, and later discovered quilting. She says, "I enjoy experimenting with colors and patterns, working improvisationally to create my own designs. One of my first impulses, when responding to my life, is to create art."

Dowd created a series of sculptures based on the concept of "nest" as a symbol of sanctuary. The pieces reflect an aesthetic aligned with the Japanese concept of Wabi-sabi, which she defines as, "that which acknowledges and respects the beauty, integrity, and impermanence of nature." To form the substructure of the first nest, she chose willow fronds because they are a natural material and are supple enough to create the cup shape she wanted. Then, she "feathered" it, using narrow strips of fabric, yarn, and thread.

After completing two more nests in that series, Dowd attended a university-sponsored course on avian architecture during which she was introduced to scholarly information pertaining to nest construction. This led her to experiment with manipulating her fabric in new ways and incorporating

ABOVE RIGHT
Kendra J. Dowd. *Nest I: Home*, 2014.
24" × 12" × 12" (nest: 2" × 4.5" × 4.5"). Vintage wooden spool, found sticks, willow fronds, fabric, yarn, thread. Courtesy of Kendra J. Dowd.

RIGHT
Kendra J. Dowd. *Nest I: Home*, 2014. Detail.
Courtesy of Kendra J. Dowd.

other materials. She notes, "I gained an even greater appreciation for the incredible variety of shapes and sizes, in addition to the range of materials, that birds use to make their nests. I was excited to continue my exploration of this subject."

With her work, Dowd hopes to express her fascination with nature, as seen in *Nest I: Home* and *Nest IV: Spring Shower*. She remarks, "I hope my pieces encourage people to slow down and look carefully, not just as they walk through a gallery, but also as they stroll through the environments around them."

RIGHT
Kendra J. Dowd. *Nest IV: Spring Shower*, 2014. 24" × 22" × 8" (nest: 3" × 5" × 5"). Vintage brass showerhead, foam board, found sticks, fabric, thread. Courtesy of Kendra J. Dowd.

BELOW
Kendra J. Dowd. *Nest IV: Spring Shower*, 2014. Detail. Courtesy of Kendra J. Dowd.

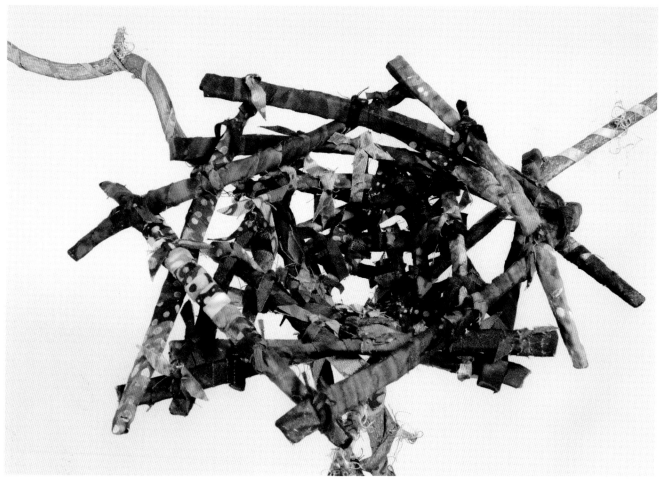

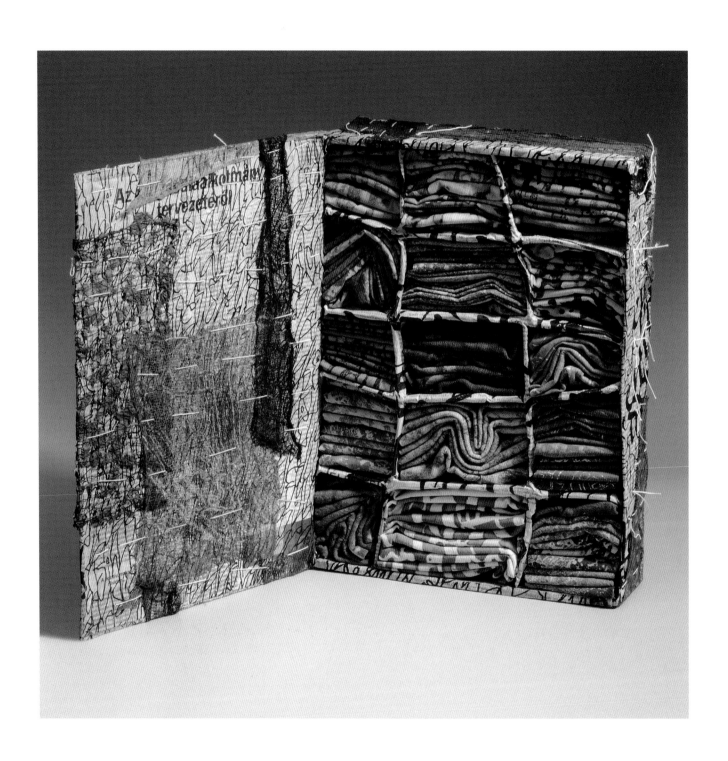

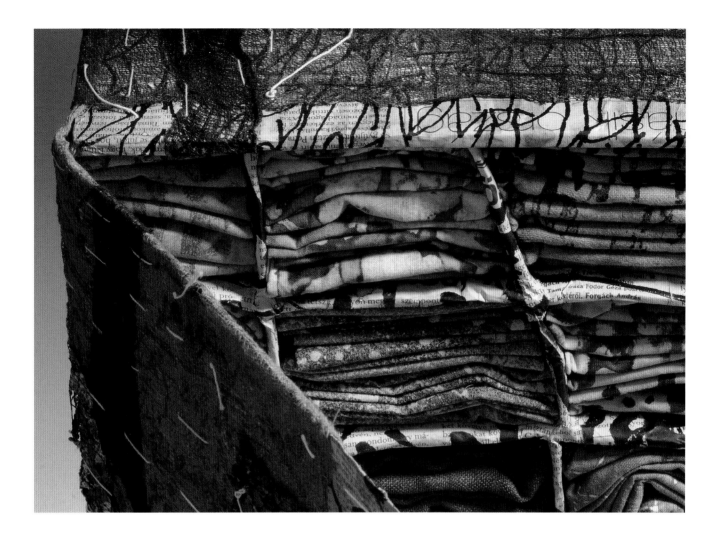

Eszter Bornemisza hails from parents who were scientists, and she herself studied mathematics and became a researcher before deciding to turn to art at age forty-two. She recalls, "I grew up with an experimental surgeon and a physicist, and eventually earned a PhD in math, but I was always doing something with my hands—sewing, weaving, shoemaking—all of which I taught myself. In 1996, I had the chance to visit a contemporary quilt show in France. It totally drew me in and led me to start making modern quilts. The next year, I entered a piece in a juried show in the Netherlands and won an award. This was the start of my art career and I am now a full-time studio artist."

Finding and experimenting with new materials and techniques allows Bornemisza to explore dimensional art. She says, "Working in three dimensions challenges me to conceive my ideas on a wider scale than ever before."

Primitive Findings is a cardboard box covered with fabric. Bornemisza explains, "The compartments are filled with folded fabrics I had screen-printed, monoprinted, or painted with my urban patterns. This piece is a kind of self-

reflection, a looking back. After experimenting with various surface design processes, I often put the results aside, usually forgetting I've made them. Then, years later, sorting or searching for something, they pop up like precious archeological finds. This time I decided to make a case for some of these pieces and arrange them so they can be seen as an open book, with the folds of the fabric appearing as strokes of some enigmatic writing."

Jan Mullen

Australia | www.janmullen.com.au

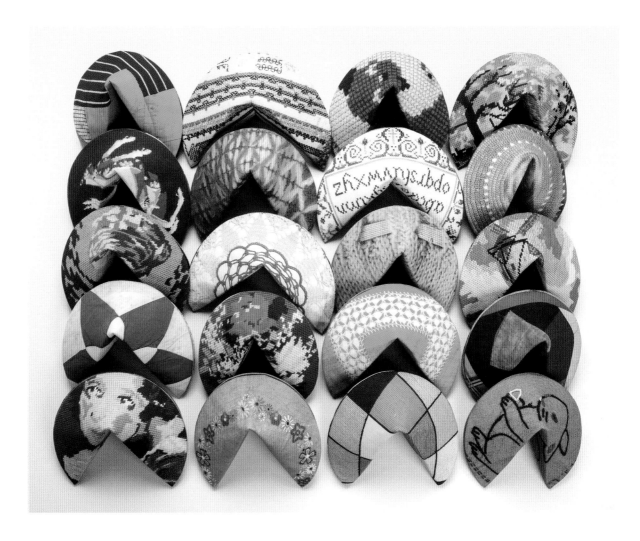

Jan Mullen tends to prefer simple construction with a crisp, clean aesthetic. A constant theme that flows through her work is "the concept of home and the value of making a home, especially the women who traditionally have been in charge of that process."

When asked if she could relate to the fiber revolution of the 1970s, Mullen replied, "Even now I feel it is still a struggle to break down barriers. Textiles are still regarded by many as a female pursuit, just as woodwork has traditionally been seen as a male pursuit. The divide is decreasing as talented artists of both genders produce beautiful, well conceived artworks."

Fortune Favors the Makers #2 is an example of Mullen's effort to explore the theme of valuing domestic work, including the textiles made by women in the past. To construct the

Jan Mullen. *Fortune Favors the Makers #2*, 2013. 20 pieces, 5.9" × 6.2" × 4.7" (each). Cotton fabrics, thread, interfacing. Courtesy of Jan Mullen. Photography: Bewley Shaylor.

sculpture, the artist took thrift shop textiles, photographed them, enhanced their color digitally to show the often beautiful details of the print, then printed them onto fabric, which was then fused to a support, shaped, and stitched. Mullen notes, "Exploring heritage and the importance of family life has given me psychological freedom. It is now, finally, time to make for myself."

CHAPTER FIVE
TAKE HEED

For many artists, their role in society is to challenge the status quo. With protest-oriented art, they seek to alert us to their apprehension about the future of the planet and its ability to survive wars, political and social upheaval, as well as throw-away, consumer-oriented cultures.

Perhaps preserving nature is a recurring artistic theme because makers of art often tend to be tuned in, more than most, to the sense of connection they feel with the natural world. The passing of the seasons provides a steady, comforting background rhythm to all our lives, but it is especially a source of great inspiration and awe to those who seek to depict it through art. Kinship with the wild confers a feeling of belonging to something larger than oneself and one's culture—a sense of wonder, purity, and sanctuary.

Greed and self-centeredness, or simply a lack of familiarity with nature, can result in a psychological disconnection from the land and its fragile ecological systems. This, in turn, leads to an underappreciation of nature's vulnerability, or even an indifference to it, and to mindless destruction of what we depend on for our physical and mental health and well-being. This is a pressing message many artists seek to convey.

Furthermore, it is not just the precariousness of the land that artists want to bring to our attention, but our frequently hostile attitude toward new or different cultures, or nonstandard physical or emotional human traits. Much "protest art" embodies feelings of ostracism, alienation, and rejection artists have felt based on personal experience with an intolerance of these and other differences.

Above all, protest art is art that strives for respecting and protecting the natural world, and for developing a world of empathy and compassion toward all people.

Regina V. Benson

United States | www.reginabenson.com

Regina Benson has always "felt like" an artist. She remembers as a young child in Lithuania "balling up my bread to make it into moldable material and shaping it into animals, objects, and people." Although she wanted to study art in college, her parents and employment counselors convinced her to take another direction because they were sure she would not be able to find work in the art world. Instead, she pursued a degree in business.

However, Benson continued to explore art and worked with textiles for many years. At one point, it occurred to her that she was limiting herself by creating only flat pieces. She says, "The work I was doing mimicked canvas paintings. I began to question why I was so intent on limiting my textiles' natural ability to drape and flow. So I set my work free, first by letting it drape and undulate on the wall, and then to shape my work purposefully into greater dimensionality. Eventually, I began creating freestanding objects. I took classes in sculpture and architecture to learn more about fabrication—how to form textiles and how to engage natural forces like gravity and electrostatic energy."

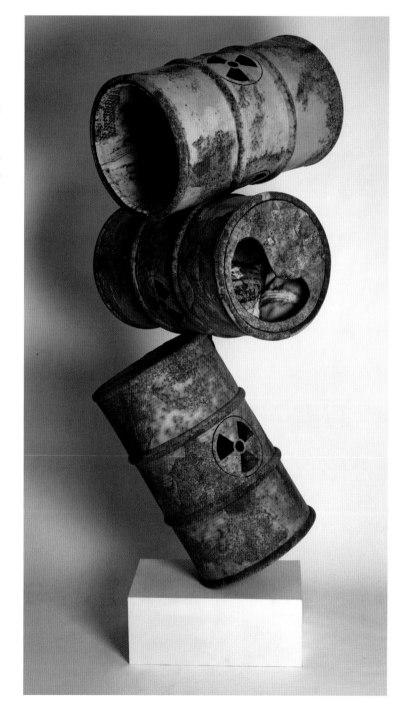

Regina V. Benson. *Safe Storage*, 2016.
102" × 38" × 38". Cotton and polyester, found rusted metal, powdered iron oxide, acrylic paints, polyester batting, polyester threads. Courtesy of Regina Benson.

OPPOSITE
Regina V. Benson. *Safe Storage*, 2016. Detail. Courtesy of Regina Benson.

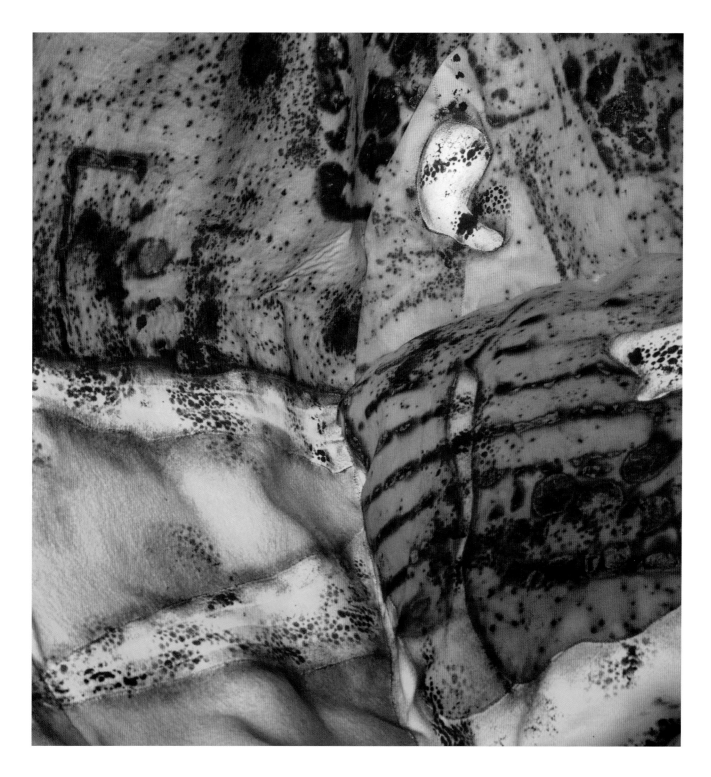

Safe Storage—constructed of rusted, burned, and painted fabric; and found metals—reflects the artist's concern about the degradation of the natural world. She notes, "The concept of containing toxic wastes, which can stick around for as long as 10,000 years, in modestly constructed tanks and systems is ludicrous to me. With *Safe Storage*, I wanted to encourage the audience to question our current waste management strategies. The very use of fiber for this piece reflects my opinion about inadequate waste containment. The staggered, off-balance configuration of the barrels is intended to call out the physical precariousness of our approach. Each barrel represents a different stage of internal and external deterioration, and the leaking of the very hazardous materials it was tasked to protect us from."

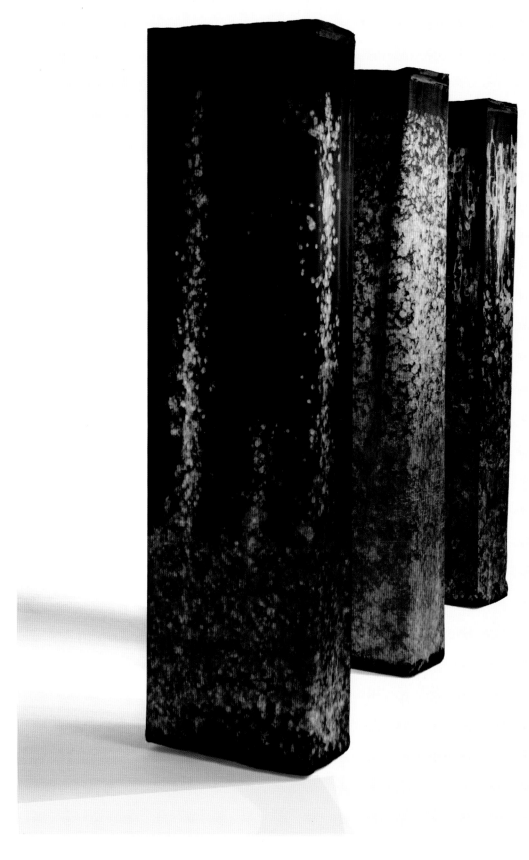

Burning Monoliths, Benson explains, "was an installation based on my personal exposure to our planet's ever-increasing incidences of wildfires. Through the use of these huge archetypal forms and their fiery markings, I am posing harbingers of universal events. I've created a sculptural environment in which visitors pass around and through these burning giants that glow from within as if in various stages of ignition. Each monolith was created from rayon cloth that was dyed and discharged on snow banks, burned, assembled, stitched, and installed with strings of digitally programmed LED lights."

Benson's *Sea Gypsies* was created entirely of recycled materials. She says, "From the Great Barrier Reef to the depths off the islands of Turks and Caicos, there has been a change in the population of fish and corals as sea temperatures have risen due to climate change. Jellyfish, in particular, are migrating to waters that do not usually host them in such great numbers. My jellyfish in *Sea Gypsies*, although beautiful and graceful, are causing dramatic damage because of their extensive numbers. I created this entire installation with polyester organza recycled from an old bridesmaid dress, which was disperse-dyed, heatformed, burned, and assembled with clear food container lids and bubble wrap."

OPPOSITE
Regina V. Benson. *Burning Monoliths*, 2015. 104" × 28" × 14" (each). Rayon satin, dyes, polyester thread, LED lights. Courtesy of Regina Benson.

RIGHT
Regina V. Benson. *Burning Monoliths*, 2015. Detail. Courtesy of Regina Benson.

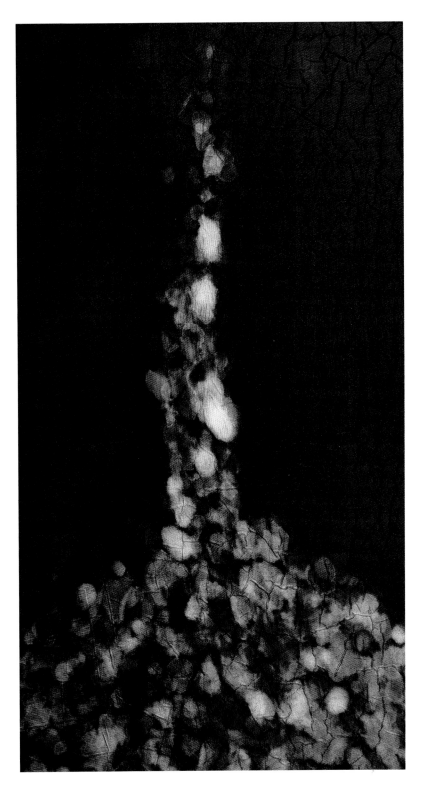

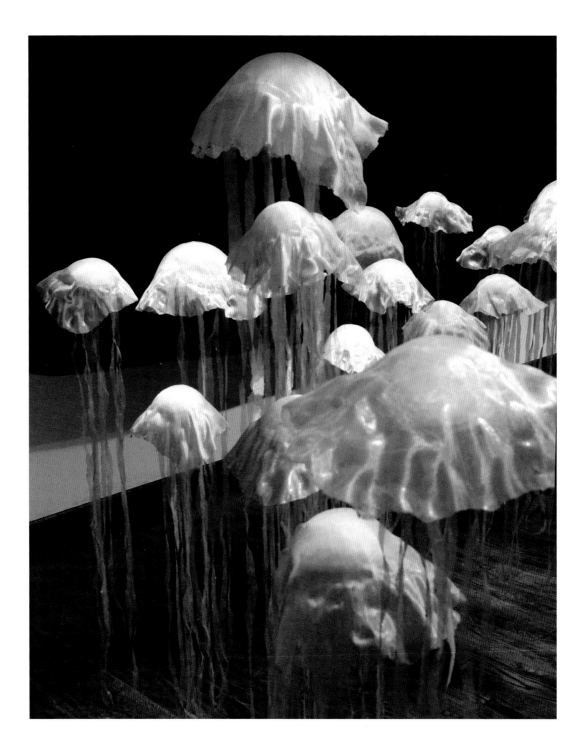

Regina V. Benson. *Sea Gypsies*, 2016. From 36" × 6" × 8" to 52" × 9" × 18" (varies). Polyester organza, recycled plastic lids, recycled bubble wrap. Courtesy of Regina Benson.

Benson relates that she strives to challenge preconceptions about fiber art. "I harness the materiality of textiles and use a variety of techniques to create sculpture. My creative process starts from the landscape—rock beds, a river's edge, a field of snow, the side of a mountain—and ends in my studio, which is populated with metal hardware, a laser cutter, heat presses, and a welding torch. I'm a student and admirer of sculptors such as Richard Serra, Christo and Jean-Claude, Andy Goldsworthy, and Magdalena Abakanowicz. I'm proud to continue my material innovations in their acknowledged spirit."

Diane Savona

Australia | www.dianesavonaart.com

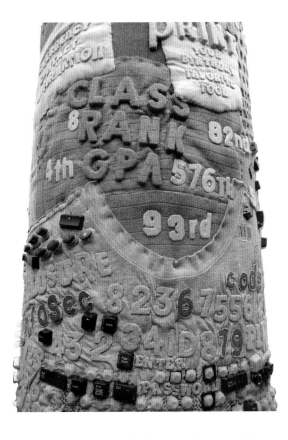

RIGHT
Diane Savona. *Kiosk*,
2016. 8' × 16". Old
T-shirts, wire fencing,
old blanket, plastic,
wood letters. Courtesy
of Diane Savona.

LEFT
Diane Savona. *Kiosk*,
2016. Detail. Courtesy
of Diane Savona

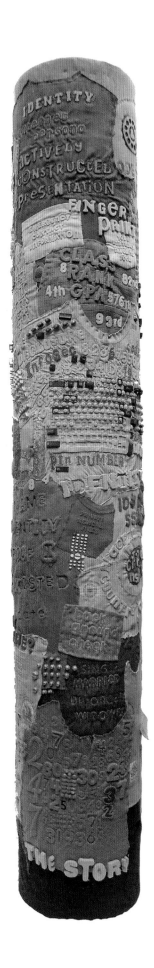

Diane Savona firmly believes art is part of her core identity. She recalls, "I was socially awkward as a child, but my art was admired. It was the thing I did well." She studied sculpting in wood, stone, and ceramics in college, although she did not pursue art as a career because of its financial limitations. But, she kept at art as her "semisecret addiction."

In fact, the artist remembers, "I sewed obsessively, figuring out everything I could do with a needle and thread. I purchased my vintage materials at garage sales, and used the embroidery and crochet of a previous generation of women for my own work. In a way, I collaborated with the dead." She created two-dimensional art quilts whose "stuffed figures exploded out of them," which evolved into her embedded object technique, which she calls, "an extreme variation of trapunto. I thought, if you can sew a cord underneath fabric to create a raised surface, why not sew buttons or scissors or darning eggs? It's a kind of bas-relief quilting."

When Savona finally became a full-time artist, she continued to develop her unique style and used it to explore her keen interest in her ancestors. She explains, "My peasant grandparents lived in thatched huts in Poland. What was their story?"

Later, she expanded this theme to include all people from the past, and not just information about their domestic lives, but information about all aspects of their lives. She continued to collect used fabrics and incorporate them into her work. "Collecting materials is my equivalent of excavating archeological sites. I unearth once-common items that are now nearly extinct. My textile works are part art and part archeology. They are the stories of past generations."

Much of Savona's textile art centers on her concern about loss of knowledge between generations as a result of a cultural shortsightedness and lack of effort to save it and pass it on. Because most of our knowledge is invisible—hidden in our technology and potentially irretrievable—making sure information is accessible is a subject that deserves to be addressed. She says, "Ancient knowledge was preserved on clay tablets, scrolls, and in books. Today, we have computers. What information will be available to future generations? Like rotary phones and typewriters, technology once considered cutting-edge often becomes obsolete. What if someday we can't access what's on our thumb drives or in 'The Cloud?' By disassembling technological devices and sewing the parts

TOP
Diane Savona. *Maintain*, 2015. 10" × 4" × 3" (each brick).
Vintage hand-dyed, hand-sewn fabric; salvaged foam.
Courtesy of Diane Savona.

ABOVE
Diane Savona. *Maintain*, 2015. Detail.
Courtesy of Diane Savona.

under cloth, I am fossilizing them, preserving their forms, to remind us that we need to find a way to ensure information about our lives will be available to future generations."

On the other hand, for her sculpture *Kiosk*, Savona used old gray T-shirts as a base to expose words related to the issue of decreased privacy in the modern age. She recalls, "In San Francisco, I saw telephone poles encrusted with notices; they are the equivalent of kiosks. Research reveals a long history of such kiosks and other columns that were used to disseminate information to the public. These days, our personal information is being collected and displayed regardless of whether we want to make it public. My sculpture is a three-dimensional discussion about this issue. Embedded letters spell out names and addresses whereas pockets hold secret codes and passwords."

Maintain was created by Savona at the request of a museum in New Jersey. She says, "This rural section of the state was once a center for brickmaking, so I created textile bricks to tell its history. I cut brick shapes from old couch cushions and upholstered them with fabric dyed to resemble red clay. Each brick contains embedded letters spelling out the names of extinct clay mines or manufacturers. Displayed in an old wheel barrow, the loose bricks can be picked up and examined."

Similarly, for a show involving an old textile mill, the artist printed out the history of the mill on cloth, cut the strips, and assembled them as one long strip, which she then wrapped around bobbins, thus creating *Mill Bobbins*. Diane notes, "The bobbins tell the story of the mill. I really like the concept of exploring history in this hands-on fashion."

ABOVE RIGHT
Diane Savona. *Mill Bobbins*, 2010. 8"–12" (varies). Printed cloth, wood bobbins. Courtesy of Diane Savona.

RIGHT
Diane Savona. *Mill Bobbins*, 2010. Detail. Courtesy of Diane Savona.

Deborah Kruger

Mexico | www.deborahkruger.com

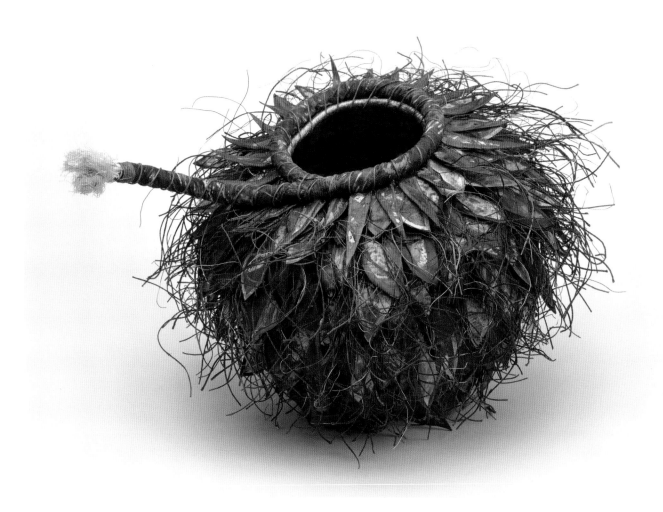

Deborah Kruger. *Red Basket*, 2011. 8" × 8" × 8".
Fiber, encaustic, oilstick, paint, rope, waxed linen,
wire thread. Courtesy of Deborah Kruger.

By the time she was five, Deborah Kruger understood what artists were and that she was one of them. She received encouragement from her parents and teachers, who recognized her creativity. While holding down a career in finance and raising kids, she managed to pursue her artistic interests. Even when she was struggling financially, she maintained an art studio and remained determined to continue making art.

Kruger was inspired by the pioneering fiber sculptors of the 1960s and the Guerrilla Girls—an anonymous group of seven female artists, formed in 1985, who continue to be spokeswomen for artists who are not represented adequately in the art world. Their work resulted in more women, in general—and women of color, in particular—being accepted into shows and galleries. Kruger notes, "I prefer, however, to be seen as an artist rather than a woman artist or belonging to other identity groups."

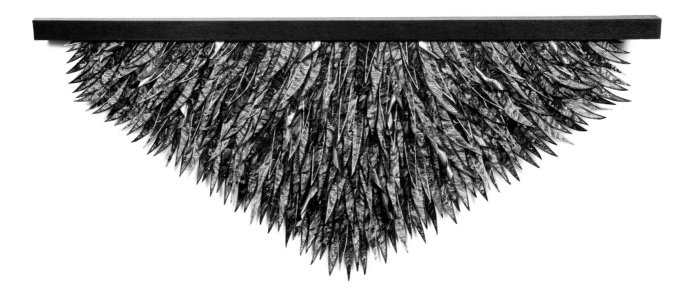

Kruger attended the Fashion Institute of Technology in New York City, where she studied textile design, and she also studied surface design at a variety of other venues. She says, "As my domestic responsibilities waned, I was able to work in my studio more often and explore new techniques, such as digital printing on alternative surfaces."

Today, the theme that runs through all her art is her awareness about the health of the environment. "As climate change has become an increasingly urgent issue, my artwork reflects my personal concern about the destruction of bird habitats and the subsequent worldwide decrease in bird populations. I challenge myself to create work that is visually beautiful, layered, and complex, as well as imbued with meaning about my environmental concerns."

Red Basket, for example, is part of an ongoing series that uses scraps left over from the artist's previous work. She says, "There is a women's basketry collective across the lake from where I live in Mexico, and I use their baskets as the internal structures for this series. The baskets are made from palm, which is plentiful here. By using their wares, I'm helping to preserve the long tradition of women collaborating and working together."

Kruger continues, "As with all my pieces, I create feathers from a complicated process of building up the surface of an existing piece of fabric with encaustic (wax), paint, and oilstick. I spend two months creating my palette of colors and cutting them into shapes. Then, I organize boxes of feathers sorted by color, shape, and direction. At this point, I'm ready to build the piece, which I design directly on the basket or wall, layering and pinning each feather. Once I'm satisfied with the design, I attach each piece to a linen background using a mini iron and fusible tape. Then, everything is stitched together."

Kruger's sculpture *Redtail* was commissioned by a private collector whose family once raised red-tailed hawks. She recalls, "I worked closely with the collector to create a piece that would convey the grandeur, color, and texture of this gorgeous raptor. The commission marked the first time I used metal in my work. I found the coiled copper feathers increased the reflected light, and so the visual complexity of the piece."

ABOVE
Deborah Kruger. *Redtail*, 2008. 39" × 52". Fiber, encaustic, oilstick, paint, metal. Courtesy of Deborah Kruger.

BELOW
Deborah Kruger. *Redtail*, 2008. Detail. Courtesy of Deborah Kruger.

For *Migration*, Kruger used digital imagery for the first time. She explains, "I had envisioned a very large piece and realized it would be inefficient to construct each feather laboriously from fiber and wax, so I scanned my feathers and printed them on heavy watercolor paper as a way to scale up to 12 feet wide by 5.5 feet high. From a distance, it's hard to tell the difference between the fabric feathers and the digitally scanned feathers. In this piece, my goal was to create an airier and less dense piece that suggested the migration of birds and butterflies."

Remnants 18 is part of Kruger's ongoing series of recycled art. She says, "My family members were immigrants who worked in the garment center of New York City. Fabric remnants were among our childhood toys. Scraps were also recycled into clothing, quilts, and accessories. Now, as a mature artist, I am still unable to discard leftovers. My own scraps from a piece of artwork show up in my other projects. *Remnants 18* is both a nod of gratitude to my textile roots and part of an ongoing dialogue with my own materials as they morph into new forms."

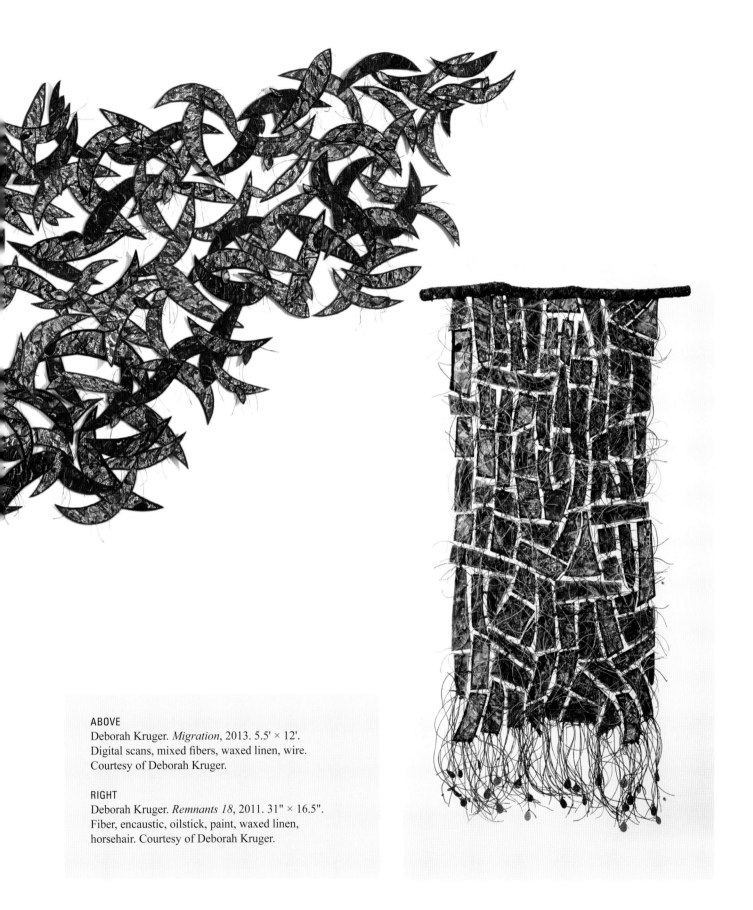

ABOVE
Deborah Kruger. *Migration*, 2013. 5.5' × 12'.
Digital scans, mixed fibers, waxed linen, wire.
Courtesy of Deborah Kruger.

RIGHT
Deborah Kruger. *Remnants 18*, 2011. 31" × 16.5".
Fiber, encaustic, oilstick, paint, waxed linen,
horsehair. Courtesy of Deborah Kruger.

Sara Rockinger

United States | www.sararockinger.com

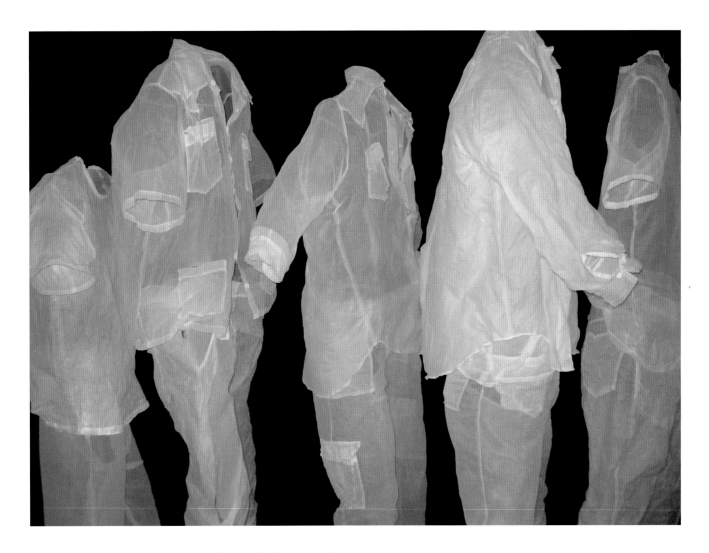

Sara Rockinger is a textile artist who originally pursued a degree in international relations, foregoing her love of art for something "more practical." After graduating college, her first job was in sales for a photographic lighting company. She soon realized that the photographers to whom she sold were having more fun than she was, and she left the job to pursue her own creative career.

The theme of most of Rockinger's work is timely and timeless—the harrowing journey of immigrants, human and animal, as they cross the globe to make new lives. She says, "I hope to inspire viewers to think about their own im/migra-

Sara Rockinger. *In/Visible*, 2010–2016. Life-size. Silk organza, cotton muslin, thread, silk screen pigment. Courtesy of Sara Rockinger.

tion stories, and that of their ancestors, in order to foster understanding and compassion for migrants living locally and globally."

Sensitive and aware, Rockinger created *In/Visible* as a sculptural and video installation with multiple layers of meaning, information, and perspective. She explains, "This work was inspired by imagery of clothing left behind in the desert by people crossing the United States–Mexico border. I began to wonder who were the immigrants/migrants in my own community and what were their stories? With the help of my good friend and videographer, Mark Conkle, the project grew to include video of and personal interviews with present-day migrants, immigration lawyers, teachers, and so on. I don't want to hit anyone over the head with my opinions, but at the same time, I do hope my message of tolerance and compassion comes through."

For *In/Visible*, the artist constructed cloth sculptures from silk organza and cotton. She tells us, "I modeled them after photos of the migrants and stitched quotes from our interviews with them onto the backs. I also silk-screened migrating birds to suggest migration in a different way, as a natural phenomenon. To create the form of the shirts and slacks, I tried several fabric stiffeners before creating my own made up of a white glue mixture. I dipped each item of clothing into the mixture and put it over a form composed of shaped window screen. I used the window screen because it can be scrunched down and easily removed from the fabric once the glue dries and the fabric hardens. Removed from the screen, the fabric holds the shape of someone walking across the gallery space."

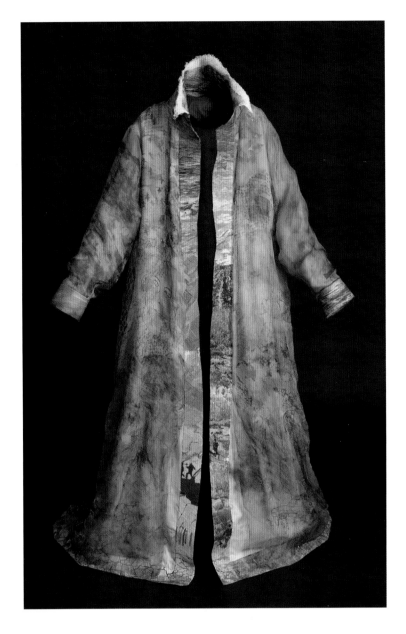

Sara Rockinger. *This Land*, 2010. 70" × 35" × 35".
Silk organza, cotton duck, thread, silk screen pigment, dye.
Courtesy of Sara Rockinger. Photography: Ken Sanville.

This Land is an oversized robe containing layers of historic imagery of human and natural migrations to North America, including buffalos and birds. Rockinger says, "It's a matter of resources. People and animals go where there is the possibility of obtaining food and shelter. My ideas are suggested not only by the earth tones and imagery I chose, but also by the size of the robe; it can receive and protect many."

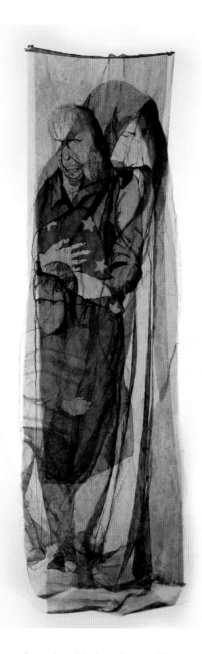

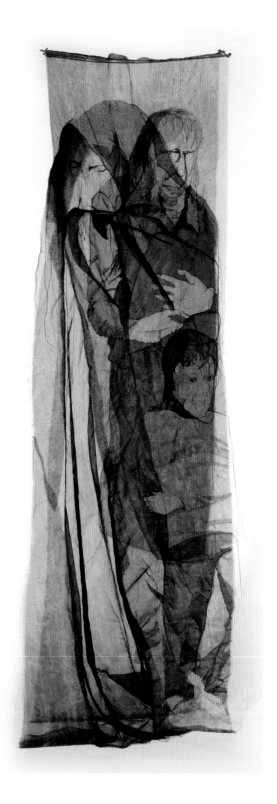

Two-Sided War is part of a series titled *Un/Wearable War*. It is one long piece of fabric draped over a four-inch-wide frame so both sides are observable. "This piece depicts, on one side, an American woman clutching the country's flag as if she was just given it because of the death of a loved one in battle. The other side depicts an Iraqi woman grieving the loss of her own loved one, perhaps as a result of the same incident. A child grips the leg of his mother, but due to the transparent nature of the material (which is nylon organza), the viewer must determine on what side the boy stands. Which mother is he gripping? What future does he hold? Because of the four-inch gap between the two sides of the fabric, static electricity builds up and attracts the threads from one side of the sculpture to the other, and the women connect through that physical network. My intention with this piece is for the viewer to consider two perspectives of the same event—war— and how they are connected and similar."

Sara Rockinger. *Two-Sided War*, 2008.
90" × 34" × 26". Front and back views.
Nylon organza, acid dyes, thread. Courtesy of Sara Rockinger.

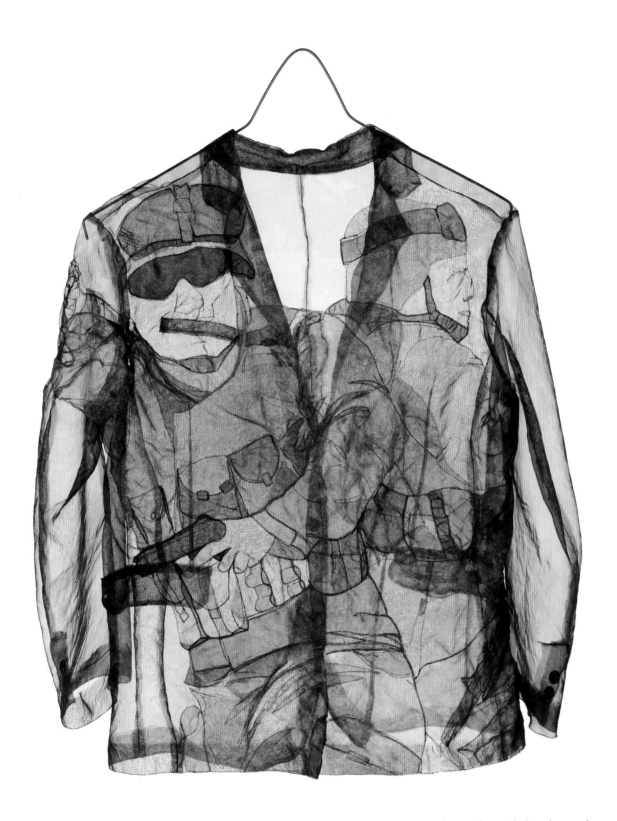

Sara Rockinger. *Got Your Back Jacket*, 2008. 35" × 31" × 5". Nylon organza, acid dyes, thread, buttons. Courtesy of Sara Rockinger.

Got Your Back Jacket is another sculpture belonging to the series, *Un/Wearable War*. "My intention was to honor our troops, but also to inspire people to think about who benefits and who suffers when there is war. Who might be wearing this jacket? A businessman? A politician? A soldier returning home from war? The businessman and politician are the ones responsible for the war. What psychological burdens are all of these individuals carrying, and why?"

Sandra Jane Heard

United States | www.sandrajaneheard.com

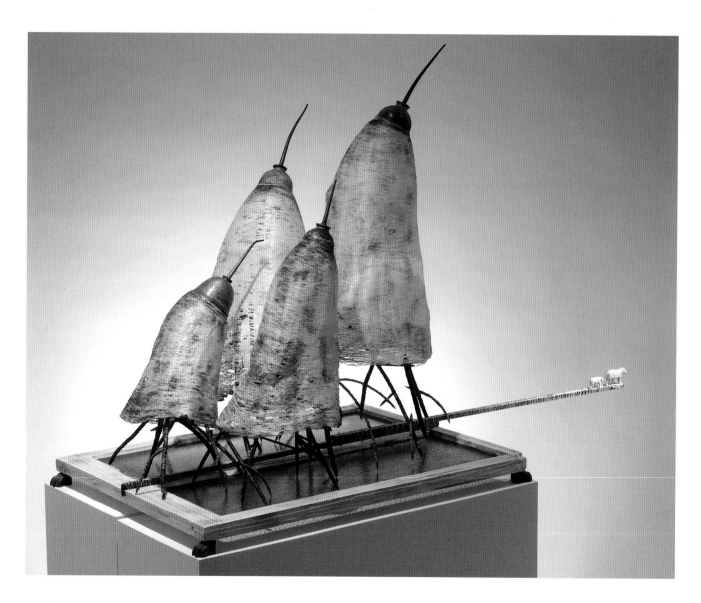

Sandra Jane Heard became fascinated with art during her adolescence and, after graduating high school, entered an art foundation program. She says, "It was a natural choice. I was always interested in the minute details of my environment: the textures, colors, and shapes. I love to absorb this visual information. In the program, I was introduced to textile art, which then led me to pursue textile design."

Sandra Jane Heard. *Indigenous Expulsion*, 2014. 72" × 50" × 32" (on custom 32" pedestals). Silk and linen yarn, reeds, vintage paper, glass, chosen objects. Courtesy of Sandra Jane Heard. Photography: William Jordan.

During her investigation of textiles, Heard began to create sculptural forms. She recalls, "I was interested in combining traditional craft techniques with experimental techniques, using unusual materials and chosen objects. I source materials for my works from where I happen to be living. When I lived in the American Southwest, I collected natural objects that I came across on hikes in the desert. In the Midwest, where I live now, I'm attracted to objects from a bygone industrial era, such as vintage oilcans, and steel or cloth tape measures. I reenvision these discarded objects and use them as messengers from the past."

In general, Heard uses her artwork to showcase the idea of fostering equality and diversity, and the preservation of nature. *Indigenous Expulsion*, for example, represents the artist's concern regarding "the survival of all species in the face of the devastating exploitation and damage being inflicted upon Earth by our modern, industrialized society."

Made of silk, linen, reeds, vintage paper, and chosen objects, *Indigenous Expulsion* consists of four hand-molded silk forms that sit atop an old amber-colored glass window. Sandra explains, "The amber window represents something intrinsically fragile that needs to be preserved. The strange forms are hybrid creatures—part natural and part industrial. Their oilcan heads provide them with stingers. These hybrids are presented as both menacing and inherently fragile themselves, suggesting their actions will lead to their own demise. They dominate the glass foundation and force an indigenous species onto a narrow path, leading to an uncertain future. The inherently brittle, vintage toy polar bears—representing indigenous species—are bound in silk yarn, which ensnares them and leads them along their fateful journey."

Sandra Jane Heard. *Indigenous Expulsion*, 2014.
Details. Courtesy of Sandra Jane Heard.
Photography: William Jordan.

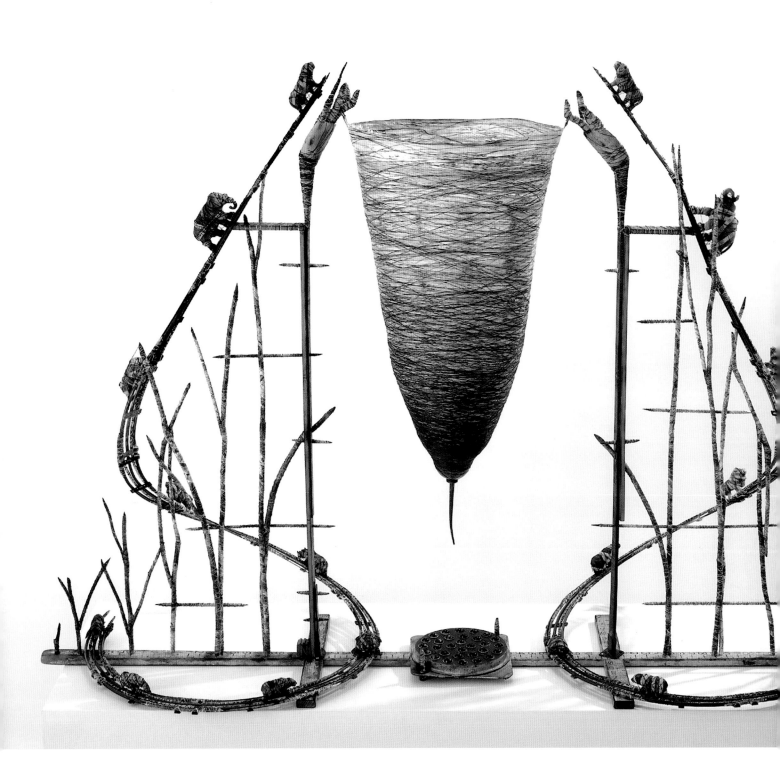

The Reversal of Her Alchemy explores similar concepts. Says Heard, "This work reflects the blight of the human footprint on nature's majestic beauty. It aims to be provocative, with its depiction of imminent species extinction set in play by human dominance and exploitation. In creating this piece, I was influenced by the idea of a roller coaster—a thrill ride—representing the human tendency to take destructive risks, especially toward the environment. Bound to the metal tracks are vintage toy animals representing endangered species. They are swathed in cloth tape measures and yarn, and are set on a forced march toward a precipice. They will drop into a vessel reminiscent in form of a tornado. This vessel was sculpted by hand from wrapped silk and linen, and suggests, too, a cocoon—offering the hope of transformation and recovery."

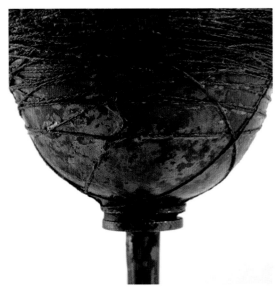

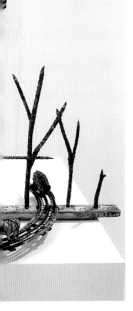

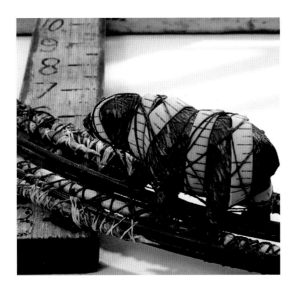

OPPOSITE
Sandra Jane Heard. *The Reversal of Her Alchemy*, 2014. 72" × 55" × 25". Silk and linen yarn, vintage paper, wood, metal, chosen objects. Courtesy of Sandra Jane Heard. Photography: William Jordan.

ABOVE AND RIGHT
Sandra Jane Heard. *The Reversal of Her Alchemy*, 2014. Details. Courtesy of Sandra Jane Heard. Photography: William Jordan.

Susan Lenz

United States | www.susanlenz.com

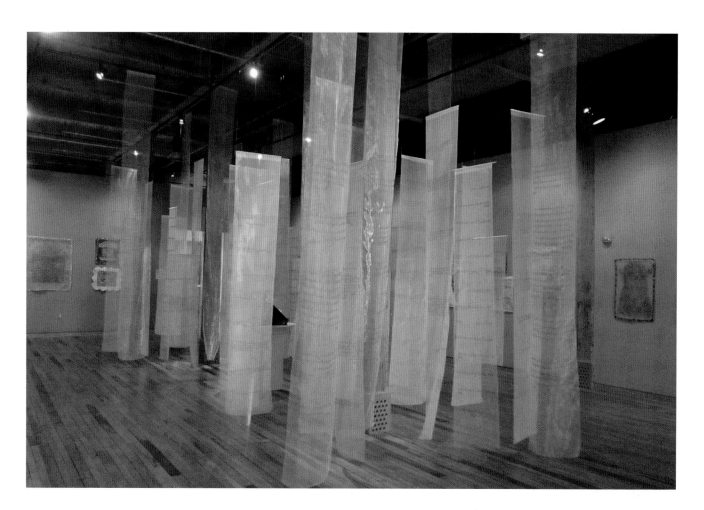

As a youngster, Susan Lenz did not believe a career in art was possible so she did not pursue one, although she attended graduate school in art history and ran a custom picture-framing business. She says, "As a picture framer, I had to consider all the math involved—the depth of the moldings, the ratio of mat to image, and so on—which primed me for three-dimensional art. Equally important, as a picture framer, it's necessary to take into account the presentation of the finished piece—the room, setting, mood, style—which comes easily to me. This awareness of presentation also led me to express myself in three dimensions."

Primarily self-taught, Lenz has constructed dozens of
installations and sculptural pieces. Much of this work is
predicated on her deep feelings about preserving memories
to honor the legacy of those who have passed on.

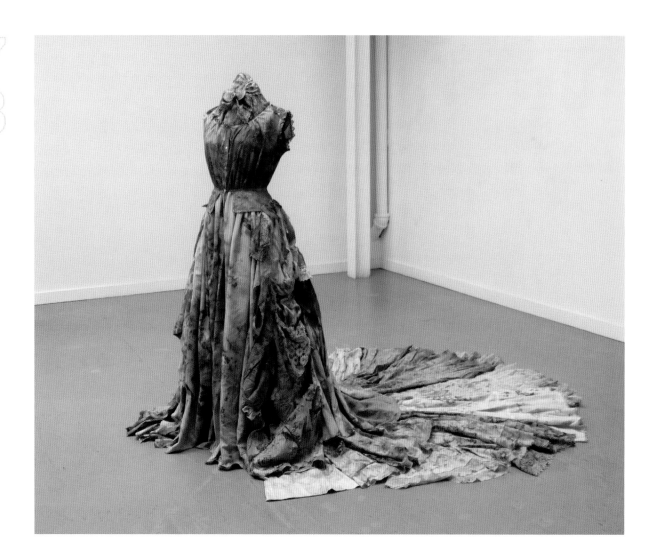

Epitaph Banners, for example, is an installation of more than forty sheer chiffon banners. They transform the interior of an art gallery "into a space that feels like walking through a cemetery." Words of grief and loss, through Lenz's stitched rendering of real epitaphs, hang in the air like ghosts. She notes, "Observers can't help but be drawn closer to read them and contemplate their meaning." *Epitaph Banners* is part of Lenz's solo exhibition called Last Words.

In *A Day's Catch*, scrolls of lace represent "a memory, a story, a precious moment collected during the human voyage." *Exodus* suggests the "hardship experienced when marginalized people, in particular, are forced to leave one place—their home—for another."

Although they're not three-dimensional, *Lunette VI* and *Lunette XII*, part of Lenz's *In Box* series, are stunning fabric mosaics based on Austrian architect Friedensreich Hundertwasser's* unique architecture. For these pieces, Lenz free-motion stitches colorful polyester squares onto a substrate of recycled felt, overlaid with metallic foil and chiffon pieces, which are then melted with a soldering iron.

ABOVE
Susan Lenz. *Exodus*, 2015. 54" × 60" × 70". Dress form, rusted vintage garments and fabric, frog closure, button. Courtesy of Susan Lenz.

OPPOSITE TOP
Susan Lenz. *Lunette VI*, 2013. 17" × 23" (unframed). Polyester stretch velvet, recycled industrial felt, metallic foil, chiffon scarves, thread. Courtesy of Susan Lenz.

OPPOSITE BOTTOM
Susan Lenz. *Lunette XII*, 2013. 17" × 23" (unframed). Polyester stretch velvet, recycled industrial felt, metallic foil, chiffon scarves, thread. Courtesy of Susan Lenz.

* As a point of interest: Hundertwasser was one of the first to live off the grid using solar panels, a water wheel, grass roofs, and a biological water purification plant. He also helped the Dalai Lama escape religious persecution in Tibet.

251

GENERAL

Constantine, Mildred, and Jack Lenor Larsen. *Beyond Craft: The Art Fabric*. New York, NY: Van Nostrand Reinhold, 1973.

Constantine, Mildred, and Laurel Reuter. *The Whole Cloth*. New York, NY: Monacelli Press, 1997.

Draper, Jean. *Stitch and Structure: Design and Technique in Two- and Three-Dimensional Textiles*. London, UK: Batsford, 2014.

Flint, India. *Eco Colour: Botanical Dyes for Beautiful Textiles*. Fort Collins, CO: Interweave, 2011.

Hedley, Gwen. *Drawn to Stitch: Line, Drawing, and Mark-Making in Textile Art*. Fort Collins, CO: Interweave, 2010.

Henderson, Neroli, ed. *Textile*. Ashburton, Australia. [magazine].

Koren, Leonard. *Wabi-sabi for Artists, Designers, Poets & Philosophers*. San Francisco, CA: Imperfect Publishing, 2008.

McFadden, David Revere, and Jennifer Scanlan. *Radical Lace & Subversive Knitting*. New York, NY: Museum of Arts and Design, 2008.

Mornu, Nathalie. *500 Felt Objects: Creative Explorations of a Remarkable Material*. 500 series. London, UK: Lark Books, 2011.

Oka, Hideyuki. *How to Wrap 5 Eggs: Traditional Japanese Packaging*. Boston, MA: Weatherhill, 2008.

Parrott, Helen. *Mark Making: Fresh Inspiration for Quilt and Fiber Artists*. Fort Collins, CO: Interweave, 2013.

Pitcher, Joe, and Sam Pitcher, eds. *Textile Artist*. TextileArtist.org. [magazine].

Porter, Jenelle, and Glenn Adamson. *Fiber: Sculpture 1960–Present*. New York, NY: Prestel, 2014.

Russell, Carol K. *Fiber Art Today*. Atglen, PA: Schiffer, 2011.

Sielman, Martha. *Masters: Art Quilts: Major Works by Leading Artists*. New York, NY: Lark Crafts, 2008.

Studio Art Quilt Associates. *SAQA Journal*. Hebron, CT. [journal].

Surface Design Association. *Surface Design Journal*. Albuquerque, NM. [journal].

Textiles Re:imagined. Kindle/Amazon Digital Services, LLC 2015. www.TextileArtists.org. [magazine].

Wada, Yoshiko Iwamoto, and Mary Kellogg Rice. *Memory on Cloth: Shibori Now*. New York, NY: Kodansha USA, 2012.

Wellesley-Smith, Claire. *Slow Stitch: Mindful and Contemplative Textile Art*. London, UK: Batsford, 2014.

White, Christine. *Uniquely Felt*. North Adams, MA: Storey Publishing, 2007.

Young, Marcia, ed. *Fiber Art Now*. North Hollywood, CA. [magazine].

HOW-TO

Barnes, C. June. *Exploring Dimension in Quilt Art*. London, UK: Batsford, 2015.

Breier, Susan. *It's a Wrap II: Sewing New Shapes, Exploring New Techniques*. Bothell, WA: That Patchwork Place/Martingale, 2007.

Danswan, Kath, and Andrew Newton-Cox. *Beautiful Bowls and Colorful Creatures*. London, UK: Linen Press, 2006.

Dean, Jenny. *Wild Color, Revised and Updated Edition: The Complete Guide to Making and Using Natural Dyes*. London, UK: Potter Craft, 2010.

Dunnewold, Jane. *Complex Cloth: A Comprehensive Guide to Surface Design*. Bothell, WA: Martingale, 2009.

Edmonds, Janet. *Three-Dimensional Embroidery*. London, UK: Batsford, 2005.

Gilman, Rayna. *Create Your Own Free-Form Quilts: A Stress-Free Journey to Original Design*. Concord, CA: C&T Publishing, 2011.

Johansen, Linda. *Fast, Fun & Easy Fabric Bowls*. Concord, CA: C&T Publishing, 2003.

———. *Fast, Fun & Easy Fabric Vases: 6 Sensational Shapes—Unlimited Possibilities*. Concord, CA: C&T Publishing, 2005.

Lee, Ruth. *Three-Dimensional Textiles with Coils, Loops, Knots and Nets*. London, UK: Batsford, 2010.

Meech, Sandra. *Connecting Design to Stitch*. Concord, CA: C&T Publishing, 2012.

Reid, Alison. *Stitch Magic: A Compendium of Techniques for Stitching Fabric into Exciting New Forms and Fashions*. New York, NY: Abrams 2011.

Rezendes, Cheryl. *Fabric Surface Design: Painting, Stamping, Rubbing, Stenciling, Silk Screening, Resists, Image Transfer, Marbling, Crayons & Colored Pencils, Batik, Nature Prints, Monotype Printing*. New York, NY: Workman Publishing, 2013.

Vyzoviti, Sophia. *Supersurfaces: Folding as a Method of Generating Forms for Architecture, Products and Fashion*. Netherlands: BIS Amsterdam, 2006.

Wolff, Colette. *The Art of Manipulating Fabric*. Lola, WI: Krause, 1996.

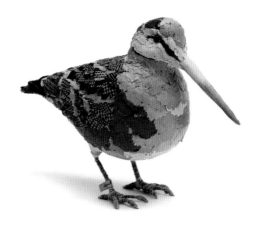

ANDRA F. STANTON is a retired psychotherapist currently writing about and manipulating fabric in Boulder, Colorado. She first investigated fiber art for her book, *Zapotec Weavers of Teotitlán* (Museum of New Mexico Press). She went on to explore other art forms, especially art quilting, surface design, mixed media, and dimensional composition.

Stanton's artwork, such as *Crooked Path*, is based on her psychological response to her physical disability, the result of a failed spinal surgery. The best way to find comfort, she has concluded, is contributing to the story of humanity through friendship, altruism, curiosity, and creativity—and celebrating those whose art lifts us all. Stanton is also the author of *Pilates for Fragile Backs* (New Harbinger).

Andra Fischgrund Stanton. *A Crooked Path*, 2016. 24" × 3" × 3". Driftwood, wood blocks, leaf-printed cotton fabric, hand-painted thread, Sashiko and commercial cotton thread. Photography: Michael Lindenberger.

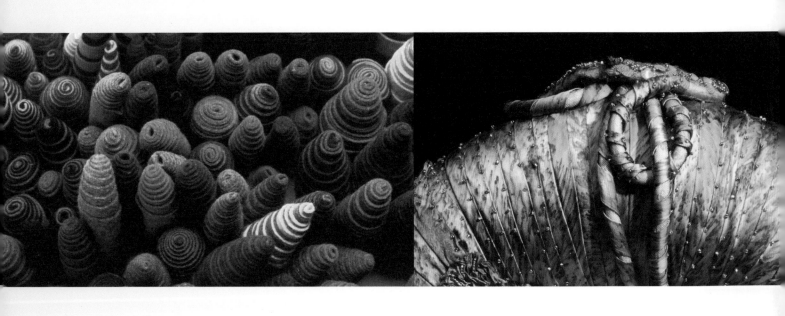